Comics & Ideology

POPULAR CULTURE ▲ EVERYDAY LIFE

Toby Miller
General Editor

Vol. 2

PETER LANG
New York • Washington, D.C./Baltimore • Bern
Frankfurt am Main • Berlin • Brussels • Vienna • Oxford

Comics & Ideology

EDITED BY

Matthew P. McAllister,
Edward H. Sewell, Jr.,
and Ian Gordon

PETER LANG
New York • Washington, D.C./Baltimore • Bern
Frankfurt am Main • Berlin • Brussels • Vienna • Oxford

Library of Congress Cataloging-in-Publication Data

Comics and ideology / edited by Matthew P. McAllister,
Edward H. Sewell, Jr., and Ian Gordon.
p. cm. — (Popular culture and everyday life; vol. 2)
1. Comic books, strips, etc.—Political aspects. I. McAllister, Matthew P.
II. Sewell, Edward H. III. Gordon, Ian. IV. Series.
PN6714 .C656 741.5—dc21 00-048743
ISBN 0-8204-5249-1
ISSN 1529-2428

Die Deutsche Bibliothek-CIP-Einheitsaufnahme

Comics and ideology / ed. by: Matthew P. McAllister....
—New York; Washington, D.C./Baltimore; Bern;
Frankfurt am Main; Berlin; Brussels; Vienna; Oxford: Lang.
(Popular culture and everyday life; Vol. 2)
ISBN 0-8204-5249-1

Cover design by Lisa Dillon

The paper in this book meets the guidelines for permanence and durability
of the Committee on Production Guidelines for Book Longevity
of the Council of Library Resources.

Printed in the United States of America

Matt McAllister dedicates this book to his friends, especially Mary Beth Oliver and John Christman.

Edd Sewell dedicates this book to Judy, whose patience and understanding simply boggle his mind!

Ian Gordon dedicates this book to his wife Chaity.

Acknowledgments

As with all books, this one is the product of many people. First of all, we would like to thank the chapter authors of *Comics and Ideology* for their hard work and intellect. They have been patient, dedicated and insightful as this project has moved forward.

We would also like to thank Sophy Craze, our acquisitions editor at Peter Lang and Toby Miller, the series editor, for taking a chance on the project and providing valuable insight throughout the project's development. Janet Sadler, our copy editor, provided meticulous editing of the manuscript. Bernadette Alfaro, the production coordinator, has provided key advising tips about preparing the manuscript. Jing Jiang read the manuscript for typos and stylistic errors. Two esteemed comics scholars, Amy Kiste Nyberg and Rusty Witek, offered valuable prepublication comments about the project.

We would also like to thank the many previous scholars who have written about the comics. Researchers such as Amy and Rusty as well as John Lent, editor of *International Journal of Comic Art*, have contributed mightily to the legitimization of comic art scholarship.

Grateful acknowledgment is hereby made to copyright holders for permission to use the following copyrighted material that did not fall under fair use guidelines:

Lau, L. (1998). *Mom's drawer at the bottom*. Reprinted with permission of Lau Lee-lee. Permission also granted for cover art, Lau, L. (1998). Big difference. *Mom's drawer at the bottom*, p. 63. Reprinted by permission of Lau Lee-lee.

Trudeau, G. B. (1976, February 9–10). *Doonesbury*. DOONESBURY © G. B Trudeau. Reprinted with permission of Universal Press Syndicate. All rights reserved.

Johnston, L. (1993, March 26–27). For Better or for Worse. FOR BETTER OF FOR WORSE © UFS. Reprinted by permission. All rights reserved.

Denson, A. (1997, July). *Tough Love,* 6(8), p. 45. © 1997 Abby Denson, *XY Magazine.* Reprinted by permission. All rights reserved. Permission also granted for cover art. Reprinted by permission of Abby Denson and *XY Magazine.* All rights reserved.

Phillips, J. (1999, March). Club Survival 101, *1*(17), p. 42. © 1999 Joe Phillips, *XY Magazine.* Reprinted by permission. All rights reserved. Permission also granted for cover art. Reprinted by permission of Joe Phillips and *XY Magazine.* All rights reserved.

Fox, G. (1999). *Kyle's Bed and Breakfast, 1*(5 & 6). © 1999 Greg Fox. Reprinted by permission of the publisher. All rights reserved. Permission also granted for cover art. Reprinted by permission of Greg Fox. All rights reserved.

Adams, S. (1996). *Dilbert daily calendar,* n.p. DILBERT reprinted by permission of United Feature Syndicate, Inc.

Adams, S. (1999). *Don't step in the leadership,* p. 188. DILBERT reprinted by permission of United Feature Syndicate, Inc.

Contents

Figures

Chapter 1

Introducing Comics and Ideology

Matthew P. McAllister, Edward H. Sewell, Jr.,
and Ian Gordon

All comics are political.
—Alan Moore, comic book writer (quoted in Sabin, 1993, p. 89).

In 1895 the Yellow Kid, one of the first regularly appearing comic characters, premiered in Joseph Pulitzer's newspaper, *The New York World*. The Kid, an impish, bald child in a yellow nightshirt created by Richard Felton Outcault, lived in a mythical urban environment called *Hogan's Alley*, the early title of the comic. Although this strip is often discussed by comic art historians because of the influence it had on later strips, including the promotion and merchandising of popular comics characters and the establishment of the importance of comic strips to the U.S. newspaper industry (Gordon, 1998; Witek, 1999), a modern look at the Yellow Kid is striking not because of how similar it was to later strips, but rather how different it was.

Compared with the middle-class orientation of many modern comic strips, the setting of the Yellow Kid's adventures was dirty, cluttered, and characterized by in-your-face urban poverty. The Yellow Kid and his friends were poor, and many seemed to live on the streets. Their environment was a slum, their clothes were simple, and there was often a look of poverty even in their facial expressions. Although Outcault took heat from his contemporaries who felt that his work celebrated life in the slums (De Haven, 1995), later comics historians pointed to the social criticism in *Hogan's Alley*. One critic argued about the Yellow Kid that his world "was that of tough, dirty little immigrant kids and disheveled old women with sad eyes and a hopeless look on their faces," and although the strip was designed to

be funny, "the sense of fantasy and use of humor masked a sense of despair" (Berger, 1973, p. 27). Humor was often based on the kids imitating "high class" activities and pretensions. When a Hogan's Alley resident asked a friend of the Kid's, "Little Rosilia McGraw," to join the group in a game, she indignantly snapped: "No; we won't come and play with youz, Delia Costigan. Our rejuced means may temporary necessitate our residin' in a rear tenement, but we're jist as exclusive as when we lived on the first floor front and papa had charge of the pound in the Department of Canine Captivity!" (to view this strip, see Gordon, 1998, p. 27). No strip appearing in current U.S. mainstream newspapers today comes even close to portraying urban blight as starkly as did *Hogan's Alley*.

The obvious portrayal of the urban poor in an historically significant comic, creating a "sharp satire on city poverty" (Sabin, 1993, p. 134), highlights the role of ideology in comic art. This book will explore several of the implications and manifestations of ideology in the comics. Admittedly, the definition of "ideology" can be a slippery one. It can be defined narrowly, focusing explicitly on mainstream Politics (with a capital P) when discussing liberal versus conservative positions on issues, a definition that comics critic Arthur Asa Berger seems to adopt in his discussion of the ideology of the U.S. comic strip *Pogo* (1973, p. 173). Or it can be defined very broadly, to encompass issues of mediated-persuasion and discussions of the influence of the mass media on its audiences, no matter what the nature of that influence (Barker, 1989, chapter 1). For the purposes of this book, ideology is strongly tied in with issues of social power. It asks: Why and how may comics challenge and/or perpetuate power differences in society? Do comics serve to celebrate and legitimize dominant values and institutions in society, or do they critique and subvert the status quo?

These, of course, are complex questions, with many different approaches that can be used to address them. Accordingly, this book examines how issues of social power are interwoven in various forms of comic art—including comic books and comic strips—with different critical lenses. Essays in this book take diverse theoretical perspectives such as cultural studies, political economy, feminist criticism, queer studies, and mythic analysis, all focusing on the relationship of comics with issues of social division. Diverse social divisions—including

gender, nationality and ethnicity, sexual orientation, and class—are also covered. Mainstream comic icons such as Superman, Wonder Woman, and Dilbert are the subject of chapters, as are alternative forms such as feminist comics and comics in gay/lesbian publications. The authors often take different positions from each other, arguing at times that comics serve as oppositional culture, that comics connect to dominant ideologies, or even, of course, that comics have contradictory ideological dimensions.

Why is it important to focus on ideological issues when discussing comic art? Certainly much research about comics has focused on elements other than the ideological. Scholarship about comic art—comic strips, comic books, and editorial cartoons—is highly diverse in its approaches and perspectives (Lombard, Lent, Greenwood, & Tunc, 1999). Research has been conducted that explores the ways comics communicate (Carrier, 2000; McCloud, 1993); the potential for comics as an educational and literacy tool (Gower, 1995); the effects of comics on children (Wertham, 1954 is of course the most notorious here); the persuasive rhetoric of the comic form (Edwards & Winkler, 1997); the psychoanalytic nature of comics (Adams, 1983); the history of comics and their controversies (Barker, 1984; Harvey, 1996; Lent, 1999; Nyberg, 1998; Rubenstein, 1998); and the fans/audience of comics (Brown, 1997; Pustz, 1999; Tankel & Murphy, 1998), to name but a few. Despite this diversity, an ideological approach to comics is warranted for at least two reasons.

First, the nature of comic art makes the form ideologically interesting. Comic art combines printed words and pictures in a unique way. The complex nature of this combination allows for much flexibility in the manipulation of meaning, but often in a context that is constrained within a small space (four panels in a newspaper strip; 20 pages or so in a typical comic book issue). These characteristics have implications for both representation and interpretation of ideological images and meaning. On the one hand, the communicative elements in comic art encourage the form to occasionally create a closed ideological text, imposing on the reader preferred meanings. The limited space in which the artist/writer has to work, for example, may entice the creator to use stereotypes to convey information quickly (Walker, 1994, p. 9). Similarly, the use of storytelling devices such as captions and thought balloons can make the themes and

values in a comic especially explicit. On the other hand, techniques—such as the ease of comics to visually change the point of view in a comic strip or book (Carrier, 2000, p. 55) and the semantic space created by the sometimes ambiguous relationship between word and picture (Barker, 1989, pp. 11–12)—make comics a potentially poly-semic text, encouraging multiple interpretations, even ones completely oppositional to any specific artistic intent.

A second reason that ideological analysis may apply to the understanding of comics is the form's social significance. Although often comics are dismissed as the insignificant "funnies," they are also highly ego-involving for many readers, children and adult. The ritual nature of reading the comic-strip page of the newspaper (something read every day by both adults and children) can make the form a key part of the morning routine. One early example of mass media uses and gratifications research argued that people missed the habitual reading of the comics during a 1945 newspaper strike as much if not more than the front-page news (Berelson, 1949). The literally thousands of worldwide television and newspaper stories about the February 2000 death of Charles Schultz, the creator of *Peanuts*, illustrates the newsworthiness of celebrities made in the funny pages. With comic books, the "fanboy" culture cultivated in published letters to the editor, comic book conventions, and retail shops are indicative of diverse interpretative "reading communities" (Pustz, 1999, p. 20) that debate with passion the interpretation of various story threads and character assets. Thus for many people the comics are quite significant to their lives.

This is true not just in the United States, but throughout the world. Comic art is much higher on the cultural hierarchy in such countries as France, Italy and Belgium than in the United States (Sabin, 1993, pp. 184–199). By the early 1990s, the largest comics industry in the world was found not in the United States, but in Japan (Sabin, 1993, p. 199). Local production of comic books in Hong Kong, Korea, and Taiwan, often in the shadow of the Japanese *manga* comic books, thrived by the mid-1990s (Lent, 1995). In Mexico, comic books have historically been among the best-selling periodicals, appealing to both adults and children (Rubenstein, 1998, p. 8). How these comics fit in with the socio-political context of these countries, given the different roles that the comics may play in these countries, is a question of

ideological import, as is the potential of the role of the comics in the creation or resistance of cultural identity and imperialism, given the economic and cultural dominance of such countries as the United States and Japan.

The ideology of the comics has of course been dealt with in comics scholarship well before this book. This previous research has emphasized the fact that the portrayals of life found in comic art are not neutral or random images. In practice, not just in theory, often comics' portrayals of social issues and representations of particular groups have significant ideological implications. In fact, some of the most significant studies of comic books and popular culture—key research texts—have focused on the ideology of comic books. These studies have not just influenced comic book scholarship, but also have been profoundly visible in media studies and critical theory.

Probably the most famous, and infamous, example of comic book research—although it was intended for a popular audience—is Fredric Wertham's 1954 *Seduction of the Innocent* (*SOTI*). Derided and hated by many comics fans today, Wertham's book is seen as the catalyst for an anti-comics campaign that economically crippled and culturally bowdlerized comic book production not just in the United States, but in as many as seventeen countries during the 1950s (Barker, 1999, p. 69). Intended as a polemic against what Wertham saw were abuses by the U.S. comic book industry, this book was highly ideological in its arguments, the background of its author, and the political players that became enmeshed in the resulting controversy.

The most sensational images and descriptions of comics in the book were of the explicit sex and violence found in crime and horror comics of the time. Although Barker (1989) argues that these typical "media effects" issues are ideological in and of themselves, other charges made by Wertham in *SOTI* are even more firmly ideological.

Wertham at times seems progressive and even Marxist in tone when he explores the sexist, racist, and fascist values he believed to be found in many comic books. His chapter on advertising in comics raises concerns similar to later critical scholarship about advertising dealing with body image and commodity fetishism (although Wertham does not use that term). As Nyberg concludes about *SOTI*, "Wertham's ideological analysis, while relatively unsophisticated,

would not be out of place in the company of media scholarship that addresses many of the same issues" (Nyberg, 1998, p. 95).

Wertham himself, in fact, was arguably influenced by European "mass culture" theorists such as Theodor Adorno (Nyberg, 1998, p. 87). Certainly Wertham's ideas struck a chord with many critical scholars and political activists at the time. The critical sociologist C. Wright Mills wrote a favorable review of *SOTI* in the *New York Times Book Review* and before the review was published sent Wertham a complimentary letter wishing him "good luck" (quoted in Gilbert, 1986, p. 103). In Britain and Australia, activists in the Communist Party used the controversy sparked by *SOTI* to raise issues about American cultural imperialism and the dangers of mass culture (Barker, 1984; 1999).

Other parts of Wertham's critique of comics—and the resulting alliances and policies that followed—had anti-progressive elements to them. Certainly some of his arguments reflect, in modern context, a conservative critique of comics' ideology. Wertham's elaboration on the Batman and Robin relationship as "a wish dream of two homosexuals living together" (p. 190), and his accompanying quotations from gay youth under his treatment, may trigger a feeling of empathic despair in modern readers for the sexual repression done to youth during such "treatments" (for a discussion of *SOTI* from a queer studies perspective, see Medhurst, 1991). Barker (1999) argues that Wertham's potentially radical critique was undermined by his faith in traditional institutions such as the law and the alliances he struck with more conservative institutions like organizers in the Catholic Church (see also Nyberg, 1998). By attacking all comics with such a broad stroke, Wertham also missed more subtle textual and interpretative cues that actually critiqued dominant institutions rather than celebrated the status quo, especially true in his interpretations of some EC Comics (Nyberg, 1998). Sabin argues, in fact, that war comics of the 1950s, often more patriotic in tone but just as violent as other books, were generally ignored by crusaders while the more liberal-leaning EC books were targeted (1993, p. 153). In the United States, the self-regulatory Comics Code which resulted from the controversy fanned by Wertham constrained comics in their potential role as oppositional culture. With such provisions as "Policemen, judges, government officials and respected institutions shall never be

presented in such a way as to create disrespect for established authorities," the Comics Code established in the mid-1950s muted "the vitality of comics and to ratify authoritarian social control" (Witek, 1989, p. 49).

If Wertham's work is dismissed by media studies scholars as a product of its times or as populist propaganda, other research that highlighted the ideology of comics is often lauded as having a significant impact on later ideological research. Next to *SOTI*, perhaps the best known example of comics criticism is Ariel Dorfman and Armand Mattelart's *How to Read Donald Duck: Imperialist Ideology in the Disney Comic*, originally published in 1971. An attack on Disney comic books that were imported into South America (particularly Chile) in the late 1960s and early 1970s, this book has been called "one of the most important studies of comics ever undertaken" (Barker, 1989, p. 16), and is "often cited as a paradigm of Marxist cultural analysis" (Bongco, 2000, p. 9). Focusing specifically on the pro-capitalistic values in Disney comics, Dorfman and Mattelart's book sold 500,000 copies in the 1970s alone. It was seen as such an effective anti-capitalist work that the corporate friendly dictator Augusto Pinochet specifically targeted this book for burning when he forcibly came into power in Chile in 1973 (Solomon, 1999).

Similarly, Angela's McRobbie's various works on the British teen-girl magazine *Jackie*—a magazine that had strong comics elements—is also influential in the development of feminist cultural studies. Beginning with work published in Britain in the late 1970s, and then made more widely available in 1991 with the publication of *Feminism and Youth Culture*, McRobbie was one of the first scholars to treat girls' culture as something worthy of academic study. Arguing that the message of the 1960s' *Jackie* ultimately served patriarchal culture by preparing girls for adulthood through the values of traditional femininity and consumer culture, McRobbie's work has been called "groundbreaking" (Mazzarella, 1999, p. 97) and has been credited specifically with cultivating scholarship about girls' culture (Pecora & Mazzarella, 1999). (For a critique of both Dorfman and Mattelart's work and McRobbie's work as comics scholarship, see Barker, 1989).

The above research mainly focused on mainstream comics: the work produced by for-profit businesses and distributed in routinized publication outlets and, this research argues, often producing

messages that especially flow with dominant ideology. But another interesting element in the ideology of comics is the role of alternative, even underground, comics as oppositional culture. Although other media have radical forms, the availability of self-publishing technologies and political freedom of underground "comix" is especially influential, shaping both the development of the comics industry and the ideological scope of the medium.

Grounded in the counter-cultural movements of the 1960s, underground comix are perhaps the most significant cultural legacy of this movement, excepting music (Witek, 1989, p. 51). Taking advantage of cheap printing technology such as offset litho printing and alternative outlets like music stores and "head shops," these comix reflected and commented on the social divisions and tensions of American society during this time (Sabin, 1993). Characters such as "Whiteman," created by Robert Crumb; the anarchist hero "Trashman," by Manuel 'Spain' Rodriguez; and titles including *Class War Comix* and *Slow Death* ridiculed dominant institutions like government and consumer culture with explicit language and portrayals.

The underground comix influenced current comics and the social messages in these comics. For example, comix illustrated to mainstream creators the potential for social criticism that the comics medium may have. They also loosened organizational constraints by encouraging creators to form independent production companies and retain the ownership and copyright to their characters as an alternative to the traditional "work for hire" system in which the company owns the character and the pages (Sabin, 1993). In addition, many of the most provocative comics of the 1980s and 1990s, such as Art Spiegelman's *Maus* and Harvey Pekar's *American Splendor*, have direct lineages to the undergrounds (Witek, 1989). Even in the comic-strip pages one sees the influence of underground comix, especially in papers that carry Bill Griffith's absurdist *Zippy the Pinhead*. Today, the Internet provides an additional alternative "publishing" outlet for comic book creators who wish to go a different route than the mainstream offers.

However, another legacy of the undergrounds is more a reaction to them than their outgrowth: the rise of feminist comics (Sabin, 1993, p. 224). Although many of the early feminist comic creators lived in

the environment of the underground comix of the late 1960s/early 1970s and thus were used to the idea of self-published comix, the sexist themes and images of many of the underground comix (as well as their inaccessibility to women contributors) sparked such creators as Trina Robbins and Joyce Farmer to create comics with a decidedly feminist orientation (Robbins, 1999). Dealing frankly with such issues as rape, abortion, sexual harassment, and gender discrimination, these works helped cultivate the women's voice in comics beyond works such as *Jackie* in Great Britain or *Superman's Girl Friend: Lois Lane* in the United States.

Building on the research legacy of such critics as Angela McRobbie, and noting the potential for both dominant and resistant ideology in comics, specific chapters in this book focus on many of the ideological issues discussed above. Applying political economy to comic books, Matthew P. McAllister explores in the next chapter the relationship between the production context of comic books and the constraints on messages that these books may produce. He argues that recent trends toward ownership concentration and media conglomeration undermine innovation by stressing conventional content, contribute to a financial crisis faced by the industry in the mid-1990s, and disadvantage smaller publishers and retailers who often present alternative voices in the industry.

The next three chapters discuss gender themes in comics. Taking a historical perspective, J. Robyn Goodman's chapter focuses on the depictions of women's suffrage in cartoons in the early twentieth-century humor magazine, *Life*. Concentrating on the years 1909 to 1914, the author notes that over 80% of the cartoons reflected an antisuffragist ideology. Women, for example, were often portrayed as being biologically unfit to vote, and suffragists were portrayed as unnaturally masculine.

Although the two chapters that follow continue to focus on images of women in comics, they bring in an international perspective by concentrating on Asian comics. Wendy Siuyi Wong and Lisa M. Cuklanz examine the recent work of Lau Lee-lee, a prominent feminist comic artist in Hong Kong. After presenting a history of key women comic artists in Hong Kong, the chapter provides a detailed examination of the themes and ideology in Lau's work to illustrate the ways in which she provides a feminist critique and vision within

the Hong Kong context. Alternatively, the next chapter, "The Dominant Trope," by Anne Cooper-Chen, explores dominant patriarchal ideology portrayed through the gender roles and sexualized portrayals of women in three contemporary life narratives found in the Japanese manga *Weekly Young Jump*. The author points out that portrayals of the male gaze in this publication often focus on nude women and "panty views," and sexual assaults by males figure prominently.

Chapters 6 and 7 highlight portrayals of nationality and international conflict in comics. Chapter 6 begins with the premise that Wonder Woman, an Amazon figure attempting to live in the United States, has symbolized the immigrant in Western society since her first appearance in the 1940s. However, author Matthew J. Smith also notes that the portrayal of Wonder Woman has not been static, but rather the image of the character as an immigrant has been viewed with changing ideological frameworks that include various models of assimilation and accommodation. Using post-colonial literature, this chapter does a deep reading of the different depictions of Wonder Woman's adjustment to a dominant culture, highlighting the ideological implications of each. Annette Matton's chapter is an analysis of Marvel's *The 'Nam*, published from 1986 to 1993, and touted as a "realistic" portrayal of the United States' involvement in Vietnam. Exploring the ideology of realism and military conflict that pervaded *The 'Nam*, Matton argues that American soldiers were often portrayed heroically, while the Vietnamese were visually dehumanized.

The role of the superhero and the antihero in comics—and their ideological implications—comprise the next two chapters. Ian Gordon examines numerous incarnations of Superman to show the ideological dimensions of nostalgia. His essay highlights an intersection between nostalgia and mythology in the ongoing tale of Superman. Gordon points out that recent versions of Superman, such as in DC Comics' *Kingdom Come* and TV's *Lois and Clark*, have attempted to rework the character of Superman for [post]modern times while deploying features of earlier incarnations. In this essay, Gordon suggests that newer incarnations, demonstrating deep-seated yearnings for an idealized, more innocent time, construct nostalgia ideologically. The essay by Matthew T. Althouse analyzes the polysemic nature of a more brutal character—*Judge Dredd*, a British comic. The author contends

that Dredd's early appeal hinged on the reader's ability to participate in the creation of meaning in relation to social fallout created by Margaret Thatcher's reform initiatives during the 1980s. The study argues that *Judge Dredd* is an equivocal text that appealed to both liberals and conservatives in the British public.

The portrayal of gay characters, readers' reactions to these characters, and the application of queer theory to comics scholarship are themes explored by chapters 10 and 11. Morris E. Franklin III conducts an analysis of Letters to the Editor, including the editors' response to these letters, of comic books that featured gay characters. The essay focuses on DC's *Superman* and *Green Arrow* titles in the late 1980s, and DC's *The Flash*, Marvel's *Alpha Flight* and Innovation's *Quantum Leap* from the early- to mid-1990s. Arguing that letter columns in comic books, coupled with the nature of the medium, provide a unique way of thinking and writing about social issues, the chapter illustrates the distinct manner of "outing" that matches up with a decisive change in the way readers' reactions are handled and even presented in the different comic books. Similarly, the chapter by Edward H. Sewell, Jr. critiques queer characters in both traditional and alternative publications from a queer theory perspective. The primary question is: What does it mean to be queer in the comic strips? Sewell argues that mainstream portrayals tend to present gay characters as assimilated in straight society, whereas alternative publications stress the unique nature of gay and lesbian communities.

Finally, in chapter 12 Julie Davis tackles one of the most popular comic strips in the United States by exploring the degree to which *Dilbert* serves as oppositional culture by critiquing certain economic and social ideals of society. By looking at the characters and plots of the cartoon as well as the official *Dilbert* web site, the essay argues that *Dilbert* exposes the excesses of the American business system and helps build a "community of labor."

References

Adams, K. A. (1983). The greatest American hero: Ego ideals and familial experiences. *The Journal of Psychoanalytic Anthropology, 6*(4), 345–413.

Barker, M. (1984). *A haunt of fears: The strange history of the British horror comics campaign*. London: Pluto Press.

Barker, M. (1989). *Comics: Ideology, power and the critics.* Manchester, England: Manchester University Press.

Barker, M. (1999). Getting a conviction: Or, how the British horror comics campaign only just succeeded. In J. A. Lent (Ed.), *Pulp demons: International dimensions of the postwar anti-comics campaign* (pp. 69–92). Cranbury, NJ: Associated University Presses.

Berelson, B. (1949). What "missing the newspaper" means. In P. F. Lazarfeld & F. N. Stanton (Eds.), *Communications research, 1948–1949* (pp. 111–128). New York: Harper & Brothers.

Berger, A. A. (1973). *The comic-stripped American.* Baltimore: Penguin Books.

Bongco, M. (2000). *Reading comics: Language, culture, and the concept of the superhero in comic books.* New York: Garland Publishing.

Brown, J. A. (1997). Comic book fandom and cultural capital. *Journal of Popular Culture, 30*(4), 13–31.

Carrier, D. (2000). *The aesthetics of comics.* University Park, PA: Pennsylvania State University Press.

Dorfman, A., & Mattelart, A. (1971/1984). *How to read Donald Duck: Imperialist ideology in the Disney comic.* New York: I.G. Editions.

De Haven, T. (1995). Borrowing Richard Outcault. *Inks, 2*(3), 18–20.

Edwards, J. L., & Winkler, C. K. (1997). Representative form and the visual ideograph: The Iwo Jima image in editorial cartoons. *Quarterly Journal of Speech, 83*(3), 289–310.

Gilbert, J. (1986). *A cycle of outrage: America's reaction to the juvenile delinquent in the 1950s.* New York: Oxford University Press.

Gower, D. L. (1995). Health-related content in daily newspaper comic strips: A content analysis with implications for health education. *Education, 116*(1), 37–43.

Gordon, I. (1998). *Comic strips and consumer culture, 1890–1945,* Washington: Smithsonian Institution Press.

Harvey, R. C. (1996). *The art of the comic book: An aesthetic history.* Jackson, MS: University Press of Mississippi.

Lent, J. A. (1995). Comics in East Asian countries: A contemporary survey. *Journal of Popular Culture, 29*(1), 185–198.

Lent, J. A. (Ed.). (1999). *Pulp demons: International dimensions of the postwar anti-comics campaign.* Cranbury, NJ: Associated University Presses.

Lombard, M., Lent, J. A., Greenwood, L., & Tunc, A. (1999). A framework for studying comic art. *International Journal of Comic Art, 1*(1), 17–32.

Mazzarella, S. R. (1999). The 'superbowl of all dates': Teenage girl magazines and the commodification of the perfect prom. In S. R. Mazzarella & N. Pecora (Eds.), *Growing up girls: Popular culture and the construction of identity* (pp. 97–112). New York: Peter Lang Publishing.

McCloud, S. (1993). *Understanding comics.* Northampton, MA: Kitchen Sink Press.

McRobbie, A. (1991). *Feminism and youth culture: From Jackie to Just Seventeen.* Boston: Unwin Hyman.

Medhurst, A. (1991). Batman, deviance and camp. In R. E. Pearson & W. Uricchio (Eds.), *The many lives of the Batman: Critical approaches to a superhero and his media* (pp. 149–163). New York: Routledge.

Nyberg, A. K. (1998). *Seal of approval: The history of the Comics Code*, Jackson, MS: University Press of Mississippi.

Pecora, N., & Mazzarella, S. R. (1999). Introduction. In S. R. Mazzarella & N. Pecora (Eds.), *Growing up girls: Popular culture and the construction of identity* (pp. 1–10). New York: Peter Lang Publishing.

Pustz, M. J. (1999). *Comic book culture: Fanboys and true believers.* Jackson, MS: University Press of Mississippi.

Robbins, T. (1999). *From girls to grrrlz: A history of women's comics from teens to zines.* San Francisco, CA: Chronicle Books.

Rubenstein, A. (1998). *Bad language, naked ladies, & other threats to the nation: A political history of comic books in Mexico.* Durham, NC: Duke University Press.

Sabin, R. (1993). *Adult comics: An introduction.* New York: Routledge.

Solomon, N. (1999, March 11). *Keeping Mickey in the private domain.* Retrieved July 4, 2000 from the World Wide Web: http://www.fair.org/mediabeat/990310.html

Tankel, J. D., & Murphy, B. K. (1998). Collecting comic books: A study of the fan and curatorial consumption. In C. Harris & A. Alexander (Eds.), *Theorizing fandom.* (pp. 53–66) Cresskill, NJ: Hampton Press.

Walker, L. (1994). The feminine condition: Cartoon images of women in *The New Yorker. Inks, 1*(3), 8–17.

Wertham, F. (1954). *Seduction of the innocent.* New York: Irwin & Company.

Witek, J. (1989). *Comic books as history: The narrative art of Jack Jackson, Art Spiegelman, and Harvey Pekar.* Jackson, MS: University Press of Mississippi.

Witek, J. (1999). Comics criticism in the United States: A brief historical survey. *International Journal of Comic Art, 1*(1), 4–16.

Chapter 2

Ownership Concentration
in the U.S. Comic Book Industry

Matthew P. McAllister

In the May 24, 1998 issue of *The New York Times*, there appeared a
3,200-word essay about the Marvel Entertainment Group, for years
the dominant publisher in the comic book industry (Bryant, 1998).
The illustration that accompanied the story was a drawing of two
angry figures slugging it out in a fierce battle royale. However, this
article did not appear in the entertainment section, the arts section, or
even the book section. It appeared in the business section. The article
was not about the hottest titles, characters or artists, but instead about
stock values, junk bonds, and corporate assets. And the two figures
pummeling each other were not fictional superheroes, but rather cari-
catures of two Wall Street moguls, Ronald Perelman and Carl Icahn. In
fact, the news article focused specifically on the dire nature of the
comic book market and the struggle for control over Marvel, the
industry leader, that took place between these two financial tycoons.
This article joined a series of news reports from 1996 through 1998
that appeared in other business venues like *The Wall Street Journal*,
The Hollywood Reporter, and *The Financial Times* of London.

 Such articles collectively presented a troubled image of the
economic and industrial dynamics of the comic book industry in the
late 1990s. This chapter will focus on these dynamics from the
perspective of political economy, arguing that the comic book
industry is characterized by increased conglomeration and ownership
concentration. Such characteristics do not just affect corporate inves-
tors, but have profound implications for the future of the industry,
both in terms of its economic stability and the ideological diversity of
its content.

Political Economy and Media Ownership

A political economy perspective of media focuses on the "interplay between the symbolic and economic dimensions of public communications" (Golding & Murdoch, 1991, p. 15). It asks how the economic makeup of media industries—including such issues as market concentration/diversity, media organization ownership, institutional power and revenue sources, and state intervention—influences democratic life (Mosco, 1996). This perspective connects issues of media production to issues of media content, media access, and economic equality. Political economy assumes that the ideal media system for a democracy would have certain characteristics, including content diversity, open access, and political relevance. Approaching media from a decidedly normative and evaluative perspective, this perspective often argues that what may be in media organizations' best economic interests is not always in society's best democratic interests.

Political economy has been especially valuable in understanding recent directions in modern communication systems—including increased economic influence over media systems by advertising (Andersen, 1995; Baker, 1994; McAllister, 1996) and the global reach of media conglomerates (Barnet & Cavanagh, 1994; Herman & McChesney, 1997). Political economy analyzes the reasons for these trends; their social, cultural, political and economic implications; and possible avenues for change.

One significant example of a trend targeted by political economists is the concentration of ownership and market control by large media conglomerates. In fact, Mosco writes about this research perspective that "one of the principal substantive themes in North American research draws from political economy's general concern with ownership concentration" (1996, p. 89). As McChesney (1997) points out, Ben Bagdikian, a leading critic of the growth of media conglomerates, has long documented with each new edition of his much-cited book the increasing power in a decreasing number of dominant media: from 50 in 1984 to 26 in 1987; from 23 in 1990 to less than 20 in 1993; from 10 in 1996 to just 6 in 2000 (Bagdikian, 2000). Such giants have influence in many different media industries (such as Time Warner's presence in film, television, publishing and other media) and/or dominate one particular media industry (such as

the newspaper chain Gannett). Critics have raised serious concerns about this development (Aufderheide et al., 1997; Bagdikian, 2000; McAllister, 1996; McChesney, 1997; Meehan, 1991). The control of information in so few hands grants these leading corporations the ability to influence cultural and economic trends, political policy, and technological development in ways that may benefit the short-term quarterly report but not the long-term society. Similarly, the diversity of information produced by corporations driven by the same basic corporate structure and economic forces and moving the same media images through a variety of outlets may be minimal.

Political Economy and Comic Books

Although several scholars have analyzed economic and industrial issues with comic books in the United States (McAllister, 1990; Gordon, 1998; Nyberg, 1998; Rhode, 1999; Rogers, 1999; Sabin, 1993), the majority of comic book scholarship since the 1970s has focused on message criticism and analysis (McAllister, 1989). Yet a political economy approach toward comics is important for several reasons.

First, the comic book industry is economically significant. Although the industry experienced a major economic downturn in the mid-1990s, comic book sales reached approximately $425 million in 1997, down from $850 million in 1993. The "direct market"—the more than 4000 comic book shops across the United States—generated $241 million of this, with the remainder coming from such outlets as mass market retailers like Wal-Mart and newsstand distribution. The industry employs approximately 12,000 people. In the grand scheme of media economics, such figures are relatively small. Comic books, however, have additional economic impact. Besides comic book revenue, licensing activities (the sales of comic-book-related merchandise) brings in many more millions. Marvel alone generated $15 million in licensed properties in 1995 (all of the above statistics from Pearson & Miller, 1996; Miller, 1998a; Miller 1998c). The licensing practices of the comic book industry also influence the creation of motion picture and television productions that collectively generate revenue in the billions of dollars. The movie

that generated the biggest domestic box office ($250 million) in 1997 was *Men in Black* ("1997 box office report," 1998), published by Malibu Comics and later acquired by Marvel. *The X-Men*, based upon another Marvel property, brought in over $54 million in its opening weekend in 2000, one of the largest motion picture debuts in history.

A second reason for a political economic perspective is that we might better understand issues surrounding the content and accessibility of comic books through an understanding of the economic structure of the industry. By spotlighting the economic incentives and makeup of the industry, a political economic perspective helps to explain why certain comics may be available and others not available—either because they were not published at all or were not distributed or exhibited.

Finally, analyzing the political economy of comic books can help scholars to better understand the economic behavior and consequences of media generally. Many of the trends discussed below are not peculiar to the comics medium, but are also found in other media. In fact, because of specific dynamics of the comic book industry in the 1990s, trends of modern media industries may be particularly illustrated and effects of these trends starkly revealed. The comic book industry since 1993 has experienced a severe downturn in sales, for example. This downturn can be understood in terms of the industry's political economic behavior, and may help us to understand modern media performance in similar economic circumstances. Similarly, the comic book industry is potentially a revealing microcosm of the increased concentration and conglomeration of media industries as well as of the potential reasons for and effects of this concentration.

Ownership concentration was perhaps the most salient industrial trend of the comic book industry in the 1990s. Two dominant facets of concentration of ownership are discussed below, both having profound implications for the economic health of the comic book industry and for comic book content. The first trend is the high degree of horizontal control found in the contemporary comic book industry. The second is the emphasis on synergistic growth among the major comic book producers, a growth that has increased ownership concentration and placed the comic book industry in jeopardy.

Horizontal Integration in the Comic Book Industry

Although such terms as horizontal integration and vertical integration are commonly used, their definitions may vary (Mosco, 1996). This chapter defines horizontal integration as occurring in a media industry when one or a few key companies control one level of the industry: production, distribution, or exhibition. Three types of horizontal integration are therefore possible. Vertical integration occurs when one company internally has production, distribution, and exhibition resources. Thus, a newspaper company is a vertically integrated organization as it produces the newspaper itself, distributes the newspaper to circulation managers it employs, and exhibits the newspaper via a home delivery system using carriers.

At the turn of the millennium, the comic book industry is dominated by two types of horizontal integration. Oligopolistic integration occurs at the production level, and near monopolistic integration occurs at the distribution level.

Horizontal Integration of Comic Book Production

One way to determine the degree of concentration in an industry is to look at market share: to what extent is industry revenue controlled by a few companies? By this standard, the comic book industry is characterized by an oligopoly at the production level. The direct market accounts for about 80% of all new comic books sold. In 1997, the "Big Two" companies controlled over 60% of direct market sales—Marvel Entertainment Group, Inc. (33%) and DC Comics (28%). Image Comics, created in the early 1990s, accounted for 17%, and Dark Horse rang up 6%. The other 16% was divided among the 496 smaller publishers. This large number of publishers is deceptive, however, because more than a third of them only published one issue of one comic book during 1997 (Miller, 1998b). In mass market retail outlets, such as in Wal-Mart, the Big Two historically dominate even more (Stuempfig, 1994b).

Although figures can vary widely from month to month, both DC and Marvel's direct market share probably increased in the late 1990s, or at the very least stayed level. In August 1992, for example, the two

combined controlled 56% of comic book shop sales. The increased/ sustained concentration has occurred mainly for two reasons, the first being publisher and talent acquisitions by the Big Two. In November 1994 Marvel increased its share of comic sales by acquiring Malibu Comics, which publishes the popular Ultraverse titles (Thompson, 1994), and controlled about 5% of the market before the acquisition (Stuempfig, 1994b). A similar move took place in 1998, when DC bought WildStorm Studios, formerly affiliated with Image comics (Miller, 1999a). The second, more significant, reason concerned sales trends. As noted above, beginning in mid-1993 the comic book industry entered a "bust" period in which direct market sales were halved. The "boom" period that had helped the comics industry in the early 1990s was fueled largely by comics investors—those who bought large quantities of the same issue of certain comics hoping these books would increase in value. In 1993, as publishers played to the investor market with manufactured "special issues," the investor market became oversaturated and collapsed (see, for instance, Bryant, 1998; Evanier, 1996). As a result of economic hardship, many mid-range publishers such as Acclaim, Defiant, Innovation, and Eclipse ceased publishing comics.

However, just looking at market share is not an adequate measure of industry concentration. One should also consider "strategic alliances" in the industry, in which direct ownership is not a factor but competition between separate companies is nevertheless suspended while they share resources for special projects (Mosco, 1996). If industry leaders are involved, such joint ventures accentuate the economic concentration in an industry. Such alliances often undermine the diversity and innovation that economic competition brings, as the dominant companies create connections and partner-ships for their mutual benefit.

In comics, the most common version of the strategic alliance is the inter-publisher cross-over—a story or series of stories where the characters of one publisher interact (translated as fight in the comics world) with characters from another publisher. Such strategic alliances have exploded in the mid-1990s. There were at least 29 different publisher cross-overs in 1996 involving 17 different publishers (Pearson & Miller, 1996). By far the most publicized of the cross-overs was the one involving the two industry leaders, DC and Marvel. Using a

reader polling system to determine readers, the Marvel vs. DC books (published by Marvel) and DC vs. Marvel books (published by DC), featured such contests as Superman versus the Hulk and Captain America versus Batman ("DC takes on Marvel," 1995). Other crossovers, between the two companies as well as between Marvel and the third-place leader in the industry, Image, followed. As one industry observer noted, "Things got out of hand when the Punisher met Archie—yes, *that* Archie" (Voger, 1997, p. 56).

Another indication of market concentration, besides market share and strategic alliances, is the informal organizational influences of dominant companies on smaller companies. Where, for example, are the creative personnel of smaller companies trained? Are the creative personnel trained by the industry leaders, and when these creative personnel move on to form their own companies, do they bring the mindset of the leaders with them? In this light, one may wonder how truly innovate Image Comics was when it was created in early 1992. Given that Image founders such as Jim Lee, Rob Liefeld, and Todd McFarlane cut their creative teeth at Marvel, to what extent could new perspectives prosper? As one industry analyze noted, "...it was once commented that Image wanted to be Marvel in the worst way (and succeeded)..." (David, 1995, p. 102).

Finally, one last indicator of industry concentration is the extent to which the industry leaders are part of a larger, stronger conglomerate (Mosco, 1996). By this measure, DC has a very secure market position. It is part of a company, Time Warner, which had over $24 billion in combined revenues in 1997 (Time Warner, 1998). It is anchored by such holdings as CNN, Warner Films, and HBO. Although as of this writing the corporation is heavily in debt, it has deep pockets to allow its DC subsidiary to survive tough economic times, whereas other independent publishers do not.

But what might this market concentration mean for the content of comics just after the turn of the century? One main implication of Marvel and DC's dominance in comic book production is the glut of superhero comics. This focus is encouraged both by the network of talent cultivated by the Big Two, as well as the target market of these companies. Because Marvel and DC have a stable of characters from this genre and have hired creators skilled in this genre, they tend to focus on the genre. Although many older adults read comics, the

superhero genre, especially, is dominated by teens and even younger children. The buyers of Superman and Batman, according to a 1995 survey, mostly are six- to 19-year olds, and the great majority of comic book purchasers are male ("Who Buys Comic Books," 1995). An added incentive is that the buyers of these books are also desirable for large entertainment companies to reach, companies to which the Big Two are connected. This targeted readership has a lot of disposable income, and the willingness to dispose of it.

The licensing of comic book characters, as will be discussed later, also cultivates this market. Because toys, video games, trading cards, movies and television programs have become dominant generators of revenue for comic book companies, they will produce comics that appeal to buyers of toys, video games, and other merchandise. The teenage-boy demographic, seen as having vast amounts of disposable income, tend to be prime markets for these ancillary products (for a discussion of the emphasis on the teen market by the motion picture studios, see Corliss, 1998).

As DC, Marvel and the similarly marketed Image establish the marketplace definition of comics (featuring overly-endowed male or female superheroes itching for a fight), even new publishers, seeking to fit in with marketplace predictability, accept this definition. At the peak of publishing revenue—generally believed to be the winter of 1992 when sales of DC's "Death of Superman" story line may have led to a $30 million *day* in U.S. comics shops (Miller, 1995)— publishers became attracted to the industry by seeing the superhero comic as the way to make a quick dollar. In fact, often the "innovation" introduced by the smaller publishers was to exaggerate the violence, gore, and sexist portrayals of the superhero comics as a way to compete with the bigger companies (Sullivan, 1996; Voger, 1997). The promotional potential of cross-overs also encouraged a superhero glut as more "special issues" were created to feature such cross-overs and smaller publishers developed superhero comics to exploit cross-over potential.

Such a marketplace hegemony turns away potential readers, publishers, and creators; overshadows other comic genres that crea- tively stretch the medium (see Witek, 1989 for a discussion of histor- ically based comics, for instance); and may have contributed to the drop in sales that began to occur in 1993. By limiting creator

innovation, the "superhero mindset" of the Big Two may have squelched reader attention. As one comic book writer noted: "The industry is still defined by superhero titles. And since readers are sick of or bored by or oversaturated with (pick one) superheroes, they are turning away from our industry, even though we have other items on the menu" (Evanier, 1996, p. 28).

Publishers who attempt to publish non-superhero comics may find distributors and retailers not supporting their efforts, given the predominance of superhero themes and images. When Jim Valentino of Image Comics announced that he was discontinuing his project of publishing diverse genre comics because of a lack of economic success, he argued that "the current market is not a comic-book market; it's a superhero market. The entire industry is in a war of attrition and these kinds of non-superhero titles are the first to feel the crunch" (Dean, 1998, p. 6). The strong oligopolistic emphasis on the superhero comic left the industry in poor shape to react appropriately to the crash by discouraging the development of alternative genres of comics to attract new readers.

Creators may feel the pressure not only to produce superhero comics, but to create *hyper*-superhero comics with maximum potential for cross-overs. Peter David, a columnist for the trade publication *Comics Buyer's Guide* and the writer for Marvel's *The Incredible Hulk* for over a decade, was known for his unconventional story lines including those involving social issues such as domestic violence, capital punishment, and AIDS. David resigned from the title in 1998; one reason given was the organizational pressure to increase the brutality and cross-over potential of the character. As David wrote about his decision to leave the title:

> Ultimately, it was up to me. Up to me to produce the mandated Hulk-centric major storylines that could spread throughout the entire Marvel universe, so that more cross-overs could be done. Up to me to produce a Hulk that was even darker, nastier, and more savage (even mute, it was suggested) than was currently being written. (David, 1998b, p. 82)

A writer who followed David on the title, John Byrne, later stated that the character would indeed change to become the more manic "Hulk Smash!" version of the character. "That's the direction Marvel wants to go," said Byrne (Shutt, 1998, p. 29).

Horizontal Integration of Comic Book Distribution

In addition to the production level, market concentration of the comic book industry occurs at the level of distribution. In this case, it is not an oligopolistic control by a few equally powerful companies, but rather near-monopolistic control by one omnipotent (in terms of industry power) company. This has occurred because of the 1990s economic shakeup and an attempted industrial coup by Marvel. The result was industry-changing. In 1994, there were 10 significant distributors of new comics to comics shops (Pearson & Miller, 1996). Four years later, one distributor, Diamond Comics Distributors Inc., controlled over 90% of comic book distribution (Miller, 1998a).

The industry began noting a long-term decline in direct sales by at least 1994. Individual comics that may have sold a million copies per issue before 1994 sold barely half as much after (Stuempfig, 1994a). Marvel Entertainment reacted to this slump by implementing their "Marvelution" restructuring plan ("Marvel Announces," 1994). This plan included the solidification of horizontal integration with the previously mentioned purchase of Malibu Comics. But, at the end of 1994, Marvel also implied that the plan included vertical integration, specifically *forward* vertical integration. Forward vertical integration occurs when a company acquires another company to extend its ownership control further along the circuit of production–distribution–exhibition (Mosco, 1996). When Marvel, a comics producer, announced it would buy Heroes World, the third-largest direct comics distributor ("Marvel Buys Heroes World," 1995; "Distributors, Retailers Respond," 1995), then Marvel was engaging in forward vertical integration. It was a tactic for gaining increased control over an increasingly uncertain market.

It was Marvel's announcement about how it would use its new distributor, though, that profoundly altered the industry. Marvel announced that, beginning in July 1995, Heroes World would be their exclusive distributor of Marvel comics and merchandise ("Marvel Goes Exclusive," 1995). The advantage of such an arrangement is the guarantee of distributor attention to the owner's products, including enhanced promotion and distribution of products to retailers. In addition, when ownership is a part of the arrangement as it was when Marvel bought Heroes World, the distributor will match up its

distribution activities to the marketing strategy of the publisher.

The exclusivity policy caused a domino effect of similar deals. DC, to gain "most favored nation" status with the largest distributor, Diamond, signed an exclusive deal soon after Marvel's announcement (Gray, 1996, p. 26); the other major publishers—Image and Dark Horse, among others—later also signed exclusive deals with Diamond. With 80% of the comics controlled by two distributors, other comic book distributors found they could not compete. Smaller distributors quickly went out of business. Capital City Distribution, which before the Marvel purchase of Heroes World was the second-largest distributor, was bought by Diamond in July 1996 ("The Distribution Wars," 1996). With this purchase, the distribution level was controlled by a duopoly, Diamond and Heroes World. Finally, the duopoly became a monopoly. Although Heroes World was the third-largest distributor at the time of the Marvel purchase, it still was mainly a regional distributor to the Eastern United States. Marvel management, soon realizing that starting a full-scale distribution system was expensive and difficult, then dismantled Heroes World, finally going exclusive with the sole-standing Diamond (Thompson, 1997).

Thus, Marvel's failure at vertical integration led to the horizontal integration of distribution. Diamond is now a major player in the industry, perhaps *the* major player. Peter David wrote about the industrial influence that Steve Geppi, president of Diamond, wields:

> Steve is now in a position to completely control the ebb and flow of the comics market. If he liked a particular comic book, he could promote the hell out of it. If he didn't like a particular comic book, he could bury it. If a particular publisher offended him or proved too troublesome to carry, he could effectively put the publisher out of business (unless the publisher had the patience, organization, or wherewithal to distribute itself). He could issue editorial fiats: Diamond, he could say, won't carry any comic books that are not in keeping with Steve's personal tastes or preferences. Diamond could also take forever to pay smaller publishers, causing major (possibly terminal) headaches for them. (David, 1996a, p. 106)

Although Geppi has pledged to value the interests of small publishers and diversity (Thompson, 1997a), the complete horizontal control by one company allows that company to exert a large amount of economic and content control. In 1997, the U.S. Justice Department began investigations to determine if illegal trade restraints

exist in comic book distribution (Dean, 1997b).

Small publishers and small retailers alike were potentially weakened by the distributor control. Kitchen Sink Press was one of the casualties of the upheaval during the 1990s. By reprinting the work of former underground artists such as Robert Crumb and providing outlets for adult material like *Omaha The Cat Dancer*, Kitchen Sink was perhaps the most visible of alternatively voiced publishers. Announcing the company's withdrawal from the comics industry, founder Denis Kitchen noted that "I knew—and every other alternative publisher knew—that Capital City was by far their most supportive and progressive distributor," and added

> Diamond is a good organization and has been very helpful to [Kitchen Sink] during our recent rough spots, but everyone understands that competition is in everyone's best interests, and we've all lost that. A good deal of our industry's problems today stem from Marvel's acquisition of Heroes World Distribution and the collective industry's short-sighted stampede to Diamond (Thompson, 1999, p. 10).

Smaller publishers were also worried that Diamond only had so much publicity space available in its distribution catalog, *Previews*, which goes to comics retailers. Marvel comics was integrated into *Previews* beginning in the April 1997 issue, after it closed Heroes World ("The Splash Page," 1997). At the exhibitor end, with one distributor dealing with a diversity of retailers both small and large, meeting the individual needs of all retailers becomes problematic (David, 1998a).

Moreover, despite the tremendous amount of industrial clout Diamond acquired, if as the sole distributor to comics shops the company should fall on hard economic times for whatever reason, the resulting economic effect on the industry would be disastrous (David, 1996a).

Corporate Synergy and Licensing Activities

Another modern characteristic of the political economy of comics is the stress on inter-media activities, which are, in fact, a characteristic of large media firms generally and through which media conglomerates look to acquire complementary media organizations to make "the

whole greater than the sum of the parts." Television, book, magazine, motion picture, and video game companies are constantly partnering with each other. The blurring of traditional divisions in media is one of the challenges to political economists as the economic landscape becomes more difficult for scholars to maneuver (Mosco, 1996).

The archetype of synergy in the comic book industry has traditionally been DC Comics, whose parent company, Time Warner, is the largest communication conglomerate in the world. Its many holdings illustrate how a license—in this case a superhero character—can be moved across various media industries. For example, with the Batman license in Time Warner's stable through its ownership of DC, it may use its subsidiaries to release the 1997 *Batman and Robin* film through Warner Films; release the comic book adaptation through DC Comics; release the novelization through Warner Books; release the sound track through Warner Records; release parodies through *Mad* magazine; advertise the movie on The WB Network; and publicize the movie through CNN's "Showbiz Today," *People Magazine*, and *Entertainment Weekly*. Such a synergistic strategy cuts down on development time (one license can provide content for several subsidiaries), allows internal control of licensing use, and maximizes potential profits from licenses. Of course, Time Warner also looks for lucrative licensing deals even with companies it does not own, such as toy, T-shirt, game and card companies (for critical analyses of corporate synergy, see McAllister, 1996; Meehan, 1991).

Smaller comics companies have also been heavily involved in licensing and synergistic activities. In 1996 Dark Horse entered a joint film production venture with Intermedia Film Equities to make upcoming movies based on Dark Horse characters (Dean, 1996). McFarlane Toys, created by comic book auteur and Image co-founder Todd McFarlane, produces, among other items, action figures based on their comic book characters including Spawn. In 1997, Spawn could be found in the movie theaters as a New Line Cinema release and on television in a prime-time animated program on HBO.

But in the mid-1990s the comics company that drew the most press attention with its synergistic attempts—and the consequences of these attempts for the comic book industry—was Marvel. Marvel's direction was defined until the late 1990s by majority stockholder Ronald Perelman, who had bought the company in 1989 and had

begun in 1991 to offer public stock in it (Serwer, 1997). In an attempt to duplicate DC's synergistic success, Marvel, as of 1994, had as its stated goal to become, in the words of one executive, "a comprehensive, global, youth-marketing company" ("Marvel Acquires Welsh Publishing," 1994). To achieve this goal, Marvel went on a spending spree, purchasing or creating all or part of the following:

- Summer 1992: Fleer Cards, a sports and entertainment card company, for $265 million ("Marvel Comics to Acquire Fleer," 1992).
- Spring 1993: Toy Biz, a marketer and developer of toys, including action heroes, partial ownership for $7 million cash plus a $30 million loan (Chiang, 1993).
- Summer 1994: Panini stickers for $150 million ("Marvel to Pay," 1994).
- Fall 1994: Welch Publishing, a children's magazine publisher that specializes in magazines based on popular licenses like Major League Baseball. The amount of the purchase was undisclosed, although Welch's annual revenue was estimated to be about $50 million ("Marvel Buys Welsh Publishing," 1994).
- Fall 1994: Malibu Comics, amount undisclosed (Thompson, 1994).
- Winter 1994: Heroes World Distribution, amount undisclosed ("Marvel Buys Heroes World," 1994).
- Winter 1995: SkyBox Sports Cards for $150 million ("Marvel Announces Intent," 1995).
- Summer 1996: Marvel Studios announced it will oversee Marvel's TV and film operations with as much as $50 million in start-up costs from Marvel ("Marvel and Toy Biz Form Marvel Studios," 1996).

In addition to these ownership deals, Marvel heavily invested in general licensing activities through Marvel television cartoons, video games, amusement parks and theme restaurants (Allstetter, 1994; "Scott Sassa is New Chairman," 1996; "Universal Theme Park," 1994). Marvel's revenues have reflected this multi-media philosophy. The company went from generating $500,000 in licensing fees in 1992 to $15 million 3 years later (Pearson & Miller, 1996).

What does this synergistic direction mean for the comics industry? There are two ramifications of the industry leaders' stress on the importance of the comic book character license over the comic book.

One effect was the subordination of the comic book subsidiary to the larger licensing goals of the parent corporation. For example, by the late 1990s, Marvel management clearly viewed the organization as a licensing, not a comic book, company. Its revenues shifted away

from comic book sales. In 1991, 86% of Marvel's revenues were generated by publishing (Rogers, 1999). By 1996, Marvel's publishing businesses accounted for 15% of its revenue, despite the fact that it controlled about 30% of the direct market (David, 1996b). In other words, the comic book industry needed Marvel more than Marvel needed the comic book industry. The revenue from comics was quickly becoming, to use the words of one industry analyst, "chump change" (David, 1995, p. 102). Symbolic of this, when the Planet Hollywood-esque "Marvel Mania" theme restaurant opened in Los Angeles, patrons could purchase any sort of Marvel merchandise at the restaurant *except* comic books (Sangiacomo, 1998).

In addition to the revenue shift, the background of Marvel executives, at least in the mid-1990s, also revealed a non-comics orientation. Between 1994 and 1996, for its top management levels Marvel hired a former executive from Kenner Toys, an executive from Fox Television, an executive from the NBA, and two executives from TBS, Inc. ("Fox Vice President Moves to Marvel," 1996; "Licensing VP Helen Isaacson Moves from Turner to Marvel," 1996; "NBA Marketer David Schreff becomes Marvel President;" 1996; "Scott Sassa is New Chairman," 1996; "Stein is Marvel Entertainment Group President," 1994). *Direct*, a trade magazine for direct mail marketers, reported that Gerald Calabrese, the Group President of Marvel Entertainment, does not read comic books (Dean, 1995). Peter David argued that these new executives "came into the comics business with an utter lack of knowledge as to the dynamics of our little industry" (David, 1996b).

Marvel, then, had a dearth of key executive personnel with specific knowledge of the comic book industry and a lack of strong economic motivation to pay attention to points of stress in the industry until they become crises. This may have led Marvel to move too quickly in attempting to solidify its market position as illustrated by the company's attempt at vertical integration with the purchase of Heroes World. Industry analysts argued that comics are an ebb-and-flow business, and that patience is often the preferred strategy in such times by simply waiting out a comics slump (David, 1996b; Voger, 1997). By its acquisition of Heroes World, Marvel may have pushed the industrial panic button, thus irrevocably increasing concentration in the comic book industry.

Likewise, the emphasis on licensing, rather than on comic books, may influence the creation of comic books in a way that may be good for licensing activity but not good for the comic book industry. As the comics industry becomes one link in the chain of media conglomerates, it may set less priority for the creation of good books and allocate more resources to the marketing and licensing of comic book characters to other subsidiaries or media outlets. Changes in comic book characters reveal the lower status that the comic book medium has in comparison with other windows of revenue, especially film and television. For example, radical character developments initiated in the comic book—such as the "death" of Superman in 1992 and the redefinition of the character's powers and costume in 1997—often are short-lived to re-orient the comic book character to match the characteristics of the multi-mediated licensed property. Or, conversely, the comics company may feel compelled to change characters or schedule special comic book issues that tie-in with developments of the license in other media, whether or not these changes were part of the comic book writers' original plans for the characters. An example of such synergistic scheduling includes the coordination of Superman and Lois Lane's comic book wedding with the television wedding that occurred in the more visible and higher-priority 1996 season of ABC's *Lois & Clark* ("Lois Lane and Clark Kent," 1996).

Finally, though, a last effect of Marvel's full-steam-ahead drive to synergize is the massive corporate debt it acquired, and the economic vulnerability that resulted. Marvel may have felt pressure to compete at the same synergistic level as DC, but the enterprises did not have the economic protection of a corporation like Time Warner when trying to achieve this licensing parity. To acquire all the above-listed companies, Marvel took on a debt of as much as $1 billion (Strom, 1996). One argument for corporate synergy is that the company does not put all of its revenue eggs in one basket: different industries provide multiple revenue streams. However, the size of Marvel's debt, given its assets, left the company vulnerable to industry recession, and in Marvel's case, *two* industries that it had invested in experienced severe slumps. The comics industry dropped to half its monetary levels after the boom of the early 1990s; the trading-card industry busted during this time as well, in large part because of the disillusioning play stoppages in hockey and baseball (Fabrikant, 1996). Making matters

worse was a sharp increase in paper prices in 1995 (Kelly, 1995; "Marvel Stock Sinks," 1995).

The corporate debt, the decline of revenue in the two markets, and the increase in paper prices made Marvel, the leading comic book publisher, financially shaky. In 1995, Marvel's financial situation began to be evident as quarterly revenues dropped, followed by stock values ("Marvel Stock Sinks," 1995). By the fall of 1996, the situation had become critical: Marvel stock had dropped from $35 a share in 1993–1994, to less than one tenth of that by November 1996 (Sandler, 1996; Serwer, 1997). The stock eventually would drop to 50 cents a share (Miller, 1998a), and in April 1998 the New York Stock Exchange moved to have Marvel stock removed from its stock exchange listings because of the poor financial performance of the company ("Marvel's NY Stock Exchange Listing," 1998).

The resulting Wall Street intrigue was highlighted throughout the financial pages of major newspapers and trade journals. In November 1996, Perelman proposed a reorganization plan to "save" the company, infusing cash through a complicated acquisition of Toy Biz stock and 410 million new Marvel shares to Perelman. Such a plan, however, would have seriously diluted existing Marvel stock as well as the bonds that Perelman sold in 1993 to generate $1 billion, using his own Marvel stocks as collateral. Carl Icahn, a high-powered financier who bought 25% of the bonds when they dropped in price, blocked the re-organization plan. In response to this block, Perelman had Marvel file for bankruptcy protection to prevent the bondholders from taking control, even though the company apparently was in no immediate danger of folding. The bondholders, in turn, attempted to put into place their own board of directors at Marvel (and, later, at Toy Biz) to take control (for descriptions of the early developments in the struggle over Marvel, see Bryant, 1998; Jenkins, 1997; Jereksi & Lippman, 1996; Sandler, 1996; Vest, 1996).

This signaled the beginning of an 18-month financial war that included at various times Perelman, Icahn, lending banks, and Toy Biz (in which Marvel was a minority owner). At the end of 1997, the U.S District Court appointed an independent trustee to oversee Marvel's reorganization plan, and in July 1998 the court approved such a plan that would make Marvel a subsidiary of Toy Biz (Frankenhoff, 1998a). This "chapter" in Marvel's history was closed in October

1998 when Marvel merged with Toy Biz and renamed the corporation Marvel Enterprises, Inc. (Frankenhoff, 1998b).

What does this corporate saga mean for the comics industry? Although licensing may seem like a panacea for solving the problems of the comic book industry, the emphasis on subsidiary rights has drawbacks. It was not just the larger publishers that were hurt by this strategy. Besides the corporate debt sustained by Marvel during its push, the accent on licensing may also have weakened Kitchen Sink Press, soon to be gone from the comics industry, when it offered merchandise based on the 1996 film *The Crow II* (Rhode, 1999).

If Marvel had ceased production as a result of its debt, the financial devastation inflicted on already-weak retailers would have been severe, perhaps wrecking the entire infrastructure of the industry (David, 1996b). The economic recovery for the industry was made difficult as comics collectors and organizational financiers avoided an industry whose leader, Marvel, had received so much bad financial press. During one week in late August 1997, several newspapers, including the *Wall Street Journal* and the *New York Times*, reported that Marvel was on the brink of liquidating its assets (see, for example, "Marvel Says Liquidation," 1997).

The financial crisis faced by Marvel put Marvel creators and employees in a difficult situation. The lack of ownership stability may have encouraged the company to emphasize short-term sales strategies (such as cross-overs and melee-oriented story lines) over evolving character development. As one Marvel executive argued:

> It would be kind of nice to have ownership that allows us to have a longer term viewpoint. It's difficult to have long-term planning when you don't know who your owner is going to be and what direction or strategy they would have for the company. You have to be careful that you're looking ahead, but you also have to be careful that you're not doing anything that someone would want to come in and undo. (O'Neill, 1998)

Finally, the Marvel fiasco also highlighted a very real effect of modern corporate life: a dichotomy between "haves and have nots." To cut expenses during its downturn, Marvel laid off 40 employees in January 1996, 115 employees in November 1996, and several more in October 1998 ("Marvel to cut," 1996; Thompson, 1996; Miller, 1999a). This is in contrast to Ronald Perelman, who made an

estimated $50 million off the sale of Marvel bonds, and who, according to *Forbes*, was the 16th richest American at the height of the financial crisis ("Anticipated End-of-Year losses," 1996; Norris, 1996). It is also in contrast to Scott Sassa, the former CEO of Marvel hired the same month as the November 1996 layoffs. Near the time Marvel filed for bankruptcy protection, Sassa reportedly paid $10 million for a Manhattan townhouse (Dean, 1997a).

Conclusion

Such is the picture that a political economy analysis paints of the comic book industry, especially during the 1990s. Increased concentration at both the production and distribution levels undermines innovation by stressing economic predictability (and the conventionality that accompanies such predictability, such as violent superhero story lines), and disadvantages smaller publishers and retailers. Real and perceived economic instability may prevent new voices and resources from entering the industry and may cost the industry some of its most ideologically complex publishers. In addition, the movement toward licensing and synergy also promotes a mainstreamed, superhero version of content while also encouraging a "home run" mentality that may weaken comics producers.

Although the picture is grim, the industry is still very much in flux, and the future direction of the industry is not determined. The industry has had time to adjust to the financial upheaval of 1995 and 1996. Marvel achieved economic stability by the end of the 1990s, decreasing its corporate debt by divesting itself of such assets as Panini and SkyBox ("Marvel Sells," 1999; "Topps Lands," 1999). There were also signs of industry-wide recovery (Miller, 1999b). In terms of diversity, the ease of physically publishing a comic book has created more publishers than ever before, even if a large percentage of these publishers release only one issue. The Internet has also become an outlet for comic art, granting international distribution possibilities for those with access to a server. Perhaps new visions of what the comics have the potential to do can find and open new cracks in the market.

References

1997 box office report. (1998, January 30). *Entertainment Weekly*, pp. 36–37.

Aufderheide, P., Barnouw, E., Cohen, R. M., Frank, T., Gitlin, T., Lieberman, D., Miller, M. C., Roberts, G., Schatz, T. (1997). *Conglomerates and the media*. New York: The New Press.

Allstetter, R. (1994, March 4). Marvel's X-Men will be joined on TV by Spider-Man, Fantastic Four, Iron Man. *Comics Buyer's Guide*, p. 6.

Andersen, R. (1995). *Consumer culture and TV programming*. Boulder, CO: Westview Press.

Anticipated end-of-year losses trigger 42% drop in Marvel stock. (1996, November 1). *Comics Buyer's Guide*, p. 6.

Baker, C. E. (1994). *Advertising and a democratic press*. Princeton, NJ: Princeton University Press.

Bagdikian, B. H. (2000). *The media monopoly* (6th ed). Boston: Beacon Press.

Barnet, R. J., & Cavanagh, J. (1994). *Global dreams: Imperial corporations and the new world order*. New York: Simon & Schuster.

Bryant, A. (1998, May 24). Pow! The punches that left Marvel reeling. *The New York Times*, pp. C1, C10, C11.

Chiang, C. (1993, April 26). The X-Men. *Forbes*, pp. 18–19.

Corliss, R. (1998, August 3). The class of '98. *Time*, pp. 66–68.

David, P. (1995, March 31). But I digress... *Comics Buyer's Guide*, pp. 102, 100.

David, P. (1996a, August 23). But I digress... *Comics Buyer's Guide*, p. 106.

David. P. (1996b, December 13). But I digress... *Comics Buyer's Guide*, pp. 94, 92.

David, P. (1998a, February 20). But I digress... *Comics Buyer's Guide*, p. 86.

David, P. (1998b, April 3). But I digress... *Comics Buyer's Guide*, pp. 80, 82.

DC takes on Marvel. (1995, October 6). *Comics Buyer's Guide*, p. 6.

Dean, M. (1995, August 25). Clipping service. *Comics Buyer's Guide*, p. 56.

Dean, M. (1996, June 21). Clipping service. *Comics Buyer's Guide*, p. 44.

Dean, M. (1997a, February 7). Clipping service. *Comics Buyer's Guide*, p. 8.

Dean, M. (1997b, November 14). Justice Department Anti-Trust Division investigates comics distribution. *Comics Buyer's Guide*, p. 6.

Dean, M. (1998, April 10). Requiem for a non-line. *Comics Buyer's Guide*, p. 6.

Distributors, retailers respond to Marvel's purchase of Heroes World. (1995, February 3). *Comics Buyer's Guide*, p. 6.

Evanier, M. (1996, January 5). POV. *Comics Buyer's Guide*, pp. 28, 34.

Fabrikant, G. (1996, November 13). Ailing Marvel receives offer by Perelman. *The New York Times*, p. D4.

Fox vice president moves to Marvel. (1996, July 5). *Comics Buyer's Guide*, p. 10.

Frankenhoff, B. (1998a, August 7). A Newco dawns for Marvel. *Comics Buyer's Guide*, p. 6.

Frankenhoff, B. (1998b, October 30). Marvel merges with Toy Biz: New company is Marvel Enterprises, Inc. *Comics Buyer's Guide*, p. 6.

Golding, P., & Murdoch, G. (1991). Culture, communications, and political economy. In J. Curran & M. Gurevitch (Eds.), *Mass media and society* (pp. 15–32). London: Edward Arnold.

Gordon, I. (1998). *Comic strips and consumer culture, 1890–1945*, Washington, D.C.: Smithsonian Institution Press.

Gray, B. (1996, August 23). Distribution fallout. *Comics Buyer's Guide*, pp. 22, 26, 30, 32.

Herman, E. S., & McChesney, R. W. (1997). *The global media: The new missionaries of global capitalism*. London: Cassell.

Jenkins, H. W., Jr. (1997, January 21). Mythic titans battle over a comic empire—or vice versa. *The Wall Street Journal*, p. A19.

Kelly, K. J. (1995, April 24). How the paper chase spiraled out of hand. *Advertising Age*, pp. S1–S2.

Licensing VP Helen Isaacson moves from Turner to Marvel. (1997, February 7). *Comics Buyer's Guide*, p. 6.

Lois Lane and Clark Kent will marry in October. (1996, September 20). *Comics Buyer's Guide*, pp. 6, 8.

Marvel acquires Welsh Publishing. (1994, November 11). *Comics Buyer's Guide*, p. 24.

Marvel and Toy Biz form Marvel Studios. (1996, July 26). *Comics Buyer's Guide*, p. 8.

Marvel announces intent to buy SkyBox. (1995, March 31). *Comics Buyer's Guide*, p. 6.

Marvel announces 'Marvelution 1995'. (1994, November 11). *Comics Buyer's Guide*, pp. 6, 24.

Marvel buys Heroes World distribution operation. (1995, January 2). *Comics Buyer's Guide*, p. 6.

Marvel buys Welsh Publishing (1994, November 15). *Folio*, p. 13.

Marvel Comics to acquire Fleer for $265 million. (1992, August 21). *Comics Buyer's Guide*, p. 36.

Marvel goes exclusive in July. (1995, March 24). *Comics Buyer's Guide*, p. 6.

Marvel's NY Stock Exchange listing in jeopardy. (1998, May 8). *Comics Buyer's Guide*, p. 6.

Marvel says liquidation is a possibility. (1997, August 29). *The New York Times*, p. D4.

Marvel sells Panini, signs Activision deal. (1999, November 5). *Comics Buyer's Guide*, p. 8.

Marvel stock sinks. (December 1, 1995). *Comics Buyer's Guide*, p. 6.

Marvel to cut 115 workers at its comic book business. (1996, November 20). *The New York Times*, p. D3.

Marvel to pay $150 million to acquire Italy's Panini. (1994, July 7). *The Wall Street Journal*, p. 5.

McAllister, M. P. (1989, April). *Comic book research: A bibliography and brief history*. Presented at the meeting of the Southern States Communication Association, Louisville, KY.

McAllister, M. P. (1990). Cultural argument and organizational constraint in the comic book industry, *Journal of Communication, 40*(1), 55–71.

McAllister, M. P. (1996). *The commercialization of American culture: New advertising, control and democracy*. Thousand Oaks, CA: Sage.

McChesney, R. W. (1997). *Corporate media and the threat to democracy*. New York: Seven Stories Press.

Meehan, E. (1991). `Holy commodity fetish, Batman!': The political economy of a commercial intertext. In R. E. Pearson & W. Uricchio (Eds.), *The many lives of the Batman: Critical approaches to a superhero and his media* (pp. 47–65). New York: Routledge.

Miller, J. J. (1995). State of the industry 1995. In M. Thompson, M. Dean, B. Frankenhoff, J. Greenholdt, & J. J. Miller (Eds.), *Comics Buyer's Guide 1996 Annual* (pp. 50–69). Iola, WI: Krause Publications.

Miller, J. J. (1998a, January 23). 1997: The year in comics. *Comics Buyer's Guide*, pp. 26–28, 30.

Miller, J. J. (1998b, February 13). A look at the publishers who fueled the industry in 1997. *Comics Buyer's Guide*, p. 30.

Miller, J. J. (1998c, February 13). Your guide to the Publishers 50: What we did, how we did it and why. *Comics Buyer's Guide*, p. 30.

Miller, J. J. (1999a, January 22). 1998: The year in comics. *Comics Buyer's Guide*, pp. 40–43.

Miller, J. J. (1999b, December 3). It's getting better. No, really! *Comics Buyer's Guide*, p. 4.

Mosco, V. (1996). *The political economy of communication*. Thousand Oaks, CA: Sage.

NBA marketer David Schreff becomes Marvel President. (1996, September 13). *Comics Buyer's Guide*, p. 8.

Norris, F. (1996, December 28). 2 Financiers cross swords over Marvel. *The New York Times*, pp. A39, 41.

Nyberg, A. K. (1998). *Seal of approval: The history of the Comics Code*. Jackson, MS: University Press of Mississippi.

O'Neill, P. D. (1998, February 13). Marvel Comics. *Comics Buyer's Guide*, p. 31.

Pearson, L., & Miller, J. J. (1996). State of the industry 1996. In M. Thompson & J. J. Miller (Eds.), *Comics Buyer's Guide 1997 annual* (pp. 12, 14, 16, 18, 20, 22–30). Iola, WI: Krause Publications.

Rhode, M. G. (1999). The commercialization of comics: A broad historical overview. *International Journal of Comic Art, 1*(2), 143–170.

Rogers, M. C. (1999). Licensing farming and the American comic book industry. *International Journal of Comic Art, 1*(2), 132–142.

Sabin, R. (1993). *Adult comics: An introduction*. New York: Routledge.

Sandler, L. (1996, November 18). Marvel investors find the perils in Perelman's superhero plan. *The Wall Street Journal*, p. C1.

Sangiacomo, M. (1998, February 19). Store a Marvel, but it needs comics. *The Plain Dealer*, p. 8E.

Scott Sassa is new chairman and CEO of Marvel, president and COO of Andrews Group. (1996, November 15). *Comics Buyer's Guide*, p. 6.

Serwer, A. E. (1997, January 13). The dustup over Marvel. *Fortune*, p. 21–22.

Shutt, C. (1998, September). Byrne's Hulk to have TV influence. *Wizard*, p. 29.

Stein is Marvel Entertainment Group president, COO, director Stewart is Marvel Comics president, CEO. (1994, July 15). *Comics Buyer's Guide*, p. 6.

Strom, S. (1996, October 10). Marvel's bad quarter raises doubts about Perelman's plans. *The New York Times*, p. D8.

Stuempfig, J. (1994a, December 2). Publishers feel the pinch: Now what? *Comics Buyer's Guide*, p. 20.

Stuempfig, J. (1994b). State of the industry. In D. Thompson, M. Thompson, & J. Stuempfig (Eds.), *Comics Buyer's Guide 1995 annual* (pp. 28–35). Iola, WI: Krause Publications.

Sullivan, R. L. (1996, April 8). Batman in a bustier. *Forbes*, pp. 37–38.

The distribution wars are over: Diamond acquires Capital, control of nearly all non-Marvel comics distribution. (1996, August 16). *Comics Buyer's Guide*, p. 6.

The splash page. (1997, March). *Previews*, p. 13.

Thompson, D. & Thompson, M. (1992, August 21). Editorial. *Comics Buyer's Guide*, pp. 4, 6.

Thompson, M. (1994, November 25). Marvel acquires Malibu. *Comics Buyer's Guide*, p. 6.

Thompson, M. (1996, January 26). Marvelution meets 'Black Wednesday': Dozens are dismissed, as the industry's biggest publisher downsizes. *Comics Buyer's Guide*, p. 6.

Thompson, M. (1997a, February 14). 'As an industry, we're a *new* industry.' *Comics Buyer's Guide*, pp. 40–41.

Thompson, M. (1997b, February 28). Diamond gets Marvel. *Comics Buyer's Guide*, pp. 6, 8.

Thompson, M. (1999, January 8). Founder pulls plug on Kitchen Sink. *Comics Buyer's Guide*, pp. 6, 8, 10.

Time Warner. (1998). Retrieved August 13, 1998 from the World Wide Web: http://www.pathfinder.com/corp/fbook/fbframe.html

Topps lands Marvel card license. (1999, October 15). *Comics Buyer's Guide*, p. 6.

Universal theme park will feature Marvel characters. (1994, October 7). *Comics Buyer's Guide*, p. 54.

Vest, J. (1996, December 23). Spider-Man vs. Wall Street: Round 2. *U.S. News and World Report*, p. 52.

Voger, M. (1997, November 14). The dark age. *Comics Buyer's Guide*, pp. 54, 56.

Who buys comic books? (1995). In M. Thompson, M. Dean, B. Frankenhoff, J. Greenholdt, and J. J. Miller (Eds.), *Comics Buyer's Guide 1996 Annual* (pp. 62–64). Iola, WI: Krause Publications.

Witek, J. (1989). *Comic books as history: The narrative art of Jack Jackson, Art Spiegelman, and Harvey Pekar*. Jackson, MS: University Press of Mississippi.

Chapter 3

The Women's Suffragist Movement Through the Eyes of *Life* Magazine Cartoons

J. Robyn Goodman

The first half of the nineteenth century marked a progressive change in the economic and social order of the United States. Rural New England had been a household economy in which there were "face-to-face transactions between neighbors, noncash payments for goods and services, and an ethos of restraint in the collection of debt" (Kelly, 1999, p. 3). However, with land shortages, population increases, agriculture's commercialization, and the birth of industrial production in the mid-1800s, the household economy yielded to a market-based economy in which families increasingly worked outside the home (Kelly, 1999, p. 5).

Because a market-based economy "...increased the spatial and social distance between home and work," the differences between public/male and private/female were expanded (Kelly, 1999, p. 20). By the early twentieth century, the separation of the spheres was in full force. With their sphere being the home, women were isolated from most political, intellectual, and public life.

Although their political role was greatly limited, affluent white women found an opportunity to express themselves through the various women's clubs that supported suffrage and through the ideology of the republican mother (a romanticism of domestic duties and motherhood in which women's patriotic duty was to educate their sons to be virtuous citizens). Rhetorically grounded in the ideal of the republican mother, they fought for a larger role in setting public policy. Thus, women's suffrage organizations conducted 480 suffrage campaigns in 33 states from 1870 to 1910, and membership in the National American Women's

Suffrage Association increased 175% from 1893 to 1910 (Flexner, 1975; Kraditor, 1981).

Coinciding with the increase in women's agitation for suffrage was the rise of American humor magazines including the three largest—*Puck*, *Judge*, and *Life*. These humor magazines "were read and widely quoted, and they popularized humor to such an extent that many other periodicals found it advisable to maintain departments consisting entirely of original humorous matter" ("Century of American Humor," 1901, p. 490). The humor magazines and their numerous cartoons are particularly interesting sources to use in studying an era because they "...portray social trends, reflect attitudes, and reproduce phases of universal culture" (Meyer et al., 1980, p. 21) and "...illuminate the social customs, pretensions, and prejudice of the time more clearly than do any of their contemporaries" (Murrell, 1938, p. 93).

By examining the cartoons found in humor magazines, one may better understand the role of cartoons in reinforcing political, cultural, social, and gender ideologies at the turn of the century. The purpose of this chapter, then, is to explore how cartoons in a representative humor magazine reflect suffragist and antisuffragist ideologies during the women's suffrage movement. The chapter also presents arguments for why certain suffragist and/or antisuffragist ideologies were reflected and others ignored as well as what the implications of the cartoons may be.

In investigating these questions, this chapter incorporates the theoretical frameworks of hegemony and feminist theories on media and patriarchal ideology. Hegemony refers to the systematic naturalization of the ruling class's values and ideas to form mass consent of the established social order; it is how the ruling class maintains its dominance without overt force (Gramsci, 1971; Gitlin, 1980; Shoemaker & Reese, 1996). Key to hegemony is the role of ideology, which serves as a unifying force in society (Shoemaker & Reese, 1996). "Under hegemony, ideology is regarded as an essentially conflicted and dynamic process, which must continually absorb and incorporate disparate values" (Gitlin, 1980, p. 51) to reproduce itself and maintain its power (Gramsci, 1971; McQuail, 1983). When the majority embraces these disparate values and, consequently, challenges the ruling class, a new social order is formed (Kellner, 1995; Lindlof, 1995). Despite the occurrence of these challenges, Raymond Williams points out that much of the opposition to the dominant ideology is still hegemonic because it takes place within a

framework allowed by the dominant ideology (Williams, 1980).

As part of the sociocultural system, the mass media provide a significant role in hegemony. They "...continually produc[e] a cohesive ideology...that serves to reproduce and legitimate the social structure through which the subordinate classes participate in their own domination" (Shoemaker & Reese, 1996, p. 237).

In conjunction with hegemony, feminist theories state that we live in a patriarchal society that maintains the power relations between the sexes through an unquestioned consensus of male supremacy (Frazer & Lacy, 1993; Berger, 1995; Tuchman, 1978). Because of this male supremacy, feminist theorists maintain that the underlying patriarchal ideology defines and frames gender and thereby makes "woman" less valued and less powerful.

To understand how this patriarchal ideology operates in society, feminists analyze "the network of practices, institutions, and technologies that sustain positions of dominance and subordination" and that shape, proliferate, and construct our conceptions of normal and deviant female behavior (Bordo, 1993, p. 15). One of the most significant sites for exploring patriarchal ideology's operation is the mass media because their images of women teach society the patriarchy's required rules of femininity (Bordo, 1993) and they are the primary means of conveying hegemonic values (van Zoonen, 1991).

To place suffragist and antisuffragist arguments in context, it is necessary to first look at an abridged history of the suffragist and antisuffragist movements.

The Suffrage and Antisuffrage Movement
at the Turn of the Century

Historians cite the 1848 Seneca Falls meeting—the first national women's rights convention—as the beginning of the women's suffrage movement because part of the proposed reforms were for the vote. Although there were many women's rights conventions after the initial Seneca Falls meeting, the Civil War interrupted and stalled these women's activities.

In 1890, a new generation of leaders emerged and created the National American Woman Suffrage Association (NAWSA) from the

two leading women's rights factions (Scott & Scott, 1975; Kraditor, 1981). NAWSA was able to gain full women's suffrage in Colorado, Utah, and Idaho between 1890 and 1896. However, from 1896 to 1910, hundreds of state suffrage campaigns and 19 national campaigns were unsuccessful (Flexner, 1975; Kraditor, 1981). Many historians refer to these ineffective years as the "doldrums" of the movement (Scott & Scott, 1975; Kraditor, 1981).

Despite the suffragists' problems winning support, their agitation was enough of a threat to motivate the opposition's organization (Scott & Scott, 1975, p. 25). Beginning in the 1870s with the founding of the first state antisuffrage group, the antisuffrage movement grew rapidly and reached its peak of power and influence between 1895 and 1907—the above-mentioned doldrum years for the suffragists (Scott & Scott, 1975; Camhi, 1994, p. 2). Finally in 1911, a national antisuffrage organization, National Association Opposed to Woman Suffrage (NAOWS), was formed. Unlike NAWSA, whose members continually campaigned all over the country for their cause, NAOWS actively campaigned only when specific types of situations arose in specific areas of the country (Camhi, 1994).

The antisuffrage movement began to weaken around 1910, while the suffrage movement strengthened due, in part, to changes in women's place in society. Recent household inventions and declining birthrates gave women more time for outside activities. The number of women factory workers increased, and these women saw the ballot as a way to improve their bargaining power (Scott & Scott, 1975; Kraditor, 1981).

The change in women's political status and the suffragists' efforts helped women gain the vote in Washington, California, Oregon, Kansas, and Arizona from 1910 to 1912. In 1917, New York approved a constitutional amendment for full women's suffrage. Congress passed the constitutional amendment in 1919, and all the states ratified it by 1920 (Kraditor, 1981).

Arguments of the Suffragists and Antisuffragists

Throughout the fight over women's suffrage, both sides used various arguments to support their position. Between 1890 and 1920, the most common suffrage and antisuffrage arguments were religious, biological/

anthropological, and sociological.

With religion, antisuffragists often cited the version of creation in which Eve was created from Adam's rib. Antisuffragists said this story showed men were meant to be the superior being because they were created first. They also used God's statement to Eve that her husband was to rule over her (Kraditor, 1981). Therefore, the antisuffragists argued that women's suffrage was going against the will of God ("The Argument Against Woman Suffrage," 1913).

In response to these arguments, suffragists showed the contradictions in the creation stories as well as citing the rib story as "a petty surgical operation" (Stanton, 1895, p 20). They further addressed God's statement that the husband was to rule over the wife by citing other places in the Bible that indicated women were equal to men or acted in heroic ways (Kraditor, 1981).

The second type of debate was based on biological issues of women's physical or mental nature. Antisuffragists insisted that the right to vote was based on physical strength because one must have a physical power to enforce the laws. Men voted because they had the strength to enforce the laws and to fight for their country's rights in war (Blackwell, 1895; Cooper, 1890; Abbott, 1903). Antisuffragists further argued that women's health was too delicate to withstand the mental strain and physical exertion of political life (Kraditor, 1981; Camhi, 1994). In fact, some antisuffragists argued that voting would place such a strain on women that they were apt to go insane (Camhi, 1994).

Antisuffragists also asserted that voting would cause women's sexual degeneration. According to neurophysiologists, women's sex organs would atrophy, causing women to become men and resulting in their hatred of being a wife and mother (Camhi, 1994). With their visions of women becoming men and the separate spheres merging, antisuffragists expressed concerns that women's voting meant an end to progress as well as a kind of racial suicide (Benjamin, 1991; George, 1913).

Besides the arguments based on physical issues, antisuffragists claimed that, as biological beings, women were too emotional, illogical, and irrational to vote (Kraditor, 1981; Moody, 1898; Collins, 1912). "Woman is impulsive; she does not inform herself...she does not consider the consequences of a vote. In her haste to remedy one wrong she opens the way to many. The ballot in her hands is a dangerous thing" (Bock, 1913, p. 3).

Suffragists countered the biological determinism used by anti-suffragists in their rhetoric. They attacked the defense point of physical differences by arguing that if physical abilities were a true measure of voting legitimacy, only men capable of entering military service should be allowed to vote. This of course was not the case; elderly and feeble men were allowed to vote even though they did not have the physical strength to enforce laws or defend the country (Blackwell, 1895). Some men also were prevented from voting because they were illiterate (Blackwell, 1895), further making the point of argument dubious.

Suffragists' response to arguments about psychology was twofold. First, they provided illustrations of men's irrationality and emotionalism. For example, Alice Stone Blackwell cited the riots in the French Chamber of Deputies, fistfights in the House of Commons, and beard-pulling in the Nebraska Senate as cases of men's irrational behavior (Blackwell in Kraditor, 1981). Second, suffragists compared men's and women's "political" behavior. Anna Howard Shaw used examples of men screaming at each other and knocking off each other's hats during political conventions and stated women would never act in such a manner (Shaw in Kraditor, 1981). As for the argument that women were mentally inferior, suffragists pointed out that women did not have the intellectual training that men had so such a comparison was unjust (Kraditor, 1981).

Other points of debate were more sociological in nature. Suffragists claimed that they were being taxed without representation and therefore, needed the ballot for self-protection. Because more women were wage earners, NAWSA said working class women needed the vote to protect their interests (Kraditor, 1981; Stanton, 1882). They argued that their wages were low because wages are dependent on one's position in society. With women being politically inferior, working women cannot compete with voting men (Kelley, 1898).

Antisuffragists rhetorically countered the taxation-without-representation and self-protection justification in several ways. They showed that few women pay taxes and that the colonists' cry of taxation without representation was related to their desire for national representation and not representation of each individual citizen (Benjamin, 1991). Furthermore, antisuffragists cited women's improved living conditions that had occurred without their vote, including the first tenement house laws and pure food laws (Camhi, 1994). Finally, it was said, women

already had great influence over men through the home and raising their sons (Scott & Scott, 1975).

Ultimately, though, the rhetoric of the antisuffragists when dealing with sociological issues tended to focus on how voting would erode women's traditional roles in society. Antisuffragists stated that women's voting would lead to the destruction of the home and family as institution, which they argued was already disintegrating with the blurring of the spheres (Collins, 1912; Gibbons, 1902). They supported their point by comparing divorce rates in suffrage versus nonsuffrage states (Thompson, 1900; Benjamin, 1991). Moreover, they claimed that men do immoral things and children are left motherless when women are out participating in politics (Tarbell, 1912). Antisuffragists added that women best protect the home not by influencing policy, but by molding children who will not become immoral once they grow up (Winston, 1896).

The rhetoric of antisuffragists concluded that voting created mannish, unattractive women (Benjamin, 1991). Therefore, many descriptions of typical suffragists called them "two-thirds men" or "biologically belonging to neither sex" and urged men not to marry these mannish women (Benjamin, 1991, p. 82). Antisuffragists even warned that with equality of the sexes women would have to go to war and sacrifice chivalry (Ramee, 1909; Winston, 1896).

Suffragists of course responded to these points in their public discourse. The increased status and social position of women provided suffragists' with rhetorical material. Because working women live alone, men do not represent them (Lowe, 1912). Suffragists also insisted the vote would help them in their roles as wives and mothers. Mothers needed the vote and the knowledge of the inner workings of the government to make their children "loyal and patriotic citizens" (Drukker, 1897, p. 260). Without the vote, women "cannot possibly be capable of transmitting the enlightened ideas, the breadth of vision, the power of calm judgment, which come with the exercise of this civic function in a free government" (Drukker, 1897, p. 260). Furthermore, suffragists said the vote would help them protect the home from immorality (Winston, 1896).

In summary, the content of suffrage and antisuffrage justifications were often biological, religious, or sociological in nature, but the two sides were not equally balanced along these three dimensions. Antisuffrage arguments tended to use religion and biology as their main rhetorical weapons. Their predominant sociological justification was that

suffrage created mannish women. On the other hand, most of the suffragists' contentions were sociological, including a focus on the role of working women, women's improved role as mother and self-protector if allowed the vote, and the unfairness of taxation without representation.

Activists' Depiction in Media

Before moving to the analysis of how the suffragist movement was presented in early–nineteenth-century humor magazines, one additional discussion that may help contextualize the discourse is a brief review of how the mainstream media have portrayed protestors in general. Researchers have found that media tend to cover protestors in a social disruption frame rather than in one that shows their activities communicating their cause with the public (Gustainis & Hahn, 1988). This frame compounds the mainstream Middle America's desire to maintain the status quo and current values. Generally, if activists support values that run counter to the predominate values in mainstream society, Middle America feels threatened and negatively evaluates the cause (Gustainis & Hahn, 1988). Therefore, a basic distrust by Middle America toward activists and the media's framing of activists as a social disruption produce a negative view of the group.

The traditionally negative depiction of activists in the media was evident during the earliest years of the suffrage movement. News editorials about the 1848 Seneca Falls Convention described the suffragists as "unsexed women" with "hook-billed noses, crow's feet under their sunken eyes" and charged that the women were activists because they could not find a man to marry (Wolf, 1991, p. 68). Many of these early verbal news accounts were accompanied by negative visual portrayals of the suffrage movement (Perry, 1994; Sheppard, 1994). Accordingly, it is likely that the cartoons created later in the suffrage movement supported antisuffrage ideologies and helped produce negative public opinion toward the suffragism.

Methodology

In exploring the research question of how cartoons in *Life* magazine reflect suffragist and antisuffragist ideologies during the women's

suffrage movement, the author looked through every *Life* issue from January 1909 to December 1914 and collected every cartoon referring to women's suffrage (N = 214). This time period was chosen because there were no suffrage cartoons prior to 1909, and the subject of World War I began dominating cartoons in 1915.

Life magazine was chosen over *Judge* and *Puck*, its counterparts, for three reasons. First, *Puck*'s influence and circulation began to decline during the 1890s, whereas both *Life* and *Judge*'s were increasing (Sloane, 1987; Peterson, 1964). Second, magazine historians cite *Life* as one of the most influential of its time (Sloane, 1987, p. 142). Finally, *Life* "had become the expression of the liberal social conscience" by the turn of the century (Murrell, 1938, p. 121). Because *Life* broadly published liberal and reform ideas and viewpoints different from its editorial stance, it had the potential for a wider range of societal views in its cartoons (Horn, 1980, p. 784; Murrell, 1938; Sloane, 1987).

It is important to explain that the *Life* magazine in this study was a humor magazine and not the same picture magazine that was found on modern newsstands until its cancellation in 2000. Three Harvard graduates founded, in 1833, the *Life* magazine used in this analysis, largely basing it on the *Harvard Lampoon* (Mott, 1930; Peterson, 1964). From the outset, *Life* "was a magazine devoted to delicate social satire, a little more subtle than its contemporaries *Puck* and *Judge*" (Wood, 1971, p. 214). When this *Life* magazine folded in 1936, Henry Luce and Time, Inc. bought the *Life* name for $92,000 (Peterson, 1964).

Because the purpose of this research is to examine the role of *Life* cartoons in articulating and/or reinforcing suffrage and antisuffrage ideologies during the women's suffrage movement, as well as the implications of these ideologies on public opinion, ideological criticism was used to interpret the cartoons. According to Foss (1996), there are three primary concerns involved in an ideological analysis: identification of the ideology's nature, the interests included, and the strategies that support the ideology. Along these lines, this analysis will focus on the different suffrage and antisuffrage ideologies that were reflected in the cartoons but will also note any additional themes that arose from the discourse. After discovering the most prominent suffrage and antisuffrage arguments, this chapter addresses the role of dominant ideology in the cartoons, and the implications of this ideology.

In analyzing the *Life* cartoons and their ideological import, the author

examined the characters' facial expressions, postures, actions, appearances, and the unfolding scene in general. The author also looked at the verbal components of the cartoons, especially because captions may guide the reader toward the dominant system's preferred, coded meaning and away from alternative meanings (Barthes, 1977).

Suffragists in *Life* Magazine Cartoons

This section maps the use of the three major ideological constructions—religious, biological, and sociological—in the *Life* magazine cartoons throughout the time period studied. However, among the 214 cartoons, only the biological and sociological arguments were found, constituting approximately 70% of the cartoons (158 of the sample). The lack of arguments based on religious issues reflected in the cartoons may be due to religion's conflation with other arguments, particularly sociological. During this era, society believed that women had a special influence on and leadership in morality and religion (Kelly, 1999). Because women were responsible for morality, religion, and the household, religion was often considered part of motherhood and "their household duties"; this is a sociological argument.

As will be discussed, of the 158 cartoons that reflected the arguments of the suffragist debate, 125 could be seen as supporting antisuffragist viewpoints, a finding which complements an earlier analysis of *Life*'s cartoons using a slightly different time span (cited in Sheppard, 1994, p. 89). These 131 were not the total number of negative cartoons found in the magazine during the time period studied. Some of the negative cartoons appearing in *Life* did not reflect specifically the prominent arguments in the suffragist movement, but instead ridiculed in other ways. These included the depiction of suffragists as militant (14), suffragism as silly (5), and suffragists going to jail (5).

Of the non-negative cartoons, many depicted suffrage in a neutral manner. Four cartoons, in fact, specifically depicted the antisuffragist-suffragist debate. Since these cartoons clearly favored neither side, they cannot be classified as bolstering either. Another seven cartoons supported the need for women's suffrage in order to outnumber the black and immigrant votes. About 10% of the total number presented suffrage in a positive way. These prosuffrage cartoons showed suffragists as

generally feminine characters and the women's suffragist movement as something to hope for.

The sections below focus on the 158 cartoons that were concordant with the specific points in the suffragist movement and the debates it sparked. The cartoons as a whole show a strong leaning toward anti-suffragist arguments.

Biology and the Suffragist

Women's Inferior Bodies. Eighteen cartoons (10%) reflected biological arguments in suffragist debate. Although this is a small percentage, some cartoons in the category are worthy of discussion in light of the public debate over women's suffrage. One of these portrayed women's physical attributes in such a way as to support the antisuffragist argument that women are too weak to vote (Figure 3.1). This cartoon showed women hurling objects at a court house and unable to break a window. The splatter marks around the window symbolize women's supposed lack of physical coordination. By showing women as physically inferior because they cannot break the window, this cartoon reinforces the antisuffragist belief that the right to vote is based on physical strength since one must have the power to enforce the law. Another, similarly themed cartoon from February 13, 1913, used the old stereotype of women's fear of mice to show the gender as inherently irrational. It shows two mice conspiring to enter a room filled with suffragists to "bust up the meeting" (p. 318).

Also notable in the cartoon is that several of the women appear to have a club in their hand, and one woman is waving her club at the window in seeming defiance. Because these women are throwing objects at a government building and have clubs in their hands, this cartoon also depicts suffragists as militants. According to Flexner (1975), a few suffragists did use violent means such as breaking windows and attacking government members with whips. Because these women were not part of the mainstream movement, characterizing the movement as militant was unjust and obviously supports the antisuffragist movement. In this sample, "militant" women are attempting to "take over" a courthouse, a symbol of America's truth and justice. By association, then, these women are fighting against America and the "truth."

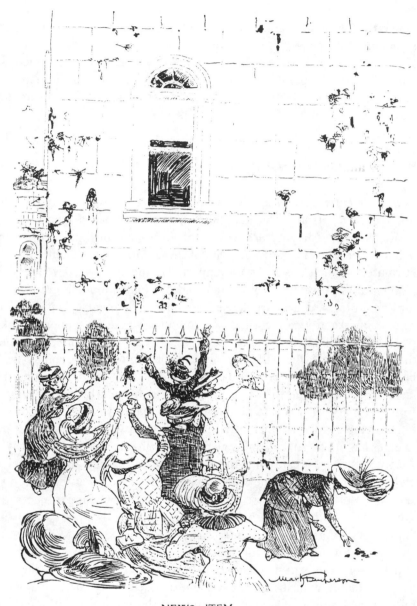

NEWS ITEM

AN ATTEMPT WAS MADE YESTERDAY BY SUFFRAGETTES TO DESTROY
ONE OF THE WINDOWS IN THE COURT HOUSE.

Figure 3.1. From *Life*. (1910, June 9), p. 1062.

The Absurd Frivolity of Women. Another theme in the biologically oriented cartoons reflected women's illogic and triviality by depicting their love for shopping and fashion. In one cartoon (Figure 3.2) two doors are shown. Next to one door is a sign about the polls being open, and outside the door is a heavy-set woman with glasses and a cane attached to her back. She is stooped over and peering at the unfolding scene next door because no one is attempting to enter the polls. The other door of the building has signs in the windows announcing a "special bargain" and "selling out." Hordes of women are rushing madly into the store and coming out with numerous packages. Presumably, these women are buying the latest fashions at a sale price. Because women prefer shopping to voting—even to the point of fighting each other to get into the store— this supports the antisuffragist contentions that women are too frivolous to vote and have no desire to vote (Kraditor, 1981; Camhi, 1994).

The emphasis on women's desire for fashion merchandise further supports their triviality. According to Kelly (1999, p. 219), fashion defied moral and religious sensibilities during this era because Christian values dictated that one should be concerned with the spiritual rather than the secular world (Kelly, 1999). Domestic manuals of the time as well as the press often said that fashion reflected women's triviality because fashion was false and fleeting (Kelly, 1999). Thus, women's obsessive desire for fashions made them less wise and less reasonable.

Sociology and the Suffragist

Life of a Husbandette. Most cartoons reflected sociological ideologies (N = 133), and the most common sociological argument tackled issues related to the separation of the spheres, which constituted almost one third of all the cartoons (N = 64). Many cartoons reflected role reversals in which men were left to care for home and children while women participated in politics (Figure 3.3). This cartoon from 1910 depicts the scrawny "husbandette" in the kitchen washing the large stacks of dishes piled alongside the sink with his children standing by his side. His slight frame and his resignation to fate ("My Goodness, but I'll be glad when election is over," he speaks through the caption) signals his loss of masculinity. His wife, a heavy-set woman in a military-style uniform, is

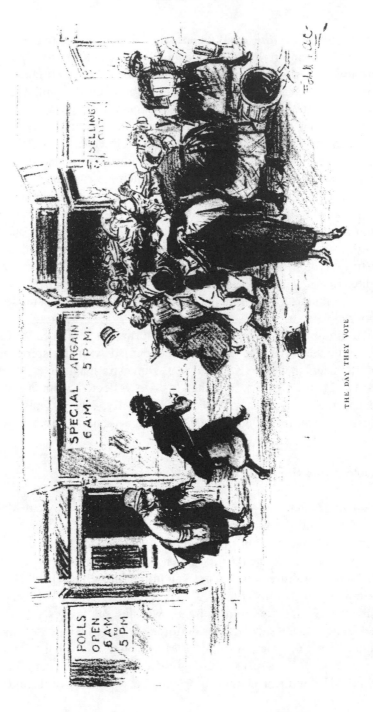

THE DAY THEY VOTE

Figure 3.2. From *Life.* (1910, June 2), p. 1015.

walking out the door to join a march. One of the marchers has a sign reading, "Man is tyrant." This cartoon clearly supports the antisuffragist conclusion that women in politics blurs the spheres and eventually leads to the destruction of the home because the notion of family is built on the separation of the public and private spheres (Abbott, 1903; Collins, 1912). With the home destroyed, progress ended and racial suicide ensued.

The photo of the heavy-set, unattractive suffragist is typical of the media's characterization of female activists. For example, antisuffragists fostered an image of suffragist and feminist Lucy Stone as "a big masculine woman, wearing boots, smoking a cigar, swearing like a trooper" (Wolf, 1991, p. 18). Similarly, in this cartoon the woman is big, masculine, and wears boots, thus reinforcing antisuffragists' negative characterizations of suffragists.

Finally, the military-style uniforms worn by the suffragists clearly evoke thoughts of militant women marching off to war. Again, the militant image signifies women's suffrage as a challenge to the middle-class hegemony because women are attempting to leave their designated private sphere to enter the public sphere (Kelly, 1999, p. 190). This depiction of suffragists as disrupting society is an early prototype of the media's coverage of social movements (Gustainis & Hahn, 1988).

The Deterioration of Society. Other cartoons presenting the separation of social spheres characterized women disenfranchising men (Figure 3.4). For example, a 1909 cartoon depicting a future life "20 Years After" women earn the right to vote, shows a heavy-set, female police officer arresting a man carrying a "votes for men" sign. Behind the arrested man is a small group of men. One is orating, and another carries a "votes for men" flag. The crowd also includes a monkey pushing a baby carriage. In this cartoon, disaster has overtaken society as men have lost the right to vote. Although neither suffragists nor antisuffragists argued that women would disenfranchise men, this cartoon bolsters antisuffragist beliefs over those of the suffragists. Antisuffragists in particular feared that "men will gradually come under the power of women [if women's suffrage is passed], who will tyrannize over them and degrade them" (Cooper, 1890, p. 28).

The inclusion of the monkey pushing a baby buggy further maintains antisuffragist ideology. Antisuffragists argued that the breakdown of the

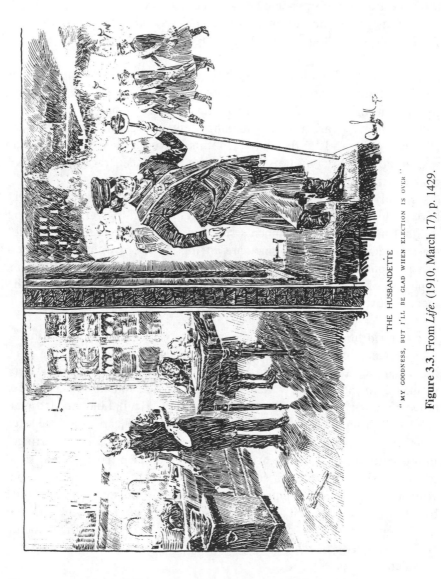

THE HUSBANDETTE

"MY GOODNESS, BUT I'LL BE GLAD WHEN ELECTION IS OVER"

Figure 3.3. From *Life.* (1910, March 17), p. 1429.

spheres was retrogressive (Camhi, 1994). Therefore, it follows that anti-suffragists would believe the breakdown of spheres leads to man devolving to ape because Darwin's *Origin of Species* implied that man evolved from apes. Darwin's theory had great influence over people in the early 1900s.

Finally, the juxtaposition of the stout female officer and the slender men suggests the new division of power. Stoutness and superior height connote a woman's superior strength and dominance, whereas slender, shorter men connote frailty, weakness, submissiveness, and lack of importance (Goffman, 1979; Malson, 1998). Although these connotations reverse the antisuffragist claim that men can vote because they have the physical strength to enforce the laws, it plays on middle-class fears and reinforces antisuffragist beliefs. According to Gustainis & Hahn's (1988) study on war protestors, many in the middle class feel threatened by those whose values run counter to hegemonic societal values, which during this era would include women's submissiveness to men. By playing on the idea that women's political participation equals male subordination, "mainstream America" may have easily been persuaded that women's suffrage displaces both men's and women's roles and ultimately destroys the social order.

The Marrying Kind. Besides issues associated with separation of gendered social spheres, the sociological cartoons often revolved around marriage themes. A typical marriage theme, as exemplified in this 1914 cartoon (Figure 3.5), was that marriage was more desirable than suffrage. The cartoon depicts three main circus tents—labeled feminism, suffrage, and matrimony—with a fourth tent in the background labeled "eugenics." Representatives from the feminist and suffragist tents are desperately trying to draw customers. These representatives, furthermore, are unattractive, wear glasses, appear older, and have their hair in buns. The matrimony tent with a sign calling it "the big show" has a crowd of men and women around the entrance and Cupid presiding over the admission booth. In the foreground, a thin, fashionable woman moving near the tents appears to be leaning toward the matrimony tent. The caption reads: "Only side shows after all."

The lack of men at the feminism and suffragism booths—indeed, the lack of anyone except suffragist stereotypes—signals the undesirability of these "types" of women. This undesirability particularly plays on

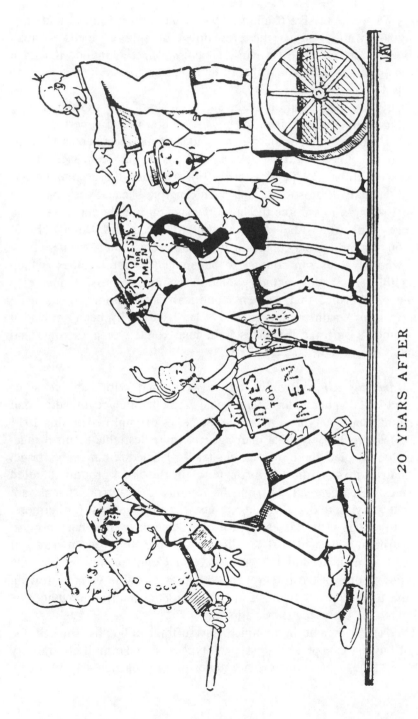

20 YEARS AFTER

Figure 3.4. From *Life*. (1909, March 25), p. 400.

women's fears. During this era, spinsterhood made for an uneasy future because women had little independence and depended on men for their subsistence (Kelly, 1999). Therefore, a woman's inability to find a husband threatened one's life. Another such cartoon, appearing in the September 22, 1910 issue, also plays on these fears by showing Cupid holding up his hand in a "STOP" gesture to a group of suffragists to "ban" them from love (p. 468). Clearly, these types of cartoons support the antisuffragist argument that marriage and family constitute women's true natures (Abbott, 1903).

Related to the undesirability of suffragists is the unattractive, unfashionable suffragist. The cartoon depicts the suffragists and feminists as dowdy, heavy-set women and the woman heading for the marriage tent as svelte and fashionable. Another cartoon, from February 9, 1911, even showed an unattractive "suffragette" dressed in masculine attire inquiring to a bearded lady at a circus sideshow, "How did you manage it?" (p. 315). Depicting suffragists as unfashionable and matronly would be a typical tactic of this era. According to Kelly (1999), society used discourses of fashionable dress to describe liked and disliked women (p. 238).

As for the eugenics tent, it is marginalized in the cartoon by its position on the far right and by its smaller sign. The cartoon seems to imply that eugenics—a belief that societal improvement would occur through proper genetic breeding—is as, if not more, insane and undesirable as suffrage and feminism. Because antisuffragist arguments during this time saw marriage and children as the primary means of societal and racial progress, this cartoon challenged the legitimacy of eugenics and further supported antisuffragism (Benjamin, 1991; George, 1913).

In Figure 3.5, moreover, the young woman who is walking toward the marriage tent clearly exemplifies the Gibson Girl look. The Gibson Girl, created by *Life* magazine cartoonist Charles Dana Gibson, became the epitome of fashion and beauty at the turn of the century (Seid, 1989). Whereas "the 'fat' woman had symbolized the family, the new slender woman symbolized 'youth' and projected a 'disquieting and alert glamour'" (Seid, 1989, p. 85). The new Gibson Girl, with her narrow skirt to show off her slender physique, was the height of fashion (Seid, 1989). Because the standards of society society used fashion to describe women in positive and negative terms and antisuffragists argued that

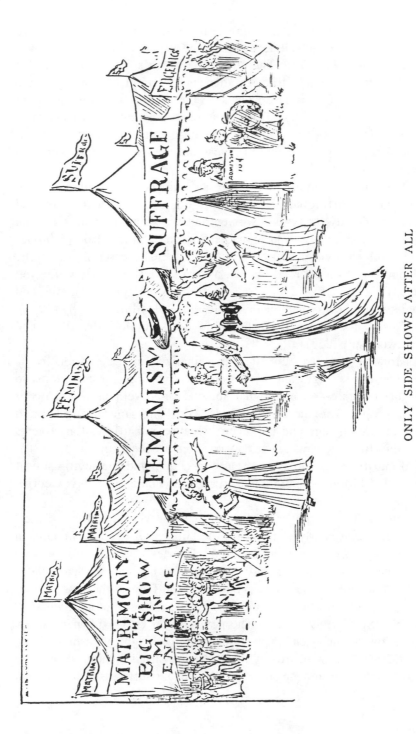

ONLY SIDE SHOWS AFTER ALL

Figure 3.5. From *Life.* (1914, September 17), p. 476.

suffragists were unattractive and mannish (Benjamin, 1991; Cooper, 1890), these types of cartoons seem to support antisuffragist ideology. It is likely that readers saw marriage and the Gibson Girl type that marriage attracts as positive and desirable over the suffragists who did not exemplify the ideal. In addition, it is important to note that many of the cartoons between 1909 and 1914 depict suffragists as hag-like, old maids with glasses, or dowdy, fat women even though an earlier study did not primarily categorize them under "unattractive" (Sheppard, 1985).

Taxation Without Representation. It should be noted that several cartoons in the sample represented the suffragist movement in a favorable light. For example, one cartoon addressed the sociological argument of the taxation without representation debate (Figure 3.6). This cartoon juxtaposes a 1776 patriot knocking out the English monarchy with a 1913 suffragist knocking out a man. Both point to a "taxation without representation" sign, and the caption reads: "Sauce for the gander." This cartoon upholds the suffragist belief that women were unjustly being taxed without true representation (Kraditor, 1981), and it refutes antisuffragists' claims that "taxation without representation" can only be applied in terms of national representation (Benjamin, 1991). The cartoon further alludes to a well-known American Revolution theme—taxation without representation—and equates the American patriots with suffragists. Through this equation, the patriots' fight for freedom from England's tyranny becomes analogous to women's fight for freedom from man's tyranny. It is likely that this cartoon, then, produced patriotic and freedom-loving feelings in the readers and made readers more likely to sympathize with suffragist arguments.

Ideology Embodied and Implications

Considering that more than 80% of the cartoons either reflect antisuffragist ideologies or favor the antisuffragist cause, these cartoons clearly support the dominant ideology during this era: separation of the public and private spheres, domesticity, Victorian values, and republican motherhood. Moreover, the prevalence of cartoons mirroring antisuffragist ideologies suggests that the dominant ideology is continually renewed, reinforced, defended, and constructed, all of which is required

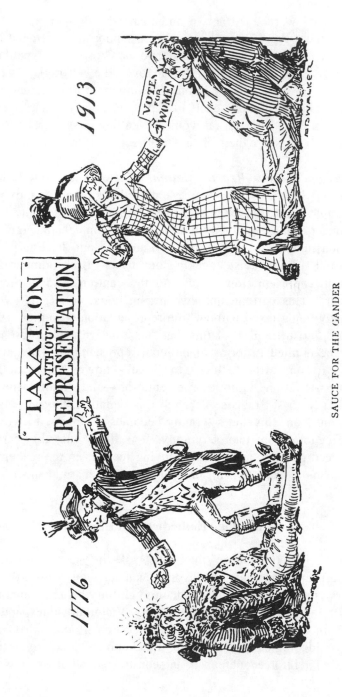

SAUCE FOR THE GANDER

Figure 3.6. From *Life.* (1913, July 3), p. 14.

for an ideology to maintain dominance (Foss, 1996, p. 295).

The nature, use, and purpose of humor further advances this contention. Humor is used "as an essential form of social communication" (Boskin, 1979, p. 5). Because it "is integrally related to a culture's code," humor thrusts societal members toward social coherence and control (Boskin, 1979, p. 5). Cartoons, as a form of humor, portray human attitudes and "reflect basic social values with intense clarity" (Boskin, 1979, p. 7; Bogardus, 1945). Through the cartoons' reflection of antisuffragist ideologies, the broader social values reinforced by the cartoons include maintaining separate spheres, women's submission to male authority, and women's primary role as wife and mother.

In addition to bolstering dominant values, the humor of the cartoons also undercut alternative and oppositional values. Humor is often used against upwardly mobile minority groups such as suffragists (Boskin, 1979, p. 30). The mocking of minority groups conveys accepted behaviors and attitudes to society. When a social group threatens the dominant ideology, humor also may be used to subvert their message. Thus, humor may function as a corrective for societal outsiders and "is tied to power, autonomy, and aggression" (Walker, 1988, p. 13).

Cartoons in *Life* reinforced the negative portrayal of suffragists found in other social discourses at the time. As Murrell argues, "throughout the country generally…the [suffrage] movement was but a subject for ridicule" (Murrell, 1938, p. 18). When one ridicules and belittles one's opponents, one is attempting to secure domination. Since cartoons express this "wish for domination and control" (Bogardus, 1945, p. 141), one may conclude that, because suffragists were going against the dominant ideology, suffrage cartoons subverted their message by reflecting antisuffragist ideologies and imagery to maintain the status quo.

Exploring the identity of those who create the cartoons further sustains the argument that suffrage cartoons upheld the dominant ideology. Because most cartoonists were men, it follows that they would reveal men's view of women, which at this time was domestic, moral, submissive, motherly, chaste, and dependent (Franzen & Ethiel, 1988, p. 13; Evans, 1989). "Rarely did early cartoonists concern themselves with women's own feelings and desires—especially for equality. They were far more concerned with the threat these desires posed to their own comfortable way of life" (Franzen & Ethiel, 1988, p. 13). Therefore, male cartoonists mocked suffragists because women's suffrage threat-

ened their position in society and the societal order.

The editorial content of *Life* further supports the dominant ideology and antisuffragist ideologies. During most of 1909, nearly all of *Life's* editorial neither favored nor disfavored women's suffrage. For example, *Life* in its February 18, 1909 issue ran an article that said when both sides arguments are encountered, "that the strongest argument against it is 'Because,' and the strongest argument for it the same" (p. 220). However, 1910 marked vehement antisuffrage editorial as exemplified by the birth of Priscilla Jawbones' weekly columns, which mocked suffragists and their ideologies, and by *Life's* essay contest on why a man should not marry a suffragette. In addition, it is important to note the characterization of Priscilla Jawbones corresponds with antisuffragists' belief that suffragists are unattractive and mannish. Jawbones is depicted as a gap-toothed old hag who wears glasses—the stereotype of a suffragist. The Jawbones column continued through 1911.

In 1912, *Life* again ran a contest, this time asking if a suffragette should marry. The winner's answer, according to the November 14, 1212 issue, was "Certainly not. A man's wife should be his ideal, not his ordeal" (p. 2192). After 1912, the editorial was mixed again, but more was antisuffragist than suffragist.

The ideology of *Life* suffragist cartoons began to change later in the decade, however. Most of the cartoons between 1919 and 1920 focused on two consistent themes, the first theme being how women's voting was good for society and would clean up the world. An example pictured a woman talking with Uncle Sam and pointing to an angel who governs over the "better organized world." The caption read: "Don't forget where we're going." The second theme depicted the political parties courting women's vote. For example, the political party symbols, the elephant and donkey, bow on one knee while extending their top hats to a fashionably thin woman. The caption reads: "Tell me, pretty maiden, are there any more at home like you?"

Clearly these themes diverge from previous suffrage cartoons. These new cartoons emphasized the value of women's votes—women's votes will improve society, which was a common suffragist argument (Addams, 1906; Winston, 1896). Also, the portrayals of the suffragists themselves began to change. *They* began to be depicted as the typical Gibson Girl—beautiful, fashionable, and thin—rather than the heavy-set, bespectacled hag. The cartoons show them as desirable to men and

feminine. They also show politicians actively seeking women's votes, which connotes their vote's importance. Interestingly and symbolically, the October 28, 1920 cover of *Life* featured a romanticized illustration by Charles Dana Gibson in which an attractive suffragist is congratulated on winning the vote by Lady Liberty (this cartoon is duplicated in Sheppard, 1994, p. 93).

The implication of the earlier cartoons bolstering dominant and antisuffragist ideology is that the cartoons, as part of a mainstream medium, may have negatively influenced the public opinion about women's suffrage. According to Maurice and Cooper (1970), the primary purpose of cartoons in this era was to mold public opinion. Cartoons also sought "to influence public opinion through its use of widely and instantly understood symbols, slogans, referents, and allusions" (Fischer, 1996, p. 122). Moreover, politicians abhorred cartoons because these depictions were able to solidify complex issues into simple metaphor. They were widely available, able to present issues in unflattering manners, and easily understood by the illiterate (Harrison, 1981, p. 14; Fischer, 1996). In fact, Thomas Nast's cartoons of Boss Tweed helped sway public opinion and expel him from office (Fischer, 1996).

Conclusion

In summary, *Life* magazine cartoons reflected both suffrage and antisuffrage ideologies, but more than 80% reflected antisuffrage arguments. The two most prominent antisuffrage ideologies mirrored in the cartoons were separation of spheres and marriage issues, and these ideologies were akin to the dominant ideology that included separation of spheres, republican motherhood, and domesticity. The prevalence of antisuffrage ideologies in the cartoons thus supported the dominant ideology and helped subvert social change. By reflecting antisuffrage ideologies in the cartoons, public opinion may have been influenced against the women's suffrage movement, especially because *Life* was "the most influential cartoon and literary humor magazine of its time" (Sloane, 1987, p. 142) and humor magazines "were read and widely quoted" ("Century of American Humor," 1901, p. 490). The passage of the 19th Amendment to the U.S. Constitution of course granted nationwide women suffrage, but not until 1920, 72 years after the Seneca

Falls Convention.

Certain ideologies have changed little in 100 years. Friedan's (1963) observation that the media subject women to the femininity myth still applies. This myth asserts that women are passive, dependent, and nurturing and that women's "natural" place is in the home. With this debilitating myth in place, women such as those who are feminist or politically powerful who go against this are often characterized as a suffragist—unattractive and mannish (Wolf, 1991). Because this characterization has survived, it impedes women from an absolute break from the traditional private/home sphere.

References

Abbott, L. (1903, September). Why women do not wish the suffrage. *The Atlantic Monthly, 92,* 289–296.

Addams, J. (1906, February). The modern city and the municipal franchise for women. In M. J. Buhle & P. Buhle (Eds.) (1978) *The concise history of woman suffrage: Selections from the classic work of Stanton, Anthony, Gage, and Harper* (p. 371). Urbana, IL: University of Illinois Press.

Barthes, R. (1977). *Image, music, text* (S. Heath, Trans.). New York: Hill & Wang.

Benjamin, A. M. (1991). *A history of the anti-suffrage movement in the United States from 1895 to 1920.* Lewiston, NY: Edwin Mellen Press.

Berger, A. A. (1995). *Cultural criticism: A primer of key concepts.* Thousand Oaks, CA: Sage Publications.

Blackwell, A. S. (1895, May 4). The physical force argument. *The Woman's Column.*

Bock, A. (1913, August 9). *Woman suffrage—Address opposing an amendment to the constitution.* U.S. Senate Committee on Woman Suffrage. Washington, DC.

Bogardus, E. S. (1945). Sociology of the cartoon. *Sociology and Social Research, 30* (1), 139–147.

Bordo, S. (1993). *Unbearable weight: Feminism, Western culture, and the body.* Berkley, CA: University of California Press.

Boskin, J. (1979). *Humor and social change in twentieth-century America.* Boston: Boston University Press.

Camhi, J. J. (1994). *Women against women: American antisuffragism, 1880–1920.* Brooklyn, NY: Carlson.

Century of American humor. (1901, July). *Munsey's Magazine, 25,* 490.

Collins, F. W. (1912). Do a majority of women want the ballot? In A. F. Scott & A. M. Scott (Eds.) (1975) *One half the people: The fight for woman suffrage* (pp. 106–110). Philadelphia: J. B. Lippincott.

Cooper, S. W. (1890, October 25). The present legal rights of women. *The American, 21:* 27–28.

Drukker, S. T. (1897, April 5). Voting mothers. *The American Jewess.*

Evans, S. M. (1989). *Born for liberty: A history of women in America.* New York: The Free Press.

Fischer, R. A. (1996). *Them damned pictures: Explorations in American political cartoon art.* North Haven, CT: Archon Book.

Flexner, E. (1975). *Century of struggle: The woman's rights movement in the United States.* Cambridge, MA: Harvard University Press.

Foss, S. K. (1996). *Rhetorical criticism: Exploration and practice* (2nd ed.). Prospect, IL: Waveland Press.

Franzen, M., & Ethiel, N. (1988). *Make way! 200 years of American women in cartoons.* Chicago: Chicago Review Press.

Frazer, E., & Lacy, N. (1993). *Politics of community: A feminist critique of liberal-communication debate.* New York: Harvester Wheatsheaf.

Friedan, B. (1963). *The feminine mystique.* New York: Dell.

George, A. N. (1913). *Woman's rights vs. woman suffrage.* New York: National Association Opposed to Woman Suffrage.

Gibbons, C. J. (1902, January). The restless woman. *Ladies Home Journal,* p. 6.

Gitlin, T. (1980). *The whole world is watching.* Berkeley, CA: University of California Press.

Goffman, E. (1979). *Gender advertisements.* Cambridge, MA: Harvard University Press.

Gramsci, A. (1971). *Selections from the prison notebooks of Antonio Gramsci.* (Q. Hoare & G. Smith, Eds. & Trans.). New York: International Publishers.

Gustainis, J. J., & Hahn, D. F. (1988). While the whole world watched: Rhetorical failures of anti-war protest. *Communication Quarterly, 36*(3), 203–216.

Harrison, R. P. (1981). *The cartoon: Communication to the quick.* Beverly Hills: Sage.

Horn, M. (1980). *The world encyclopedia of cartoons* Vol. 2. New York, Chelsea House.

Kelley, F. (1898, February 13–19). Working woman's need of the ballot. In M. J. Buhle & P. Buhle (Eds.) (1978) *The concise history of woman suffrage: Selections from the classic work of Stanton, Anthony, Gage, and Harper* (pp. 367–368). Urbana, IL: University of Illinois Press.

Kellner, D. (1995). *Media culture.* London: Routledge.

Kelly, C. E. (1999). *In the New England fashion: Reshaping women's lives in the nineteenth century.* Ithaca, New York: Cornell University Press.

Kraditor, A. S. (1981). *The ideas of the woman suffrage movement, 1890–1920.* New York: W.W. Norton.

Lindlof, T. R. (1995). *Qualitative communication research methods.* Thousand Oaks, CA: Sage.

Lowe, C. A. (1912, April 23). On behalf of 7,000,000 wage-earning women: Address to U.S. Senate. In A. F. Scott & A. M. Scott (Eds.) (1975) *One half the people: The fight for woman suffrage* (pp. 122–128). Philadelphia: J.B. Lippincott Company.

Malson, H. (1998). *The thin woman: Feminism, post-structuralism and the social psychology of anorexia nervosa.* London & New York: Routledge.

Maurice, A. B., & Cooper, F. T. (1970). *The history of the nineteenth century in caricature.* New York: Cooper Square Publishers.

McQuail, D. (1983). *Mass communication theory.* London: Sage.

Meyer, K., Seidler, J., Curry, T., & Aveni, A. (1980). "Women in July Fourth cartoons: A 100-year look." *Journal of Communication, 30*(1), 21–29.

Moody, H. W. (1898). The unquiet sex: Third paper—women reforms. *Scribner's Magazine, 23,* 116–120.

Mott, F. L. (1930). *A history of American magazines.* Cambridge, MA: Harvard University Press.

Murrell, W. (1938). *A history of American graphic humor (1865–1938).* New York: Macmillan.

Perry, E. I. (1994). Introduction: Image, rhetoric, and the historical memory of women. In A. Sheppard. *Cartooning for suffrage* (pp. 3–19). Albuquerque, NM: University of New Mexico Press.

Peterson, T. (1964). *Magazines in the twentieth century.* Urbana, IL: University of Illinois Press.

Ramee, L. (1909). The woman problem: Shall women vote? A study of feminine unrest—its causes and its remedies. *Lippincott's, 83,* 586–592.

Scott, A. F. & Scott, A. M. (1975). *One half the people: The fight for woman suffrage.* Philadelphia: J.B. Lippincott.

Seid, T. J. (1989). *Never too thin: Why women are at war with their bodies.* New York: Prentice Hall.

Sheppard, A. (1985, Spring/Summer). Political and social consciousness in the woman suffrage cartoons of Lou Rogers and Nina Allender. *Studies in American Humor, 4,* 39–49.

Sheppard, A. (1994). *Cartooning for suffrage.* Albuquerque, NM: University of New Mexico Press.

Shoemaker, P., & Reese, S. (1996). *Mediating the message: Theories of influences on mass media content.* New York: Longman.

Sloane, D. E. E. (1987). Introduction and *Life.* In D. E. E. Sloane (Ed.) *American humor magazines and comic periodicals* (pp. xii–xxxii; 141–153). New York: Greenwood Press,.

Stanton, E. C. (1882, February 20). Address to U.S. Senate on woman suffrage. In A.F. Scott & A.M. Scott, A.M. (Eds.) (1975) *One half the people: The fight for woman suffrage.* Philadelphia: J.B. Lippincott Company.

Stanton, E. C. (1895). *Woman's bible* (Part I). New York: European Publishing.

Tarbell, I. M. (1912). The irresponsible woman and the friendless child. *American Monthly Magazine 74,* 49–53.

The argument against woman suffrage. (1913, August 7). *The Independent 75,* 301–302.

Thompson, F. M. (1900, November). Retrogression of the American woman. *North American Review,* 748–753.

Tuchman, G. (1978). Symbolic annihilation of women by the mass media. In G. Tuchman, A.K. Daniels, & J. Benet (Eds.), *Hearth and home: Images of women in mass media* (pp. 3–30). New York: Oxford University Press.

Van Zoonen, E. (1991). Feminist perspectives on the media. In J. Curran & M. Gurevitch (Eds.), *Mass Media and Society* (pp. 33–54). New York: Edward Arnold.

Walker, N. A. (1988). *A very serious thing: Women's humor and American culture.* Minneapolis, MN: University of Minnesota Press.

Williams, R. (1980). *Problems in materialism and culture: Selected essays.* London: Verso.

Winston, E. W. (1896). Foibles of the new woman. *Forum 21*, 186–192.

Wolf, N. (1991). *The beauty myth: How images of beauty are used against women.* New York: Doubleday.

Wood, J. P. (1971). *Magazines in the United States: Their social and economic influence.* New York; Ronald Press.

Chapter 4

Humor and Gender Politics:
A Textual Analysis of the
First Feminist Comic in Hong Kong

Wendy Siuyi Wong and Lisa M. Cuklanz

Comic books constitute one of the most popular reading media of Hong Kong people. The market share of locally produced comics in Hong Kong is dominated by boys' comics such as *Oriental Heroes, Bruce Lee* and *Wind and Cloud* (Wong & Yeung, 1999). And, like most places all over the world, Hong Kong's comic books, whether locally produced or imported from Japan or Taiwan, are highly stratified by gender in style, character profiles, content, and audience. There is a clear division of audience into male or female, with boys reading action comics, and girls reading "soft" comics about romance rather than martial arts. There are very few locally produced comics designed for female audiences, and women comic artists are also very rare in the history of Hong Kong comics.

Reviewing the past 30 years of the development of Hong Kong comics, only about 10 women comics artists of any note can be found. These include, from the 1960s, Lee Wai-chun, Kwan Shan-mei, and Tse Ling-ling; from the 1970s, Kam Tung-fung; in the late 1980s, Chan Ya; in the 1990s, Mak Ka-pik, and Shuet Ching, and most recently, Lau Lee-lee. Only three of these, Lee Wai-chun, Chan Ya, and Lau Lee-lee, can be described as in any way prominent. Although this list of women comics artists of Hong Kong is short, it does not mean the topic is not worth examination, research, and analysis. Rather, this is a topic that has not received the scholarly attention it deserves. The only scholarly article in the field of communication on gender in cartoons in Hong Kong examines television cartoons

rather than print comics (Chu & McIntyre, 1995), and two articles cover the general field of comic art in Hong Kong (Lent, 1995; Bolton & Hutton, 1997). This chapter thus takes up an important but so far unexamined subject, that of women cartoonists in Hong Kong. More specifically, it examines the recent work *Mom's Drawer at the Bottom* by Lau Lee-lee (1998)[1] in historical and cultural context, arguing that as the first self-proclaimed feminist cartoon in Hong Kong Lau's work displays many of the central defining elements of feminist humor while adding new dimensions uniquely suited to the Hong Kong context. The following sections outline the relationships of gender, humor, feminist social critique, and comics. Then, the chapter provides a brief history of key women comics artists in Hong Kong. Finally, it provides a detailed examination of the themes and ideology in Lau's book to illustrate the ways in which it provides a feminist critique and vision within the Hong Kong context.

Gender Ideology and Humor

For over a century, gender has been one of the central topics of concern to theorists and practitioners in the general field of humor and in the more specialized field of comics (see Bruere & Beard, 1934; Meyer et al. 1980; Toth, 1994; Walker, 1988). There are several important reasons for this. As a form or mode of communication, humor has been a masculine genre because its use is understood as a manifestation of aggression (Walker, 1991, p. 61). In part because of this, women have been discouraged from participating in humorous genres and from entering fields such as stand-up comedy and comic art. Finally, because they have often been the subject of male-produced humor and have thus not found it funny, women have been found lacking in "sense of humor." As Alice Sheppard notes: "We conceptualize 'women humorists' as a special category because humor is implicitly defined as a male realm, and the terms comedian, cartoonist, and humorist are implicitly gender-referenced. We thus feel compelled to distinguish comediennes, woman/lady humorists and woman/lady cartoonists from their male counterparts" (Sheppard, 1991, p. 36). Woman-authored humor is still studied separately from that of men for these reasons.

For women, the use of humor is in itself a politically charged act. Thus, those women who do venture into fields such as comic art are often aware of their "outsider" position and the power of their medium to critique patriarchal ideology and norms from a female perspective. As Trina Robbins (1999) points out, comics and the venues where they are sold have historically been areas of almost exclusively male activity, with women either marginalized or forced out. In recent decades, comics with "female" subject-matter have found a market niche very separate from that occupied by traditional, male-oriented comics. This has been no less true in Hong Kong than in other places.

The nature of comics as a means of social critique and as a factor in the political sphere has been observed by many. As Kathleen Turner (1977) notes, comics usually depict contemporary settings and issues, so that "like other symbolic acts, comics as popular art cannot be isolated from the times from which they developed and with which they contend" (p. 28). Turner observes that comics help people cope with their own situations by providing "equipments for living that size up situations" (p. 28). Martin Barker also emphasizes the relevance of political and ideological themes in comic art, noting that "the history of comics is a history of controversies" that have involved arguments over the meaning and influence of comics (Barker, 1989, p. 19). Within the sub-field of comics, gender has been an especially important factor influencing content, ideology, and audience. Like other types of comic art, especially other political cartoons, feminist cartoons have taken part in their social contexts and surrounding controversies.

Feminist Humor as Social Critique

Feminist humor can of course be defined in many ways, but several consistent definitional themes emerge among the many efforts to delimit this genre of humorous political discourse. A particularly clear and useful definition is offered by Gloria Kaufman (1994) in "Pulling our own strings: Feminist humor and satire." She writes: "Feminist humor is based on the perception that societies have generally been organized as systems of oppression and exploitation, and that the largest (but not the only) oppressed group has been the female. It is

also based on the conviction that such oppression is undesirable and unnecessary. It is a humor based on a vision of change" (p. 23). Kaufman further adds that feminist humor is a "humor of hope" rather than of hopelessness, and that it tends to stereotype male actions rather than characters because it is written by and for people with a low tolerance for stereotyping of people and groups. Importantly, and surprisingly for some, feminist humorists have not created negative male stereotypes to counter those of women found in male-produced humor.

The key characteristic of feminist humor, then, is that it "exposes" reality in its "desire for reform" (Kaufman, 1994, p. 25). Toth's (1994) analysis is in general agreement with Kaufman's characterization of feminist humor, while Sheppard's (1991) defini-tion of women's humor asserts that its key characteristic is that "it derives from the experience and feelings we have shared by virtue of having been born and raised female in our culture" (p. 42). Sheppard delineates five types of women's humor, the most radical of which is "role-transformative" humor which "most obviously and directly seeks to attack gender roles" (p. 47). This type could also be labeled feminist. Feminist humor in general has been characterized as having four defining elements: directly attacking or critiquing gender roles, exposing the realities of gender inequality and discrimination under patriarchal ideology, expressing elements of experience that are shared by women generally, and expressing hope toward a vision of change. These four elements can be seen clearly in Lau's comics.

Background on Hong Kong History and Opportunities for Women

The basic history of the economic development of Hong Kong tells the story of the tough and impoverished era of the 1950s. During the 1950s, although the economy was beginning to develop more rapidly, the society was still confined by traditional Chinese values as well as insufficient resources. Under such conditions, women were often the first chosen to make sacrifices, and many elder sisters born in the 1950s were forced to give up their educational opportunities, with the result that it was common to find girls completing their education only through primary school at best. Chances and resources were

given to boys in the family to further their education, with very little being saved for girls. In such a social environment, the concept of equality between men and women was difficult to imagine. Luckily, with the improvement of the Hong Kong economy in the 1960s and 1970s, opportunities were created for women to join the work force in the industrialization stage. These opportunities, once created, remained open to women. According to Westwood, Mehrain, and Cheung's (1995) study *Gender and Society in Hong Kong*, work force participation of women in Hong Kong was at a steady 45% to 50% during the 1970s and 1980s. With the increasing number of women working in the production sector, women enjoyed the freedom of being in control of their finances and the power to create wealth on their own.

In the 1970s and 1980s, an era in which Hong Kong faced drastic changes, basically all boys and girls received equal educational opportunities (family-level decisions may not have been fully equal yet during this period) and legal rights for women were also constantly improving. By the 1990s, Hong Kong families were spending approximately equal amounts of money on the primary and secondary school education of boys and girls (Equal Opportunities Commission of Hong Kong, 1997). Under such circumstances, women were able to demonstrate their ability and gain recognition from the larger society. Also, many successful women became socially recognized figures. Especially for those women with secondary school or university education, hard work was almost a guarantee of success. Many women were able to further their studies, and those who could not get into post–secondary education had opportunities for employment in the commercial sector. These basic facts of the historical trajectory of the Hong Kong economy and its relationship to workplace opportunities for Hong Kong women have also impacted the development of women's comics and women comics artists in Hong Kong.

The Rise of Women Comics Artists in Hong Kong

The appearance of women comics artists in Hong Kong after World War II began in the 1960s. Lee Wai-chun is the most outstanding woman comics artist from the 1960s, and no discussion of women's comics in Hong Kong can omit attention to her historic role. Her

work *13-Dot Cartoons*, first published in 1966, ran continuously until the beginning of 1980, with 178 issues. This work was re-published in 1996 and Lee was recognized as the "master of girls' comics" and as a "paper fashion designer." Indeed, the countless fashion styles worn by the main character, Miss 13-Dot, and drawn meticulously in every issue are the most established achievement and most easily recognizable characteristic of *13-Dot Cartoons*. Because fashion was such a prominent feature of the *13-Dot Cartoons* and was so closely followed by readers, the comic also functioned as a fashion trend reference source for readers in the 1960s (Wong, 1997; Wong & Cuklanz, 2000).

The image of 13-Dot represented a Westernized modern identity and model for local Chinese women, and this influence is obvious, especially in the period before the arrival of Hong Kong television's golden era in the mid-1970s. Although the *13-Dot Cartoons* cannot be classified as feminist because of their emphasis on fashion and style rather than on any overt political or social commentary, the cartoon did sometimes convey the idea of gender equality through the narrative of the story. Lee did not accommodate herself and her creative works into the dominant power structure, the traditional Chinese values according to which men are always more important than and superior to women, but she did not directly critique it. For instance, in issue no. 55, "Preference for daughter rather than son," published in 1969, Lee depicts a father as uninterested in taking a second wife, which was still legal at that time in Hong Kong. In not taking a second wife to try for a son, this father also shows preference for the daughter he already has. The story line does not overtly critique the practice of husbands taking multiple wives or the preference for sons, but the sympathetic and positive character of this husband/father is simply shown to be uninterested in doing so. Shifts in social practice are suggested, but not openly advocated. *13 Dot Cartoons* relied on the popular appeal of fashionable design and usually light story lines to attract a wide mainstream female audience.

After *13-Dot Cartoons* came to a close, there were almost no women comics artists in Hong Kong during the whole decade of the 1980s. Comic reading materials for women were dominated by imported Japanese comics. Then, in 1989, Chan Ya began a newspaper comic strip that was soon collected in a book entitled *One*

Woman–Three Markets, also published in 1989, an historic year for China and Hong Kong. While Lee Wai-chun had turned to comics as virtually the only possible avenue to earning a living as a woman artist at the time, Chan Ya's full-time job was as a newspaper columnist, and her comics work was a sideline activity. She produced only one book of comics, which was a collection of work previously published in the newspaper.

Chan Ya's comic art centered on an unappealing character with thick lips and a loud voice. This character fits Montresor's (1994) definition of the "grotesque," which is often used by women comics artists to subvert "conventional standards of feminine beauty" (p. 335). In addition to providing some humor to our understanding of a wide range of contemporary political topics such as Tiananmen Square, the more than 160 comic strips in her book also underlined some important issues related to the equality of the two genders and disturbed the territory previously occupied entirely by male comics artists. As a woman, she expressed and sarcastically criticized complicated and serious political incidents from an outsider perspective. She is the first woman comic artist ever to achieve this "outsider critique" in Hong Kong. Unfortunately, after her newspaper comic strip column was canceled, and with the publication of her book in September, 1989, her output as a comic artist came to an end. It is important to note that although it did critique mainstream politics from a distinctly female perspective, her work did not systematically focus on issues related to patriarchal domination, such as sex, sexuality, discrimination, and gender oppression.

After Chan Ya's work was published in 1989, there was no other similar type of politically oppositional women comics artist in Hong Kong until Lau Lee-lee in 1998. There are many possible reasons for the dearth of women comics artists in Hong Kong, a place in which comic art in general has been a thriving and popular enterprise for many decades. In addition to the perceived threat of female-produced comics with any sort of social critique or political "edge," factors related to the economy and the availability of publication venues are perhaps most important. As Lau Lee-lee has observed (Wong & Cuklanz, 1999), the range of publication venues for non-traditional comics was not yet well diversified through the 1980s, making it difficult for political comics artists to earn a living from their art. Only within

the last decade have a range of magazines and small newspapers emerged, offering a start for new and critical comic artists within political niche markets. Lau's comic art has appeared regularly in a feminist magazine and in a film magazine since 1997. Two of the comics included in the book were previously published in *Hong Kong Cultural Studies* (no. 5, Summer 1996), a semi-academic publication consisting mainly of articles on Hong Kong culture.

Another important factor relating to the absence of women comic artists and feminist comics in Hong Kong is the persistence of traditional gender ideology. Even though Hong Kong women were gaining success and public attention particularly in mainstream politics with figures such as Anson Chan, Emily Lau, Ann Wu and Christine Loh and serving as role models for mainland women, still there was no public expression of a woman's viewpoint on the political and social life of Hong Kong being expressed in comic art. The status of women and men in Hong Kong seemed to be gaining equality, but in fact women were still making less than men in the same jobs, there was still discrimination against women in the business sector, and the mass media was still exploiting women's images. According to a survey of gender equality (Equal Opportunities Commission of Hong Kong, 1997), people who used the media for entertainment were more likely to have a "stereotypic perception of women" (p. 15). In addition, most people agreed that gender discrimination was still common, with dismissal due to pregnancy, sexual harassment, and specification of gender in job advertisements the most common forms recognized.

Although the equality of the sexes and education in general in Hong Kong was much better than in the 1960s and laws supported gender equality, still Hong Kong people had not developed a progressive mentality with attitudes supportive of the principal of full gender equality. As Walker has observed about the emergence of radical feminism (and radical feminist humor) in the United States, the central enabling factor is "a critical mass" (Walker, 1991, p. 72) of women who have experience outside the home so that they are exposed to the realities of patriarchal ideology and its accompanying discriminations against women. By the late 1990s, Hong Kong did have such a group of well-educated and experienced professional women who might understand and appreciate Lau Lee-lee's message.

The general awareness of Hong Kong people towards this issue was not strong, as reflected in the mass media, and under such circumstances Lau's comics provide a needed channel to consider issues of gender equality. Almost immediately, her work generated some media attention and sparked discussion of the ideology of feminism in Hong Kong. Lau notes that the written responses to her work, both in the magazines and in *Mom's Drawer at the Bottom* (1998), have been very positive, and she receives no "hate" mail criticizing her for exposing inequality and hypocrisy in the life of Hong Kong (Wong & Cuklanz, 1999).

The Initiation: The Birth of Feminist Comics in Hong Kong

In the current political and economic context of post-handover Hong Kong (that is, after the resumption of Chinese sovereignty over Hong Kong in 1997) Lau Lee-lee's feminist comics have been well received by her audience. This indicates that there is at least a segment of the Hong Kong comics audience that is sympathetic to her message of ideological critique and social change. However, it may not mean that a large percentage of the people are feminists. Lau believes that her comics contain enough ambiguity and subtlety that they can draw in a large audience without offending many people. She does not aim for a feminist audience who will already agree with her perspective, but tries instead to address a wider audience of people who might be open to her observational style of conveying ideas about contemporary topics and situations. Indeed, her style of humor is subtle and in- offensive, often treating radical subject matter in understated ways.

In contrast to previous works of women comics artists in Hong Kong, Lau Lee-lee's collection *Mom's Drawer at the Bottom* published in 1998 is a self-proclaimed collection of feminist comics. Lau sees the "promotion of self-determined sexual desire" (p. 1) as a central part of her project. She labels herself a feminist, and, as the title of the book indicates, the main themes are concerned with power issues in gender politics. Even the title of the book implies that the gender equality of the society has still not been achieved, with the housewife's place still literally at the bottom. The drawing on the cover shows a dresser with drawers stacked like a ladder, with a small

girl climbing up the drawers toward the top of the dresser. Lau is playing with the symbolic meaning of the positions of the drawers as indications of the gendered power relations within the family and in society at large. In Lau's (1998) words, the motivation behind her comics work is the optimistic idea "to resist and disrupt, the beginning is never far away" (p. 201). Thus, the fundamental motivation of the creation of this comic is precisely the central purpose used by Kaufman (1994) and others to define feminist humor: the use of humor to expose reality and express a desire for change toward a better society. Lau uses her feminist label to disturb and challenge the power system of Hong Kong, using her own observations to stimulate some critical thinking about power relations and social realities. As Lau says, using the label of "feminist" for herself is the result of some internal struggle, since she understands that the term is misinterpreted in many ways in Hong Kong, and is often considered to refer to a dogmatic ideologue.

Lau's collection includes many examples that illustrate the four central defining characteristics of feminist humor. Her visual stories directly attack traditional gender roles, expose the realities of discrimination under patriarchy, draw on the shared experience of women, and begin to delineate a vision of change. In addition to these elements, her work sometimes focuses on themes and topics unique to the Hong Kong context, incorporating history, myth, common experiences, and elements of popular and political culture to create a humorous critique of mainstream ideology and perspectives. Her style of humor employs simple and direct observation to point out the shortcomings of political and social life. She often uses the visual element to convey the more controversial or potentially offensive elements of the message while using language sparingly.

The general understanding of the connotations of feminism can be problematic in Hong Kong. Even well-educated men may consider women involved in women's liberation to be an untouchable group with whom extra caution should be exercised. These negative associations reflect the fact that most Hong Kong people have limited exposure to this term and the ideology it represents. Without trying to provide interpretations and definitions that the term "feminism" has for Hong Kong people, the contents of Lau's comics give feminism a simple definition. It is the use of a principle of self-awareness to see

and to think critically about one's daily environment, using a fair analytical attitude (Lau, 1998). Often, but not always, the subject matter she chooses from the environment is gender-related. As Lau notes, feminism is a powerful analytical tool that can be used to gain insight and critical distance from personal and social realities. Her perspective is well reflected in the thematic categorization of the issues in the book, which begins with "sex and sexuality" and includes "sex roles," "gender politics," "living," "media," and "home-nation-earth."

Direct Attacks on Gender Roles and Stereotypes

Perhaps the most basic and important element of feminist humor is direct attack on traditional socialization, gender roles, and stereotypes. Lau engages in this strategy frequently, with numerous strips on how society unfairly views men and women differently. In strips utilizing this strategy, either Lau as narrator or one of her characters verbally questions elements of socially constructed gender. In one story, "Sex Counts" (p. 57), Lau comments on sexual stereotyping and the function of toys in sex role socialization, noting that the character of a baby might be influenced by many things, but that social influences such as gendered toy assignments are the most important.

Similarly, in "Big Difference" (p. 63) (Figure 4.1), she puts identical pictures side by side, labeling one of the pictures as a woman and the other as a man. In the subsequent frames, Lau discusses how society will react differently to the same behavior depending on whether it is undertaken by a man or a woman. Thus, for example, if condoms are found in a man's wallet, he is called a playboy, whereas if condoms are found in a woman's purse, she will be called a slut. Or, if a man shows his desire to climb the ladder of success, he is called ambitious, whereas a woman with the same attitude would be called aggressive. The only "Big Difference" between women and men is how people perceive and label them.

Lau points out the double standard operating in society's judgments of men and women, with judgments of women coming out more negative than those of men in many cases, even when the behavior of both is similar or identical. Her critique is direct and

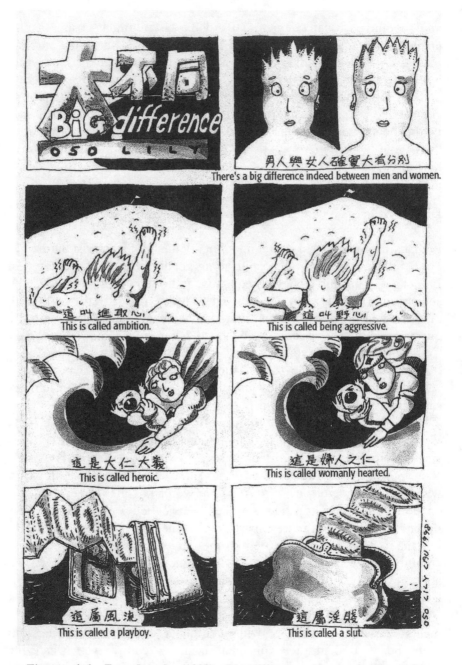

Figure 4.1. From Lau, L. (1998). Big difference. *Mom's drawer at the bottom*, p. 63. Reprinted with permission of Lau Lee-lee.

unmistakable in this example: men and women are often treated differently in the same situation, and this generally accepted practice is wrong. Yet her style, though direct, does not overtly state "this is wrong," but tends rather to leave the reader to draw a conclusion about the simple observations that she has presented. In two very similar strips, "Superior Jobs" (p. 95) and "Body Sell" (p. 97), the negative reputation of prostitutes is called into question. In the first, "Superior Jobs" such as lawyer, senator, and real estate agent are compared to the job of a prostitute as she comments "I still don't understand why the desire I pursue is any different from theirs."

A final example of direct attack on traditional gender roles and concepts, "Something More Important" (p. 77) depicts a girl who helps out with housework at home while her father and brothers do nothing because the father does "big things" outside the home and the brother will do "big things" in the future. Later on, when the girl is an adult woman, she ends up doing a "big" job outside the home after all. She benefits from a Philippine domestic helper and her own mother to help with the housework and child care. In the final frame, the woman wonders why doing housework does not count as a big thing. The woman seems to be noting that traditional women's work should be considered important like other work, even though it is not the type of work she herself does. Her childhood experiences seem to have made her realize that housework should be valued too.

Exposing the Realities of Gender and Discrimination under Patriarchal Ideology

Many of Lau's comics simply depict situations with almost no dialogue or critical commentary from herself or her characters. Often, these strips highlight gendered situations or relationships in a subtle or ambiguous way. Unlike the "direct attack" strategy, which questions socially constructed ideas about gender, strips exposing gender realities more passively make points about the realities of gendered life. In these strips neither the narrator's voice nor any of the characters verbalize an ideological critique. Rather, situations are described and examined, simply revealing problems and truths. In "Explosion" (p. 39) (Figure 4.2), a man who has trouble sleeping calls for phone

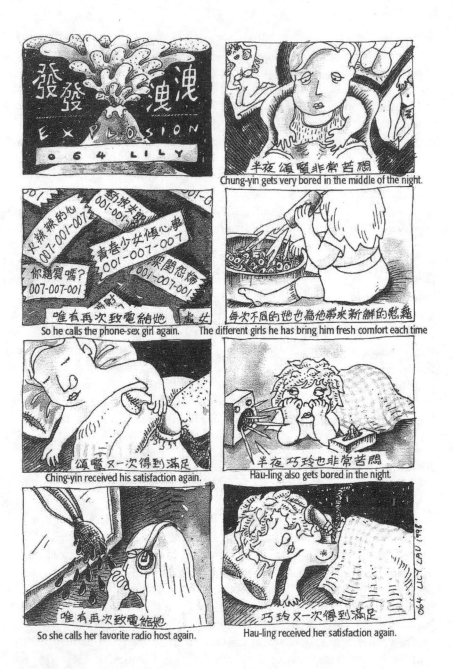

Figure 4.2. From Lau, L. (1998). Explosion. *Mom's drawer at the bottom*, p. 39. Reprinted with permission of Lau Lee-lee.

sex and achieves satisfaction, falling asleep with the phone in his hand. A woman who also cannot sleep listens to a radio talk show host and telephones in to discuss her problems. She also gains satisfaction and falls asleep holding the phone. The point of the strip is open to interpretation, but at least Lau is definitely suggesting similarities and differences between men and women. While both are so lonely that they must resort to anonymous phone relationships for gratification and both contact women to have their needs met, the man calls for sexual stimulation and the woman calls for emotional support. Various observations about gender are made without overt comment or critique.

Lau also examines male power in many of her comics. One typical strategy is the re-telling of a popular myth in a new way that adds a feminist perspective and a new interpretation critiquing the traditional myth. For example, she tells a story based on a Chinese myth of the beginning of the universe. The story is called "Before He Shoots the Suns" (p. 33) (Figure 4.3), and recounts the tale of an ancient time in which there were thousands of suns in the sky. A legendary woman who has the best aim decides to shoot down most of the suns because it is too hot, but after shooting all but ten, she begins to feel bored, so she leaves the rest of the duty to her best-behaved son, and goes to take a bath. The son who was told by his mother to finish up the job and shoot down nine more suns becomes the legendary hero of the traditional Chinese myth that tells of a heroic man who shot down nine extra suns and left just one so that the earth's temperature would be just right. So, Lau's version points out the idea that women's contributions may not be remembered in the traditional myths and histories, and also makes the point that male successes may have women behind them. In telling this "myth before the myth," she puts a woman back into the story as the central heroic character, thus using comic humor to reclaim women's role in pre-history and pointing out the fact that the traditional myths usually only emphasize the contributions of men. Her strategy is simply to change the story, leaving readers to draw their own meaning from it.

In a final, perhaps more daring example, "Who's Next?" (p. 91) (Figure 4.4), a young girl is shown cornered by a dark shadow, which turns out to be her father. The father is never clearly drawn, and has no spoken lines, so he is not really "characterized" or "stereotyped."

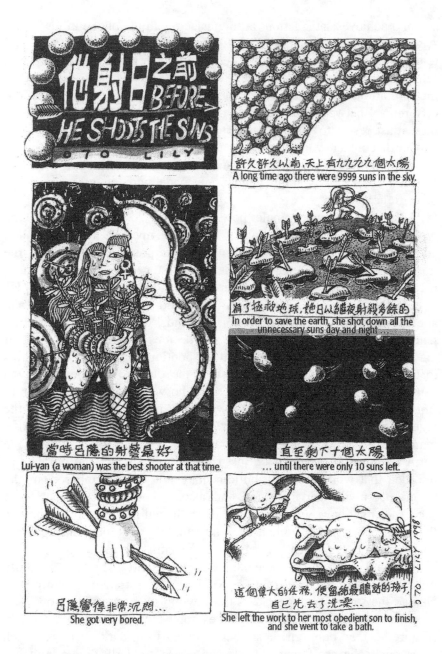

Figure 4.3. From Lau, L. (1998). Before he shoots the suns. *Mom's drawer at the bottom*, p. 33. Reprinted with permission of Lau Lee-lee.

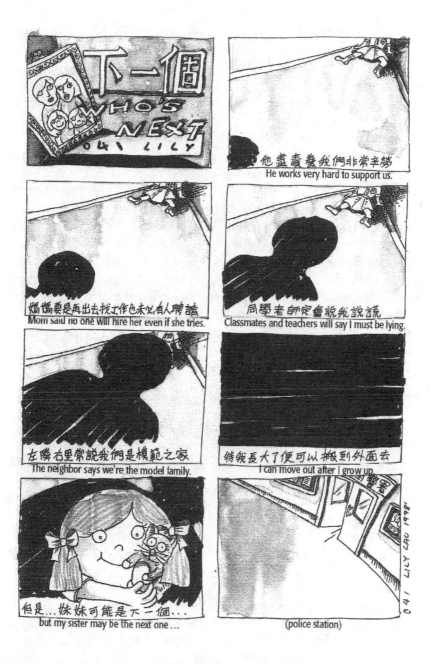

Figure 4.4. From Lau, L. (1998). Who's next. *Mom's drawer at the bottom*, p. 91. Reprinted with permission of Lau Lee-lee.

Thus, like other feminist humorists, Lau avoids creating such negative
stereotypes of men even when the subject is child rape. She does not
shy away from the subject, but treats it with a feminist and
unoffending sensibility. The father is sexually abusing the daughter,
but this is never stated or shown explicitly in the strip. Rather, the
daughter's thoughts are written while the visuals show her increasingly
obliterated by the dark shadow. The daughter's thoughts indicate that
she is considering what to do and would rather not tell anyone about
the situation. At one point she thinks, "I can move out when I grow
up." But, in the end, the final frame's view of the police station
suggests that she has decided to tell her story so that her sister will not
become the next victim. Lau says that she targets some of her comics
toward a young audience (Wong & Cuklanz, 1999), with the idea that
young people will always read comics almost regardless of the subject
matter. Here her work can suggest to teenage readers in abusive
family situations that their actions can make a difference and that they
can help others such as younger siblings. At the same time, the strip
calls attention to a gendered reality that is quite unusual to see treated
in cartoon form.

Depicting the Shared Experiences of Women

Control of sex and sexuality has been at the center of gender
oppression and the analysis of this oppression for centuries. Many of
Lau's comics examine sex and sexuality from a female perspective,
examining experiences that may be common to many women. In
"Well-Behaved Woman" (p. 25) Lau depicts a narrator who says she
is a well-behaved woman because she never engages in "bad"
behaviors. She says she never wears sexy clothing because other
clothing is more natural, and she never watches X-rated videos unless
she can't sleep. In the final frame she adds one more item to the list:
she never reveals her sexual desire casually to men because they
always disappoint her. In each case the woman gives a personal reason
for not engaging in "bad" behavior. She is not blindly following the
moral prescriptions of society and simply avoiding things that are
called "bad," and she also, almost in passing, makes a general
critique of men's sexual behavior based on her own experience.

Young readers may not find it easy to understand and identify

with the concepts of sexual liberation and self-determination. How-
ever, the section on sex roles may cause them to reflect seriously on
their own experiences while at the same time commenting on a shared
experience of women. For example, "A Record Throw" (p. 53)
(Figure 4.5) tells the story of a young girl who is teased by other kids,
as are many young girls, because her period causes some blood stains
on her clothes. After a while the girl gets tired of getting teased, and
she decides to take revenge by collecting her used sanitary napkins
and then throwing them at people who once teased her. The frame
showing the faces of the victims of this treatment depicts truly
horrified, ghoulish characters. Then, in the final frame, the story ends
happily as the young girl turns out to become a successful handball
player because she had so much practice at aiming and throwing from
her younger days. The story makes a humorous link between the used
sanitary napkins and the handball game. Here Lau brings the taboo of
the used napkin directly into the story, suggesting that it may not be
necessary for women to hide their periods as a shameful or unnatural
phenomenon. Bringing the taboo out into the open can begin to
normalize it, and Lau takes the first step in helping to create change in
social attitudes about women's physical nature. Yet she treats this
perhaps shocking subject matter primarily through the visuals.

Some of Lau's comics combine more than one of the four fem-
inist techniques discussed here. In exposing the realities of discrim-
ination under patriarchy, she often also naturally suggests a critique of
gender roles. One such example is in "Changing Demand" (p. 65),
which depicts the "needs" of various generations. While some of the
needs are related to culture more than gender (using a mobile phone,
owning a tomagochi electronic pet, or understanding "one country,
two systems" in the post-handover era), the point of the cartoon
seems to be that different eras ask women to construct their bodies in
different ways. The 1970s required a full-figured look, the 1980s
required a muscled in-shape body, and the 1990s required a slim
figure. This cartoon has no dialogue after the first frame, and Lau
uses her technique of simple observation to reveal the reality of how
gender ideology affects women's body image in different eras.

In many of Lau's stories, the woman's perspective on daily life is
shown to be marginalized, eliminated, or forgotten. In these comics,
Lau tells how women's bodies are treated as a sexual subject

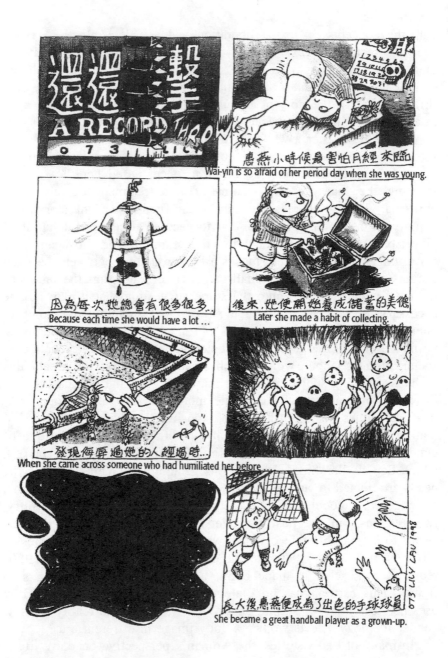

Figure 4.5. From Lau, L. (1998). A record throw. *Mom's drawer at the bottom*, p. 53. Reprinted with permission of Lau Lee-lee.

matter, or as a field that requires artificial enhancements to be acceptable. She shows the women whose bodies are subject to these "improvements" being unhappy and unsatisfied with the idea of making such artificial changes. For instance, in "Professional Cut" (p. 99) she draws a woman having a nightmare about a tumor in her ovary. She has gotten some contradictory advice from doctors, one of whom says that she should keep the ovary because she has only one child so far. The other says she already has one child, so she should probably have the ovary removed. The final expert says she should have a full hysterectomy to play it safe. With so many different opinions, the woman cannot understand who her body belongs to, herself, her children or future children, or one or more of the experts who give her such conflicting advice. Again, the familiar experience of feeling subject to a range of expert opinions rather than in personal control over one's body and destiny is shared by many women, particularly in relation to the medical system. And again, Lau uses a simple technique of observation and first-person comment from the woman herself to convey a subtle message that something is wrong. By simply depicting a situation that is probably shared by many readers, Lau makes her critique without articulating a negative commentary on medical practice and without directly attacking gender roles.

Suggesting a Vision of Change

Lau engages in elements of humor that are quite radical in bringing traditionally private or even taboo subject matter out into the public sphere as the focus of her humor. She does not hesitate to discuss "private" elements such as sexual practices, tampons, and other markers of feminine identity and experience. In many instances she softens her critique rhetorically, even though the subject matter could be considered radical or taboo. She is able to use subtle humor to begin to delineate a vision of change for a more positive future. In "Show Them Some Colors," p. 61 (Figure 4.6), Lau tells the story of a woman who, when first going out for job interviews, is advised not to wear black clothing. Since she only has black clothes, she is not happy with this, and she wonders why her clothing should make any differ-ence. Later, the woman attains the position of chair of a human

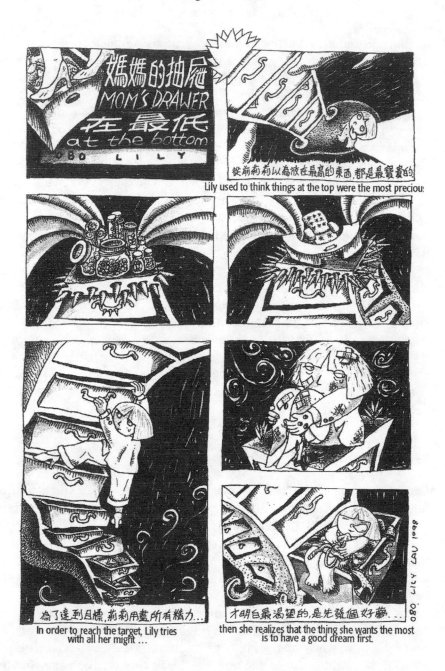

Figure 4.6. From Lau, L. (1998). Show them some colors. *Mom's drawer at the bottom*, p. 61. Reprinted with permission of Lau Lee-lee.

resources department where she can make her own decisions about whom to hire and why. The caption notes that she likes people who have their own views. This strip encapsulates a vision of change in that the same person who was unhappy with an unfair practice in the past is now in a position to do things in a different way. Lau suggests, especially to her young readers, that individuals can make a difference in their own sphere of influence, which might be as large as a whole department. All together, the cartoons in the book suggest a possibility of change at the individual, organizational, and conceptual levels.

"Point of View" (p. 81) highlights the way in which events can be seen from different angles of perspective, with the concluding suggestion that including both male and female perspectives provides a more whole vision of reality. The visuals depict the developmental history of humankind, with the "male" symbol on top, reflecting the idea that history and knowledge are often from the male perspective. Lau shows the human development book with the "female" symbol on the other side, and then, in the final frame, she shows both covers of the book with the "male" and "female" symbols showing at the same time. The story reveals the writer's opinion that perspective and balance are important and that we should be aware of the perspective represented by stories, histories, and accepted knowledge. In this example and the following one, Lau's vision of change is conceptual. By changing our frames of thought we can achieve significant beneficial change for the future, in this case by seeing a fuller perspective of life and humanity.

In a final example, the title cartoon from the front cover ("Mom's Drawer at the Bottom," p. 83) (Figure 4.7) is spelled out in story form. Here a girl is shown understanding that the good things are at the top, and she climbs the symbolic ladder of the dresser toward an unknown prize at the top. Arriving there battered and bruised, the girl decides that it is easier to go back to the bottom drawer and be comfortable rather than struggle with the challenges of climbing. In the final frame, the girl notes that to succeed in life it is better to have a good vision first. In one of the most ambiguous conclusions of the book, Lau suggests that "vision" is important for success and enjoyment of life, and that it may be possible to reframe our understanding of what is worthwhile and not worthwhile such that we can actually see the traditional woman's position or role as

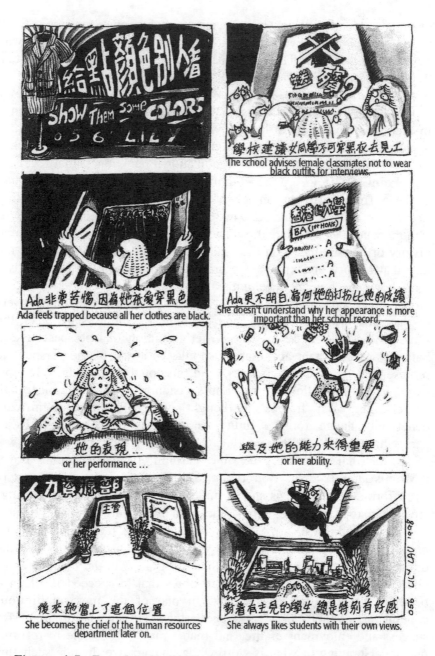

Figure 4.7. From Lau, L. (1998). Mom's drawer at the bottom. *Mom's drawer at the bottom*, p. 83. Reprinted with permission of Lau Lee-lee.

potentially positive. She does not give reasons that can justify this re-framing of traditional thought; she provides only the idea that struggling toward the top can be painful and unrewarding. She suggests that finding your own place somewhere is the best thing to do, even if you are not at the "top."

Elements of Hong Kong Context and Experiences

In its elements of subtlety and ambiguity, Lau's work goes at least a step beyond what theorists of feminist humor have set forth as the defining characteristics of the genre. Lau says the target audience of her comics is those who do not understand what she is trying to say, and thus one of the intended functions of her comic art is consciousness-raising of non-feminist or pre-feminist audience members. This element entails a specific encouragement of the self-awareness of the audience, urging individuals to reflect on their own lives and bodies. This may be a particularly adaptive approach to the authorship of politically-charged comics in the Hong Kong context, where feminism has been seen as dangerous and radical, and where a significant feminist market niche may not be available for popular culture offerings such as comics. The added element of moving the political consciousness of her audience a bit further than its members have previously ventured is Lau's way of carrying out what is probably the most important facet of feminist comics, that of providing an attitude of hopefulness and perhaps also a partial vision of a better future for those in the audience and for society at large.

In addition to making use of subtle, simple observation and ambiguity in her comic art, Lau also includes a number of strips that treat subject matter specific to Hong Kong and perhaps only secondarily related to gender issues. In "My Own Room" (p. 71) she depicts the distinctive rooms of various household residents including the sister, brother, master, dog, and finally the maid. Although every family member including the dog has his or her own room, only the domestic helper sleeps under the kitchen stove in a little cubbyhole rather than in her own private space. This strip depicts reality for many Hong Kong households and focuses on the situation of the female domestic helper, but it does not articulate gender politics as a part of

its critique. It observes simply that the domestic helper has her place under the stove and leaves it up to the reader to decide why she is pointing this out. The strip also provides an unusual example of out-right sarcasm, as Lau comments that the "r o o m" under the stove is "well-ventilated."

"Good Old Days" (p. 135) (Figure 4.8) also calls attention to themes that are specific to the Hong Kong context. It notes humor-ously that although in the old days the rice tasted sweeter, love affairs were more passionate, the old government was better, you could buy a bigger house with the same money, things were more clearly black-and-white, and time moved more slowly, still the protagonist feels good because she understands herself more now. It would be difficult to draw any specifically feminist message from this strip. Instead, Lau here focuses on elements of the Hong Kong experience that would be familiar to anyone who has lived there for more than a couple of years. She creates a feeling of nostalgia and then uses a concluding frame that seems to comment on human nature rather than on gender, sexuality, or social critique. Though not as numerous as these other types of themes, examples such as this one help to soften the social critique of the book and bring the pleasure of common understanding and common experience to a wider audience.

Conclusion

Lau's comics, although just beginning to gain some recognition, already mark an important first step that no other woman comics artist has achieved so far in Hong Kong. Because Lau's feminist comics do not critique a specific political party or leadership hierarchy, they will most likely continue to circulate freely in post-handover Hong Kong. And, as long as the economy remains healthy, magazines and books conveying critical ideological messages should continue to flourish, furthering a cultural environment in which feminist voices are wel-come. Hopefully, as her comics reach a wider audience including those who do not readily understand her work, these comics may achieve the important political work of helping an ever-wider audi-ence to see the humor in what she depicts and to reflect on the issues she discusses. As such, her influence may help to raise a feminist

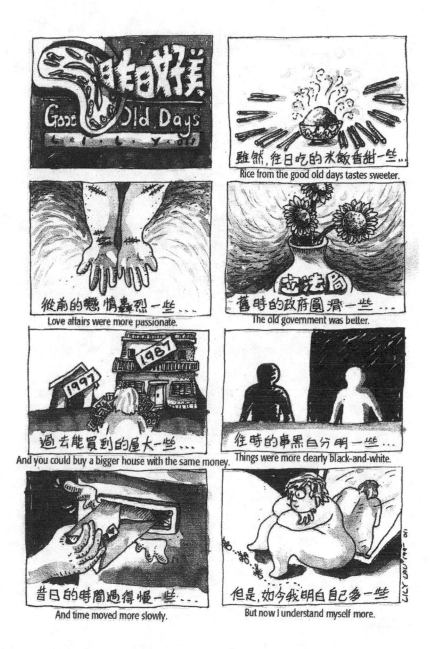

Figure 4.8. From Lau, L. (1998). From Good old days. *Mom's drawer at the bottom*, p. 135. Reprinted with permission of Lau Lee-lee.

consciousness in Hong Kong, particularly on issues related to socially constructed gender roles and traditional Chinese notions of proper gender roles. Her willingness to address new audiences including young girls and non-feminists may help ensure her continued success.

Note

1. The initial print run of *Mom's Drawer at the Bottom* (1998) was 1,000 copies, of which about 800 sold within a year of publication. Since publication of this work, Lau has produced a special comic work on anti-racism for the Hong Kong government. A second book expanding on the themes and style of the one examined in this chapter is forthcoming (2001). The translation used for the analysis in this chapter is the authors' own version. Cantonese names have been romanized with the last name (surname) first. A bilingual version of *Mom's Drawer at the Bottom* is also forthcoming in 2001.

References

Barker, M. (1989). *Comics: Ideology, power, and the critics.* Manchester: St. Martin's Press.

Bolton, K., & Hutton, C. (1997). Bad boys and bad language: Chou hau and the sociolinguistics of swearwords in Hong Kong cantonese. In G. Evans & M. T. Siu-Mi (Eds.), *Hong Kong: The anthropology of a Chinese metropolis* (pp. 299–331). Honolulu : University of Hawaii Press.

Bruere, M. B., & Beard, M. R. (1934). *Laughing their way: Women's humor in America.* New York: Macmillan.

Chan, Y. (1989). *One woman three markets.* Hong Kong: Man's Company.

Chu, D., & McIntyre, B. T. (1995). Sex role stereotypes on children's TV in Asia: A content analysis of gender role portrayals in children's cartoons in Hong Kong. *Communication Research Reports, 12*(2), 206–219.

Equal Opportunities Commission of Hong Kong. (1997). *A baseline survey of equal opportunities on the basis of gender in Hong Kong, 1996–1997.* Research Report #1.

Kaufman, G. (1994). Pulling our own strings: Feminist humor and satire. In L. A. Morris (Ed.) *American women humorists: Critical essays* (pp. 23–32). New York: Garland.

Lau, L. (1998). *Mom's drawer at the bottom.* Hong Kong: Association of Advanced Feminist.

Lent, J. (1995). Comics in East Asian countries: A contemporary survey. *Journal of Popular Culture, 29* (1), 185–198.

Meyer, K., Seidler, J, Curry, T, & Aveni, A. (1980). Women in July fourth cartoons: A 100-year look. *Journal of Communication, 30*(1), 21–30.

Montresor, J. B. (1994). Comic strip-tease: A revealing look at women cartoon artists. In G. Finney (Ed.), *Look who's laughing: Gender and comedy* (pp. 335–347). London: Gordon & Breach.

Robbins, T. (1999). *From girls to grrrlz: A history of women comics from teens to zines.* San Francisco: Chronicle Books.

Sheppard, A. (1991). Social cognition, gender roles, and women's humor. In J. Sochen (Ed.), *Women's comic visions* (pp. 33–56). Detroit: Wayne State University Press.

Toth, E. (1994). A laughter of their own: Women's humor in the United States. In L. Nochlin, (Ed.), *American women humorists: Critical essays* (pp. 85–107). New York: Garland.

Turner, K. J. (1977). Comic strips: A rhetorical perspective. *Central States Speech Journal, 28*(1), 24–35.

Walker, N. (1988). *A very serious thing: Women's humor and American culture.* Minneapolis: University of Minnesota Press.

Walker, N. (1991). Toward solidarity: Women's humor and group identity. In J. Sochen (Ed.), *Women's comic visions* (pp. 57–81). Detroit: Wayne State University Press.

Westwood, R., Mehrain, T., & Cheung, F. (1995). *Gender and society in Hong Kong: Statistical profile.* Hong Kong: Hong Kong Center of Asia-Pacific Studies, Chinese University.

Wong, W. S. (1997). A construction of modern life in the 13-Dot cartoons. In Y.C. Kwok (Ed.), *(Re)-Discovering design: A critical consideration of the Hong Kong culture of design* (in Chinese). Hong Kong: A Better Tomorrow Workshop.

Wong, W. S., & Yeung, W. (1999). *An illustrated history of Hong Kong comics.* Hong Kong: Luck-win Bookstore.

Wong, W. S., & Cuklanz, L. M. (1999). Unpublished interview with Lau Lee-lee, 19 June.

Wong, W. S., & Cuklanz, L. M. (2000). The emerging image of the modern woman in Hong Kong comics of the 1960s & 1970s. *International Journal of Comic Art, 2*(2), 33–53.

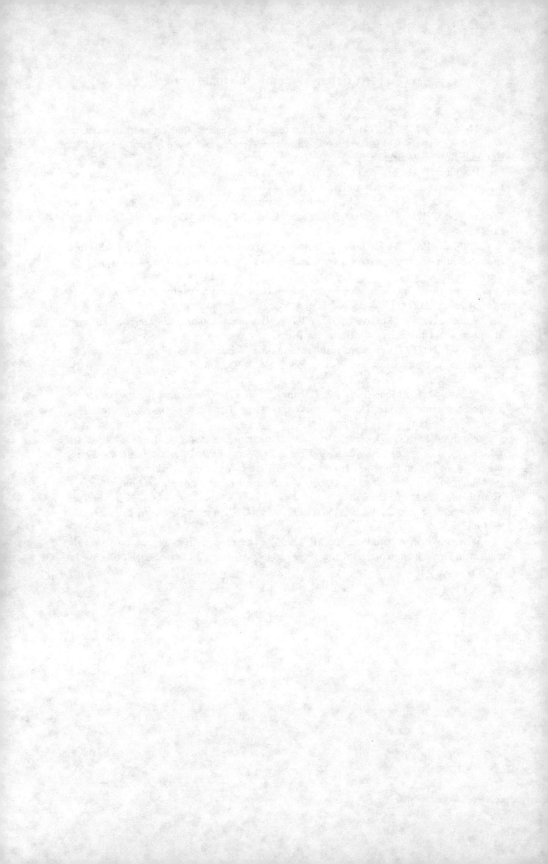

Chapter 5

"The Dominant Trope": Sex, Violence, and Hierarchy in Japanese Comics for Men

Anne Cooper-Chen

[We must examine] how a sexual practice or text may work for someone it gives pleasure to rather than merely against someone it ideologically oppresses.
—Allison, 1996, p. 55

It is the last night of summer vacation before the three high school friends must leave the beach resort where they have been staying to return to Tokyo (Sendo, 1997). So the three—sexually experienced Mako, whose dad owns the beach house; Miyoshi, shyest, who misses her Tokyo boyfriend; and Fumio, voluptuous but a virgin—decide to cook a dinner for two local males they've met on the beach: tattooed Naoki Endo, 17, self-absorbed and conceited, and curly-haired Naho Uchida, his friend.

Eating outside, Mako, Miyoshi and tattooed townie Endo are discussing Uchida: is he still a virgin? "I'd like to teach him gently," says Mako. (In fact, the day before, she had tried to seduce him.) Meanwhile, in the kitchen, "townie" Uchida asks Fumio, "If you did it with Naoki, why not with me?" "But I didn't!" she protests. "I'm a virgin!" Uchida shouts, "Let me verify that!" and he pulls up her flowered skirt (Figure 5.1). Just then Miyoshi walks in, sizes up the situation, declares, "Me, too!" and pulls down Uchida's overshorts, revealing his erection (Figure 5.2). Seeing her chance, terrified Fumio escapes outside, leaving Uchida and Miyoshi alone in the kitchen—where, we later learn, Uchida ejaculated all over the front of her dress.

Outside, Fumio inadvertently interrupts Mako and Endo kissing when she tells them about Uchida's aggression. As the hostess, Mako goes inside to check, asking Uchida about Miyoshi. "She's washing the

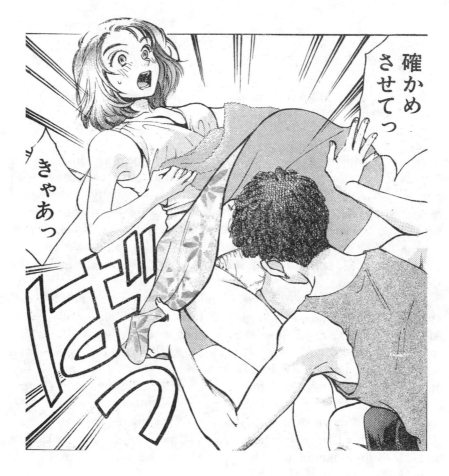

Figure 5.1. From Sendo, M. (1997, September 18). ECCHI. *Weekly Young Jump*, *1*(40), p. 298. © 1997 Shueisha.

Figure 5.2. From Sendo, M. (1997, September 18) ECCHI. *Weekly Young Jump, 1*(40), p. 301. © 1997 Shueisha.

front of her dress," he says sheepishly. Meanwhile, outside, Endo angrily confronts Fumio, saying, "You are constantly teasing me. Now you have to take responsibility [for interrupting me]; what am I going to do with this [erection]"—then roughly grabs and restrains a shocked Fumio, undoing her panties.

As the next episode opens, Fumio begins to enjoy Endo's kisses, but she murmurs, "I'm embarrassed with no panties." The situation turns menacing again when Endo takes all his clothes off, shouting, "Now you don't need to be embarrassed. And soon my knife will be piercing you" (Figure 5.3).

The scene shifts back inside, where Miyoshi has finished washing her dress. "I just grabbed it and it came out," she says of her earlier encounter with Uchida—only to walk in on him and Mako having sex (Figure 5.4). Meanwhile, Fumio pleads with Endo not to rape her: "I'm afraid it will hurt—it's my first time." Thereupon his desire fades; handing Fumio her panties, he says, "You're a virgin; I didn't mean to scare you." The scene ends with Endo getting dressed.

These two episodes of the serial "ECCHI (H): Girls Can't Help Falling in Love" by Masumi Sendo appeared in the September 18 and 25, 1997 issues of *Weekly Young Jump*, a 2.3-million–circulation comic for young men. Episode no. 40, "Involuntarily I lost my heart to him: Uchida attacks Fumio," and no. 41, "When the distance between two becomes zero," each ran 18 pages.

The story and the art itself represents many characteristics of typical *manga* comics. Visually, for example, it moves deftly inside and outside the house in the cinematic manner that characterizes *manga*, using panels of odd shapes and sizes to creatively break up the static rectangle of the page.

Despite the English-language title, beginning with the English letter "H," "ECCHI: Girls Can't Help Falling in Love" aims for a domestic audience by using aspects of life familiar to readers. Seasonality marks the domestic *manga* scene, as well as life in general in Japan, where the first day of spring and the first day of fall are national holidays. This particular contemporary-life drama exists in readers' real time, at the end of summer vacation, just before school begins again throughout Japan on about October 1. If the teenage cartoon characters had not been on vacation, they would have been wearing standard high-school uniforms—a topic for later discussion in this chapter. ("H," rendered with the syllabic

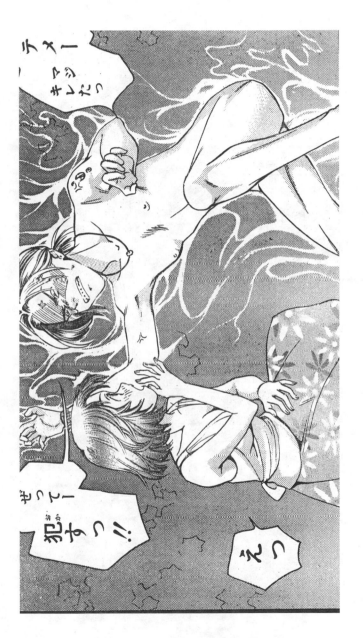

Figure 5.3. From Sendo, M. (1997, September 25). ECCHI. *Weekly Young Jump, 1*(41), p. 269. © 1997 Shueisha.

Figure 5.4. From Sendo, M. (1997, September 25). ECCHI. *Weekly Young Jump, 1*(41), p. 271. © 1997 Shueisha.

symbols *eh* and *chi*, means in Japanese sexiness or sexuality). Similarly, the blonde, "big-eyed" rendering of Fumio and Mako fits the convention for portraying Japanese, not foreign, females.

Episode 40 ends with the *manga* device of a cliffhanger, leaving the reader to wonder whether Endo will rape Fumio in Episode 41. He does not. Characteristic of *manga*, pages of foreplay and male sexual aggression seldom result in depictions of intercourse. While terrorized Fumio, crying "no, no—don't," represents the virginal victim of male aggression, Mako represents the fantasy tramp. Sex with innocent Fumio, the reader's ideal future wife, should exist for procreation—while intercourse involving Mako, who had planned all evening to seduce Endo, represents recreational sex (Figure 5.4). Never mind that only minutes before, Endo had ejaculated when Miyoshi merely touched him—the theme of Olympian virility pervades *manga*.

Likewise, blaming the victim—as when Endo justifies the imminent rape of Fumio because she must take responsibility after she interrupted him in foreplay—occurs commonly in *manga*. Thus Fumio the victim has suffered two attacks in one evening, from Uchida in the kitchen and Endo outside the house. The episodes very title, "Uchida attacks Fumio," underscores hierarchical gender roles, using as it does Uchida's last name, but Fumio's first name, as if she were a child. Yet an even stronger manifestation of hierarchy is the male gaze. Variations of Figure 5.1, a male gazing at a female's panty-clad crotch, represent an archetypal *manga* panel.

As the above discussion indicates, this chapter will explore portrayals of gendered sexuality in Japanese *manga* comics. Allison (1996, p. 54) explicates *manga* as "stories with their dominant trope [metaphor] of male conquest, rape and female victimization." These stories take two forms: as serials like "ECCHI" within mainstream, mass-circulation *manga* and in wholly erotic *manga*, glorifying the dominant trope highlighted by Allison. Although a fraction of sales, "ero" *manga* reveal a dark current in Japanese society, believes Allison (1996, p. 78): "That ero *manga* are misogynistic is undeniable. That they embed and thereby foster an ideology of gender chauvinism and crude masochism is also irrefutable." This chapter will argue that many of the characteristics of ero *manga* highlighted by Allison is also true of mainstream *manga*.

Valdivia (1995, p. 10) calls for a global perspective to gender studies because issues that may seem exotic or of "the other" affect our everyday

lived experience. Allison (1996, p. 11) agrees that much feminist thought has a Western bias. Media in Japan can provide a window through which to observe gender relations. In this chapter we will show that mainstream *manga* reflect a truly pervasive ideology of male conquest. As reflected in mass media, Japan's extreme gender role differentiation results in a hierarchy that victimizes women. This chapter contends that the stories and pictures of mainstream *manga* reinscribe patriarchy.

Context: *Manga* as an Industry

For workaholic Japanese business people or stressed teenagers, cartoon books (called *manga*) serve to "release tension" from the controlled work/school environment (Allison, 1996, p. 32). Moreover, says *manga* expert Schodt (1986, p. 27), "Reading comics is a silent activity that can be carried on alone. The Japanese...of necessity place a premium on space and on not bothering others." Thus, print *manga* fit perfectly with Japan's crowded, urbanized society.

For very little cost, commuters can buy an array of general-circulation periodicals, including *manga*, at rail and bus station news-stands; in Japan, home-delivered subscriptions are nearly nonexistent (Cooper-Chen, 1997, p. 84). Cartoons account for about 40% of all books and magazines issued (Schodt, 1997). The *manga* market is divided into boys, 39%; girls, 8.8%; young men's (with crossover female readership), 35.8%; ladies', 7.9%; and other, including erotica, 8.5% (Smith, 1993).

Given Japan's free media system (http://www.freedomhouse.org), *manga*'s status as the "defining characteristic of Japan's publishing culture" (Fujitake & Yamamoto, 1994, p. 168) reflects consumer tastes. In 1814, the woodblock artist Hokusai coined the term *manga* by combining the Chinese characters *man* ("involuntary," but with a secondary meaning of "morally corrupt") and *ga* ("picture"). The resulting combination carries the dual meaning of "whimsical (and slightly risqué) sketches" (Schodt, 1986, p. 18).

Ranging from saddle-stitched anthologies of about 350 pages to perfect-bound tomes of more than 1,000 pages, modern *manga* carry from 15 to 35 30-page stories. Printed on cheap, recycled stock in black ink on white, salmon or green paper, they cost Y200 to Y500—about the

price of a cup of coffee. Of Japan's 17 million–seller periodicals in 1993, 13 were *manga*, but pass-along readership makes *mangas'* circulation even higher. Sales of all *manga* brought in almost Y5.4 billion in 1992. Although overall sales of *manga* have almost doubled from the early 1980s to the early 1990s, sales of adult comics have almost tripled (from 311 million to more than 815 million).

The publishing industry is dominated by a few firms, which can pull together many episodes of popular stories from successive issues of their own periodicals and repackage them as books. These 200- to 300-page books, printed on a better grade of paper, sell for Y500 or more.

About 3,000 artists crank out pages for Japan's 250–300 cartoon magazines, but only about 10% gain enough popularity to sell compilations of their stories in book form, and just a handful hit superstar status. One of the most successful, Rumiko Takahashi, has sold more than 100 million paperbacks in her 20-year career (Schodt, 1997). With help from assistants, male artists with narratives running in several weeklies may turn out 500 pages a month (women usually draw for monthlies). Pay runs about $100 per page, plus 10% on book collections. This may increase, however, when the *manga* becomes popular enough to license:

> More royalties [are paid] when—as is often the case—a successful work leads to a television animation series, live-action theatrical feature films, toys, stationery gods, music inspired by the original *manga* story, and even novels based on the *manga*. (Schodt 1997, p. 12)

Drawing on the line-art tradition of brush painting and calligraphy, *manga* convey more with less. They use visual effects to pull the reader along at about 3.75 seconds per page. As Schodt notes, "with no color and with shading at a minimum, the mere curve of a characters eyebrow takes on added significance" (1986, p. 22).

Stories, which read from right to left, often continue for pages with pictures only and a variety of camera angles. Artists make a page flow by breaking it up creatively in odd-angle slices—or not breaking it up at all for a poster effect. Japanese find *manga* "faster and easier to read than a novel, more portable than a television set" (Schodt, 1986, p. 25). The readers eye moves "forward and back, absorbing the information the drawings contain and augmenting it with the printed word," creating a cinematic montage (Schodt, 1986, p. 25).

In the West, selected *manga* translated into English can now be found in specialty comics stores (Schodt, 1996). Already the TV, video and film versions of Japanese cartoons have found a vast worldwide audience (Cooper-Chen, 1999). However, exports—both print and animation—are "almost all sci-fi and fantasy," rather than *"manga* rooted in reality [which] contain so much cultural context" (Simmons, 1997, p. 5).

Context: Women in Japan

The gender differentiation in Japanese society is often quite striking to those who visit Japan or who study the Japanese language, which decrees that men use different speech patterns and words (for example, *boku* or *ore* for "I") from women (who say *watashi* or *atashi* for "I"). Hofstede (1984) has confirmed this observation empirically by studying the degree to which gender roles are distinctly defined in contrasting cultures.

Hofstede measures a concept he calls "masculinity," which, among other traits, connotes the cultural expectation of fixed gender roles in different countries' cultures. Without describing in detail the methodology of the research, suffice it to say that on a scale of 0 to 100, Hofstede found that Japan ranked highest in the world with a "masculinity score" of 95. By contrast, the United States scored a middle-range 62, while Norway (8) and Sweden (5) scored lowest

In high-masculinity (MAS) countries, traditional gender roles, such as that of the nurturing woman and the tough man, are valued. There is an emphasis on segregation of the sexes in higher education. Lower percentages of women are found in professional and technical jobs in high-MAS societies. Such societies pay women less, even though a large percent of women may work. At the same time, success in the workplace is defined as highly desirable. This trait undermines the visibility and influence of women given the barriers to entry in upper-level positions that women face in these countries. Hofstede (1984, p. 197) postulates that "people in more masculine countries, other factors being equal, live to work." All of these traits apply to Japan.

Hofstede's (1984) finding that a chasm exists between the genders in Japan is borne out by research on Japanese women's portrayals on television (Kodama, 1995), in magazines (Clammer, 1995), and in advertising (Cooper-Chen, Leung & Cho, 1995). As will be discussed, *manga*

may be added to this list.

In addition to being separate and not equal, gender roles in Japan are hierarchical. Industry, education, family life, "all are conditioned by and the condition for a gender division of labor" (Allison, 1996, p. 47). In the labor market and education, "inequity exists despite the fact that gender discrimination has been outlawed" (Allison, 1996, p. xvii). Indeed, Japan is the only industrialized country in which education has a negative effect on women's employment (Tanaka, 1995).

Although women account for 38% of Japan's work force, women earn about half of what men do and hold only 6% of managerial jobs (as compared with 34% in the United States). In broadcasting, for example, women hold just 2.2% of managerial positions (Kodama, 1995). Ito sums up gender roles in the 1990s thus:

> Most Japanese men, deep inside, do not like the idea of equality between the sexes....It is men who lose social power and direction in society where sexual equality is guaranteed and centuries-old traditions undermined. (Ito, 1994, p. 93)

Indeed, the average Japanese husband spends only 11 minutes a day on household chores (as compared with the 108 minutes for U.S. husbands).

Women react to their subordinate status socially, biologically, geographically, and culturally. Socially, women now delay marriage until nearly age 27. Even then many "couples continue to live separately in their old apartments...[because women] want to keep their single lifestyles" (Gaouette, 1999, p. 10). Moreover, the divorce rate has doubled since 1970, now affecting one in three marriages.

Biologically, since "the domestic work of reproducing the labor force" has low "symbolic capital" (Allison, 1996, p. xx), women have virtually stopped having babies. The average family, which had 3.65 children in 1950, now has 1.39 children. At the same time, abortions (70% performed on married women) now nearly equal the number of live births. In France and Britain, 70% of women in one poll said they considered bringing up children a joy, but only 21% of Japanese women felt that way. In sum, their reaction "amounts to the nation's wombs going on strike" (Pons, 1993).

Geographically, vast numbers of Japanese women have moved overseas, including many to the United States. Culturally, for example, the all-female Takarazuka revue, featuring non-macho leading "men,"

attracts a female audience of rabid fans (Robertson, 1998). Moreover, adult women have a segment of the *manga* industry aimed specifically at them—a subject for future research.

Grounded in Hofstede's and other's work, we can deconstruct mainstream *manga* to show pervasive gender differentiation—separate, unequal, and hierarchical.

Related Research on *Manga* and Gender

Despite the above, the issues of gender and sexuality are relatively new in Japanese studies (Allison, 1996, p. 9) and largely unexplored. Few studies exist in English on gender portrayals in mainstream *manga*. Ito (1994, p. 85), who looked at 31 comics targeted at a male readership, found that female characters are "cheerleaders at best…[the typical male character] seems to be always yearning for the good old days when their women were innocent, good, and accessible." Similarly, Kinsella (1999) found *manga* as supporting the chauvinistic status quo., while Ledden and Fejes (1987) explored the nature of male–female relationships in Japanese comics.

Allison (1996, p. 62), who studied erotic rather than mainstream *manga*, observes that "men appear on the *manga* page, though nowhere to the degree that women do and not as consistently naked." For girls and women, "a naked body is a sign of captivity"—they are subordinated when naked (Allison, 1996, p. 65). Moreover, facial expressions are gender related—female characters show pain and anguish, while male characters often look smug (Allison, 1996, p. 76).

Allison (1996, p. 29) further found that in erotic *manga* "the image of males gazing at females either naked or shown in their underwear is a common motif." After reviewing Western theories of male gaze (Allison, 1996, pp. 34–40), she proposes that in Japanese *manga* "the imagery of naked female bodies is sexual but that it constructs male sexuality in such a way as to maintain the male's primary role as worker"; encoded in the male gaze are messages of social status and gendered difference, including the idea that recreational sex is the domain of the male but not the female (Allison, 1996, p. 48). The situation differs, however, in mainstream *manga*; some women are wildly passionate, such that they often seduce men as if to test their femininity (Ito, 1994, p. 86).

After 1952, Japan's obscenity laws were interpreted as forbidding depictions of female or male genitals or pubic hair (Beer, 1984). This interpretation has had two effects. First, the state has *de facto* institutionalized voyeurism, fetishism, and fantasy as a substitute for genital realism (Foucault, 1980). Second, the state "protects as real one region of the social body from the sexualization of mass culture...that which is most sacred and central to the states ideology of national identity—stable families, reproductive mothers, and orderly homes" (Allison, 1996, p. 151).

Debates about the effects of sexism in *manga* comics touch on several issues. On of these issues is the universalism of pornography versus the specific impact such images may have in Japanese culture. Some writers contend simply that all cultures have pornography. "Any video rental store in the United States easily carries as much sex and violence as any *manga* shop in Japan," argues Schodt (1996, p. 53). However, as Hofstede (1984) showed, the separateness of gender roles in Japan indeed does not mimic other cultures; it has a unique, extreme form.

A second set of counter-arguments to those who advocate the harmful nature of sexism in manga stresses the fringe nature of ero *manga*. These "filthy and violent *manga*...represent mere droplets here and there in the vast *manga* scene," but receive excessive publicity in the Western press (Reid, 1997, p. 63). Erotica now carry warning labels, and some have closed due to consumer pressure, such as the violent *Rape Man* (Kristof, 1995, p. 5). This counter-argument, however, does not consider the potential sexism in mainstream manga.

Other *manga* commentators also stress the apparent cathartic nature of pornographic *manga*, citing as proof the low crime rates in Japan. For 1988, the National Police Agency of Japan reported 2,610 cases of rape with an arrest rate of 89%, whereas the U.S. figure (for a population double that of Japan's) was 82,088 cases, with only a 48.8% arrest rate (Ito, 1994). According to Schodt (1996, p. 51), catharsis operates because the "gap between fantasy and reality in Japan is enormous....the stability of family life may give people *more* leeway in their fantasy lives."

How then does the stability of the home give rise to a fantasy life based on female victimization? According to Allison (1996, p. 153), *manga* reflect "a strong view of work as the main vessel for energy, identity, duty and responsibility. Implicitly, home and its management are left to women." Hofstede's (1984) research, discussed below,

confirms the existence of separate spheres for women and men. This pervasive ideology creates a border between the outside world and ones home—a peripheral place in terms of time, work, and leisure. At home, sexuality has a reproductive purpose; away from home, sexuality represents leisure (Foucault, 1980).

Case Study: *Weekly Young Jump*

The largest-circulating *manga* is Shueisha's *Shonen Jump*, which targets young boys and does not contain contemporary adult female characters. Thus to understand mainstream men's *manga*, a hugely successful publication aimed at older straight men was chosen for analysis: Shueisha's *Weekly Young Jump*, with a circulation of 2.3 million a week. Of its mostly male readers, 28% are age 10–19, and 45% are age 20–29.

The titles of many *manga*, including *Weekly Young Jump*, use English to impart an aura of trendiness—as do the titles of many narratives. Yet the language, practices (e.g., *kuji* sticks are used to pair up couples), food (e.g., cold-water *somen*), surroundings (e.g., sushi restaurants with tatami seating) and actual place names (e.g., Odaiba Beach Park) would have little meaning outside Japan.

Method

Of the weekly's 20 or so serialized stories, topics range from samurai battles, sumo wrestlers, and yakuza gangster life to sports heroes, science fiction fantasies, and contemporary life. The author chose three narratives that treat contemporary life: "My Home Mirano" by Yukiya Sakuragi (1997) and "Pure" by Kenjiro Kakimoto (1997), in addition to the serial mentioned in the Introduction, "ECCHI (H): Girls Can't Help Falling in Love" by Masumi Sendo (1997). All three had female icons next to their titles on the contents page, indicating that women played key roles in the narrative. (Many narratives in the weekly, such as sports and gangster stories, had virtually no women at all. The fantasy genre, as noted earlier, does not tell us much about gender roles in Japan today.)

The story line of "My Home Mirano" concerns Naoto Kikuchi, a moody high-school male student away from home, living in Tokyo, and

dimly aware of his love for his housekeeper; Mirano Furada, about 23, a kind and solicitous female manager of a small boarding house. Other characters include Yamamoto, a high school classmate of Mirano's from their home town; Chiyako, Mirano's cousin; and various friends. The story line of "Pure" concerns two high school seniors prepping for college entrance exams: handsome Yano, who is infatuated with voluptuous singer Yuki Kagami, and Sakamoto, his bumbling and horny friend. The main female character is Tsukasa Kamijo, also a senior, who loves Yano and actually *is* the singer Yuki, unbeknownst to her classmates.

Consecutive issues rather than a random sample had to be used to capture the continuing story lines. A native speaker translated all the dialogue balloons and descriptive sentences. This study looked at 21 episodes—seven each of three narratives—in all August and September 1997 issues. The three narratives each averaged 15 pages a week and in total covered 352 pages. Each weekly issue ranged from 360 to 427 pages, so the three represented only a small portion of each issue's content, but a large portion of the contemporary narratives about male-female relationships found in the issues.

Themes

Gender differentiation can be understood through four themes: Passion/Aggression; Gaze/Nudity; Physical Appearance; and Service. These themes, which lend themselves to illustration, figure prominently in *manga*.

Passion/aggression. Figure 5.5 as well as Figures 5.1–5.3 show out-of-control male violence and the resulting female victimization. Infrequently, a strong female attacks a male as in Figure 5.6, but always in response to male aggression. In this case, the scene presents an opportunity to show nudity and a crotch view. Interestingly, too, the male victim's expression in Figure 5.6 show physical trauma, whereas the female victims' expressions confirm Allison's (1996) observation of distress or anguish. Like the tutor (Figure 5.5) and the singer in "Pure," they may react to assault with the word "Dame" [don't]; alternatively, they may express shock and surprise, like Mirano's cousin Chiyako

Figure 5.5. From Kakimoto, K. (1997, September 11). Pure. *Weekly Young Jump*, *1*(39), p. 228. © 1997 Shueisha.

Figure 5.6. From Kakimoto, K. (1997, September 11). Pure. *Weekly Young Jump, 1*(39), p. 231. © 1997 Shueisha.

(Figure 5.7), who thought she was signing on for work as a waitress, not a prostitute. But invariably the male persists, and often the women begin to moan "ahhhh," with obvious enjoyment, as does Fumio—until she realizes she is about to be raped.

The contrast in "ECCHI" between sweet Fumio and over-sexed Mako has echoes throughout *manga*. Nice women like Fumio are often shown terrorized, resisting assaults, until a persistent male evokes a plea-sure response. Fantasy tramps like Mako can feel self-directed passion, as Ito (1994) noted. Only two scenes of consummated sex, both involv-ing Mako, were shown in all of the 352 cartoon pages in this study. One was a visual memory, as the three girlfriends in "ECCHI" talked about their first sexual experiences, and one was part of a real-time episode, when Miyoshi walks in on Mako and Uchida (Figure 5.4). Both scenes have a voyeuristic, stolen-moment quality. They were de-emphasized, each occupying just one small frame, confirming Allison's (1996) thesis of procreative sex as protected from mass culture.

When women are the sexual pursuer, the transgression is framed in a particular way. The student teacher in "Pure" masquerades as a nice woman despite her ulterior motive. Instead of sexual aggression, she arranges a seductive situation—taking a shower and throwing her under-wear towards her student Yano—whereby they end up in bed. This time, a plot device prevents consummation. Completely naked, she neverthe-less tells Yano, "Well, that's it for today! It's 11—you'll miss the subway." Shortly afterward, the singer Yuki, driving with her agent, sees Yano and the student teacher on the street kissing. We later learn that this was all a setup, carefully timed. The agent hired the student teacher to tempt Yano so Yuki would lose interest in him and quit school to devote time to her career.

Gaze/Nudity. Figure 5.8 supports Allison (1996, p. 5), who sees female nudity in the presence of clothed men as "a sign of captivity" and subordination. Moreover, male readers, who need to identify with the cartoon men, probably also have their clothes on! Indeed, nude and semi-nude women (Figure 5.4) but relatively few semi-nude males or nude males appeared in the narratives; Endo (Figures 5.3 and 5.7) is the isolated exception that proves the rule. Granted, story lines in the month of August provided a seasonal justification for swimsuit depictions (Figure 5.9), but voyeuristic freeze frames like Figure 5.10 serve up

Figure 5.7. From Sakuragi, Y. (1997, September 18). My home Mirano. *Weekly Young Jump, 1*(40), p. 284. © 1997 Shueisha.

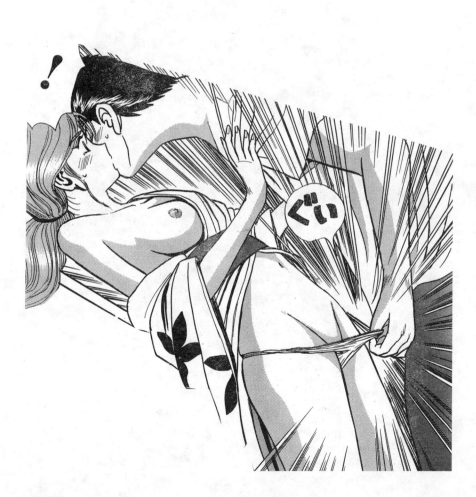

Figure 5.8. From Kakimoto, K. (1997, September 4). Pure. *Weekly Young Jump*,
1(38), p. 197. © 1997 Shueisha.

Figure 5.9. From Kakimoto, K. (1997, August 7). Pure. *Weekly Young Jump*, *1*(34), p. 280. © 1997 Shueisha.

female body parts as an eye feast for the reader.

Whether the reader's or the protagonist's, the eyes in *manga* take on special significance, since they are thought to mirror the emotions (Schodt, 1996, p. 61). The bug-eyed extreme male gaze (Figure 5.10) tells us that readers accept this *manga* convention as an exaggerated metaphor for acceptable behavior. Allison (1996) discusses only this male gaze, but a parallel female gaze exists. Figure 5.9 represents a saucy female wink common in advertising and photographs as well as in *manga*. Rather than the self-absorbed, self-pleasuring male gaze, it infantilizes the adult flirtatious women who invite engagement by eye contact.

The male gaze focuses on, in addition to nude female bodies, cloaked or partly revealed genitals. Since censors allow the depiction of covered genitals, women's underwear takes on high erotic symbolism (Figure 5.1, Figure 5.5). Allison (1996) attributes panty-ripping scenes (Figure 5.7) to censors' ban on depicting genitals and pubic hair. An incident in "Pure" illustrates the power of the crotch/panty fetish: in response to an insult, high school student Tsukasa has karate-kicked fellow student Yano in the groin. Yano gets worried when he then gazes up under a female's sailor uniform at her crotch (Figure 5.11, top), but no erection results (Figure 5.11, bottom). Because it is assumed that normally a powerful erection would be caused by such a view, Tsukasa and Sakamoto take Yano to the hospital to investigate possible erectile dysfunction. It turns out that no permanent damage has occurred, permitting Yano to continue his sexual exploits in succeeding episodes.

Does a parallel cartoon erotic zone exist for girls and women? Although aimed at young men, *Weekly Young Jump* attracts some crossover female readers. (Women's/girl's *manga*, by contrast, attract virtually no male readers.) Cloaked male genitals (Figure 5.2) could serve to attract a parallel female gaze, but compared with the lavish displays of female breasts, buttocks, and genitals, male depictions are rare.

Physical appearance. In one form of gender differentiation, the Western look of the line-drawn female characters contrasts with the Japanese look of the males. Figure 5.5, for example, shows dark-haired Yano assaulting Western-looking Tsukasa. In addition, Fumio and Mako in "ECCHI" (Figures 5.1–5.4), the student teacher in "Pure" and cousin Chiyako in "Mirano" (Figure 5.7) are all Barbie clones: tall, buxom, long-legged

Figure 5.10. From Kakimoto, K. (1997, September 18). Pure. *Weekly Young Jump*, *1*(40), p. 177. © 1997 Shueisha.

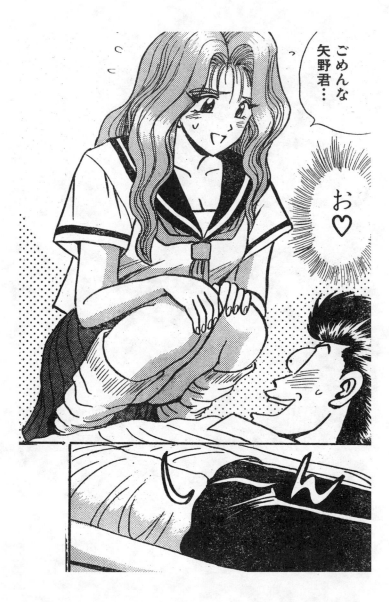

Figure 5.11. From Kakimoto, K. (1997, August 28). Pure. *Weekly Young Jump*, *1*(36–37), p. 208. © 1997 Shueisha.

blonde women with large eyes. (All females, whatever their hair color, have large eyes). As *manga* feed fantasies, these Japanese women are remade to fit an unreal dream image—that of the unattainable, exotic creatures appearing in Western movies and Caucasian models in ads. Japanese male characters in *manga* (and vicariously readers) act out straight male fantasies, while women conform to fit these fantasies.

Service. Various women are shown as delighting in the service of men, whether emotional (Mirano), gastronomical (Mirano and the girlfriends in "ECCHI"), or sexual (the student teacher and Tsuksa in "Pure"). Needless to say, men are never shown preparing food. Men rarely delight in serving women; indeed, they are unappreciative of women, blaming them for mishaps the women have not caused. Yano's memory of a pornographic video he has previously seen has inspired him to attack his tutor—not his fault, after all, but the tutor's for reminding him of the actress in the video. And as noted in the introduction, Endo blames Fumio for interrupting his foreplay and causing him to have an unsatisfied erection. There are rare examples of a man in a helping mode, however, including in "My Home Mirano" when Naoto Kikuchi holds his landlady's son while they are on a summer outing.

Conclusion

Figure 5.11 encompasses some of the most potent erotic images in the *manga* fantasy world: a clothed, Japanese-looking young man; a Western-looking, dewy-eyed young woman; a crotch view; and a bug-eyed male gaze. Perhaps second only to a nude female, the "smiling junior high school virgin, clad in her 'sailor suit' school uniform" (Schodt, 1996, p.55), engenders male arousal.

This chapter's epigraph asks why men victimize women in *manga*. Cartoon men victimize women to confirm a power that real life may not bestow. Many school-age and older male readers may have in mind particular sailor-clad classmates about whom they have had sexual fantasies. As subordinate to someone in the hierarchy himself, the Japanese male may see a teenage girl as someone subordinate to him. But as Allison comments, "The power that is achieved...seems fairly pathetic" (Allison, 1996, p.76).

De-emphasizing the amount of sex and violence in Japanese comics, Schodt (1996) compares the range of *manga* to the plethora of choices in video stores. Using this analogy, "ECCHI: Girls Can't Help Falling in Love," would earn an R rating for its level of sex and violence, whereas "Pure," would earn an X rating. By contrast, "My Home Mirano," the story of a male high school student who lives in a boarding house, would earn a PG-13 rating; Figure 5.12 shows a typically gentle scene—young single mother/landlady Mirano attending a high-school reunion.

Schodt (1996) fails to see three truths. First, *Weekly Young Jump* does not represent the adults-only "special room" in a video store; as a mainstream, high-circulation comic book available for purchase by anyone, it represents the status quo (Kinsella, 1999). Second, with two of its three contemporary-life serials depicting recurring violations of women, the weekly comic can hardly be dismissed as benign. Third, even a gentle serial like "My Home Mirano" embeds notions of hierarchy, which takes both violent and non-violent forms. Mirano, always smiling and upbeat, devises a way to make noodles in a riverbed, fixes attractive box lunches, bakes cakes, and keeps others from distracting the student Naoto while he studies. Naoto for his part falls into moods and makes snide remarks, petulantly acting many years younger than Mirano, although they are quite close in age.

Above we noted the biological, social, geographic and cultural reactions of women to their victimization. Beginning in the 1970s, women have appropriately created a graphic reaction to *manga* specifically and misogyny in general. As Suzuki (1998, p. 244) explains, the *yaoi* genre of *manga* derives from the words *Yamanashi, ochinashi, imi nashi* ("no climax, no punchline, no meaning"). This mainly amateur genre, written by teenage women and circulated through elaborate distribution networks, concerns the love affairs of gay men. Rather than a fringe element, the semiannual *yaoi* book fairs attract about half a million fans.

The earliest *yaoi* writers were self-conscious first daughters in a society that values sons as the first child and especially as the only child (Suzuki, 1998, p. 256). As Suzuki explains

> Homosexuals—who are forced to endure great difficulties to attain and express their love—offer a more compelling, authentic voice of love and equality in relationships. It was onto this canvas that Yaoi participants projected their own desires: for a love free from calculation, capable of withstanding societal pressure, and achieved only after great sacrifice. (Suzuki, 1998, p. 257)

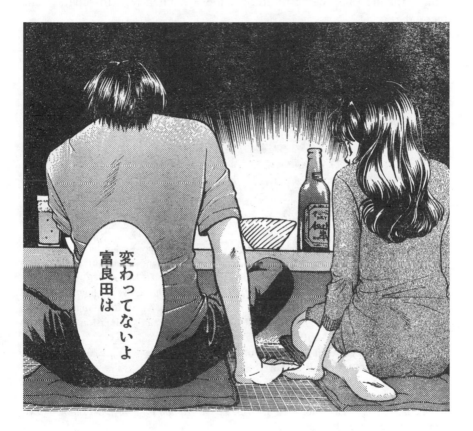

Figure 5.12. From Sakuragi, Y. (1997, September 25). My home Mirano. *Weekly Young Jump, 1*(41), p. 245. © 1997 Shueisha.

Gay men's relationships, liberated from procreative purposes, present an ideal love that these young women can never experience. In their "rage against the sexist society surrounding them" (Suzuki, 1998, p. 260), they write not about lesbian women but about gay men. The unconditional love that they long for cannot be found in a merging of two subordinates. Groped on subways and relegated to serving tea in corporate board-rooms, for the foreseeable future, Japanese women remain separate and unequal.

Note

The author would like to thank her husband, Dr. Charles Chen, for translations from Japanese to English and Tsutomu and Tomoko Kanayama for providing copies of *Weekly Young Jump*.

References

Allison, A. (1996). *Permitted and prohibited desires: Mothers, comics, and censorship in Japan*. Boulder, CO: Westview.

Beer, L. W. (1984). *Freedom of expression in Japan*. Tokyo: Kodansha.

Clammer, J. (1995). Consuming bodies: Constructing and representing the female body in contemporary Japanese print media. In L. Skov & B. Moeren (Eds.), *Women. media and consumption in Japan* (pp. 197–219). Honolulu: University of Hawaii Press.

Cooper-Chen, A. (1997). *Mass communication in Japan*. Ames: Iowa State U. Press.

Cooper-Chen, A. (1999). An animated imbalance: Japan's television heroines in Asia. *Gazette 61*(3–4), 293–310.

Cooper-Chen, A., Leung, E., & Cho, S. (1995). Sex roles in East Asian magazine advertising. *Gazette 55*(3), 207–223.

Foucault, M. (1980). *The history of sexuality* vol. 1. (R. Hurley, Trans.). New York: Random House.

Fujitake, A., & Yamamoto, T. (1994). *Zusetsu Nippon no komyunikeshion*. Tokyo: Nippon Hoso Shuppan Kyokai.

Gaouette, N. (1999, February 11). Japanese language of love—or lack of it. *Christian Science Monitor*, pp. 1, 10.

Hofstede, G. (1984). *Culture's consequences* (abridged edition). Beverly Hills: Sage.

Ito, K. (1994). Images of women in weekly male comic magazines in Japan. *Journal of Popular Culture 27*(4), 81–95.

Kakimoto, K. (1997, August–September). Pure. *Weekly Young Jump, 1*(34–41). Tokyo: Shueisha.

Kinsella, S. (1999). Pro-establishment *manga*: pop culture and the balance of power in Japan. *Media, Culture & Society, 21*(4), 566–568.

Kodama, M. (1995). *Japanese women in the media*. Paper presented at the Association for Education in Journalism and Mass Communication, Washington, DC.

Kristof, N. (1995, November 5). In Japan, brutal comics for women. *New York Times*, pp. B1, 6.

Ledden, S., & Fejes, F. (1987). Female gender role patterns in Japanese comic magazines. *Journal of Popular Culture 21*(1), 155–176.

Pons, P. (1993, June 19). Falling birth rate reflects traumatic nature of motherhood. *Asahi Evening News* (Reuters), p. 5.

Reid, T. R. (1997, February). Comics for career women. *Mangajin*, pp. 63–65.

Robertson, J. (1998*). Takarazuka: Sexual politics and popular culture in modern Japan*. Berkeley, CA: University of California Press.

Sakuragi, Y. (1997, August–September). My home Mirano. *Weekly Young Jump, 1*(34–41). Tokyo: Shueisha.

Schodt, F. (1986). *Manga! Manga! The world of Japanese comics*. Tokyo: Kodansha.

Schodt, F. (1996). *Dreamland Japan*. Berkeley, CA: Stone Bridge Press.

Schodt, F. (1997, April). The hard, cruel life of the *manga* artist. *Mangajin*, pp. 12–16.

Sendo, M. (1997, August–September). ECCHI (H): Girls can't help falling in love. *Weekly Young Jump, 1*(34–41). Tokyo, Shueisha.

Simmons, V. (1997, April). Publisher's note. *Mangajin*, p. 5.

Smith, T. (1993). The world of *manga*. *Japanese Book News 2*, 1–3.

Suzuki, K. (1998). Pornography or therapy? Japanese girls creating the yaoi phenomenon. In S. Inness (Ed.), *Millennium girls*. Lanham, MD: Rowan & Littlefield.

Tanaka, K. (1995). Work, education and the family. In K. Fujimura (Ed.*), Japanese women: New perspectives on the past, present and future*. New York: Feminist Press.

Valdivia, A. (1995). *Feminism, Multiculturalism and the Media*. Thousand Oaks, CA: Sage.

Chapter 6

The Tyranny of the Melting Pot Metaphor: Wonder Woman as the Americanized Immigrant

Matthew J. Smith

Granted the *wisdom* of Athena, the *strength* of Hercules, the *speed* of Mercury and the *beauty* of Aphrodite by the gods, *Princess Diana* of Paradise Island *renounced* her immortality and entered man's world as the most *legendary Amazon*...Wonder Woman.
—Prologue appearing on the splash page of *Wonder Woman* comic books in the 1970s and 1980s; emphasis in the original.

Identity, always identity, over and above knowing about others.
—Said, 1993, p. 299.

Since her debut in December 1941, Wonder Woman has served as a symbol for a number of ideological positions. In 1944 Dr. William Moulton Marston claimed that he wanted to "create a feminine character with all the strength of a Superman plus all the allure of a good and beautiful woman" (Marston, 1944, pp. 42–43) to counter the "blood-curdling masculinity" (p. 42) of other comic book superheroes. From her inception onward, then, Wonder Woman has been a figure representative of the struggle for feminine equality. As such, a number of scholarly critics have examined the feminist themes in Wonder Woman's comic book appearances (scc, for example, Robbins, 1996), but criticism has largely neglected other ideological issues associated with the character. For one, Wonder Woman has also served as a symbol of cultural identity. Since her beginning, Wonder Woman, princess of a sovereign nation of warrior women who journeys to America, has illustrated the struggle between maintaining one's ethnic identity and adapting to life in a new culture.

For the first forty years of her adventures, Wonder Woman's cultural allegiance is rarely questioned. Even though she is the crown princess of Paradise Island, time and again she rejects the tranquil shores of her native land and elects to live her life in the strife-ridden streets of America's cities. The underlying assumption that anyone, even foreign royalty, would prefer a life in the United States to that anywhere else stands out when contrasted to a later interpretation of the character, one that allows her to participate in American culture without compromising her strong ethnic and cultural ties to her native people. However, the integrity of this pluralistic interpretation was not long-lived, and Wonder Woman's subsequent creators undertook a project to reintegrate her into the mainstream, restoring her devotion to American ideals.

Thus, both in its original and subsequent interpretations, the saga of Wonder Woman is written to fulfill expectations associated with the melting pot metaphor. In the American melting pot, people of all nations are welcomed to join the "stew" of races, nationalities, and ethnicities that blend into the populace of the United States. As early as 1914, Israel Zangwill's *The Melting-Pot* adopted the metaphor to explain American immigration. "The Great American Melting Pot" was still used decades later in instructional material for American civics in the television cartoons, books, musicals, and merchandising of School House Rock! (Yoke & Newall, 1996). As an artifact of America's national consciousness, the melting pot metaphor reinforces the idea that America is open to all kinds of people who are invited to join. However, implicit in this invitation is the understanding that immigrants will sacrifice their unique flavors in the process of blending with the homogenized essence of the melting pot's contents. In this sense, then, the melting pot represents both a melting *into* the American identity and a melting *away* of one's native identity.

The various interpretations of Wonder Woman illustrate the melting pot process. This chapter critiques this process by examining three eras from the character's six decades of published material. To establish the significance of later turns in the narrative, it begins with an exploration of Wonder Woman's early career as chronicled by her creator, Marston, who established the most enduring features of the mythos between 1941 and 1947. Next, the chapter turns to a sweeping reinterpretation of the character, her origin, and her mission guided

by writer/artist George Perez and various collaborators in an era that ran from 1987 to 1992. Finally, it follows the contributions of two subsequent authors, William Messner-Loebs and John Byrne, who each in turn assumed authorship following Perez's departure from the series and wrote stories published between 1992 and 1996. Before delving into those analyses, though, let us begin by contextualizing Wonder Woman's struggle for identity within the broader issue of a pluralistic society.

Cultural Assimilation vs. Cultural Accommodation

Both Wonder Woman and the melting pot metaphor reinforce expectations about the preferred cultural identity in the United States. The melting pot metaphor attempts to explain the idealized process of immigration: foreigners arrive in the United States and join in a great mix of cultures. However, in the process of mixing, immigrants find that as their culture melts away, it is replaced by an unaffected "American" culture, characterized by the supremacy of the English language, unquestioning loyalty to Old Glory, and reverence for artifacts like mom, apple pie, and baseball. Immigrants are assimilated into the culture and made one with it. Certainly, this melting process is not an overnight event for many immigrants; indeed, it may take generations to complete in large cities where ethnic communities thrive, but the expectation that such ethnicities will subsume their identities or altogether surrender their un-American culture persists.

Practically since the popularization of this metaphor, critics have attacked the assumptions of the melting pot. Objectors as early as Horace Kallen in 1924 have countered the presumption of homogenization by suggesting that America embrace pluralism over assimilationism (Whitfield, 1999). Cultural pluralism advocates an acceptance of cultural diversity among the populace. A pluralistic model would see society accommodate different cultures rather than assimilate them. In the past, this heterogeneous conception of society has been compared to a "salad bowl" in which each element retains its unique taste while co-existing alongside other elements. The fact is that the United States population is continuing to grow more and more diverse, with the U.S. Bureau of the Census (1996) predicting that Hispanic, Black, Asian, and American Indian populations will make

nearly half of the U.S. citizenry by 2050.

Despite the changing face of America, many mass media messages often do not reflect this trend, choosing to communicate an older, more conservative conception of American society (for a discussion of television in this regard, see Graves, 1999). In particular, comic books have served as vanguards of conservative representations. The intended target market for most comics (adolescents), the early influence of World War II and the Cold War, and the mainstream industrial context of comic book production (including the presence of the Comics Code) encourage an emphasis on traditional values in comics. Richard Reynolds (1994), for example, argues that comic book superheroes (despite their *avant-garde* fashion sense) are defenders of the social status quo. As such, they counter any antagonist's attempt to change the existing social order and as a result maintain the existing social paradigm. Though underground "comix" and alternative publishers have periodically challenged such norms, none of them have ever commanded a large enough market to effect long-term and radical reconsideration of the mainstream message, especially in the superhero genre.

Comic books have thus served as vehicles for promoting conservative values, but in the process of advocating the mainstream they have contributed to the normalization of certain prejudices. In some instances, those prejudices have been obviously and graphically depicted. Don Thompson (1970) notes how artists caricatured American's Japanese foes during World War II. Images of Japanese soldiers with thick glasses and buck teeth along with other exaggerated features visually reinforced the alien nature of America's antagonists. Though comic book artists may have grown more sensitized to their depictions of the Japanese in the last 60 years, the tendency to demonize the "other" persists. More recently, people of Arabian cultures have appeared as swarthy terrorists bent on the destruction of American society (Shaheen, 1994).

Ultimately, there is nothing particularly unusual about the American brand of nationalism. Pride and dominance are characteristics of many nation-states, but these qualities become problematic when they are physically or discursively forced on others. Over the last several decades, literary critics have taken note of how the writing of natives has offered resistance to the colonizing forces of other

nations. Such critics seek to focus attention toward the assimilating nation's intolerance for diversity and expectation for conformity:

> All nationalisms have a metaphysical dimension, for they are all driven by an ambition to realize their intrinsic essence in some specific and tangible form. The form may be a political structure or a literary tradition. Although the problems created by such an ambition are sufficiently intractable in themselves, they are intensified to the point of absurdity when a nationalist self-conception imagines itself to be the ideal model to which all others should conform. (Deane, 1990, p. 8)

America certainly had reached this plateau by the time it created the first batch of patriotic superheroes, including, of course, Wonder Woman. As a model, she, like the melting pot, advocates "the ideal...to which all others should conform." Indeed, Wonder Woman's persistence as a model of assimilation may in part owe its long life to her very gender. As Ann McClintock (1995) suggests, Western imperial forces have relied upon the control of women to transmit their culture to subsequent generations of the colonized nation. The majority of Wonder Woman's creators have been male and have arguably used her as a vehicle to reaffirm American dominance. As detailed in the following sections, the saga of Wonder Woman makes it explicit that America is even preferable to paradise.

Dominance and Submission in the Original Wonder Woman

Like her predecessor and inspiration, Superman, Wonder Woman is an immigrant to America's shores. However, unlike the orphan from the doomed planet Krypton, Wonder Woman grows to maturity within her native culture on Paradise Island, rather than being raised on a farm in Kansas. Because he is reared from infancy onward as one of us, Superman's identification with truth, justice, and the American way is a product of years of association with normative patriotic values. Indeed, Ian Gordon (1998) argues that Superman was not only the embodiment of these values, but as an emerging cultural icon in the real world, he helped define what the "American way" meant. For the original Wonder Woman, though, her immediate and unquestioning obedience to the American way when encountering it for the first time as an adult seems incongruous with the circumstances of her origin.

For this reason, Wonder Woman is certainly among the most visible and enduring icons of popular culture to espouse cultural assimilation. Beginning with her debut in *All-Star Comics* no. 8, the December 1941 issue, Wonder Woman arrives in America pre-packaged in red, white, and blue. Her tight-hugging pants are spangled with white stars on a field of blue. Her red (high-heeled) boots possess pronounced white stripes at the top and running down the center of them. And for the first 40 years of her career, she wears a prominent golden eagle, long the symbol of America's national pride, on her halter top. While other comic book characters like Uncle Sam and Captain America sport equally patriotic outfits, Wonder Woman distinguishes herself through her remarkable origin in *Sensation Comics* no. 1 (January 1942). Unlike home-grown patriots, she represents the variety of ready-made patriots America has come to expect from its immigrants.

Wonder Woman is introduced as Diana, princess of the Amazons. The Amazons are fierce women warriors from ancient Greece who, after being bested in combat by Hercules and an army of men, forsake "man's world" and sail to the tranquility of Paradise Island where they establish a female-only utopia. When an America army pilot crash lands on their sanctuary in 1941, the goddess Athena directs the Amazons to return him because:

> American liberty and freedom must be preserved! You must send with him your strongest and wisest Amazon—the finest of your wonder women—for America, the last citadel of democracy, and of equal rights for women, needs your help! (Marston, 1972, p. 5)

After an Olympic-style competition, Diana emerges as the victor and receives the costume that has been designed by the queen herself. The final caption of the six-page origin confirms:

> And so Diana, the Wonder Woman, giving up her heritage, and her right to eternal life, leaves Paradise Island to take the man she loves back to America—the land she learns to love and protect, and adopts as her own! (Marston, 1972, p. 6)

What Wonder Woman's costume says implicitly, Marston makes explicit in this terminal caption. In order to come to America and

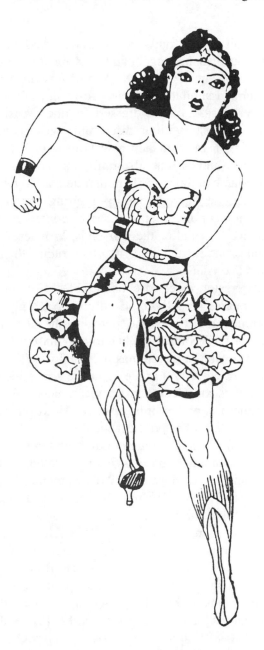

Figure 6.1. William Mouton Marston's all-American heroine came decked out in star-spangled attire for her wartime debut. Blummer, J. (1942, January). *Sensation Comics, 1*(1), cover. © 1941, DC Comics, Inc.

fulfill her dual mission of duty to the gods and love for the man, Diana is "giving up her heritage" and leaving for America, the land she "adopts as her own!" Wonder Woman is an immigrant who undergoes cultural assimilation even before she arrives in her new nation! Not only does she arrive dressed for the occasion, she comes with a mastery of English (with no discernible accent), superior health, and an unwavering loyalty to her new home—just as the dominant cultural paradigm would assume all immigrants should.

Wonder Woman continues to demonstrate this loyalty by fighting Axis saboteurs on the home front, by getting a job as a military attaché, and by joining the first superhero confederacy, the Justice Society of America. Even after the war ends, Wonder Woman stays in America to fight crime for the next 40 years rather than return to the splendor of Paradise Island.

Marston, her creator, invested considerable effort into making her a symbol that America's youth could admire. Not only did he design her heroic identity as virtuous and patriotic, he also assigned her a secret identity that further affirmed her loyalty. After a brief stint as a nurse, Diana Prince takes a position as a United States Army general's secretary. Mike Benton (1989) argues that the secret identity is one of the superhero genres most common devices; hence, Wonder Woman adopting one should come as little surprise. However, it is her choice of vocation that confirms her political leanings.

Still, of all that has been written about Marston's original mythos, an unduly amount of attention has been devoted to the theme of bondage (Wertham, 1954; Harmon, 1970; Steranko, 1970; Reynolds, 1994). Scenes with Wonder Woman, her foes, and other characters bound in chains, ropes, or Wonder Woman's own golden lasso were not uncommon images in her earliest exploits. However, comic historian Trina Robbins argues that it is unfair to single out *Wonder Woman* for this practice: "the fact is that in comics from the 1940s, if the heroes weren't getting tied up so that they could escape from their bonds, their girlfriends were getting tied up so that they could be rescued by the heroes" (Robbins, 1996, p. 12–13). Robbins goes on to point out that a frequent plot device for Captain Marvel's adventures was to have Billy Batson, bound and gagged, struggle to find some way to say the magic word "Shazam!" that transformed him into the World's Mightiest Mortal. "Still, I have never read any-

thing about bondage in Captain Marvel," Robbins concludes (p. 13). Indeed, a survey of that era's comics confirms the common theme: breaking bonds was a heroic task for both Wonder Woman and her male counterparts. As such, it is doubtful that claims of bondage in *Wonder Woman* as indicative of sexual deviation warrant much weight.

Although it may not have been fetish in nature, the inclusion of bondage in *Wonder Woman* was more than a coincidental plot device. Michael L. Fleisher (1976) suggests that this imagery, combined with explicit statements made in the text itself, advocated a philosophy of "loving submission." This was "an Amazon philosophy calling for the relentless repression of one's rebellious or assertive impulses in favor of unquestioning obedience to benevolent authority figures" (Fleisher, 1976, p. 236). Thus, the gods of Olympus could rule over the Amazons because they had the best interest of the women at heart, and Wonder Woman could imprison criminals because she had *their* best interests at heart.

Wonder Woman clearly served as a forum for Marston's ideas about dominance and submission, a perspective he held for social and psychological well-being. According to Geoffrey C. Bunn, Marston had foreseen a re-ordering of society through "freedom through submission" long before he took up the challenge of creating *Wonder Woman* (Bunn, 1997, p. 107). In this perspective, people enjoyed greater personal rewards when they yielded their own rebellious wills to the larger social order. In essence, becoming a "slave" to a societal good produced a better person and ultimately a better society.

The same theme of dominance and submission is implied in the melting pot metaphor. The dominant culture wields its considerable influence over immigrants, whose native culture seeks to resist the conformity of the homogenized melting pot recipe. The dominant culture expects immigrants to submit to the melting pot for their own good as well as the good of society. In Marston's conception, Wonder Woman's surrender to American domination is not only yielding to a benevolent servitude, it is the very will of the gods. Marston's Wonder Woman clearly went into a melting pot set on rapid boil. Her readiness to set aside her own upbringing in favor of American culture demonstrated a submission that immigrant Americans should embrace and that native-born Americans could be assured would not be

challenged.

After Marston's death in 1947, a variety of creators continued to chronicle the adventures of his Amazing Amazon without straying too far from the basic tenets established in the early narrative. Although not detailed here, their efforts were evidently successful enough to keep *Wonder Woman* in print through the fifties, sixties, and seventies, even while other, once more popular characters (like the afore-mentioned Captain Marvel), disappeared from comic book racks. In fact, the only lengthy disruption in her publication run occurred in 1986–1987, when an 11-month hiatus between the first *Wonder Woman* series and the second allowed a new creative team to prepare a number of significant revisions to the character and her mythology (and even during this hiatus, the publication of a four-part mini-series titled *The Legend of Wonder Woman* meant that the character was not long missing from public view).

Over the decades, various creative teams experimented with altering elements of the series. Wonder Woman's alter ego, Diana Prince, switched jobs on a number of occasions, retiring from her military career to accept positions as a boutique operator, then as a United Nations tour guide, and later as an astronaut. Long-time, long-stifled sweetheart Steve Trevor was killed once, brought back to life by the goddess Aphrodite, killed again, and then replaced by his counterpart from another dimension. At one point in the later 1960s, Wonder Woman herself renounced her superhuman abilities and magical weapons to fight crime with only a knowledge of the martial arts to give her an edge over villains. None of these alterations seemed to last very long and none were as ambitious in scope as what DC Comics offered when it launched a second series with the title *Wonder Woman*.

Cultural Pluralism in a Revised Wonder Woman Mythology

Although it was many decades in coming, a major shift from cultural assimilation to cultural accommodation occurred in the Wonder Woman mythos in 1987. By the mid-1980s, DC Comics had undertaken the project of reinventing its major stars by retelling their stories and renumbering their comic book series in order to appeal to a new generation of fans. When the first issue of the new *Wonder Woman* series came along, writer/artist John Byrne had already revamped Superman

and writer Frank Miller had retooled the Batman's origin. Heading the creative team that reinterpreted Wonder Woman was George Perez. Professionally, Perez was an artist renowned for his detailed artwork on series like Marvel Comics' *Avengers* and DC's *New Teen Titans*; culturally, he grew up in New York in a Spanish-speaking home (Kirby, 1989). Working with a host of collaborators (several of them women) over the next five years, Perez drew on Marston's original conception of the Amazing Amazon but departed from the original mythos by introducing a host of innovations, most notably in Wonder Woman's own expression of identity and her displays of heritage.

Perhaps the most significant departure for Perez's team was in reassessing the role of Wonder Woman in the world. Although the origin still has the gods sending Princess Diana on a mission to the outside world, it is not to combat a political nemesis. Instead, she is charged with stopping a metaphysical foe, Ares, the god of war, from wrecking havoc on all of civilization. Following this initial adventure, she takes on the role of her people's ambassador to the outside world, charged with teaching humanity the lessons of harmony that have governed her native culture for centuries. This Amazing Amazon does not see herself as a superhero, and given that, does not adopt a duplicitous alter ego. This is a significant departure from both the traditional mythos and the genre's expectations. In eschewing this trope, the creators allowed Wonder Woman to reject the notion that she as a woman and an immigrant should submit to being renamed by the dominant culture. Ill at ease with the media-inspired sobriquet "Wonder Woman," the character affirms that she is first and foremost the person she has always known herself to be, Princess Diana.

A second significant change involves the princess's displays of heritage. For example, she arrives in American without the prerequisite knowledge of English, instead speaking "some sort of gibberish—mixed with ancient Greek!" as one multilingual character describes it (Perez & Wein, 1987a, p. 6). Though she adopts a surrogate family in Boston, she is not bound to operating in that one city, seeking instead to explore her Mediterranean roots in one adventure (Perez, 1988). She frequently prays to her gods, reflects fondly upon her upbringing, and even invites a United Nations delegation to visit her home (Perez & Newell, 1989). That home itself reflects the pluralism of the rediscovered character. On her native Themyscira (the

renamed Paradise Island), many of her sister Amazons are not Cau-
casian, including Phillipus, the Black captain of the guard (Perez &
Potter, 1987). In this version, Diana does not "[give] up her heri-
tage," she shares it with the outside world. She does learn English, but
not at the cost of losing her Greek. Although she establishes a base of
operations in a U.S. city, she travels the world advocating equality and
unity. In short, she comes to an America where she is accommodated,
not assimilated: she retains her unique culture while still functioning
in this society.

Perez's team shows that individual cultural autonomy is to be re-
spected, and that it need not be stripped away in order to produce
engaging tales of social and personal relevance. Diana does not have
to be like us in the sense that she is an American because she already
is like us in the sense that she is a human being who can confront the
same challenges we do. That she occasionally exhibits customs unlike
our own demonstrates to us that the American way may not always be
the *only* way.

By examining the values of other, non-American cultures, Perez's
version of Wonder Woman explores more territory than any inter-
pretation before or since, but even it exhibits strong links to U.S.
values. Certainly, Wonder Woman's outfit remains a potent American-
ized symbol. Perez and Wein (1988) explain the paradox of an eth-
nically strong Themysciran wearing the stars and stripes based on a
link to sisterhood rather than to politics. Apparently, Diana Trevor, a
volunteer for the Woman's Auxiliary Ferrying Squadron, crash-
landed on Themyscira during World War II. Trevor aided the
Amazons in overcoming one of the island's indigenous monsters, but
at the cost of her own life. In her honor, they forged two sets of armor
using the red, white, and blue insignia from her jacket as the standard.
One set was incinerated with Trevor in her funeral and the other was
reserved for a warrior worthy to bear her mantle, which ultimately
proves to be the princess named for her.

Trevor, however unintentional her presence on Paradise Island
may have been, serves as a symbol of American imperialism. True, she
arrives not to conquer, not to assimilate, but ultimately to deliver the
struggling Amazons from a native oppressor. Like much of American
foreign policy since 1941, Trevor brings the experience of American
know-how to the less enlightened nations of the world. In gratitude,

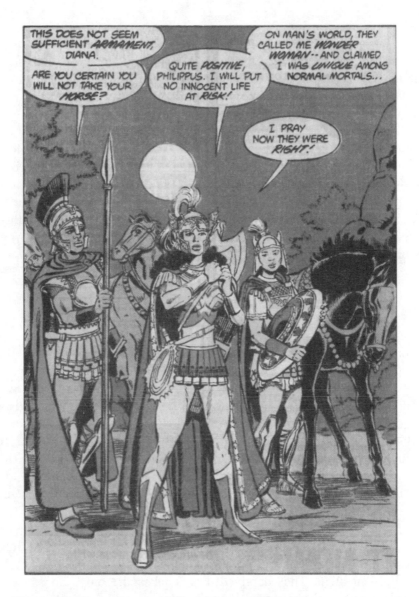

Figure 6.2. George Perez's 1980s vision cast Wonder Woman as a culturally diverse character. Here she prepares to face a challenge in her battle armor flanked by her Amazon sisters, one African and one Asian. Perez, G., & Patterson, B. (1987, November). Paradise lost. *Wonder Woman,* 2(10), p. 16. © 1987 DC Comics, Inc.

the Amazons enshrine the stars and stripes and promote her to the status of national hero. With such an example of valor, how can Wonder Woman not return the favor? In homage to the fallen hero, she must deliver America from the shadow of evil and adopt some of its ways as her own even as her people adopted Trevor as their own.

The Perez team radically reinterpreted Wonder Woman in terms of her national identity. Under their guidance the series adopted a multi-cultural perspective, providing a forum for characters of various cultures to interact without any of them having to surrender their native identity in favor of anyone else's. Here, at last, the melting pot is replaced by the salad bowl. However, this experimental challenge to the dogma of nationalistic superiority would not last as other creators, allied with mainstream conservatism, worked to re-colonize the foreign Amazon.

From Amazon to American: The Melting Pot on the Burner

When Perez left in the early 1990s to pursue other projects, Marston's theme of dominance-submission returned as other scribes took the Amazon princess in a hauntingly familiar direction. The first creator to turn the character toward being a familiar Americanized icon was William Messner-Loebs. Along with a host of editors and artists, Messner-Loebs moved the character more in line with Marston's original concept by establishing a series of events designed to assimilate the character into American culture. Yet what Marston did in one story, transforming the hero from foreign national to enculturated citizen, took Messner-Loebs the next 3 years within the series to complete.

The process begins when one of her foes causes Themyscira to disappear. Diana is cut off from her homeland; this effectively elimi-nates her source of authority as ambassador and her source of identity as a resident alien. Thus deprived, Diana takes the only job she can find, as a crew member at a "Taco Whiz"—quite a demotion for a princess (Messner-Loebs, 1993). Like other immigrants cut off from their homelands, Diana is forced to adapt to the society around her. Preaching unity becomes less important than making the next rent payment. Americans are not, after all, lofty individuals but practical,

Figure 6.3. While working at a "Taco Whiz" in order to eke out a living, Diana notes that the fast food franchise is itself "a vast melting pot!" Messner-Loebs, W., Moder, L., & Parks, A. (1993, July). Knowledge. *Wonder Woman, 2*(76), p. 5. © 1993 DC Comics, Inc.

hard-working folks. Even superhuman individuals are expected to hold down a 9-to-5 job while keeping up the fight for truth and justice.

This story line is a good example of how Diana is moved from accommodation to assimilation. Respect is associated with accommodation, and humility with assimilation. After all, to be part of the group, one must humbly deny one's past identity. Working for a fast food franchise and lacking financial stability are signifiers in American culture of humility, of "starting at the bottom and working your way up." If Diana is to become an American, which is Messner-Loebs's goal, she must undergo an American quest for identity and prove that she has the Protestant work ethic. The humor that a woman capable of lifting a train over her head must work for minimum wage seems sardonic, especially when one reconsiders that this is also a world-renowned ambassador being humiliated for the sake of enculturation.

In Messner-Loebs's final story arc for the series, Diana is deprived of her iconic costume and the title of Wonder Woman. As part of an elaborate plan to save Diana's life, Queen Hippolyta restages the contest on the rediscovered Themyscira to select the Amazon's champion, a contest won by an Amazon newcomer, Artemis. "Why did you restage the contest, so that I could be publicly humiliated and stripped of my name and signet?" demands an indignant Diana of her mother (Messner-Loebs, 1995a, p. 8). Upset over her loss of her red, white, and blue identity, Diana does not remain with her family, but returns to America to fight injustice in a star-spangled black outfit. When Artemis is mortally wounded in battle, she bequeaths the identity back to Diana, "Take back your uniform, Diana...You are Wonder Woman" (Messner-Loebs, 1995b, p. 37).

The assertion is an important one. Throughout Perez's tenure the character had been Diana, princess of Themyscira. "Wonder Woman" was a title applied to her by the American news media (Perez & Wein, 1987b). In fact, in a conversation with a friend in 1989, Diana expresses her reservations with the name:

> Diana: "Wonder Woman." Myndi [a publicist] certainly did a lot to popularize that rather pretentious appellation. Some know me as nothing else.

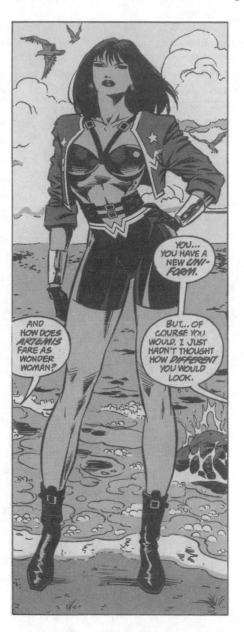

Figure 6.4. When replaced in the role of Wonder Woman by another Amazon, Diana trades in her traditional outfit for another all-American motif, black leather. Messner-Loebs, W., & Deodato, M. (1995, July). The rest of the story. *Wonder Woman, 2*(99), p. 7. © 1995 DC Comics, Inc.

Friend: Does that still bother you?
Diana: No... not really—at least not as it once did. (Perez, 1989, p. 51)

Artemis's rechristening signifies Diana's break with her native culture. Now a name which she once found strangely distant is worth fighting for, worth leaving paradise over, and worth abandoning her personally-established identity for. The name Wonder Woman has now become synonymous with America. Taking back the name is like taking the oath of citizenship.

Wonder Woman's assimilation is completed by writer/artist John Byrne. His 1995 four-part story line, "Second Genesis," served to sever Diana's persisting links with her Amazon, and inherently alien, heritage. Therein, Darkseid, an undemocratic despot, attacks Themyscira searching for the location of the Greek pantheon. After a bloody battle to defend the island nation fends off the villain, the Amazons reveal to Diana that her mother, Queen Hippolyta, has abdicated the throne and disappeared. The Amazons now expect Diana, as heir to the crown, to be their queen. Yet Diana refuses the throne, as any inculcated in the ways of democracy would: "To wear a crown and sit upon a throne requires much more than the arbitrary dictates of lineage...The throne is not for me. My lot has been cast another way. I am not a ruler, not a queen. Now and forever, I am Wonder Woman!" (Byrne, 1995, p. 20)

Returning to her new home in Gateway City, she tells her companion: "All my life I have been one thing, now it is at last time to be...something else. I suspect that will be closer to my true self than anything I have known before" (p. 22). Byrne thus completes the circle in Wonder Woman's transformation. She confirms, standing literally on the shores before a San Francisco–inspired skyline, that she has arrived in her true home, America, and fulfilled her true role, that of American superhero. The trappings of royalty, ethnicity, and identity are finally forsaken. Princess Diana, the world diplomat, has again become Wonder Woman, American superhero.

As an accurate epilogue to this process, Byrne later writes: "She has lost family and home, the sheltering comfort of history and tradition but she has gained so much more" (Byrne, 1996, p. 1). The "more," of course, one could interpret as the benefit of being an American—a privilege which native-born Americans are raised and reified to believe is well worth whatever price one must pay.

Conclusion

Even though they are part of the same narrative sequence of events, the Perez–guided Wonder Woman and the Messner-Loebs and Byrne–guided Wonder Woman present opposing perspectives on cultural identity. Perez's team seems to have made a conscientious effort to write the character as a non-native/not-interested-in-becoming-a-native visitor from another culture. In an era in which we try to see other cultures as just as legitimate as our own, Perez and company present a version of accommodation in which it is perfectly acceptable to retain one's own culture and still function within American society. Messner-Loebs's tenure, on the other hand, suggests that separation from the native culture and possession of the assimilated identity are to be prized. The "true self," Byrne later tells us, can only be found in oneself, not in one's native culture. Self-reliance, another staple of American ideology, and not sisterhood, a result of the Amazon philosophy of unity, is touted as the key to identity.

Indeed, the whole movement within the narrative from Princess Diana *in* America to Wonder Woman *of* America ultimately serves to confirm the critical suspicion that cultural imperialism is at work. As Shome explains, "Whereas in the past, imperialism was about controlling the 'native' by colonizing her or him territorially, now imperialism is more about subjugating the 'native' by colonizing her or him discursively" (Shome, 1996, p. 42). In the wake of Perez's departure, Wonder Woman has been re-colonized by creators more comfortable with her espousing American ideology than international diversity.

Within this neocolonial conception, to have Wonder Woman functioning as a world figure with strong loyalties to her native home weakens her viability as a thoroughly American figure (as if her garish outfit did not pronounce that identity in and of itself). The idea that anyone who came to America would want to leave America, much less maintain strong ties to one's native land, creates doubt in America's cultural superiority. To be fully American, one must break past allegiances and ally oneself more completely with the United States. A worldly Wonder Woman needs to be brought back in line with the dominant culture, one which perceives her first and foremost as American, despite her non-native origins.

Other comic book creations have shared in Wonder Woman's

dichotomy of being both alien and Americanized. Enduring characters like Superman, the Martian Manhunter, Thor, and various members of the X-Men were not born in the USA. Yet in stories spanning their narrative lives, these non-natives give up their heritage in part or in full for assimilation into the American melting pot.

The tyranny of the melting pot metaphor is doubly insidious in that it dictates to immigrants that they *must* conform and it dictates to natives that they should expect others to conform. Some have pointed out that many Americans have come to expect other countries, and always their own, to conform to their English-speaking, hamburger-eating needs (Nakayama, 1994). Likewise, Americans expect their heroes, even when touched with the exotic, to be fully Americanized. Though they are fictitious representations of this ideology, popular culture examples like Wonder Woman contribute to re-enforcing the importance of Ameri-centric beliefs. Clothed in an aura that is all-American, such artifacts serve as barriers to a pluralistic society—one which embraces diversity without the subordination of any one cultural identity to another.

References

Benton, M. (1989). *The comic book in America: An illustrated history*. Dallas, TX: Taylor.

Bunn, G. C. (1997). The lie detector, *Wonder Woman* and liberty: The life and work of William Moulton Marston. *History of the Human Sciences, 10*(1), 91–119.

Byrne, J. (1995). Second Genesis. *Wonder Woman, 2*(104). New York: DC Comics.

Byrne, J. (1996). Lifelines. *Wonder Woman, 2*(106). New York; DC Comics.

Deane, S. (1990). Introduction. In. T. Eagleton, F. Jameson, & E. W. Said (Eds.), *Nationalism, colonialism, and literature* (pp. 3–19). Minneapolis, MN: University of Minnesota Press.

Fleisher, M. L. (1976). *The encyclopedia of comic book heroes: Volume 2: Wonder Woman*. New York: MacMillan.

Gordon, I. (1998). *Comic strips and consumer culture, 1890–1945*. Washington, DC: Smithsonian Institution Press.

Graves, S. B. (1999). Television and prejudice reduction: When does television as a vicarious experience make a difference? *Journal of Social Issues, 55*(4), 707–725.

Harmon, J. (1970). A swell bunch of guys. In D. Lupoff & D. Thompson (Eds.), *All in color for a dime* (pp. 170–197). New Rochelle, NY: Arlington.

Kallen, H. (1924). *Culture and democracy in the United States*. New York: Boni

& Liveright.

Kirby, S. (1989, June 17). "I love to draw." *St. Petersburg Times*, Hernando Times insert, p. 6.

Marston, W. M. (1944). Why 100,000,000 Americans read comics. *The American Scholar, 13*(1), 35–44.

Marston, W. M. (1972). *Wonder Woman*. (Gloria Steinem, Ed.). New York, NY: Holt, Rinehart and Winston.

McClintock, A. (1995). *Imperial leather: Race, gender, and sexuality in the colonial contest*. New York: Routledge.

Messner-Loebs, W. (1993). Losses. *Wonder Woman, 2*(73), New York; DC Comics,.

Messner-Loebs, W. (1995a). The rest of the story. *Wonder Woman, 2*(99). New York: DC Comics.

Messner-Loebs, W. (1995b). Blank madness. *Wonder Woman, 2*(100). New York: DC Comics.

Nakayama, T. K. (1994). Show/down time: 'Race,' gender, sexuality, and popular culture. *Critical Studies in Mass Communication, 11*(2), 162–79.

Perez, G. (1988). Traces. *Wonder Woman, 2*(17). New York; DC Comics.

Perez, G. (1989). The game of the name. *Wonder Woman Annual, 1*(2). New York; DC Comics.

Perez, G., & Newell, M. (1989). Strangers in paradise. *Wonder Woman, 2*(37). New York: DC Comics.

Perez, G., & Potter, G. (1987). The princess and the power! *Wonder Woman, 2*(1). New York; DC Comics.

Perez, G., & Wein, L. (1987a). Deadly arrival! *Wonder Woman, 2*(3). New York; DC Comics.

Perez, G., & Wein, L. (1987b). A long day's journey into fright! *Wonder Woman, 2*(4). New York: DC Comics.

Perez, G., & Wein, L. (1988). Echoes of the past. *Wonder Woman, 2*(12). New York: DC Comics.

Reynolds, R. (1994). *Super heroes: A modern mythology*. Jackson, MS: University Press of Mississippi.

Robbins, T. (1996). *The great women super heroes*. Northhampton, MA: Kitchen Sink Press.

Said, E. W. (1993). *Culture and imperialism*. New York: Alfred A. Knopf.

Shaheen, J. G. (1994). Arab images in American comic books. *Journal of Popular Culture, 28*(1), 123–133.

Shome, R. (1996). Postcolonial interventions in the rhetoric canon: An "other" view. *Communication Theory, 6*(1), 40–59.

Steranko, J. (1970). *The Steranko history of comics: Volume 1*. Reading, PA: Supergraphics.

Thompson, D. (1970). OK, Axis, here we come! In D. Lupoff & D. Thompson (Eds.), *All in color for a dime* (pp. 125–146). New Rochelle, NY: Arlington.

U.S. Bureau of the Census. (1996). *Current population reports*. P25–1130.

Wertham, F. (1954). *Seduction of the innocent*. New York: Rinehart.

Whitfield, S. J. (1999 September/October). America's melting pot ideal and Horace Kallen. *Society, 36*(6), 53–55.

Yoke, T., & Newall, G. (1996). *School house rock! The official guide.* New York: Hyperion.

Zangwill, I. (1914). *The melting-pot.* New York: Macmillan.

Chapter 7

From Realism to Superheroes in Marvel's *The 'Nam*

Annette Matton

In June 1969, Captain America, Thor, and Iron Man invaded Vietnam, swiftly subjugating Ho Chi Minh and forcing him to negotiate for peace in Paris. Or at least they did in issue no. 41 of *The 'Nam* (Murray, 1990, February), a Marvel war comic book first published in 1986. In what proved to be perhaps the most fantastic plot that the comic featured, and also, notably, one of its least well-received issues, the all-American superheroes did what America failed to do; namely, they won in Vietnam.

In this imaginary tale, the Captain and his friends are brought into the story through the wishful thinking of two characters in the comic, Ice and Martini. Ice is due to leave, having completed four tours of duty in Vietnam. He discovers a pile of old comics while he is packing. The two remark that the superheroes would have loved it in Vietnam, and the comic drifts into its superhero story. One of the more cynical and least popular characters points out quite accurately that "the reason people like lookin' at a bunch of guys that can't do no wrong and can't get beat is cause there's no such thing!" Given his status within the comic, however, his opinion is quickly dismissed. The story continues with the soldiers making fun of the John Wayne film *The Green Berets* because of its lack of realism. The final frame shows Ice's helicopter leaving against the superimposed images of Captain America, Thor, and Iron Man as his friends remark that he (Ice) is a *real* hero.

For a Marvel war comic that had originally started with grand assertions of "realism" and accuracy, this plot line represented a radical break from tradition. The first 40 issues of *The 'Nam* had

Figure 7.1. From Murray, D., Vansant, W., & Isherwood, G. (1990, February). Back in the real world. *The 'Nam*, *1*(41), p. 11. © 1990 Marvel Enterprises, Inc.

established it as a war comic firmly grounded in both historical and artistic realism. The comic went to great lengths to impress on its readers just how accurate it was; examples of the techniques used include the hype surrounding the comic, the editorial introduction in issue no. 1 and a section that explained the military jargon in each issue. Compared with many other war comics, such as *Sgt. Fury and his Howling Commandos* (Marvel) and *The Losers* (DC), it is clear that *The 'Nam* did indeed represent a distinct shift in the portrayal of America at war. However, the extent to which it actually represented war realistically is an issue that will be discussed later in this chapter.

The break from tradition in issue no. 41 was thus unexpected because it appeared to reflect the fantastic war comics of the past rather than the gritty realism that had been promised. That the readers of *The 'Nam* resented such a story is not surprising, given the tone of previous letters pages which had emphasized their fondness for a comic which told the "truth" (Matton, 2000). That the story was written by Doug Murray, a Vietnam veteran and original writer of the comic who was also responsible for the editorial in issue one, *is* surprising. What prompted such an apparently bizarre plot line will be discussed in this chapter, although it is clear that such changes in structure were prompted by political and economic reasons rather than artistic ones. At the time of the fantasy issue, there had been no changes in the editorial team, apart from the usual rotation of inkers. In addition, the comic was still following its unusual "real time" structure, whereby with each monthly issue a month would have also passed for the characters in the book; it was around this concept that the original hype was based.

This chapter will also later discuss issues in the title's run that broke away from the real-time structure and featured guest appearances from another Marvel character, the Punisher. These issues symbolize another important change in the comic's approach to its representation of the Vietnam War, which again detracts from what was supposedly the comic's selling point—realism—and moves the comic back into fantasy. The reasons behind these later changes and the readers' responses to them, in light of their negative responses to the Captain America issue, will also be considered. To help establish the original reasoning and goals of the comic, as well as the changes that followed, comments from Doug Murray will be referenced (Dagilis,

1990).

A central argument of this chapter is that despite a radical change in structure, *The 'Nam* did not undergo any similar changes in its ideological representation of the Vietnam War. In fact, it is clear that regardless of the structure and style of the comic, whether it be a commitment to "realism" or fantastic superhero story lines, the ideological leanings of the comic remained constant. The nature of the comic's ideology will be established in a discussion involving issues of the comic prior to the superhero issues that adopted the original real time structure, and later in relation to the more conventional superhero and non–"real time" issues. Furthermore, the extent to which that ideology may or may not fit with the established ideology of the period, the 1980s, will also be considered. Finally, to assess the relative importance of the changes to the comic on its representation of the Vietnam War, the level and tone of responses from the readers will also be examined.

Rethinking Vietnam

An important issue in understanding *The 'Nam* is the extent to which comic books, particularly war comics, have challenged, or have the potential to challenge, the mainstream consensus. One early factor that at least temporarily shaped the argumentation in U.S. comics toward the status quo was World War II, when comics joined the war effort by celebrating American values and featuring patriotic characters (McAllister, 1990). Referring to reactions to war comics published in the post-WWII/pre-Vietnam era, Roger Sabin observed that "generally there was no backlash because the comics towed the establishment line: to put it simply, as they were only killing the enemy, nobody really took much notice" (Sabin, 1993, p. 153). The exception to this, he notes, were the EC titles, regarded by many as *anti*-war comics, that were criticized for being too left-wing. Skidmore and Skidmore (1983) also observed that any criticism war comics of the Golden Age did attract was a result of their portrayal of violence and crime and not because of ideology. *The 'Nam* too raised little public interest beyond the initial reviews in the mainstream press and interviews in the comic book press, suggesting that Sabin's comments hold true for at least

this 1980s war comic. Indeed, if we examine other examples of repre-
sentations of the Vietnam War in American popular culture produced
in the 1980s, Hollywood films in particular, a convincing argument
can be made to suggest that *The 'Nam* was following a well-established
formula of towing the establishment line.

The extent to which mainstream comic books have the potential to
challenge the status quo is perhaps limited despite the fact that they
exist on the edge of popular culture. The boundaries imposed on
comic books by either the individual publishers or the Comics Code
deny an apparently "radical" medium the chance to effectively chal-
lenge established ideology. Even when controversial topics are fea-
tured, such as the case of Lt. William L. Calley and the My Lai mas-
sacre in *The 'Nam*, they are presented in a manner that does little to
truly rock the establishment boat. It is here that an important distinc-
tion needs to be made, notably that just because a comic presents a
political issue it is not necessarily criticizing the established line. As
Skidmore and Skidmore concluded, "the comic books of today do
deal with political themes, both directly and indirectly. To a consid-
erable extent, they *reflect* the political conditions around them
[emphasis added]" (Skidmore & Skidmore, 1983, p. 91). McAllister
(1990) explores the arguments concerning the role, or potential role,
of comics to act as a means of cultural criticism and concludes that it
is independent publishers that have the most potential to provide
fundamental criticism, and even that may be significantly constrained
by the industrial context in which the publisher operates.

The limited possibilities of social criticism in mainstream comics is
illustrated by *The 'Nam*. Despite structural and organizational changes
in the comic book industry that took place in the post-WWII and Cold
War eras (Sabin, 1993), *The 'Nam* follows the tradition of earlier war
comics in supporting the established ideology. What is of particular
importance when making that argument is that *The 'Nam* was pub-
lished more than a decade after American troops left Vietnam and was
thus not under the same pressures to conform as the publishers had
been during WWII. This fact raises the question of why *The 'Nam*
towed the line. The answer to that question lies in the particulars of the
era in which it was published, namely the eighties, a decade that is
neatly summarized by the following extract from a speech Ronald
Reagan gave at the Vietnam Veterans Memorial on November 11,

1988:

> I'm not speaking provocatively here. Unlike the other wars of this century, of course, there were deep divisions about the wisdom and rightness of the Vietnam War. Both sides spoke with honesty and fervor. And what more can we ask in our democracy? And yet after more than a decade of desperate boat people, after the killing fields in Cambodia, after all that has happened in that unhappy part of the world, who can doubt that the cause for which our men fought was just? It was, after all, however imperfectly pursued, the cause of freedom: and they showed uncommon courage in its service. Perhaps at this late date we can all agree that we've learned one lesson: that young Americans must never again be sent to fight and die unless we are prepared to let them win. (Reagan, 1989, p. 366)

What this extract makes clear, it can be argued, is the extent to which the cultural climate of the eighties in America expressed a desire to rethink American involvement in Vietnam in order to present both the American people and the rest of the world with a more "acceptable" history. That revisionist history took place in the eighties is an argument that has been expressed by many writers, notably Chomsky (1989). As will be argued during the course of this chapter, *The 'Nam*, despite its initial aims of ground-breaking realism, was merely another example of that history.

Realizing *The 'Nam*

As suggested earlier, Marvel's previous experience of war comics had been firmly rooted in fantasy, as demonstrated by *Sgt. Fury*. However *The 'Nam* was not the only new war comic that Marvel published in the eighties. *Semper Fi* was a short-lived comic first published in 1988 that focused on the history of the Marine Corps and featured different battles, such as WWII. *The 'Nam* was also not Marvel's first portrayal of Vietnam. "The Origin of Iron Man," a story first published in *Tales of Suspense* in 1963, was set in South Vietnam. The story shows Anthony Stark (Iron Man) in his pre-superhero days as a weapons designer and, ultimately, a war-profiteer. He travels to Vietnam to show off his latest weapon but is wounded and captured by the Viet Cong, who promise him the life-saving operation that he needs in return for his help building a weapon. Stark agrees but the weapon that he builds

is his suit of iron, which he uses both to escape and to keep him alive. Iron Man would go on to work closely with the American government in its fight against the evils of Communism both at home and abroad. Bradford Wright (1993) described "The Origin of Iron Man" story as a "childishly simplistic" portrayal of the Vietnam conflict, noting that Stark was the "very symbol of America, a noble hero helping the South Vietnamese with his superior wealth and technology"(p. 442). Other comics occasionally dealt with Vietnam as well. Issue no. 125 of *Captain America* (Lee, 1970) featured the story "Captured in Viet Nam!" in which a "peacemaker" is taken hostage in Vietnam by the evil Mandarin who hopes that the resulting chaos, as both sides blame each other, will enable him to take power in Asia. The Captain of course saves the day enabling the warring factions to get back to the peace table. The story, published during the war, argues not for further American involvement in Vietnam but for peaceful negoti-ation. However, its lack of a critical stance of America's role in Viet-nam and its unflattering stereotypes of the Vietnamese place the comic firmly within the establishment boundaries. This representation of Vietnam, and America's role in it, can clearly be seen in *The 'Nam*, which continued this conservative tradition.

The 'Nam, published by Marvel, ran from December 1986 until September 1993, when low sales forced it to end earlier than had first been planned. It was originally intended to be a "real-time" comic, whereby with monthly publication of each issue, a month would have also passed for the characters in the stories. Such a structure allowed the reader to follow the same characters through their tours of duty, yet allowed for a constant supply of fresh characters as new recruits arrived. It followed this format for approximately half its run, until the editorial team changed the format to allow for multi-part stories. As will be shown later, though, disagreements between Marvel and Doug Murray concerning the target audience were also a factor.

Along with the real-time structure intended to heighten the comic's realistic portrayal of the Vietnam War, it also used a more realistic style of artwork compared with many previous war comics. Although the original artist, Mike Golden, favored characters drawn with a slight cartoon look about them, the comic's artwork was still noticeably more realistic than, for example, the classic 1950s EC war comics *Frontline Combat* and *Two-Fisted Tales*. However, the very

nature of Golden's style prevented the comic from achieving the gritty realism that would complement its real-time convention. Later artists such as Wayne Vansant would move away from Golden's cartoony style (although changes in the nature of the story lines prevented any further moves toward greater realism on the comic's part).

In the early hype generated by the comic, it was *The 'Nam's* "realism" that provided its main selling point, although the treatment of Vietnam by a comic book also brought publicity for Marvel and their new venture. A September 1986 article in the *Washington Post* focused on the comic's presentation of Vietnam as a "darker, more surreal place than John Wayne or Sly Stallone ever visited," and also drew attention to the unusual time narrative of the comic (Span, 1986). *The 'Nam* was also reviewed in the *LA Times* (Solomon, 1987), and this suggested that a comic published in the mid-1980s that dealt with the Vietnam War was considered to be a newsworthy event. Of particular importance seemed to be the apparent shift in the way in which comics dealt with American wars, alongside the emergence of a comics genre aimed at a definite adult audience, such as First Comics' *American Flagg*.

The first few issues of *The 'Nam* introduces the reader to the 23rd Infantry and the characters that make it up, most notably Ed Marks. Other characters such as Mike Albergo and Rob Little also play important roles, as does the corrupt First Sergeant "Top," although given the nature and demands of the real-time structure the comic does not rely on a central hero figure. Readers received their introduction to Vietnam through Ed's eyes, a greenie who arrives in-country early in 1966 and is thrown straight into a brief firefight with the enemy (Murray, 1986). The comic takes this opportunity to make use of the now classic image of American soldiers walking in a line through a paddy field. Ed is also given an introduction to the perils of Vietnam by his new friend Mike Albergo, who shows him how to avoid "Charlie's" booby-traps and how to purify water for drinking. The patrol enters a village but the locals soon "bug-out" and Ed encounters his first action. Perhaps the most important lesson that both Ed and the reader learn is that the enemy is both devious and everywhere.

The cover of issue no. 1 makes clear the ideology of *The 'Nam*,

Figure 7.2. From Murray, D., Golden, M., & Gil, A. (1986, December).
'Nam: First patrol. *The 'Nam*, *1*(1), n.p. © 1986 Marvel Enterprises, Inc.

and the opening story provides further support for this. The cover
features a map of Vietnam, split across the middle, onto which are
superimposed images of the war. American soldiers feature promi-
nently despite their place as invaders. The Vietnamese on the cover,
on the other hand, are relegated to the margins, drawn so as to be
unrecognizable shadows in somebody else's war or as children waving
at the U.S. troops. Inside the comic the reader is introduced to Ed as
he arrives at his base where he immediately encounters and, perhaps
most importantly for "America," resists the corrupt First Sgt.'s offer
to find him a better, less hazardous assignment. Ed's naiveté will stay
with him despite the experience and rough edges that he gains as the
comic and the war progress, along with his equally "innocent"
friends. This portrayal of innocence illustrates the comic's approach
to American involvement in Vietnam which, along with the bulk of
American popular culture in Reagan's eighties, took the revisionist
path in their representation of the war. Such an approach inevitably
demands that the enemy be marginalized and that the Americans be
innocent, or as Chomsky explains, they follow a "system of
indoctrination" which "erases historical memories and establishes the
'truths' that are deemed more satisfactory" (Chomsky, 1989, p. 85).

Ed's first encounter with the enemy continues the process of mar-
ginalization and dehumanization when his squad go on a "quail
hunt" and engage the blurred enemy in a hasty battle that results in
two dead "VC." However, despite Ed's reaction of horror to the
bodies, these remain out of sight for the readers who are instead
forced to rely on the blinkered American eyes for their reaction. What
makes this ideological slant even more relevant is the opening
editorial page, which, along with selling the idea of a real-time comic,
also makes the claim that The 'Nam is "the real thing" and promises
to show "what the War was really like for those who fought in it"
(Hama, 1986, n.p.). In this respect, Marvel's new comic was also
reflecting a more general trend in American popular cultural repre-
sentations of Vietnam. Pat Aufderheide (1990) makes a similar obser-
vation about films such as Platoon and Hamburger Hill, arguing that
"[t]hey claim to tell us 'the real truth' and...how to feel about the
war" (p. 94).

The "real thing," according to The 'Nam, is handsome, broad-
chested American GIs employing American superiority, both tech-

nological and moral, over a weak and physically frail enemy. Issue no. 5 provides a fine example of artwork that supports this argument, although any issue of *The 'Nam* could be used to illustrate this point regardless of artist or story line. "Humpin' the Boonies" (Murray, 1987a), as the story is called, shows an encounter between Ed's squad and an again unseen enemy. The reader is instead invited to gaze upon the "evidence" of the enemy's inhumanity in the form of a "pacified" village in which the Viet Cong have hung on posts the bodies of villagers they have slaughtered—the image of this on the cover is dominated by the color red. Such an atrocity allows the Americans a free hand in their response—a long-distance artillery strike directed by Ed and Rob.

The themes and ideological ideas established in the first issues of the comic are clear, and are supported by the artwork. Drawn by Mike Golden, the American soldiers are handsome, muscular and strong, whereas the Vietnamese are thin, weak, and frail. The Americans have technology, the enemy does not. The Americans are human(e), the enemy is not. The Americans are morally correct, the enemy will always be wrong. This final point of ideological emphasis is further supported by a later issue (Murray, 1987b), which deals with a former Viet Cong turned American supporter. "Duong" tells his story, focusing on his original faith in the Vietnamese resistance to the French. The arrival of Diem proved to be too much, however, and he joined the Americans despite his initial disdain for their methods. Duong's willingness to convert gives the American invasion of Vietnam a firm seal of approval, at the same time clearly disapproving of the "enemy's" resistance.

The 'Nam is not so single-minded as to ignore the obvious realities of the Vietnam War, although it does not devote a great deal of space to issues such as anti-war protests, out-of-control squad leaders and corruption. In issue no. 15, Ed derides the anti-war protesters (Murray, 1988b), whom he criticizes for protesting outside a napalm factory. From the perspective of Ed, a sympathetic character, the damage, both immediate and permanent, that the weapon caused is overlooked in favor of the American lives that it saved. This failure to acknowledge the physical damage caused to Vietnam by the American invasion is an idea also identified by Aufderheide in relation to Hollywood films (Aufderheide, 1990, p. 95).

The idea that not all American soldiers acted responsibly in Vietnam is covered in issue no. 14 (Murray, 1988a), which tells the story of a gung-ho young lieutenant. His behavior and demands on his less enthusiastic charges results in his death by fragging. The story also goes some way in illustrating the feelings of apathy among the soldiers, a theme that while not at the forefront of the comic is certainly featured. The characters in *The 'Nam* are never happy to be in Vietnam, beyond the circle of friends they have formed, although these feelings are based generally on immediate physical discomfort rather than ideological objections to the war. In fact, despite the lack of overt patriotic displays, the reader is left with the impression that they are proud to be fighting for the American/good cause. That the lieutenant is shown to be an aberration and that he also receives his comeuppance makes clear that his behavior was unacceptable for an "American." This is contrasted in the comic on a more general level with the atrocities committed by the Viet Cong which, the reader assumes, go unpunished because they are deemed *acceptable* within the enemy camp.

The case of Lt. Calley is also referred to in issue no. 75, near the end of the title's run, demonstrating that the comic was capable of highlighting an American atrocity (see, for example, Murray & Lobdell, 1992). In fact, this particular issue of *The 'Nam* was surprisingly critical of the U.S. military in its role as the representatives of the central government. The case of Calley was approached from four different viewpoints in issue no. 75, reflecting the "views" of two soldiers still in Vietnam: Sgt. Haeberle, a former soldier who took photos at the scene and is now a radio presenter, and a young black man who questions a police sergeant (Polkow, who also happens to be a veteran from *The 'Nam*). Despite these differing viewpoints, the comic still manages to present a consistent argument that leans toward the idea that the soldiers were just following orders, although the notion of individual responsibility is also discussed convincingly. Haeberle, his defense being that it all seemed normal, is criticized for failing to act more quickly. Polkow attempts to convince his young questioner that soldiers killing one another is different from gang violence in America because of the nature and rules of war. The radio presenter invites listeners to phone in with their opinions, but the more interesting comments are made by the pre-

senter himself who not only criticizes the government for sending 19-year-olds to war but also compares the American role in Vietnam to the British colonial role in America.

Issue no. 75 represents perhaps the best example of *The 'Nam's* potential to provide a certain level of critical commentary on America's war in Vietnam, although notably the average "grunt" remains untainted as the two soldiers cannot decide if they themselves would have followed orders also. While this issue should be noted for the criticism it levels at America, especially when viewed alongside the much more conservative attitudes expressed throughout the rest of the series, it should also be pointed out that it took an atrocity of the My Lai nature to provoke such criticism from the comic—soul-searching that arguably would not have taken place otherwise.

The Real Thing?

Following the above introduction to *The 'Nam*, which highlighted the particular style of the comic, its real-time structure, and some of the more interesting story lines, it is now possible to examine behind-the-scenes issues that affected the comic's production.

In a 1990 interview with Doug Murray (the comic's creator and original writer) conducted by Andrew Dagilis, the most startling points to emerge are those relating to relations between Murray and his bosses at Marvel. The constraints imposed on him by senior editors and the Comics Code are constantly referred to, creating the impression that *The 'Nam* that was produced differed significantly from that which Murray had intended. His aim of creating a book that was personal—and based loosely on real events and experiences—was achieved, as was, generally speaking and judging by reader responses, his aim of creating an "informative" comic. The main problem that arose, however, seemed to center on the target audience of the comic, an issue that produced conflicting opinions within the Marvel camp. Murray had originally intended for *The 'Nam* to be aimed at adults; this would allow for more graphic language, art, and story lines (within the guidelines of the Comics Code) than a comic aimed at Marvel's "traditional" audience. As the result of a change in distribution in 1988 (a shift from newspaper stands to direct sales) and

Figure 7.3. From Lomax, D., & Vansant, W. (1992, December). Stateside tragedy: The My Lai massacre. *The 'Nam*, *1*(75), n.p. © 1992 Marvel Enterprises, Inc.

price increases, however, the comic lost over half its readership, from about 250,000 issues a month to 100,000 (Dagilis, 1990, p. 73). The decline in sales prompted Marvel to insist that the comic be aimed at a wider, younger audience. The forced change in the target audience inevitably led to a demand for a change in style of *The 'Nam*, one which would suit an audience of 12-year-olds.

It is here that Marvel first hints at changes to the comic, delaying mentions of structural changes until later. The distribution changes took effect starting with issue no. 18. Although it was a while before the real-time structure was discarded, the move still produced important changes. As Dagilis (1990) points out, it is at about this time that the characters become slightly less believable; he cites "Ice" as an example, whom he describes as being a "clichéd, Dirty Harry-esque" character that bears little resemblance to original characters, such as Ed Marks, who were believable, to a certain extent, as people. This change in character type is clearly what would later prompt the introduction of superheroes. However, if one assumes that it was a decline in sales that eventually led to *The 'Nam* being axed then surely this begs the question of whether or not the younger readers really did want macho, Ramboesque soldiers. Murray, though, does suggest that Ice was popular among the younger readers and also points out that he was forced to change his style to accommodate younger readers. And it was not only the *style* of the comic that he was forced to change. Even the content of the letters page was doctored in order to reflect the new target audience of the comic:

> [at first] I was encouraged to make the letters page controversial and deal with issues pertaining to and around the Vietnam War, so a lot of our letters were from adults talking about wartime experiences and the problems thereof. More recently...I've been told to make the letters page appeal to the younger crowd and print as many letters as possible from the 12- to 15-year-old group. (Dagilis, 1990, p. 81)

The organizational and industrial context in which The Nam was created influenced its portrayals and stories. Murray blamed both the editors at Marvel and the Comics Code for factors that constrained his work, though he sees a lack of conviction from the editors as being the main problem. At first, Larry Hama (the editor for the first 10 issues) had been able to work around the limitations of the Comics

Code, using such strategies as allowing Murray to trade off one unacceptable word for another. With the departure of Hama, *The 'Nam* lost this power and was thus watered down. Murray also argues that the comic suffered even during the first years because of the limitations of the comic book medium:

> I'm trying to do the best that I can with what is essentially a flawed instrument by its very nature...I'm trading off the complete reality and truthfulness of it, the way I'd *prefer* to do it if this was a perfect world, for something that I can do and still get the message across to a wider audience [italics in the original]. (Dagilis, 1990, p. 71)

However, because Murray had started the project aware of such limitations, these factors cannot be blamed for the eventual changes to *The 'Nam*, which instead resulted from the pressure exerted by the editors. He also refers to the ideological limitations that were imposed by Marvel's "world view," in relation to the priority given to entertainment at the expense of historical fact, suggesting that it has a "conservative direction." It is perhaps because of these and other limitations that Murray created the real-time narrative in an attempt to add authenticity to a comic that he knew would be watered down for a younger audience. Referring to a discussion with his editor, Hama, he states that the decision to give the comic a real-time format was made at the start. Perhaps the most enlightening comment here refers to the process of production and distribution of power at Marvel. Murray comments that "at Marvel a change in editor doesn't mean that nothing's going to change in the book" (Dagilis, 1990, p. 72).

As has been established, Murray's relationship with Marvel's editors was never a comfortable one. He was forced to make compromises to a comic that he had originally intended to be aimed at adults and which ended being sold to 12-year-olds. It is of course this change in target audience that forced Murray, and indeed later writers, to make changes to characters and story lines. It is this history that needed to be established so that Murray's comments concerning the structural changes could be fully appreciated. Murray reveals that the changes in structure, specifically the move away from the use of real time, occurred at a time when he was having serious disagreements with the editor (no specific name is given) over a script. Dagilis (1990) suggests that perhaps Marvel wanted to "Rambo-ize" it and

Murray agrees, adding that communication became ineffective for a few months before compromises were made. It was at this point that the changes took place:

> there was a time when communication between us broke down entirely, which as a result, there'll be one or two issues that'll be done by somebody else that won't fit into the continuity at all. How we're going to reconcile that I don't know yet. When the editor gave the book to these people to do, he told them that they didn't have to pay attention to real-time, that they couldn't use the characters that currently existed and that they could do anything they wanted. (Dagilis, 1990, p. 84)

While Murray's statement goes some way in revealing why the structural changes occurred, it does not resolve the matter entirely because it is still unclear why the Marvel editor felt that the real-time structure could be ignored. It is doubtful that Murray owned the rights to specific narrative elements of the comic given that he did not own *The 'Nam*, although he admits that there was potential for "cloning" whereby he could take key parts of the comic and redo it at another publisher. And as he had not actually left Marvel at this point there was no real reason, it seems, for the editor to have decided that the real-time structure could not be used: indeed, the phrase used by Murray suggests that it was simply a matter of choice rather than, for example, a legal obligation.

The Punisher Invades *The 'Nam*!

Given the above discussion about the changes in the production dynamics of *The 'Nam*, how did these changes influence the comic itself? To examine further the arguments being put forward regarding *The 'Nam's* ideology, it is necessary to discuss stories that appeared late in its run. During the five issues that will be examined here (52, 53, 67, 68, 69), two writers, Roger Salick and Chuck Dixon, along with two pencilers, Mike Harris and Kevin Kobasic (although notably not the regular one, Wayne Vansant), were used. The editor, Don Daley, remained constant. These particular issues have been chosen primarily because they demonstrate the effects of the structural changes that took place. However, they also illustrate the first uses of multiple-part

stories in *The 'Nam*, as well as featuring another superhero invasion of Vietnam.

As it is the superhero appearances that proved to be the most radically different story lines in *The 'Nam* because of their disregard for the comic's claims of realism, it is here that this investigation will start. Issue nos. 52 and 53 (Salick, 1991) feature another Marvel character, the Punisher, although he appears under his "civilian" name, Frank Castle. Issue no. 51 previewed the forthcoming two-parter as a "comics event" and, strangely, drew attention to the fact that it was to be little more than a marketing stunt for Marvel comics. The fact that this story would also abandon the "regular *'Nam* continuity" is also mentioned. Given the adverse reaction to the Captain America issue (Matton, 2000), which is acknowledged in the preview, such a story idea would seem foolish. But the editors of *The 'Nam* had apparently decided that the problem lay not with the potential of American superheroes to win the war in Vietnam retrospectively, but with the overt displays of superpowers that had annoyed the readers. So, with promises of "No capes!, No people flying! No slug fests or supervillains!," an ordinary U.S. Army Sergeant took on a "notorious VC sniper." (Of course, the Americans were never allowed to be notorious.)

The covers of both issues are noticeably darker, in terms of color and shading, than previous ones. Whereas the norm had been to use the cover to depict a scene from inside the book, these two featured images of Castle as a grimacing and intimidating soldier. Issue no. 53 goes so far as to include a skull behind him. Notably, the traditional image of a GI in the top left corner has been replaced by the Punisher's symbol, a skull wearing a helmet, in a clumsy attempt to blend the two Marvel worlds together. Using the Punisher's symbol on the cover shatters the comic's promise that this was not going to be a superhero issue, but when placed alongside the title which screams at its readers "The Punisher invades *The 'Nam*," it seems to be perfectly apt.

As hinted at in the preview, the story follows Sgt. Castle as he hunts down and eventually kills a notorious Viet Cong sniper. The reader is introduced to the enemy in the opening scene when the sniper shoots and kills a U.S. colonel from 875 yards. The artist chooses to show the sniper's face, an unusual choice given the ten-

Figure 7.4. From Salick, R., Harris, M., & Palmiotti, J. (1991, January). The long sticks. *The 'Nam, 1*(52), p. 22. © 1990 Marvel Enterprises, Inc.

dency of American popular culture to hide the enemy in the jungle. However, to emphasize his lack of humanity, the sniper is drawn in the shadows, and his face is harsh compared to the handsome U.S. soldiers. As if his physical appearance were not enough of a handicap, he is known to the Americans as "the Monkey," a name used without even a trace of irony. The name also suggests links with the primitive or the pagan which, besides being associated negatively with superstitious and "backwards" people, is again another Vietnam-linked image observed by Aufderheide in films produced in the 1980s, specifically, *Rambo*. The character of Rambo is described as a "superguerrilla (part Indian, part German, he is thus part 'primitive', part supercivilized)" (Aufderheide, 1990, p. 106). As we will see, the comic book hero of this story will likewise adopt this hybrid "civilized/savage" persona.

A key symbol in the story is the sniper's symbolic "totem" which he kisses before he pulls the trigger. Again, it is meant to reinforce his dark and pagan nature. But the symbol has other meanings for Marvel readers as well. At first the monkey skull is confusing, bearing a striking resemblance to the symbol that is associated with the superhero version of the Punisher. Readers may believe at this point in the story that the villain's use of the symbol is ironic, in that the Monkey, obviously not familiar with the Marvel universe in which he now lives, is unaware that, in Marvel's continuity, the symbol will eventually be used by an American character (and, in fact, for years has already been a part of the Punisher's iconography for fans). Maybe, readers might wonder, there is a causal connection between the sniper's skull and the Punisher's later use of it? Maybe even the Punisher will steal the skull from the Monkey? As the comic's readers will no doubt be familiar with the Punisher, and will associate Castle with his superhero alter-ego, it seems unlikely that crass theft will occur; if not, however, what is the relationship between the Monkey's current symbol and the Punisher's later symbol?

In fact, at the end of the story, after killing the Monkey, Castle takes the totem. An obvious reading of this would be that Castle, having killed the Monkey, is entitled to take away a trophy from his victim. But the connection is deeper than this. In the context of the story, the conflict between the Monkey and Castle set the protagonist farther along the road to being the superhero known as the Punisher.

Earlier in the story, Castle, to emphasize his own savage nature (*noble savage*, as discussed below) and his dedication to defeating his enemy, paints a skull on his chest.

Thus, although the story promised "no capes," it was in fact another superhero story in the Punisher's canon: it was in part an origin story. The story has clear heroes and villains. The reader would not have been surprised to discover that Castle defeats the Monkey; he is after all still a superhero and an American. In this light, Castle is cast as more heroic and moral than his Viet Cong opponent. The Monkey worked alone, sacrificed his own men to protect himself, and is easily fooled and killed by an obvious trick set up by Castle. In contrast, Castle, admittedly in his pre-Punisher (and therefore less vicious) persona, works closely with his friend, shows remorse when his friend is killed, and displays cunning at every stage.

The Punisher story is different from the Captain America story in that the protagonist's superpowers are not needed to defeat the enemy. The story is also treated seriously, unlike the tongue-in-cheek flavor of the earlier Captain America story. And, as promised by Marvel's hype, nobody flies in the Castle story. However, the difference is only superficial, for even though Castle is not wearing his "cape," this means very little as he has been billed as the Punisher. More importantly, with the painting of his future-symbol on his chest, he ultimately *does* wear his superhero outfit, and with his taking of the totem *becomes* a superhero.

Interestingly, the portrayal of American superheroes defeating the Vietnamese represents a crude display of all-American patriotism and yet unwittingly admits that America could never have won the war, because ultimately its GIs could not magically fly, never wore capes, and did not have the unusual determination and cunning of the Punisher. Whatever the intentions, the introduction of the Punisher was obviously deemed to be a success because he featured again in a three-part story in issues 67 through 69 (1992, April–June).

The second appearance of the Punisher is a bit more critical of the Vietnam experience, although it still accepts the ideology of the rugged individualist American hero. The story is narrated by a soldier trying to keep his wounded buddy's spirits up by telling him about the "big guy named Castiglione" (a.k.a., the Punisher). The story begins with Castiglione's first days in Vietnam during which, despite

his "greenness," he quickly proves himself to be an excellent soldier. However, when he stumbles upon an American patrol unit which has been wiped out, he is confronted by his evidently corrupt superior officer who suggests that Castiglione will soon also be M.I.A. It is later revealed that the corrupt officer sells reluctant troops "g o home" tickets but is in actual fact sending them into a trap. Castiglione escapes this trap himself, killing the corrupt officer and losing his shirt but gaining a head band in the process, thus again, moving him closer to the persona of the Punisher.

The Punisher makes his way back to his camp where his warnings of an imminent invasion go unheeded and he soon discovers that the Commanding Officer was also part of the "go home" scam. When the camp is invaded, the Punisher strangles the C.O. before being seriously wounded and choppered out. The final part of the story shows Castiglione's recovery after which he tells his story to an uninterested colonel who callously sends him out "to die." However, the Punisher does not die and instead battles heroically to save his friends in many battles. The colonel is shot dead on the steps of a hotel in Saigon while the Punisher goes onto greater glory.

This story is surprising in that it deals quite graphically with the issue of corruption in the *American* army in Vietnam. Whether or not such a scam was ever used is not known, but the comic makes its point nevertheless, namely, that the war was not fought in black and white. However, the stories still portray the Vietnamese less than favorably, often drawing them in the shadows. They are also referred to as "little savages," though notably Castiglione is shown to respect them and reference is also made to the history of struggle in Vietnam.

Perhaps of greater importance, for Marvel at least, is the fact that the readers liked and heaped praise on the Punisher stories, unlike their previous criticisms of the Captain America issue. It is true that following the Imaginary Story issue, only four letters criticizing it were published, which would at first suggest that it was not all that unpopular. However, the tone of the editorial replies suggests that the story had received heavy criticism. The readers' criticism of issue no. 41 suggested disappointment with the issue and the readers' failure to take the story seriously. Despite the fact that the use of the Punisher represented little more than a thinly disguised way of giving the readers superhero story lines whether they wanted them or not, the

removal of explicit superpowers in the story seemed to convince readers that their opinions had been taken into account. Marvel, on the other hand, was able to have its cake and eat it too by having a gritty, non-powered superhero invade Vietnam.

Conclusion

Despite the changes in both the structure and story lines in *The 'Nam*, both of which have been documented here, and the reasons that lay behind those changes, there is little evidence to suggest that the underlying ideology of the comic, as reflected in its dominant themes, underwent any radical changes. The comic's portrayal of the war never strayed from the established revisionist path that dominated eighties popular cultural representations of the war regardless of whether or not the real-time format was adhered to. Certainly the use of superhero figures, notably Captain America, Thor, and Iron Man— but less so with the Punisher—detracted from the comic's goal and claims of realism. The way in which that "realism" was modeled, however, never shifted—the focus was always on American (super)heroes fighting a deceptive enemy. Only in issue no. 41 (Murray, 1990) did the enemy gain a recognizable face as Ho Chi Minh, but he was not a soldier and was spirited off to Paris for the peace talks. The comic's focus on the mundane routines of life in Vietnam continued throughout, and even Castle's stories showed his routines and procedures as a sniper. Even with the later non-superhero stories, the ideological focus on the lives of young American boys continued. Stories near the end of the run of the title allowed the reader to rejoin their favorite characters back in America. These in-cluded Joe Hallen and Ed Marks, two early characters who made repeat appearances in later issues. These later stories encouraged identification with central characters despite the comic's initial aims of "rotating" them out of the story after their tours ended.

Interestingly, despite its obvious pro-America rhetoric and ide-ology, *The 'Nam* never seems to be suggesting that America could have won the war in Vietnam. On the other hand it is also not suggesting that America was *wrong* to be in Vietnam. The introduction of superhero/human characters into the comic continued

this theme despite the successes those characters achieved. After all, it was clear to the readers that the ordinary GIs who represented the bulk of the characters were not superhuman and could not fly to Hanoi in order to apprehend Uncle Ho. And even though the Punisher appeared under his civilian name, Castle, he nevertheless represented an extraordinary individual with skills that were not to be found among the average grunt. The very nature of his job as a sniper and his mission of tracking down an equally "special" enemy singled him out as being "different."

In regard to arguments made concerning the (in)ability of comic books to present convincing cultural arguments or criticism, such as those put forward by both McAllister (1990) and Skidmore and Skidmore (1983), it is clear from this examination of *The 'Nam* that the comic was *reflecting* an established (and establishment) viewpoint rather than *criticizing* it. The comic did at least present potentially "difficult" issues such as Lt. Calley and anti-war protesters, for example, but they were either only as passing references or were quickly dismissed by a main character. An example of the latter rhetoric, as discussed earlier, was when the popular character, Ed Marks, presented the reader with arguments against the anti-war protesters in issue no. 15.

The decision to drop the real-time format of *The 'Nam* was based, it seems, on the need to attract more readers after a decline in sales; specifically, the need to attract a younger audience. As has been established, the editors made no prior mention of the forthcoming changes nor were the readers' opinions on the matter solicited. There was also a lack of comment (on the structural changes at least) after the event from both readers and the editorial team. This perhaps highlights the very nature of comic books in which readers see artist and writer changes especially as being more important than shifts in format. As the reader response to the introduction of Vansant had on the whole been favorable and there was no real outcry over the departure of Murray, it would seem to suggest a general acceptance by the readers of any changes deemed necessary by the editorial team. It may also suggest that the "realism" of the comic that so impressed the readers was a result more of the story lines and artwork than of the real-time narrative.

This examination of *The 'Nam* suggests that despite all of the

hype that had accompanied the introduction of the real-time structure, it was in fact secondary to the overall "realistic" feel of the comic. The praise that it received in readers' letters may have just been a reaction to the novelty value of the idea that eventually wore off, though as it had received nearly no criticism at all it still seems a strange decision to part from the comic's original selling point. Furthermore, even though the comic at first appeared to rely on the real-time structure to reinforce its ideological point of view, it has been shown that this was not the case. Other textual factors— including story lines, visual devices, and characterizations—established the ideology of *The 'Nam* much more definitively.

References

Aufderheide, P. (1990). Good soldiers. In M. C. Miller (Ed.) *Seeing through movies* (pp. 81–111). New York: Pantheon Books.

Chomsky, N. (1989). The United States and Indochina: Far from an aberration. *The Bulletin of Concerned Asian Scholars, 21*(2–4), 76–93.

Doug Murray. (1987). *Comics Interview, 53*, 6–19.

Dagilis, A. (1990, July). Uncle Sugar vs Uncle Charlie. *The Comics Journal, 136*, 62–84.

Hama, L. (1986, December). Incoming. *The 'Nam*, 1. New York: Marvel Enterprises.

Lee, S. (1970, May). Captured in Viet Nam. *Captain America, 1*(125). New York: Marvel Enterprises, Inc.

Lomax, D. (1992, December). Stateside tragedy: The My Lai massacre. *The 'Nam*, 75. New York: Marvel Enterprises.

Matton, A. (2000). Reader responses to Doug Murray's The 'Nam. *International Journal of Comic Art, 2*(1), 33–44.

McAllister, M. P. (1990). Cultural argument and organizational constraint in the comic book industry. *Journal of Communication, 40*(1), 55–71.

Murray, D. (1986, December). 'Nam: First patrol. *The 'Nam, 1*(1). New York: Marvel Enterprises.

Murray, D. (1987a, April). Humpin' the boonies. *The 'Nam, 1*(5). New York: Marvel Enterprises.

Murray, D. (1987b, June). Good old days. *The 'Nam, 1*(7). New York: Marvel Enterprises.

Murray, D. (1988a, January). 'Nam: First patrol. *The 'Nam, 1*(14). New York: Marvel Enterprises.

Murray, D. (1988b, February). Notes from the world. *The 'Nam, 1*(15). New York: Marvel Enterprises.

Murray, D. (1990, February). Back in the real world. *The 'Nam*, *1*(41). New York: Marvel Enterprises.

Murray, D., & Lobdell, S. (1992, December). Burn. *The 'Nam*, *1*(75). New York: Marvel Enterprises.

Reagan, R. (1989). *Speaking my mind: Selected speeches*. London: Hutchinson.

Sabin, R. (1993). *Adult comics: An introduction*. New York: Routledge.

Salick, R. (1991, January). The long sticks. *The 'Nam*, *1*(52). New York: Marvel Enterprises.

Skidmore, M. J., & Skidmore, J. (1983). More than mere fantasy: Political themes in contemporary comic books. *Journal of Popular Culture 17*(1), 83–92.

Solomon, C. (1987, May 12). Marvel sees a winner in 'Nam comics. *Los Angeles Times*, p. F1.

Span, P. (1986, September 10). Vietnam: The comic book war. *Washington Post*, p. B1.

Wright, B. (1993). In J. S. Olson (Ed.), *The Vietnam War: Handbook of the literature and research*. Westport, CN: Greenwood Press.

Chapter 8

Nostalgia, Myth, and Ideology: Visions of Superman at the End of the "American Century"

Ian Gordon

Then came, out of nowhere, nostalgia—including nostalgia for things the nostalgia lovers were too young to know.

—Friedrich, 1988, p. 72

It is perhaps self-evident that a comic book character that has been in existence for some 60 years owes some of its popularity to nostalgia. Certainly Otto Friedrich in his 1988 *Time* magazine celebration of Superman's 50 years could find no better reason to explain the resurgence of the character's popularity in the late 1970s. But nostalgia never comes out of nowhere.

In the common usage of "nostalgia," many Americans, and indeed others, probably have some wistful memories of Superman, whether from the character's portrayal as a comic book, radio show, comic strip, movie serial, television show, or movie superhero. Some might well have a sentimental yearning for the period in which they first encountered Superman, but few, I venture, would think of themselves as suffering from the disease of homesickness in their thoughts about the character. Labeling the nostalgia for Superman as ideological might suggest a too-easy criticism along the lines of the old joke that Superman, standing for truth and justice on the one hand and the American way on the other, was surely an oxymoron. Nonetheless the nostalgia associated with Superman operates at a number of levels that can be usefully explored to understand the operation of nostalgia as ideology.

There are two facets to the argument that follows. First, I want to argue that Superman connects a wistful nostalgia—nostalgia as

homesickness if you will—to a commodity, and in this fashion subjects both longings for the past, and the past itself, to the ideology of the market in which everything can be commodified and sold. Second, since World War II Superman's owners have explicitly tied the character to "the American Way," which is an ideological construct that among other things unites two seemingly disparate values—individualism and consumerism—with democracy and labels it American. Nostalgia about the character then is inevitably linked to this notion of America, which gives it a particular ideological cast, possibly more so when the subject of longings is not an American.

Nostalgia and Ideology

The manner in which I use nostalgia and ideology owes much to Clifford Geertz. The heart of the problem is in understanding how "ideologies transform sentiment into significance" (Geertz, 1973, p. 207). Geertz tries to understand this process by examining the stories people tell to and about themselves. Before turning to such tales, some working definition of nostalgia is necessary. During James Cook's extended voyage in the South Pacific from 1768 to 1771, the men on board his ship developed an acute longing for home, which the ship's surgeon named as a new disease: nostalgia. The term has been much expanded on since, but still retains the notion of a longing for return, a return to a past, to a past that we can never go back to, just as we can never truly return home once having left. In reviewing the widespread critique of nostalgia in the 1960s and 1970s, Christopher Lasch (1984) argued that what is often erased from such evaluations is that while we may not be able to return home, we also carry that home with us in ways that are inescapable. It shapes our present. But, he argued, both nostalgia and anti-nostalgia denied a dependence on the past in daily life, the first by romanticizing the past and the second by demanding life be lived in the here and now. It is also well to remember that Cook's sailors were on a long and difficult voyage in waters dangerous to Europeans, and that a longing for home, far from being pathological, may well have been eminently sensible.

Some theorists have sought to expand the concept of nostalgia beyond the limitations and oppositions Lasch identified. The anthro-

pologist Renato Rosaldo has observed that even as "we valorize innovation" we "yearn for more stable worlds, whether these reside in our own past, in other cultures, or in the conflation of the two" (Rosaldo, 1989, p. 108). Stuart Tannock made the distinction that nostalgia looks to "the past as a stable source of value and meaning" but not necessarily "with the desire for a stable, traditional, and hierarchized society" (1995, p. 455). Concepts of nostalgia have also been used to explain the shaping and performing of postmodern identities in a play of difference and repetition (Frow, 1997, p. 68). This notion has been stretched in a manner whereby nostalgia is linked to the performance of identity as a set of memory structures or grammar through which individuals "invent rhetorical performances of themselves" (Dickinson, 1997, p. 2). Susan Stewart argues nostalgia relies on the process of creating a narrative of the past, which in affect denies the present, and gives the past the whiff of authenticity. This sense of authentic comes from the narrative rather than any *a priori* veracity (Stewart, 1984, p. 23). In effect nostalgia is a construction that also denies the past except as narrative mediation. By examining a narrative then it should be possible to locate the transformation of nostalgic sentiment into significance.

The popularity in Australia in 1994 of the television series *Lois & Clark (The New Adventures of Superman)* sparked my initial interest in nostalgia as ideology. In 1994, *Lois & Clark* was a surprise hit in Australia, particularly given that its popularity in the United States was fairly marginal (it ranked third behind CBS and NBC during its September 12, 1993 network Sunday-night debut on ABC, for instance). In Australia it consistently ranked in the top 10 shows, beating the Ten Network's Commonwealth Games (a sports feast ranking second only to the Olympics) coverage in the ratings, and was poached by the Nine Network from the Seven Network. It would be easy to see the many incarnations of Superman, including this version, simply as a product marketed in different fashions, but the creators of Superman know that it carries meanings beyond its status as a commodity. For instance, Jenette Kahn, president of DC Comics, described Superman in 1983 as "the first god of a new mythology" (Harris, 1990, p. 236). *Lois & Clark's* appeal lay in the way it reworked familiar characters in contemporary settings, which to me relied on a sense of nostalgia.

Mythology

Otto Friedrich asserted in 1988 that it is "one of the odd paradoxes about Superman...that while he is a hero of nostalgia, the constant changes in his character keep destroying the qualities that make him an object of nostalgia" (Friedrich, 1988, p. 74). But those changes contribute to the nostalgia about Superman, because the character operates in a mythological dimension, which gives it a form of consistency at a symbolic level. The symbolic resonance of Superman is important in uniting diverse forms, including versions to be discussed later in this chapter as well as the comic book "imaginary tales," which are not held to be part of the main narrative of the Superman comic books but are a sort of apocrypha that further enhances the character's mythological dimension.

Umberto Eco described Superman in a 1972 article as a mythological virtuous archetype locked in a timeless state and thereby never fully consumed by his audience (Eco, 1972). That is, Superman offers infinite possibilities for storytelling focused on virtue, but Superman's virtue is limited and the character's dimensions set by the prevailing social order. Eco's Superman then acts as an instructive tool for what passes as virtue in society, and Superman's popularity at any given time is probably in direct relationship to his creators' success in capturing a dominant mood. In effect, Superman is a product by which we consume virtue. Here it is also worth keeping in mind Claude Levi-Strauss's notion that myth recycles earlier versions of the myth as part of its status (Levi-Strauss, 1968).

Eco's explanation of Superman's status remains convincing because it explains the popularity of different versions of Superman and it touches on the character's position as a consumer durable. Among the numerous earlier incarnations of Superman, four stand out as touchstones in the hero's career. In each version Superman displayed a virtue tied explicitly to his time and locale. The original Superman, who made his debut in *Action Comics* in 1938, molded the entire legend, but in a way that was substantially altered by the second version, which took shape during World War II and tied the character to America's fortunes. Although numerous other versions, including a movie serial and a radio show, intervened between the comic book versions of Superman and the 1950s television show, the TV show is an important third version of Superman because it introduced many of the baby-boomer generation to

the hero. It also introduced the important new medium of television to the character's presentation, a medium that continues to influence the portrayal of Superman. The first two entries in the motion picture series starring Christopher Reeves represent a fourth version of Superman, in this case involving both blockbuster action hero and sexually liberated man. Alongside *Lois & Clark,* important later versions of Superman have appeared in two comic book series: *Superman: The Man of Steel* (1986) and *Kingdom Come* (1997). These last three versions have all had to deal in their own way with the character's history. Whether or not one of these versions, or a mixture of parts of these versions, will coalesce into a hallmark of a particular era of the Superman character is not yet clear. The ebbs and flows of the character's development become clearer with the passing of time and the contextualization that history offers.

From the New Deal to the American Way

Both Andrae (1987) and Gordon (1998) have shown that the Superman of the first two years of *Action Comic* was somewhat of a reformist liberal, albeit one given to direct action. In his early years Superman saved a woman mistakenly condemned for murder, confronted a wife beater, prevented the United States from becoming embroiled in a European conflict, destroyed slums to force the government to build better housing (if one considers modern high-rise apartment blocks of the type built for the poor an improvement), tore down a car factory because its shoddy products caused deaths, and fought a corrupt police force. In this version, Superman's virtue was tied to Franklin Roosevelt's New Deal politics, America's 1930s isolationism, and the reality of life in Cleveland where his creators Jerry Siegel and Joe Shuster lived. This somewhat anarchic Superman captured an audience of young fans who probably reveled in his short-cut solutions to social problems and defiance of conventional authority. But this Superman was short-lived.

Beginning in the latter half of 1940, Superman was transformed into a symbol of more general American cultural values in that his individualism was tied to consumerist values. Superman's metamorphosis resulted from the confluence of a morality campaign directed at comic books, Superman's increasing commercial value, and the advent of a heightened patriotism with the growing realization that America would

be drawn into the European war. Toward the end of 1940, Superman's publishers, DC Comics, instituted an advisory board of psychologists and child educators in response to a public campaign and legislation against comic books that transgressed public morals. New guidelines for Superman stories prohibited—among other things—the destruction of private property. At the same time Superman himself had become an important piece of private property. DC Comics licensed numerous Superman products, generating over a million dollars of profit in 1940 (Gaines, 1991, passim; Gordon, 1998, pp. 135–137; Kobler, 1941, p. 76).

At first the relationship between the creators of Superman and the commercialism of Superman was strained. DC Comics had purchased all rights to Superman from Siegel and Shuster for $100. Unhappy with their loss of revenue and critical of the company's treatment of them, Siegel and Shuster got a measure of revenge by creating a bitter parody of the marketing of Superman products. In their story, Nick Williams, a shoddy businessman, steals Superman's name to sell a range of goods including bathing suits and automobiles (Siegel & Shuster, 1938). However, by 1941, Siegel and Shuster had negotiated a better deal with DC, probably as part of their arrangement to produce the new comic strip version, whereby they received 5% of all Superman royalties. (Gordon, 1998, p. 135). Thereafter, their Superman stories began to contain plugs for the various products (Siegel & Shuster, 1941).

Myth Making

The commercialization of Superman was in part responsible for the character becoming an American icon. On America's entry into World War II, the defense of the "American Way of Life," which posited the promise of consumer choice in a market of goods as the basis of a democratic society, became an important cry to rally the troops. Countless advertisements sought to mobilize the nation for war by directing consumption into appropriate expenditures that would ensure victory and lay the basis for a post-war democracy of goods. Both the government and advertisers depicted the war as a test of national resolve to curtail expectations to defend and ensure a way of life. Superman with his new respect for authority, his anarchic youthful past, and his iconization as a commodity represented that way of life. The U.S. Army recognized

Superman's importance in 1943 and distributed 100,000 copies of the comic book to overseas troops every other month until late 1944, when the practice was discontinued because the comic book was readily available through Post Exchange stores. Shortly after the end of the war, the Superman line of comic books averaged monthly sales of 8,500,000 (Gordon, 1998, p. 149).

Subsequent versions of the character demonstrated this shift of character from iconoclast individualistic liberal reformer to mainstream liberal organizational man. From time to time the producers of Superman found it necessary to address how the commodification of Superman is situated in the Superman mythology. For instance, in the first season of *Lois & Clark,* an episode played with Superman's history as a commodity and drew in part on the 1938 Siegel & Shuster story. In the episode, Clark/Superman struggled to find his true self as his fame resulted in numerous Superman products such as dolls and soft drinks. An agent, straight out of vaudeville, approached Superman with commercial endorsement offers including one to go to Cleveland—an in-joke recognizable to those aware that Jerry Siegel and Joe Shuster created Superman while teenagers living in Cleveland. Eventually Clark/ Superman decided that he controlled his own destiny and no manner of commercial product would affect his true self. Nonetheless he agreed to the licensing of his name provided that the profits went to charity.

The different plot devices in the two similar tales highlight an important difference between the 1938 Superman and the 1990s Superman. In the 1938 story the plot is driven by the shoddy business practices of Nick Williams, who seeks to commercialize Superman for his own benefit. The similarity between Siegel and Shuster's loss of their property rights to DC Comics, and Superman's difficulty in controlling the use of his name, makes the story a critique of business practices and a satire of commercialization. The *Lois & Clark* episode suggested that the producers recognized they must acknowledge, in some way, Superman's status as a commodity. The story is not about commercialization (that is a given) but about a character's true self. The story suggests that we need not be affected by the commodification of everything if we remain true to ourselves. This resolution of the problems of Superman's commercialization was inevitable given that the show was produced by Warner Brothers Television, part of the media conglomerate that acquired DC comics and thereby the Superman trademark in the late 1960s for their

licensing value. The outcome also stresses the role of individual over social forces in producing character, in the moral sense, thereby affirming Superman's adherence to individualism, another tenet of the American way. Moreover, the *Lois & Clark* episode retells a story from Superman's history in such a way that the concept of virtue is transformed from a rejection of commercialization to the preservation of individualism. Beyond the issue of commercialization, *Lois & Clark*, and its popularity in Australia, suggests new ways of examining the link between nostalgia, mythology, and commodification.

Probably most Australian viewers of *Lois & Clark* first saw Superman either in the 1950s television show or in the movies starring Christopher Reeve. The television Superman of the 1950s replicated the themes of the World War II comic book Superman and literally wrapped the character in the stars and stripes in the show's opening credits. The show appealed to its primary audience of children, in most part because they shared the secret of Superman's dual identity as Clark Kent. Although Lois Lane had her suspicions, in general she and the show's other adult characters were too slow-witted or blinded by their own preconceptions to recognize Clark and Superman as one and the same. This identification was reinforced by Clark's constant winking asides to the audience. For children, this Superman's most obvious virtue lay in his treatment of them as equals to the exclusion of adults. The undercurrent of attraction and tension between Superman and Lois Lane heightened the sense of audience superiority because we, unlike Lois, knew she already had the regular contact with Superman, albeit in the guise of Clark Kent, that she desired.

For baby-boomer Australians, the 1950s Superman television show provided one of the first contacts with the new medium. If my own experience is anything to go by, the show also acted as a minor flash point in a generational conflict. My parents at best tolerated Superman as the unfortunate but inevitable dross that came with the new medium. For me the show was an escape from the more traditionally educational BBC-derived children's programming. American programs like Superman offered a glimpse of a different society and yet one seemingly in reach of Australians. Superman was *my* show as opposed to my parents' show.

Such anecdotes are the narratives on which nostalgia is often built. That Superman is invoked in anecdotes of childhood adds to the

commodity value of Superman as brand name. These sort of narratives may be intensely personal, but the sentiment embedded in them gains significance not only in the repetition of the story but also at a material level when the creators of the narratives live out those sentiments by watching a television show, collecting comic books, or seeing the latest movie.

Let me then add some other anecdotes. A colleague of mine at the University of Southern Queensland remarked that his father, a politicized working-class unionist, had watched the 1950s television Superman and read it through a resistance practice as a satire. For him the show stood for all of the excessive claims America made about itself. An old friend of mine, an art theorist at the Queensland University of Technology, told me that she had not watched the recent *Lois & Clark* series or the 1950s show but had avidly read Superman comics as a child (in the early 1960s) and had seen the movies. A more senior colleague from the University of New South Wales told me that his first contact with the character was through an Australian radio serial in the 1950s, with Leonard Teale, a well-known local actor, as Superman. Likewise, in an account of her Indian childhood the writer Anita Desai cites Superman comic books as an indicator of the diversity of "Anglo-Indian" culture (Desai, 2000). These are very different memories than mine about the character and probably all tinged with a sense of nostalgia. It is important to note, however, that they suggest ways in which the myth can contain different aspects and versions of itself. Such memories also demonstrate how a figure such as Superman can transcend the culture of its creation and become embedded in another.

If baby-boomers remembered Superman fondly and claimed him as their own, the movie version of the late 1970s and early 1980s gave them a chance to relive those memories and introduce their children to the character. The movie Superman retained the essential characteristics of the hero with one important addition. The sexual tension and attraction between Superman and Lois formed an important element of the movies. Most notably, in the second movie Lois and Superman had sexual inter-course, although this required Superman losing, temporarily as it turned out, his super powers. For baby boomers, Superman and Lois Lane's sexual liaison repositioned Superman as a hero of his times. Superman gave up his powers for a sexual relationship, and at the same time fulfilled the fantasy of many fans. But ultimately Superman's destiny is

to be super, and so he sacrificed his relationship with Lois to regain his powers and save the world. When he reassumed his Superman status, Lois forgot about their relationship. These incidents took place in the second of the movies. The third in the series had a less serious tone, being closer in feel to the camp 1960s Batman television series. The fourth, released in 1985, took a high moral ground on nuclear weapons and met with a lukewarm reception.

Nostalgic Renderings

Having traced these incarnations of Superman, I want to point to an intersection between mythologizing and nostalgia in the movie and recent television versions of Superman. Mythology allows the hero to appear in different guises and forms and yet remain the hero. Nostalgia contains a sense of loss. So in this particular intersection while the hero is still present, something has been lost. The Superman movies of the early 1980s gave us a symbol from many of our childhoods in a form that legitimized the sexual revolution of the 1960s and 1970s. The sexual congress of Lois and Clark represented no loss of virtue and indeed helped remake and legitimize our concepts of virtue. At the very least, both the sexual revolution and a sexualized Superman represented a destabilization of an established order. Perhaps in the versions of Superman the mythical figure provides the sense of stability and continuity that we nostalgically long for, but the refiguring of the myth allows for human agency on behalf of the character's creators.

The version of Superman displayed in *Lois & Clark* embodies all the above-mentioned versions of Superman. For instance, the series recalls the 1950s television series in numerous ways, including the ongoing sparring between Perry White and Jimmy Olsen, but most notably the inclusion, albeit briefly, of Police Inspector Henderson, a character unsighted in any other version of Superman. Most importantly the show's title indicates that if there is to be a relationship, it will be between Lois and Clark. The movie versions suggested that the only way Superman could consummate a sexual relationship with Lois was to forgo his powers, a non-super Superman being the embodiment of Clark Kent. In the movies Clark was somewhat foppish and Superman, well, a super man. In *Lois & Clark,* Clark is a sensitive young man, but by no means a

fop. In the movies the relationship between Superman and Lois threatened his superness, or, if you like, his manness. In the latest television series, Superman's manliness is strengthened and developed through his relationships with Lois and his parents. It is also worth noting that in *Lois & Clark* both the characters were identified as virgins, whereas in the movie versions Lois clearly had a past.

In *Lois & Clark* we can see nostalgia for aspects of the 1950s that were undermined by the sexual revolution. I believe the series allows us a glimpse of how nostalgia can reshape and redirect social values even if through highly commodified mythical forms. The exact way in which this nostalgia plays out and the values expressed through a form such as Superman comes back to human agency. It is not too outrageous to note that there is a world of difference between the 1938 comic book Superman and the 1994 television series Superman, and that that difference in some way can be explained by the difference between two Depression-era teenage boys Siegel and Shuster and the post-feminist women producers of *Lois & Clark*. Les Daniels, the more-or-less official historian of DC Comics, has commented that *Lois & Clark* was mostly about two good-looking people getting it on; a romance novel with pictures (Daniels, 1998, p. 173).

Lois & Clark then captured a certain audience for the Superman character. There are, however, other audiences, and while the superhero–comic-book-buying public may not be the mass audience it once was, having been whittled down to a limited group of adolescent males, comic books are still an important part of the Superman narrative. Since 1986 Superman has been reborn at least twice, and possibly thrice if an "imaginary tale" or an "elseworlds" story (as they are now known) is included, in comic books. In 1985, DC Comics initiated a "Crisis on Infinite Earths" series to celebrate its fiftieth anniversary and in part to give order to its vast array of characters. The outcome of the series wiped the slate clean, and all DC characters began anew.

In a six-part mini-series in 1986, writer/artist John Byrne retold the familiar tale of Superman's origin. His version owed something to the Superman movies that preceded it and laid the basis for the *Lois & Clark* television series that followed. Byrne touched on many of the major themes of Superman, including the commercialism associated with celebrity. In trimming away some of "the barnacles" that DC had attached to Superman, Byrne retained and expanded the role of adoptive parents

Martha and Jonathan Kent. In the final episode of the series, Byrne highlighted the immigrant status of Superman, who concludes that America/Earth "gave me all that I am" and "all that matters" (Byrne, 1986). Such a conclusion addressed Superman's history. Although the narrative begins again anew, it also recycles the past allowing the "all that I am" to include the many prior incarnations of the character.

In the introduction to the collected Ballatine Books edition of the series, Byrne wrote of his childhood memories of Superman. Born in England in 1950, Byrne first encountered the character in the 1950s television show and later in black-and-white comic book reprints. For Byrne it was a window into another world.

Byrne saw the task at hand in the series as recreating "Superman as a character more in tune with the needs of the modern comic book audience." He also hopes that his version of the character will inspire some to follow in his footsteps and discover a lifetime's work through the window (Byrne, 1988, n.p.). Byrne's nostalgia about his childhood encounter with Superman, the dreams it inspired, and his eventual arrival in the USA, by way of Canada, suggest that his Superman's "humanity" rests in Byrne's own journey. If that is the case then Byrne's vision of Superman rests on a version of America, or the America of the imagination, as a land of opportunity for immigrants. At the same time, though, Byrne presents Superman's sense of self as deriving from values instilled in him by his parents and a place: America/Kansas/Smallville. The Superman story then also embodies an ideology of assimilation. That this tale was originally sketched by two Jewish teens, Siegel and Shuster, perhaps adds a dimension to this feature, but the important point is how stories told and re-told retain their symbolic features. Superman demonstrates that being American is a state of mind achievable by adopting a set of values. The ideological dimensions of this are multi-variant. Such an ideology might shut off competing notions of what it is to be American, or it might open up a debate on what values are American. On another register, however, this aspect of Superman suggests to his non-U. S. readers that they too can be Americans if they so choose.

The second rebirth of Superman in comic books occurred, according to Les Daniels, as a direct result of DC Comics selling the ABC network on the idea of the *Lois & Clark* show (Daniels, 1998, p. 166). In 1990 the comic book version of Superman had been building to a wedding between Lois Lane and Clark Kent. DC decided to hold off the comic

book wedding to coincide with the television series version. Consequently the comic book writers, who were producing four separate comic book titles a month, had to develop a new storyline. The result was the infamous death of Superman in the January 1993 issue of *Superman*, which on the wave of media hype sold some six million copies, many to people who thought they were investing in a collector's item. Superman returned from the dead in a comic book with an October 1993 cover date, and the scheduled wedding eventually took place in late 1996 in both the comic book and the television versions. The hype over the "death" of Superman and the subsequent reaction to his rebirth helped cause a slump in the comic book market, with thousands of direct sale stores closing and revenues that had reached a billion dollars being cut in half (Brodie, 1996). Blaming a gullible press, Daniels suggests in his history of Superman that DC was not directly responsible for this hype, but nonetheless DC fed the demand by reprinting the comic book (Daniels, 1998, pp. 168–169). This crass commercialism may well have undercut the symbolic worth of Superman for the comic book audience, and explains in part the initial low audience numbers for the television show in the United States. In any case, the downturn in the comic book market saw publishers developing many new projects in an attempt to regain lost ground. One of these projects involved a third rebirth of Superman and a significant contribution to the character's mythology based on nostalgia.

The third rebirth occurred in *Kingdom Come*, a special series of four comic books in DC's Elseworlds series. As DC puts it: "In Elseworlds, heroes are taken from their usual settings and put into strange times and places—some that have existed or might have existed, and others that can't, couldn't or shouldn't exist" (*Kingdom Come*, 1997, verso title page). The story strengthened and enhanced the mythological dimensions of Superman by demonstrating the symbolic values at the character's core. The production values of the book, in which the art was painted rather than drawn and colored, indicated the audience and expectations DC had for the book. The series has been gathered together and published as a hardback complete with introduction and an "Apocrypha" section, which suggests that DC takes rather seriously its claims that Superman is a new god. In the superlative-laden introduction, Elliot S! (sic) Maggin writes: "This Is The Iliad...this is a story about truth obscured, justice deferred and the American way distorted in the hands

of petty semanticists." Here Maggin deliberately evokes the 1950s
television show and its phrase "truth, justice and the American way" to
stir memories of Superman. Maggin goes on to declare *Kingdom Come*, a
message of values and iconography to future generations. *Kingdom
Come*, as Maggin states explicitly, is about filling out the values
associated with Superman (Maggin, 1997, pp. 6–7).

The story presented in *Kingdom Come* is that of the hero in exile and
pretenders occupying his place. That Superman has imposed this exile on
himself and that the pretenders are also superheroes is but little matter in
the mythological dimensions of the story. But in the economy of comic
book production in which a glut of massively muscled gung-ho super-
heroes and villains (think of the Hulk on steroids) have challenged the
market strength of earlier generations of comic book heroes, this aspect
of the story can be viewed as yet another level of nostalgia for simple
times. In *Kingdom Come* an earlier generation of superheroes has retired,
dismayed by Superman abandoning his "never-ending battle." The use of
this phrase, also drawn from the 1950s television show and highlighted
in bold, drives home the message that the Superman of *Kingdom Come* is
an aged version of the 1950s character whose parents and wife have died
and who wears the mantle of his "humanity" heavily.

The hero returns from his exile, as inevitably he must in such
mythology. His return is triggered when an errant latter-day superhero
named Magog carelessly savages a super-powered opponent who, in
reaction, manages to attack and "split open" another hero, Captain Atom,
resulting in a nuclear explosion. This battle occurs in Kansas, and the
entire state becomes a nuclear wasteland as a result of the explosion. In
most workings of Superman's origins, Kansas is his boyhood home.
After the destruction of Kansas, the remaining superheroes lose all sense
of responsibility. The story's choral figure, a preacher, observes this state
of affairs, suggesting "now more than ever we need hope!" And then a
gust of wind and the words "Look!" "Up in the sky!"—words introduced
to the Superman mythos by the late 1930s radio serial—lead to a full-
page panel of Superman. But although he has returned, all is not well
because of the rage he contains, which is cued visually by the back-
ground of the red S on his costume being black instead of the usual
yellow. Humanity, represented by the United Nations Council, is not
altogether happy with this return and the realities of power it reveals.

The story builds to a conflict between humanity and superheroes.

Superman is deeply conflicted, but retains a moral code: he does not kill. In yet another piece of nostalgia, Superman reminds Batman of when they were the World's Finest team—a reference both to a DC comic that featured team adventures of the two and to their common humanity. When the United Nations seeks to restore order by destroying super humans, who despite Superman's presence threaten humanity through their conflicts, Superman seeks revenge on the UN but is quickly brought back to earth by a reminder of his humanity. In the denouement, Superman dons his Clark Kent glasses, which are not so much a disguise but a reminder of his humanity. In the epilogue, Superman and Wonder Woman announce to Batman that they want him to raise their soon-to-be-born child to ensure his humanity. And in the penultimate panel the three decide that he, or she, will be a "battler for Truth, Justice, and a New American Way."

This equation of the generalities of humanity with the specifics of America might at first seem a slippage brought on by the desire to play with the language of other versions of Superman. But nostalgia and the mythological dimensions of the character drive this desire. The sentiment is transformed into something of significance through the act of retelling the narrative. In this story the authors have strengthened Superman's trust in his humanity, but the very manner of telling the story has reduced humanity to "American." *Kingdom Come* then has the affect of closing off some of the possibilities offered by the nostalgic musings about Superman I recounted earlier in this essay. But of course this is just one version of the character.

Conclusion

Superman is a commodity, a registered trademark, which belongs to the Time Warner conglomerate. He is a product that must be sold to justify the investment in DC Comics. The Six Flags Theme Park's Superman ride that opened in March 1997 underscores the commodity status of the name. Advertised in the words of the 1950s television series, the ride is "faster than a speeding bullet," and "more powerful than a locomotive"—seemingly an outmoded metaphor until one realizes that the ride is literally more powerful, accelerating from zero to 100 miles per hour in 7 seconds and providing 6.5 seconds of weightlessness—but is con-

nected to the comic book character in name only. A new movie version of Superman—*Superman Reborn*—directed by Tim Burton with Nicholas Cage in the title role did not move beyond pre-production, but yet another version of the character was in development. In April 2000 DC Comics announced plans for Stan Lee, the long-time doyen of Marvel Comics, to produce a series of comics for DC under the title *Just Imagine Stan Lee Creating*, starting the lives of many characters, including Superman, from birth. The wire service release notes that Lee recently established his own media company, Stan Lee Media, "to extend his globally recognized brand name…to all niche markets of the global popular culture." The wire also notes that Branded Entertainment's Michael Uslan, a producer of Warners' Batman movies, initiated the project ("Superman and Batman Join Forces," 2000). Yet another television version of Superman was announced on September 19, 2000 by The WB Network, which placed a "Teenage Clark Kent Project" into development (Adalian & Schneider, 2000).

Superman demonstrates that aspects of our past can continually be reinvented and *re*-presented to us. That our nostalgia brings with it loaded stories is but one ideological aspect of this reinvention. By tying popular memory to marketable figures, nostalgia has become a way of owning the past. This past owes little to history and is in effect a disembodied commodity. Nostalgia has become the pleasure of consumption.

Note

I wish to acknowledge Brian Musgrove, Charles Shindo and my co-editors who read earlier versions of this chapter. My thanks to Philip Bell and Toni Ross who shared stories about Superman. David Ellison graciously took time away from his own research to present a panel with me at an Australian and New Zealand American Studies Association conference where I presented a much earlier version of this chapter. My thanks to him and the audience.

References

Adalian, J., & Schneider, M. (2000, September 25). Teen "Superman" skein flies to WB. *Variety*, p. 44.

Andrae, T. (1987). From menace to messiah: The history and historicity of Superman. In D. Lazere (Ed.), *American media and mass culture: Left perspectives* (pp. 124–138). Berkeley: University of California Press.

Brodie, I. (1996, November 20). A modern marvel. *The Australian*, p. 47.

Byrne, J. (1986, December). The haunting. *The Man of Steel, 1*(6). New York: DC Comics.

Byrne, J. (1988). Superman: A personal view. In *Superman: The man of steel* (n.p.). New York: Ballantine Books.

Daniels, L. (1998). *Superman: The complete history*. San Francisco: Chronicle Books.

Desai, A. (2000, May 28). The writing life. *Washington Post Book World*, p. 8.

Dickinson, G. (1997). Memories for sale: Nostalgia and the construction of identity in Old Pasadena. *Quarterly Journal of Speech, 83*(1), 1–27.

Eco, U. (1972). The myth of Superman. *Diacritics, 2*, 14–22.

Friedrich, O. (1988, March 14). Up, up and awaaay!!!: America's favorite hero turns 50, ever changing but indestructible. *Time*, pp. 66–73.

Frow, J. (1997). *Time and commodity culture*. Oxford: Clarendon Press.

Gaines, J. M. (1991). *Contested culture: The image, the voice, and the law*. Chapel Hill: University of North Carolina Press.

Geertz, C. (1973). *Interpretation of cultures: Selected essays*. New York: Basic Books.

Gordon, I. (1998). *Comic strips and consumer culture, 1890–1945*. Washington, DC: Smithsonian Institution Press.

Harris, N. (1990). *Cultural excursions: Marketing appetites and cultural tastes in modern America*. Chicago: University of Chicago Press.

Kobler, J. (1941, June 21). Up, up and away! The rise of Superman Inc. *Saturday Evening Post*, pp. 14–15, 70–78.

Lasch, C. (1984, November). The politics of nostalgia. *Harper's*, pp. 65–70.

Levi-Strauss, C. (1968). *Structural anthropology*. London: Allen Lane.

Maggin, E. S. (1997). Introduction. In M. Waid and A. Ross, *Kingdom Come*. New York: DC Comics.

Rosaldo, R. (1989, Spring). Imperialist nostalgia, *Representations, 26*, 107–122.

Siegel, J., & Shuster, J. (1938, November). Superman's phony manager. *Action Comics, 1*(6). New York; DC Comics.

Siegel, J., & Shuster, J. (1941, November). The city in the sky. *Action Comics, 1*(42). New York: DC Comics.

Stewart, S. (1984). *On longing: Narratives of the miniature, the gigantic, the souvenir, the collection*. Baltimore: Johns Hopkins University Press.

Superman and Batman join forces with arch-rival Stan Lee for the coolest collaboration on the history of comic books. (2000, April 12). *Business Wire*. Retrieved December 12, 2000, from LEXIS-NEXIS on-line database.

Tannock, S. (1995). Nostalgia critique. *Cultural Studies 9*(3), 453–464.

Waid, M., & Ross, A. (1997). *Kingdom come*. New York: DC Comics.

Chapter 9

Kevlar Armor, Heat-Seeking Bullets, and Social Order: A Mythological Reading of *Judge Dredd*

Matthew T. Althouse

On the irradiated remains of America's eastern seaboard, Mega-City One stands plagued by crime and fear. Within this post-World War III megalopolis, most of the 400 million residents are unemployed, because automation runs almost all of the city's essential functions. Thus, people face an insufferable amount of leisure time, which is often used for misconduct. Seemingly, half of the population is criminal, and they regularly riot over food shortages and unemployment, perform unsanctioned medical experiments on neighbors, and run amok in the streets. Throngs of mutant hillbillies, sociopaths, and violent hooligans are ready to shove the remains of war-torn humanity head over heels into anarchy.

The other half of Mega-City One's population lives in terror of city Judges, who are authorized to assess crime situations and to issue on-the-spot fines, jail terms, and death sentences. Amalgamations of police officers, judges, juries, and executioners, Judges receive 15 years of intensive training before active duty. They are either cloned from proven genetic stock, or, before the age of 5, they enter the Academy of Law where they learn quickly the fundamentals of law enforcement. If they fail during their rigorous training, Cadets are expelled (Butcher, 1995, p. 6). This kind of intensive training makes Judges unyielding, emotionless, and efficient in their pursuit of justice.

Of Mega-City One's 59,000 Judges, Joe Dredd is the most ruthless. As a cadet at the Academy of Law, Dredd excelled, graduating with top honors. Dredd, who was cloned from the DNA of the legendary Chief Justice Fargo, followed the rules of his Judge-Tutors so well and with

such stoicism that his fellow cadets called him "Old Stoney Face" (Butcher, 1995, p. 51). On the streets of the "Big Meg," Dredd lives up to the reputation of toughness earned in training. In the line of duty, he is credited with the execution of his own brother, the loss of his natural eyes to a vengeful mutant, and the determent of alien invaders. What is more, Dredd adheres strictly to the letter of the law, even when he is faced with bribery or with pleas for pity from those he prosecutes.

Such is the futuristic world of Mega-City One in *Judge Dredd*. Long before *Dredd* appeared on motion-picture screens in 1995, it was a newspaper comic strip printed in England's *Daily Star* beginning in 1981. Though the strip features fictitious stories, it resonated with its readers since Joe Dredd's first appearance in the comic book *2000 AD* in 1977. To describe the allure of the character, Barker (1997) calls Dredd a "sardonic antihero within stories which have a satirical twist" (p. 15). David Bishop, an editor for *2000 AD*, believes that Dredd's popularity may be attributed to the perspective on life the comic provides for readers. Bishop states, "There is a cynicism to *2000 AD* which is, if not uniquely British, then one that strikes a chord with British readers" (Didcock, 1996, p. 16).

Why does Dredd strike a chord with his many fans? I contend that the comic strip's form empowers readers of *Dredd* to symbolize their opinions of important public issues. Among these issues is the ideological debate concerning the rise of the British "new right" and the social implications of Margaret Thatcher's political policies during her reign as prime minister. To develop my argument, I divide the body of this essay into three parts. In the first section, I discuss the socio-political context in which *Dredd* was read and suggest how this context contributes to the potential for equivocal readings of mass-mediated texts. In the second section, I survey Roland Barthes' notion of myth, which describes how the veneer of signs in everyday life hides tacit assumptions and power relations in a society. In the third section of this essay, using Barthes' notion of myth as theoretical perspective, I provide a critical reading of *Judge Dredd*. With this reading, I explore how the comic strips invited debate about the "myth" of Thatcherism in England during the 1980s.

The "Dredded" Thatcher Years

In England, and around the world, Thatcher earned a reputation as the "Iron Lady" of politics. When she was elected prime minister in 1979, England had been suffering from economic decline. Oil prices increased, and Asian industrial competition diminished England's prominence in the global market. Further, the nation's welfare structure degenerated into a "dependency culture," which inhibited innovation and enterprise (Dutton, 1997, p. 119). Thus, Thatcher launched a wave of policies designed to restore the country to its dominant position among the nations of the world. Thatcher believed that this return to dominance hinged on an eradication of socialism and a restoration of classic market economics (Schostak, 1993, p. 183). In her words, Thatcher believed that change required a return to "the values when our country became great" (in Watkins, 1992, p. 38). With a relentless sense of purpose, Thatcher downsized state services, including housing and health-care programs, through privatization. She championed the acceptance of free-market capitalism and battled for the end of Soviet imperialism. Seemingly, support for Thatcher was strong. While Thatcher guided the nation through a tumultuous decade of economic restructuring, she became the first British prime minister in the twentieth century to serve three consecutive terms before resigning in 1990. However, beneath the veneer of support for Thatcher, discontent lurked.

Thatcher stirred controversy for at least two reasons. First, some citizens perceived her reforms as an unwanted moral crusade. In a speech presented in 1981, Thatcher told an audience, "What I am suggesting to you...is that even though there are religious minorities in Britain, most people would accept that we have a national way of life and that it is founded on Biblical principles" (in Thompson & Thompson, 1994, 239). Put differently, the prime minister expected the nation's citizens to accept social and economic principles of a secular Anglicanism rather than consensus-based government. In reaction to her moral stance, some citizens felt disdain toward what one might call moral elitism (Holmes, 1985, pp. 208–209). Second, many English citizens believed she implemented her reforms autocratically. About her leadership style, Thatcher once remarked, "I am a conviction politician. The Old Testament prophets did not say 'Brothers, I want consensus.' They said 'This is my faith...If you believe it too, then come with me'" (in Dutton, 1997, p.

110). Thatcher and members of Britain's "New Right" in the Conservative Party were skeptical of the ability of moderate policies to provide a remedy for the nation's problems. To correct the country's course during the late 1970s, Thatcher and her supporters believed that immediate and drastic change was necessary. Often, quick policy changes occurred despite public outcries. Summarizing the discontent of many citizens with Thatcher's approach to politics, Punter argued that individuality became unduly subordinate to Thatcher's quest for a new order (Punter, 1986, p. vii).

In light of the controversy surrounding Thatcher's reform effort, providing a critical reading of *Dredd* is an intriguing enterprise. Britain faced economic and social concerns, which Thatcher addressed with an austere reform effort; Mega-City One faced economic and social concerns, which Judges addressed with the dour enforcement of legal statutes. Given this parallel between fact and comic-strip fiction, it is tempting to argue that *Dredd* parodied Thatcherism. However, this assessment may be too simplistic. Because Mega-City One is full of ruthless criminals, Judges must enforce laws strictly to maintain order. Thus, Dredd's unyielding actions may be justifiable. Similarly, England faced a troublesome economic situation, and "shock therapy" was a viable means of correction. Thus, Thatcher took what some might call a defensible course of action. In this context of disagreement about reforms, how could one read *Dredd*?

The answer to such a question may rest with the various readers of the comic strips. With "hypodermic-needle" approaches to the study of mass media marginalized, many scholars suggest that equivocal readings of mass-mediated texts are possible. Croteau and Hoynes argue that audience members are active, rather than passive, readers. They write, "Producers construct complex media texts, often with a very clear idea of what they want to say, but this intended message is not simply dumped into the minds of passive audiences. Instead, audiences interpret the message, assigning meanings to its various components" (Croteau & Hoynes, 2000, p. 263). Similarly, Fiske (1986) contends that many publicly-favored, mass-mediated texts are necessarily polysemic. He claims that popular television texts may contain "multiple meanings" that feature "unresolved contradictions that the viewer can exploit in order to find within them structural similarities to his or her own social relations and identity" (p. 392). Thus, consumers of communication ascribe

meanings to messages that are unintended and sometimes unwanted by a text's author.

Such polysemic approaches to reading mass-mediated texts should be applied to the form of comic-art texts. About comics, Schmitt (1992) writes, "What little research has been done centers almost exclusively on issues of content rather than analyses of form" (p. 153). Put differently, he argues that scholars know that comics may be deconstructive, but they may profit from further investigations of the deconstructive mechanics of comics. In this essay, I examine *Judge Dredd* to explore the polysemic potential of comic-art texts. I do not separate form and content entirely, as the substance of the strip is inherently equivocal; after reading *Dredd*, one wonders who is worse, the fascist Dredd or the diabolical public with whom he must cope. However, I emphasize the form of comics that encourages readers to formulate their own ideas about public debates. With this perspective, it may be hypothesized that *Dredd* may be interpreted by readers from different points of view—the political right and political left—simultaneously.

Barthes' Myth

To examine the richness of comic-art texts, it is useful to consider Barthes' notion of myth. He defines myth as a special kind of connotative message that hides behind the thin veil of conventional language. Myth is a semiological metalanguage. In *Mythologies*, Barthes (1972) contends, "Mythical speech is made of a material which has already been worked on so as to make it suitable for communication" (p. 110). However, beyond a message's intended subject-object relationship, what Barthes calls a first-order semiological system, additional interpretations are possible in second-order semiological systems where myths about cultural conventions may be (re)interpreted. Put differently, on a first-order semiological level, comics may be read literally—as simple, fictional stories about fantastic places, people, and events. Moreover, when comics are interpreted as representations of existing social concerns, signifier and signified merge; comic strips and worldly events become a sign which may seem innocuous, free from implications beyond that which is apparent. *Judge Dredd* may appear to parallel the myth of Thatcher's vision and pursuit of a revitalized England. However,

to claim that readers of *Dredd* share denotations of comic texts related to Thatcherism is shortsighted, as readers of media texts may ascribe personal value to art on a second-order semiological level. Saying that a word or graphic mark holds a universal meaning implies that all people draw from the same reservoir of consciousness, which is not completely accurate (in Sontag, 1982, p. 212–213). Barthes' semiological perspective allows critics to speculate about how readers participate in the creation of meaning in relation to different cultural contexts and ideological perspectives. To appreciate how Barthes reads myths, one must more fully appreciate his distinction between first- and second-order semiological systems.

A first-order semiological system concerns the relationship between signifier and signified as they merge to create a sign. In this pyramidal process of creating meaning, a signifier is a form, a word or a graphic mark, that conveys an idea. The signified is the mental concept that fills the signifier with "substance." Together, these two components constitute a binary pair called a sign, a symptom or state of affairs, which represents the union of signifier and signified. For example, symbolically, a rose means nothing in its natural environment, as a rose is merely a flowering plant. However, the social usage of a rose makes it more than just a plant. Barthes notes that a rose, as a signifier, can be appropriated to carry meaning. In certain contexts, roses give physical form to the concept of passion, which is, in this instance, the signified. As this association between flower and feeling has gained social recognition, a sign emerged to create an amalgamation of form and content (Barthes, 1972, p. 113).

Second-order semiological systems account for multifaceted interpretations and subversions of first-order signs. In a second-order system, one finds the same tri-dimensional construction of meaning associated with first-order semiological systems. However, that which was a sign in the first system becomes a mere signifier in the second (Barthes, 1972, p. 114). Put differently, a second-order system becomes a form to convey unexpected, marginal connotations associated with the language-object relationship represented in the first-order system. For instance, in a first-order system, one may determine that a rose and the concept of passion merge to create a sign. In a second-order system, however, the "passionified rose" becomes a new signifier to carry new meanings. Therefore, one might see a rose as more than just an offering

of affection. With a second-order interpretation, one might see a rose cynically as a product of a capitalistic system in which people are "expected" to buy gifts, thus fueling an industry that preys on romance. Whatever the concept at hand might be, the point is that second-order systems invite interpretive possibilities out of which ironies, inflections, and contradictions of meaning develop.

The goal of the mythologist is to uncover unquestioned presumptions of myths in first-order semiological systems. The mythologist uses the principles of the second-order semiological system to expose the arbitrariness of first-order signification, to explain how dominant interpretations of ideas bolster hegemonic structures, and to suggest alternative representations of dominant interpretations. Often, myths appear "natural" and, in Barthes' words, they take "hold of everything, all aspects of the law, of morality, of aesthetics, of diplomacy" (Barthes, 1972, p. 148). Throughout *Mythologies*, Barthes examines assumptions inherent in myths. For example, Barthes ponders a photograph in a magazine of a black soldier wearing a French uniform. The black soldier is saluting, and his eyes, apparently, are focused on the nation's tricolor flag. Looking at this photograph, Barthes sees two images at the same time. The first image is the literal signifier—the shapes, colors, and images in the picture. The second image is the signified, an image which may be "read correctly" as a praising—or a defense—of the French empire. According to the dominant myth, all citizens serve faithfully without discrimination based on color or ethnicity within the empire (Lavers, 1982, pp. 109–110). This "proper" interpretation of the myth is what dominant members of French culture expect "ordinary" people to see. But what is the second-order interpretation of the picture in the magazine? Barthes might respond by stating, "The reader must decide." Accordingly, at the second-order level of semiological meaning, a reader can ascribe to a given text a wide range of connotations that may be on the political right, on the political left, or on ground anywhere in between.

For a dynamic reading of myth that recognizes a message's first-order intent as well as second-order subversions, Barthes makes a useful suggestion. He recommends examining the potential of the first-order sign to create connotations as a second-order signifier (Barthes, 1972, p. 128). It is Barthes' path I follow to examine the myth of Thatcher's quest to improve life in England, a quest that may be discerned in the texts of *Judge Dredd* comic strips.

Reading *Dredd*

To conduct the present study, I examined approximately 180 comic strips published in the *Daily Star* between 1981 and 1986, during some of the most vocal protests against Thatcher and before unemployment subsided in the late 1980s. Examination of the strips reveals three broad themes—unemployment, the suppression of freedom of expression, and the supremacy of the law—that serve as focal points of reading in the following analysis. Within each subsection, two goals are accomplished. First, I expound the political context of each theme. In addition to a general discussion of the given topic, I outline both liberal and conservative perspectives about the issue. Second, mythological readings of the *Dredd* strips reveal the potential for equivocal readings. After identifying first-order elements of representative strips, I provide second-order interpretations of strips based on both liberal and conservative perspectives. By providing two ideologically opposed readings, I am not suggesting these are the only possibilities for interpretation. However, I believe these readings suggest the wide-ranging potential for semiological equivocations for readers of *Judge Dredd*.

Unemployment

A few years before Thatcher assumed the role of a prime minister in the late 1970s, England faced a pressing need for change. As the nation's economic well-being declined, unemployment figures soared, which contributed to a rise in crime rates. According to Peden, 1973 marked the end of "the 'golden age' of sustained economic growth, full employment, and reasonably stable prices" (Peden, 1985, p. 206). Between 1974 and 1975, England's GDP dropped 3.5%, the first decline since 1946. Between 1979 and 1981, the GDP fell another 4.6% (p. 206), and manufacturing output diminished more than 15% (Young, 1989, p. 534). Consequently, almost 1.5 million jobs disappeared, which meant that unemployment rose from 5.3% in 1979 to 10.5% in 1981 (Peden, 1985, p. 207). By 1987, the British economy created new employment opportunities, but many people were still struggling to find work (Young, 1989, p. 534). As employment opportunities disappeared, crime rates reached an unprecedented level in 1981. Many transgressions during the

year may be attributed to riots, including labor protests. However, from 1980 to 1981, house burglary increased 20%, robbery soared 30%, and violent crimes rose 3% ("Crime Rates Peak," 1982).

Thatcher's role in mending Britain's unemployment situation might be described as a mixed blessing. On one hand, from a liberal perspective, Thatcher did little to allay citizens' anxieties. During England's difficult time of economic transition, her conservative government took an unusual approach in coping with public sentiments concerning the issue of unemployment. According to Young, "One of the successes of the Thatcherite enterprise consisted in re-educating the electorate not seriously to care about employment. The longer it lasted, the more it was accepted as a seemingly unalterable fact of life" (Young, 1989, p. 502). Put differently, the prime minister expected the nation to bear the fallout of reform. She expected working citizens to provide for the unemployed, to purchase more British-made products to stimulate economic growth, and to avoid demanding salary increases when output slowed (Thompson & Thompson, 1994, p. 241). At the same time, government cut costs. For instance, as unemployment rose, Thatcher limited welfare benefits to cut national expenses and to encourage recipients to seek work (Peden, 1985, p. 231). Accordingly, many liberal politicians and members of the British public reacted with contempt to Thatcher's strategy, which seemed insensitive to the unemployed.

However, from a conservative perspective, economic "shock therapy" and the related issue of unemployment were unavoidable. After World War II, the British government predicted the eventual success of economic socialism in Europe. Therefore, as the nation rebuilt its bomb-riddled cities, England restructured its economy with a moderated approach to collectivization. Initial gains in economic prosperity were encouraging, but the project of fostering socialism eventually led to costly inefficiency. By the late 1970s, the state-subsidized health industry employed 1,500,000 people—three times the number of personnel in the armed forces. Further, over half of the nation's manufacturing jobs were state subsidized (Letwin, 1992, p. 89). Against the backdrop of mismanaged socialism, the oil industry collapsed and Asian nations emerged as major players in the global marketplace (Minogue, 1987, p. xiii). Therefore, conservatives in the late 1970s and the early 1980s speculated that more workers might have lost their jobs, and the capital spent on programs such as welfare might not have gone into an economy

in need of investment and growth (Peden, 1985, p. 222). Thus, many supporters of Thatcher rationalized that the prime minister's decisions would create short-term suffering but would lead to a long-term solution.

In such a context of unemployment and economic uncertainty, it is no surprise that *Dredd* was well received by England's readers of comics. Like England, Mega-City One faces a bleak employment situation. More than 87% of the population lacks employment (Wagner, Grant, & Smith, 1990, p. 9) and job opportunities are scarce, though a small percentage of the population lives well. Members of the city's economic elite enjoy vacations in resorts orbiting the earth (p. 22) and enjoy luxury apartments equipped with computerized back-scratchers and anti-gravity environments (p. 26). However, the majority of citizens struggle to find basic necessities, including food (p. 58) and shelter (p. 57). Because an alarming number of citizens live in an atmosphere of hopelessness, which breeds discontent, criminal activity is rampant. Conceivably, many ambitious citizens might pull themselves free from the quagmire of poverty. However, conditions in the city limit their opportunities for advancement, and the lure of corruption is great.

In light of such dire circumstances in the comic strips, opponents of Thatcher may read *Dredd* and argue that discontent among the masses is understandable. A strip titled "Unemployment Riot" features Dredd and his fellow Judges as they cope with a horde of angry residents who are protesting unemployment rates. After flooding the crowd with "riot foam," a hardening agent used to detain unruly mobs, Dredd sentences the protestors to one year of hard labor. The crowd's response is far from expected. After hearing Dredd's verdict, they cheer, "Hard labor! Whoopee! We're going to work at last!" (p. 9). Apparently, many of the unemployed in Mega-City One aspire to work, but they must suffer the frustration of living in idle poverty. Citizens' poor conditions are also evident in "Moonz Boonz." Waiting in a lengthy line for scarce food rations, a man encounters a black marketeer peddling a can of Moonz Boonz, a food product, for the outrageous amount of 500 credits. Other starving citizens in line notice the boonz and fight for its possession. To quell the outbreak of violence, Dredd arrives and arrests the crowd of welfare recipients who receive the news with cheers. One man exclaims, "At least in jail, they gotta feed us" (p. 58).

Seemingly, these instances of poverty and desperation are unpardonable. In both "Unemployment Riot" and "Moonz Boonz," many

common citizens of Mega-City One are dressed in rags, and their faces are taut with hunger. Employment is so scarce that people will work willingly as living mannequins in storefront windows (Wagner et al., 1990, p. 110). In a technologically advanced city where a select few live in luxury, the masses could be helped with the proper distribution of resources, but poor conditions are pervasive. The comic-strip images of unemployment and dire economic circumstances resonate with the liberal contention that Thatcher failed to serve the public's interests well. Engrained in the prime minister's conservatism is the notion that politicians concern themselves only with long-term policy decisions, not with the day-to-day concerns of workers (Punter, 1986, p. 39).

Conservatives in Britain, however, might have read *Dredd* differently than liberals did. Certainly, conservatives could not disregard or belittle the horrendous conditions encountered by many characters in the world of *Judge Dredd*. However, they could question the motives of those seeking government aid. Mega-City One is full of malcontents who take advantage of the welfare system and who are portrayed artistically as inherently dubious. For example, Judge Dredd encounters one citizen, Brewster Peck, who claims to work as a "professional patient." Peck's goal is to seek medical attention for every ailment, even the slightest ache. When a hospital's robo-doctors determined that nothing was wrong with him and declined to treat him, Peck filed a complaint with Dredd. During his discussion with Dredd, the citizen explains his chosen vocation: "I guess I just like being treated for things" (p. 67).

Another *Judge Dredd* comic strip titled "BU" features a man accused of murdering a civil servant and taking the victim's job. According to the story, Chuck Plick, the alleged criminal, graduates from a city university with a "Bachelor of Unemployment" and is unable to find work as an unemployment administrator. At his commencement, Plick is seriously concerned about his prospects for work. His robo-teacher attempts to allay the graduate by stating, "With the unemployment situation the way it is, there won't be another opening for twenty-two years. You are also well qualified to be unemployed. I suggest you give it a try" (Wagner et al., 1990, p. 21). Unwilling to become one of the many without work, Plick murders an unemployment officer, purchases a face-change operation to make himself look like the officer, and takes the murdered officer's place in the work force.

In the *Dredd* strips, supporters of Thatcher may have seen images of

selfish, malevolent people who abuse privileges and break the law for their own personal interests and gains. With an unshaven face and imperfect teeth, Peck is slight in stature as Dredd towers over him. Moreover, the "professional patient" is willing to shoot himself in the head to be returned to a hospital. In the artistic representation of him and his actions, readers may see Peck as a man who is unscrupulous, willing to pilfer services unnecessarily. Though he is not as visually unappealing as Peck, Plick is also small in stature and is represented as unprincipled. For example, Plick seems unaffected by Dredd's indictment. As if he is callous and cold, he listens to the sentence without showing remorse. These images may reinforce the conservative notion that an elaborate unemployment system is not needed. Conservatives might argue that if people behaved appropriately, perhaps the need for welfare benefits would decrease.

Freedom of Expression

While citizens of England faced poor employment prospects during the 1980s, they also faced the issue of freedom of expression. As noted previously, Thatcher promoted quasi-religious values. Therefore, she expected citizens to adhere to high standards of behavior, and, consequently, her government regulated free speech. The prime minister's thoughts about the freedom of expression may be summarized in an address to a press association in 1988. In her speech, Thatcher advocated increasing the number of television channels because "the free movement and expression of ideas is guaranteed far better by numbers and variety than it ever can be by charters and specific statutes" (in Hetherington, 1989, pp. 290–291). Within the same address, however, the prime minister announced that she would endeavor to "protect our young people from some of the violence and pornography that they otherwise might see" (p. 291). Thatcher supported the freedom of expression as long as it was, in her opinion, morally proper. On her willingness to censure mass media, Thatcher took the moral high ground to justify her position. Thatcher once told a journalist, "I am in politics because of the conflict between good and evil, and I believe that good will triumph in the end" (in Young, 1989, p. 352).

Those associated with the nation's labor and liberal parties saw

Thatcher's approach to free speech as unjust. Though Thatcher claimed to support more choices in British mass media, change was sluggish and controlled. During the 1980s, the expansion of television channels progressed slowly, as costs slowed the implementation of satellite broadcasting. Thus, most viewers were limited to four television channels (Hetherington, 1989, p. 297). Moreover, Thatcher kept a close eye on the administration of the BBC. Between 1979 and 1988, of the 18 new appointments to upper management in the broadcasting company, 11 were presumed to be loyal to Thatcher and her Conservative Party (p. 301). In addition to issues germane to media, the prime minister's Employment Act of 1980 restricted picketing and, consequently, limited unions' ability to strike. Similarly, the Employment Act of 1982 banned political strikes and increased unions' financial liability in matters concerning "unlawful" industrial actions (Young, 1989, p. 353). Therefore, members of the Labor Party might have argued that the prime minister's quest for "good" was defined unfairly with her terms alone.

At the same time, Thatcher's censorship of mass media was applauded by conservative citizens of Britain who clung to Victorian values. Only a few decades before Thatcher's rise to power, religious principles were formally legislated, as evidenced by the 1944 Education Act, which required schools to instill a sense of Christianity in young adults and to encourage daily acts of worship (Martin, 1989, p. 332). During the cultural revolution of the 1960s, "permissiveness" displaced conventions associated with conservative values. This condition was characterized by, among other occurrences, the emergence of widespread drug abuse, the passage of the 1960 Betting and Gaming Act, and the relaxation of censorship laws (Punter, 1986, pp. 31–35). Events and legislative decisions such as these challenged Victorian assumptions about appropriate behaviors and self-expression. Consequently, the 1960s paved the way for what many in England called a "loss of morality." Therefore, many conservative citizens who aligned themselves with Thatcher and her Conservative Party welcomed restrictions on crass representations of sex, violence, and rudeness in Britain's media.

On the issue of free speech, *Judge Dredd* is ambiguous. Arguably, Dredd is a fascist. In many of the strips, he and his fellow officers enforce stern laws against speech and ideas deemed harmful to society. The Judges never explain "harm" caused to society during citizens' on-the-spot trials. Seemingly, rules and regulations concerning freedom of

expression were arbitrary because the need to maintain order in a violent city was a clear, though unspoken, assumption. Thus, to ensure peace, Judges punish citizens for expressing ideas contrary to established values. Even when citizens protest laudable causes, including the shortage of food (Wagner et al., 1990, p. 58), the excess of pollution in the "Black Atlantic" (p. 33), and the lack of snow during the Christmas season (p. 20), Judges are always ready to silence the public's criticisms. Are the Judges correct to limit the freedom of expression?

Certainly, in light of Thatcher's stance on the issue, political liberals in England would read *Judge Dredd* with disapproval because saying too much is a crime in Mega-City One. The strip titled "Loud Mouth" depicts a visitor from Texas City. Full of regional pride, the Texan likes nothing in his new surroundings, and he compares everything to his lone-star home. He proclaims loudly that in Texas City the buildings are bigger, the crimes are more violent, and the Judges are tougher than in Mega-City One. Dredd overhears the Texan's banter and deports the man who asks, "Wh-What's the charge?" Dredd replies, "Rubbing me the wrong way" (Wagner et al., 1990, p. 151). Similarly, in the comic strip titled "Punch and Judgey," Dredd swiftly silences editorial commentary from a puppet that looks like himself in a performance for children. The puppet, Judge Punch, hits other puppets—including one resembling a toddler—with stern sentences and an oversized boxing glove. Dredd views the performance's comedy with contempt. He stops the show to charge the puppeteer with "Encouraging violence against minors—5 years. Illegally portraying a Judge engaged in a criminal act—to wit, beating a baby. Unauthorized public performance—ten days." The lawman concludes, "Show's over kids—Mr. Punch is doin' time" (p. 163).

Judge Dredd and other guardians of Mega-City One demand conformity, which liberals in Britain might interpret as analogous to Thatcher's dogmatic tactics. In Mega-City One, citizens want the opportunity to express themselves but face stern resistance from city authorities. Smoking (Wagner et al., 1990, p. 10), watching unsanctioned videos in the privacy of one's own home (p. 178), and dressing burlesquely like Judges to perform in a rock-and-roll band (p. 46) are all subject to prosecution. The harm to society created by these activities is unclear, but Judges allow no forms of expression that run contrary to standards maintained by unseen moral forces.

However, conservatives in England may read differently, as

regulation and close monitoring of speech curb violence and crime in the *Judge Dredd* strips. A special division of Judges includes officers with paranormal mental powers. With their special abilities, the Psi-Judges make predictions about the potential for crime on the city's streets. In one instance, a Psi-Judge senses an impending disturbance at a bank and directs Dredd to the scene. Dredd arrives at the bank just as an armed robbery begins. Seeing the Judge approach, the thief exclaims, "Someone squealed!" Dredd replies stoically: "You've been found guilty of armed robbery. Anything you think may be used against you" (Figure 9.1). On another occasion, Dredd utilizes an "emotion machine" to convict a criminal. During a demonstration of the newly invented emotion machine, Dredd watches inventor Heath Rubix use the apparatus on an assistant. Rubix elicits a number of emotions from the subject, including happiness, hatred, and guilt. When guilt is summoned, Rubix's assistant begins a confession about a crime committed in his past. Hearing the man's disclosure, Dredd uses the machine to induce additional confessions. In the end, Dredd convicts the lab assistant with "14 charges, grand total 23 + years" (p. 100).

English conservatives, who suffered through the rise in crime rates and labor protests in the early 1980s, may interpret Dredd's actions favorably. Many in Mega-City One cannot express themselves without inciting violence. Fans, cheering for their favorite team at sporting events, create riots (Wagner et al., 1990, p. 15); editorial comments exchanged by passing strangers trigger major disturbances (p. 118); and a lottery winner's expression of glee provokes a mob of envious citizens who attempt to steal the winning ticket (p. 161). In *Dredd*, conservatives see the potential for violence associated with each openly expressed controversial opinion. Stern laws against the freedom of speech may not be ideal, but they may be the only way to maintain peace in a tumultuous city.

Supremacy of the Law

When Thatcher entered office, the issue of law and order was a serious matter for the British. Television and vivid newspaper reporting brought a wide range of atrocities into the public's homes. To many, such events as the Vietnam War, the Olympic massacre in Munich, and the rise of domestic crime served as a clear indication of an epidemic of violence.

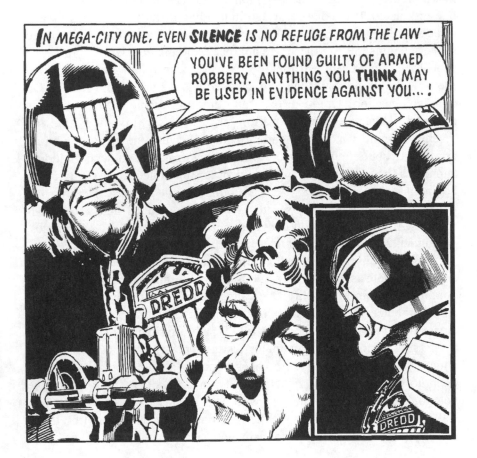

Figure 9.1. From Wagner, J., Grant, A., & Smith, R. (1990). *The Judge Dredd mega collection*. London: Fleetway, p. 38. © 1990 Fleetway Publications, Ltd.

Furthermore, many conservative citizens believed that a diminished sense of civility contributed to the decline of order. Jenkins explained this public perception by speculating that traditional means of conveying a sense of order disappeared. He argued, "It may be that relative prosperity, working mothers, changes in manners, and the general climate of opinion concerning freedom and authority had together resulted in the family becoming a less effective agency of control on behalf of society" (Jenkins, 1988, p. 74). Regardless of the reasons for the rise in crime rates, courts were flooded, unable to cope with the growing number of cases. Consequently, in 1983, some of England's leading experts in criminal law recommended abandoning the jury system in favor of judges empowered to issue sentences by themselves ("English Justice," 1983). In light of the nation's inability to cope with rising crime, Thatcher assumed the role of the nation's chief disciplinarian.

Though Thatcher believed that strong legal reform from above was necessary, many liberals resented the legal system's, and Thatcher's, growing powers. Under Thatcher's administration, a number of formidable alterations were made to the nation's legal codes. For example, the Interception of Communications Act of 1985 allowed authorities to tap phones during criminal investigations. The Police and Criminal Evidence Act of 1984 and the Prosecution of Offences Act of 1985 extended the powers of police officers dramatically (Zellick, 1989, pp. 278–280). What is more, Thatcher used heavy-handed tactics to spur reform. She often dismissed disagreeable cabinet members because, in her words, "there was a period when the Cabinet did not seem and, in fact, was not acting with collective responsibility" (in Kavanagh & Seldon, 1989, pp. 105–107). Because Thatcher was perceived as authoritarian and because her administration moved to pass laws quickly, Young (1989) called Thatcher's style as prime minister "leadership without delegation" (p. 118).

On the other hand, conservatives believed that a strong rule of law was necessary. In light of the growing potential for violent labor protests, mob violence, and terrorism, Thatcher campaigned on and underscored the issue of law enforcement. In a speech to the American Bar Association in 1985, Thatcher stated that a strong rule of law is needed to maintain order because the "crust of order over the fires of human appetite and the lust for naked power" is thin (in Thompson & Thompson, 1994, p. 261). In light of this perspective, Thatcher promoted laws, for

example, which allowed for police to stop and search citizens on the street, and she improved pay for police officers. As a result, prosecutions increased. In 1983, Britain's prisons held about 44,000 people in cells meant to hold 37,000 (Hewitt, 1983, p. 163). Though the effectiveness of Thatcher's actions was uncertain, some people's fears were assuaged by the fact that more criminals faced incarceration.

The resulting tension between the need for stronger laws and the perceived excesses of reform created a context in which *Dredd* could be read with great interest. Judge Dredd frequently barks at criminals his infamous line, "I am the Law," and these four words are not far from the truth. Legalism is supreme in Mega-City One, and statutes are enforced with reckless tactics. Demonstrating no compassion or leniency, Judges uphold laws to maintain order and conformity. Citizens are without recourse against the Judges' unfeeling verdicts, as the law enforcers issue binding, irrevocable decisions. Consequently, residents of the metropolis are without civil liberties and suffer innumerable invasions of privacy. However, violence in Mega-City One is pervasive and, therefore, strict law enforcement may be necessary. Does Dredd need to prosecute with reckless abandon? Or does the population of Mega-City One deserve improved treatment from the Judges?

Liberals may read *Dredd* with disagreement, as Mega-City One's Judges are legally all powerful. Because of the pervasive nature of criminal activity, the city's law officers are empowered to take an aggressive, proactive approach to law enforcement. The broad scope of their authority allows them to engage in "crime blitzes," routine searches of premises for "incriminating evidence" (Wagner et al., 1990, p. 88). Accordingly, Judges reserve the right to enter any home, business, or building without a warrant to search for signs of illegal conduct.

The Judges' rights are well illustrated in the strip titled "Wrongful Arrest" in which Dredd and a group of Judges burst into an apartment for an investigation. During his search of the premises, Dredd is radioed by a dispatcher who states: "Attention, Judge Dredd! Correction to that last message. Address should read 1114 Hi-Lo High Rise—not 1114 Hi-Lo Low Rise." Taking note of the incoming message, one of Dredd's associates realizes they entered the incorrect apartment and exclaims, "Looks like we've got the wrong man." To this statement, Dredd replies that there is no such thing as a "wrong man" and commands the officer to cite the citizen. Surprised, Dredd's fellow Judge asks, "For what?" Dredd an-

swers briskly, "How long have you been on the job? For whatever you can find!" Dredd's fellow Judge learns his lesson quickly and, after conducting a brief search, he asks the apartment's resident, "You got a permit for this goldfish?" (p. 159). In light of this treatment of a citizen, it is apparent that Judge Dredd believes that *all* inhabitants in Mega-City One hide some kind of misdeed.

In such strips, liberals may see that the alleged criminals committed no real, or serious, crimes. People are prosecuted because of Dredd's unfair assumptions about individuals. Occasionally, Dredd contemplates his relationship with the city's residents. After thwarting an armed robbery and coping with a deadly traffic incident, he reflects silently: "Yeah, one [criminal] under every stone. 400 million people in the city—each one a potential perp. It's my job to winkle 'em out and deal with 'em. To make the streets safe for decent citizens. If there is such a thing!" (p. 87). Judge Dredd believes that the law must be a paramount force, as citizens cannot discern what is good. Thus, Judges must adhere to the law, even when exceptions present themselves. Dredd's decisions may not be fair, but, in his words, "It's the law" (p. 12).

However, not everyone in England may see Dredd's actions as entirely inappropriate. In some cases, those with conservative values do not just see Dredd as necessary for an orderly society, they may even identify *with* the character of Judge Dredd rather than the citizens he terrorizes (Barker, 1997). For these readers, Mega-City One is a violent city and crime must be curbed, and Dredd is the man for the job. The supremacy of the law is illustrated in strips including "Sus-Animation." Here, Dredd tracks an escaped prisoner with infra-red technology. When ambushed by the criminal, the law officer defends himself, fatally wounding his attacker. With his last breaths, he tells Dredd, "You got me, Dredd, but at least you'll never get me back in that stinkin' iso-cube. Bullet hit my chest I'm dyin' for sure" (Wagner et al., 1990, p. 16). However, Dredd rushes the fugitive to "The Vaults," where criminals are frozen until cures for terminal injuries can be found. As the criminal is placed in suspended animation, Dredd thinks to himself, "Even death is no escape from the law" (Figure 9.2). In this case, not only is there one less criminal prowling Mega-City One, but the criminal is forced to take individual responsibility for his actions through the power of the law.

To such strips, conservatives may respond favorably because Mega-City One stands as an analogy for crime in England. On the streets of the

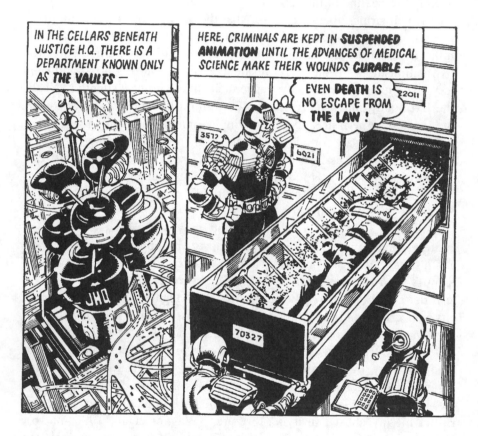

Figure 9.2. From Wagner, J., Grant, A., & Smith, R. (1990). *The Judge Dredd mega collection*. London: Fleetway, p. 16. © 1990 Fleetway Publications, Ltd.

megalopolis, Judges face a wide range of dangerous criminal activity, including wars between rival city blocks (Wagner et al., 1990, p. 53), professional thieves armed with disintegrators (p. 74), scientific experiments resulting in the deaths of innocent citizens (p. 86), and muggers who donate profits from their robberies to the "Victims of Muggers" charity (p. 94). In addition to hardened criminals' activities, many ordinary people engage in crime. For example, in response to violence and misconduct, common citizens band together in packs of vigilantes to thwart criminals. One vigilante justifies his actions by stating, "We're only trying to do what's right" (p. 92). However, Dredd replies by proclaiming: "There's only one law in this city. I AM THE LAW!" (p. 92). In the violent streets of Mega-City One, as in England, stern tactics are deemed imperative by the city's leaders. Otherwise, criminal activity may go unchecked.

Conclusion

At this point, it is useful to reflect on a question posed early in this essay: is the strip *Judge Dredd* far removed from the reality of everyday life? For Britains in the early 1980s, the answer is no. Citizens in the imaginary world of Mega-City One cope with a number of pressing issues germane to citizens of Thatcher's Britain. First, unemployment is rampant. Without jobs, citizens face and often succumb to the lure of illegal activities. Second, residents of Mega-City One are forced to limit their freedom of expression. Because of the pervasiveness of crime, Judges try to maintain order by demanding citizens' conformity. Consequently, people could not speak, act, and—in some cases—think freely. Third, law and order are paramount concerns for Judges. In Mega-City One, authorities assume that all people harbor criminal tendencies. Therefore, Judges enforce statutes rigorously. When reading *Dredd* and grasping these three themes, fans of strips could discern England's situation, which was paradoxical. Many scholars argue that radical reform was needed to mend England's economic woes. Thatcher, justifying some of her austere policies, is quoted often in relation to her famous acronym, "TINA," which means "There Is No Alternative" (Hasler, 1989, p. 3). However, it is also arguable that a minority of people in Great Britain supported the prime minister's free-market remedies

for the problems of extreme socialism (p. 42) and that many citizens believed that Thatcher's penchant for authoritarianism violated an implied social contract between the government and the public (p. 46).

Though Thatcher's legacy may still be in question, this study presents an important semiological perspective for future studies of comic strips and books. By demonstrating how readers co-author texts in relation to social exigencies, this study strives to contribute in at least two ways. First, it complements conventional approaches to the form of comic art. Well-known studies that examine the aesthetics of comics, including McCloud's (1993) fascinating *Understanding Comics* and Harvey's (1994) insightful, history-driven *The Art of Funnies*, emphasize the craft behind the art. Color, storytelling techniques, visual narratives, timing, speech bubbles, and similar concepts are all detailed. However, such studies do not explain how readers associate real-world political and social issues with their reading of texts. Second, the present study provides alternatives to singular readings of comic texts. For example, Inge discusses the popularity of comic strips in terms of satire. He claims that comics "soften the impact of reality by providing a comic distance on life's dangers, disasters, and tragedies" (Inge, 1990, p. 15). Reynolds writes that comics provide "substance to certain ideological myths about the society they address" (Reynolds, 1992, p. 74). That is, characters like Thor, a Norse god; Swamp Thing, a plant entity; or Silver Surfer, an alien, provide readers with unique perspectives on social issues. However, it is limiting to assume simply that comics give readers a buffer against reality or that comics give readers a certain perspective.

The study of myth looks beyond intended "substance" of a text to consider the implications and the social meanings that emerge from multiple and marginal interpretations. Because the study of myths invites equivocal readings of a text, it has obvious application in the realm of comics. Many comic strips may be read in relation to real-world events and, consequently, may mirror the myths embedded in a culture. However, comic strips are not meant to be read literally, as they are artistic expressions of fanciful stories. Therefore, comics possess a conspicuous aesthetic quality that may defy a uniform interpretation. About interpreting art, Kaplan writes that formalist readings fail "to give an account of the distinctive mode of signification in the arts" (in Weitz, 1970, p. 272) and fail as well to account for the chance that aesthetic experiences may differ from culture to culture and from subculture to subculture (p.

273).

Surber writes, "Barthes…insisted that signs must be recognized as polysemic, that is, capable of taking on various values or meanings depending on the various systems in which they almost always functioned" (Surber, 1998, p. 175). For Barthes, the text is considered a point of departure for readers to produce something unique, which is the case in the current study. *Judge Dredd* presents its readers with rich texts, full of subtleties and equivocations. Joe Dredd and his fellow Judges are cold, ruthless officers of the law; the citizens of Mega-City One exhibit criminal tendencies. Are the Judges of Mega-City One unnecessarily heartless? Was Thatcher wrong to advance her vision of a better England? In the controversial environment surrounding Thatcher's policy initiatives in the early 1980s, the answers to these questions may be as diverse as the readers of the Sunday funnies.

Note

The author thanks Tom St. Antoine at Palm Beach Atlantic College, Ken Zagacki at Louisiana State University, and this volume's editors for their assistance with this essay.

References

Barker, M. (1997). Taking the extreme case: Understanding a fascist fan of Judge Dredd. In D. Cartmell, I. Q. Hunter, H. Kaye, & I. Whelehan (Eds.), *Trash aesthetics: Popular culture and its audience*, (pp. 14–30). London: Pluto Press.

Barthes, R. (1972). *Mythologies*. New York: Hill & Wang.

Butcher, M. (1995). *The A-Z of Judge Dredd: The complete encyclopedia from Aaron Aardvark to Zachary Zziiz*. New York: St. Martin's Griffin.

Crime rates peak in Britain last year. (1982, October 22). *The Xinhua News Agency*. Retrieved December 9, 2000, from LEXIS-NEXIS on-line database (Item 102254).

Croteau, D., & Hoynes, W. (2000). *Media/society: Industries, images, and audiences* (2nd ed.). Thousand Oaks, CA: Pine Forge Press.

Didcock, B. (1996, July 6). Simply Dredd. *The Scotsman*, p. 16.

Dutton, D. (1997). *British politics since 1945* (2nd ed.). Malden, MA: Blackwell.

English justice—5; more crime, less justice. (1983, August 27). *The Economist*. p, 20.

Fiske, J. (1986). Television: Polysemy and popularity. *Critical Studies in Mass Communication, 3*(4), 391–408.

Harvey, R. (1994). *The art of the funnies: An aesthetic history.* Jackson, MS: University Press of Mississippi.

Hasler, S. (1989). *The battle for Britain: Thatcher and the new liberals.* London: I.B. Tauris.

Hetherington, A. (1989). The mass media. In D. Kavanagh & A. Seldon (Eds.), *The Thatcher effect* (pp. 290–304). Oxford: Clarendon Press.

Hewitt, P. (1983). The law. In J. Lansman & A. Meale (Eds.), *Beyond Thatcher: The real alternative.* London: Junction Books.

Holmes, M. (1985). *The first Thatcher government, 1979–1983.* Boulder, CO: Westview Press.

Inge, M. (1990). *Comics as culture.* Jackson, MS, and London: University Press of Mississippi.

Jenkins, P. (1988). *Mrs. Thatcher's revolution: The ending of the socialist era.* Cambridge, MA: Harvard University Press.

Kavanagh, D., & Seldon, A. (1989). *The Thatcher effect.* Oxford: Clarendon Press.

Lavers, A. (1982). *Roland Barthes: Structuralism and after.* Cambridge, MA: Harvard University Press.

Letwin, S. (1992). *The anatomy of Thatcherism.* London: Fontana.

Martin, D. (1989). The churches: Pink bishops and the iron lady. In D. Kavanagh & A. Seldon (Eds.), *The Thatcher effect* (pp. 330–342). Oxford: Clarendon Press.

McCloud, S. (1993). *Understanding comics: The invisible art.* New York: HarperCollins.

Minogue, K. (1987). Introduction: The context of Thatcherism. In K. Minogue & M. Biddiss (Eds.), *Thatcherism: Personality and politics,* New York: St. Martin's Press.

Peden, G. (1985). *British economic and social policy: Lloyd George to Margaret Thatcher.* Oxford: Philip Allan.

Punter, D. (1986). *Introduction to contemporary cultural studies.* New York and London: Longman.

Reynolds, R. (1992). *Super heroes: A modern mythology.* Jackson, MS: University of Mississippi Press.

Schmitt, R. (1992). Deconstructive comics. *Journal of Popular Culture, 25*(4), 153–161.

Schostak, J. (1993). *Dirty marks: The education of self, media, and popular culture.* Boulder: Pluto Press.

Sontag, S. (Ed.). (1982). *A Barthes reader.* New York; Hill & Wang.

Surber, J. (1998). *Culture and critique: An introduction to the critical discourses of cultural studies.* Boulder, CO: Westview Press.

Thompson, J. S., & Thompson, W. C. (1994). *Margaret Thatcher: Prime minister indomitable.* Boulder. CO: Westview Press.

Wagner, J., Grant, A., & Smith, R. (1990). *The Judge Dredd mega collection.* London: Fleetway.

Watkins, A. (1992). *A conservative coup: The fall of Margaret Thatcher* (2nd ed.). London: Gerald Duckworth.

Weitz, M. (1970). *Problems in aesthetics* (2nd ed.). New York: Macmillan.

Young, H. (1989). *The iron lady: A biography of Margaret Thatcher.* New York: Farrar Straus Giroux.

Zellick, G. (1989). The law. In D. Kavanagh & A. Seldon (Eds.), *The Thatcher effect*, (pp. 274–289). Oxford: Clarendon Press.

Chapter 10

Coming Out in Comic Books: Letter Columns, Readers, and Gay and Lesbian Characters

Morris E. Franklin III

Ellen DeGeneres' coming out as a lesbian, both personally and pro-fessionally as her TV persona of Ellen Morgan, marked a rare instance in the mainstream media. The "Puppy Episode" of *Ellen* boosted the ratings of the program for a time, earning *Ellen* a number-one spot for a week in May 1997 (Sweeping out the closet, 1997, p. 97). Several web sites were devoted to the show, and in particular to the lead character's ambiguous sexual identity (To Ellen and back, 1997, p. 63). During the 2000–2001 television season, NBC's *Will and Grace* and ABC's *Spin City* featured gay characters in leading and supporting roles.

While these programs received their share of press attention, they were not the first fictional portrayals of gay men and lesbians on prime time. A 1973 television movie, *That Certain Summer*, marked the first network portrayal of a gay man coming out. Proposed pro-grams with gay themes during the early 1980s were aborted or altered by the networks, but the latter half of the decade did see the appearance of several story lines about gay and lesbian issues and characters in network shows (Moritz, 1999, pp. 318–319). Despite these isolated portrayals, however, it seems that gay and lesbian char-acters and their audiences have been mostly ignored. In the words of Larry Gross, gays and lesbians are "narrowly and negatively stereo-typed," and ultimately, "symbolically annihilated" (Gross, 1995, p. 63). Television is not alone in this. Film has seen stereotypes such as the "predatory lesbian" as well as other essentializing characteriza-

tions (Sheldon, 1999, p. 303).

While much has been written about gays and lesbians in television and film studies, very little has been done in the area of comic books, a medium that predates widespread television use and traces its roots to pre-film industry years. Medhurst's (1991) "Batman, Deviance and Camp" is an interesting evaluation of the Batman mythos, for example, but the article focuses primarily on the television show from the 1960s. The piece does a wonderful job of detailing the camp pleasure derived from viewing the Batman television program and also addresses the vital need for more research into the audience's desires and interactions with mediated texts. For this chapter, I address areas that have gone largely untouched: the comic book audience and gay and lesbian characters. Before *Ellen, Spin City* and *Will and Grace,* gays and lesbians were coming out as ongoing, recurring characters in comic books. Between late 1988 and early 1993, mainstream comic books began to represent gay and lesbian characters at an unprecedented rate.[1]

I will discuss the representation of gay and lesbian characters in the comic book medium, readers' reaction to the representations, and editors' comments to and about the readers' reactions. The text through which I will explore this representation and discussion is the comic book itself, or more specifically, issues that deal with characters coming out as gay or lesbian. Letter columns, comic book versions of "Letters to the Editor," will provide access to readers' reactions on the specific coming-out issues, a difference from televised or filmic representations of gays and lesbians in which the audience's reactions are not part of the mediated presentation. In the case of comic books, the reader has the potential to move from a position as an isolated individual, separate from the text, to part of a discourse community in the form of a letter column; the reader's ideas become part of the textual product itself. In this way, comic books can serve in the stories they tell and in the discussions of those stories as epistemology, a way of knowing about particular subjects, ideas, and opinions.

Previous work (McAllister, 1992) has discussed how comic books provide knowledge about, and comment on, social issues and concerns by addressing the ability of comics to educate readers on AIDS.[2] Palumbo (1983) and Mondello (1976) have examined the character of Spider-Man as a representative, respectively, of the "existential"

and "liberal" superhero traditions. Similar work has been done with the patriotic superhero Captain America (MacDonald & MacDonald, 1976). More work on the process of how comics act as distributors of social knowledge is needed, given that much of the research on comics deals with aesthetic structures of the medium (Abbot, 1986; Harvey, 1979). As mentioned earlier, the discussion of readers' reactions to the medium has not been as extensively researched as other aspects of comics, though exceptions include Matton (2000), Pustz (1999), and Tankel and Murphy (1998). Of interest to this work is why people collect and read comic books, and how they form a community:

> ...the audience takes an active role in the direction and maintenance of the product. Through the letter pages and fan produced magazines, the fan is in the position to determine the direction of the plot...the readers...of comics converge symbolically as they share similar reactions to the dramas played out in the narrative... (Tankel & Murphy, 1998, p. 62)

It is this concept of readers that will be served in this project. Using specific gay and lesbian coming-out stories as examples of social knowledge, and then examining readers' and editors' responses to the stories and each others' comments, we attempt to fill this research gap.

The opinions of the people reading a particular comic book are placed within certain social boundaries. As Bennet writes: "[R]eading as an isolated silent activity can be put into historical context, and decisions about what to read...and how to read can be determined by social, religious or political restraints" (Bennet, 1995, p. 5). Characteristics of particular media and its production routines may, however, influence the reading process. The silence of readers as suggested by Bennet is broken by the use of letters columns, yet paradoxically maintained as editors select certain letters rather than print all letters received on a specific issue or topic. The letters columns make manifest the breaking of social restraints, while at the same time supporting them. Similarly, De Certeau points to the producers of a text and their ability to "inform." He writes: "The image of the 'public' is not usually made explicit. It is nonetheless implicit in the producers' claim to *inform* the population, that is, to 'give form' to social practices" (De Certeau, 1995, p. 151). In the instance of comic books, the producers are the writers, artists, and editors; the public is the body

of readers; and the comic book is the social practice made manifest.[3]

I argue that the letter columns in comic books, coupled with the nature of the medium, provide a unique way of thinking and writing about social issues. The history of the comic book medium also shows a distinct way of reflecting social trends and concurrent history. Comic books have consistently reflected the society from which they emerge, dealing with World War II, the "counterculture" of the 1960s, and other social issues. Even during the short period of time between 1988 and 1993, distinct changes in the manner of "outing," and in the way readers' reactions are handled and even presented, are apparent. Letters printed in letter columns are, of course, subject to editorial discretion and therefore "selected" under certain criteria. I will also speculate on the criteria used for letter selection.

As I will demonstrate, comic books continued a social reflection trend when the stories began to acknowledge issues not normally discussed in other media. In the case of mainstream comics, characters were coming out in 1988. The stories dealt with minor or supporting characters and showed a good deal of reader support for the revelations. By the early 1990s, however, the characters were more important to the story lines. Topics of gay and lesbian lifestyles also changed through the years, moving from discussions of prejudice and discrimination to the importance of role models and finally to gay politics and social history.

Along with the change in character status, presentation, and topics came a change in the response to gay and lesbian characters. The readers' responses in the early 1990s are both positive and negative, and the editorial responses are less neutral than in the 1988 issues. The overall presentation of "outing" itself had changed between 1988 and the early 1990s as well, with the revelation being much more obvious. There is also a "normalizing" quality to the presentations. Representation of gay and lesbian characters takes the general form of normal people, working normal jobs (at least in the superhero world), and leading relatively normal lives. Gay and lesbian characters are not portrayed as evil, deranged, or abnormal. At the same time, the relationships of gay and lesbian characters are generally compared against heterosexual relationships.

The texts selected were high-profile examples of coming-out stories in the comic book medium. Gay and lesbian characters had

appeared in other books prior to these, but these appearances were in independently published books, none of which answered to the Comics Code Seal of Approval.[4] During this time period, gays and lesbians became part of the mainstream comic book fabric alongside such flagship characters as Batman and Superman.

Support, Tolerance, and Normalizing: 1988

The year 1988 marks an interesting period for DC Comics because the company had several references to gay characters in their books. The responses are positive from readers, and the editors' responses to readers' letters are guarded. The gay and lesbian characters of 1988 have minor or supporting roles, or they are major characters in smaller anthology titles. These are not the company's flagship characters coming out, but rather "second-string" characters. The representation of homosexuality is also downplayed and subtle; there are no scenes, for example, of men kissing or women lying together in bed.

One such supporting character "outed" by DC Comics in 1988 was Metropolis Police Captain Maggie Sawyer, a minor character in the *Superman* family of books. In the story "Wings," Maggie asks Superman for help in locating her runaway daughter, Jamie. Maggie is convinced to seek the superhero's help by a woman named Toby, who appears to be a very close friend to Maggie, calling her "Babe" and holding her as she cries. It is never stated explicitly in the story, but the visual and verbal interplay between the two women indicates a lovers' relationship. This allows for inference on the reader's part rather than an overt reference to a lesbian relationship.

In a later conversation with Superman, there are more subtle references to Maggie's sexuality when she reveals the story of her marriage:

> I was...confused, in those days. There were things happening in my head that I'd been denying, for a long time...When Jim popped the question, I thought maybe that was what I'd been looking for...I was nearly thirty. I should've been coming to terms with myself...The only thing we had in common was the police force. At home, we fought all the time...I let myself get pregnant...a baby might save Jim an' me. For a little while I was right. Then the fighting started again. Pretty soon, Jim wasn't even coming home every night...That's when I finally started to come face to face with myself.

> With reality [Maggie is seen in the flashback walking away from another
> woman]...What was left of the marriage—which wasn't much—dissolved
> into mud, Jim's lawyers went after the baby, they said I wasn't a fit mother.
> The judge agreed with them. Jim was granted full custody. I knew an appeal
> would only drag on. Put my daughter through a hell she had not done
> anything to deserve...I came to Metropolis...built a whole new life for
> myself. (Byrne, 1988, pp. 9–10)

Nowhere in Maggie's reflection does she directly state "I got
divorced because I'm a lesbian." The indications are masked. Maggie
has long hair in her flashback scenes, but after she "come[s] face to
face with herself," the artist renders her hair shorter, stereotypically
categorizing lesbians as masculine (Mangels, 1988b, p. 52) (Figure
10.1). Nonetheless, the representation is generally sympathetic, not
judgmental. This is particularly evident in the thoughts and actions of
the title character of the book, Superman. He accepts Maggie for who
she is, even if we don't actually see him refer to her as a "lesbian."
Superman treats her as a person, not a category.

Reader reactions that were printed indicated enthusiasm for the
story, although the words "gay" or "lesbian" appeared nowhere in
the letters. Because editors select which letters will be printed, I cannot
attribute this to a blanket readership that failed to use those words or
to editorial censorship. Responses to Maggie's sexuality were just as
subtle as the references in the story:

> Maggie Sawyer's history made for surprising reading. Certainly a delicate
> subject but it was handled well, if mostly between the lines. (Carlin, 1988,
> n.p.)

Another reader writes:

> I'm proud to have a character...with as much depth as Maggie Sawyer! By
> showing us so much of Maggie's persona, you've really opened up the
> character. I have unending respect for her strength and courage. (Carlin,
> 1988, n.p.).

One reader comments on the subtle storytelling:

> I like the understatement....It takes more talent to gracefully reveal
> Maggie's lifestyle (and the price she pays for it) than to shout it. (Carlin,
> 1988, n.p.)

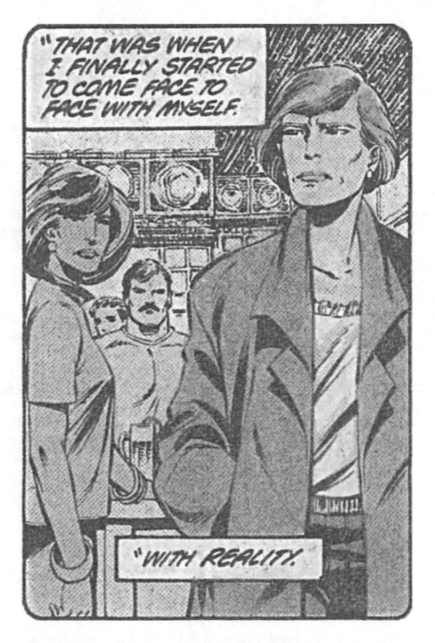

Figure 10.1. Maggie's "change." From Byrne, J. (1988). Wings. *Superman, 2*(15), p. 10. © 1988 DC Comics.

The issues of telling the story tastefully are apparent, indicating that the writers and editors had planned for some type of reaction to the revelation. It would be easy to speculate on their intent in selecting these particular letters, but I will refrain from doing so and simply point out once again that although readers have an opportunity to respond to stories, the editors have the final say in publishing those responses.[5]

The next set of examples regarding representations of gay men and lesbian characters comes from *Action Comics*, a weekly book that for a period of time featured Superman and six different features in serial story lines. One such feature was "The Secret Six," which followed the story of a group of strangers brought together by one common characteristic: a physical disability. One character, for example, is blind, another mute, and another deaf. A shadowy figure known as "Mockingbird" gives these six people mechanical enhancements to correct their individual disabilities. The Secret Six must follow Mockingbird's orders, or else he renders their devices inoperative.

A story in *Action Comics* issue no. 624 focuses on Tony Mantagna, a deaf investigative journalist who relies on the Mockingbird for the mechanical device that enables him to hear. Tony is guarding Shelley, a young woman who makes romantic advances towards him. He refuses, telling her the story of how he lost his hearing while covering a story for his magazine. Tony and his photographer, Tom Pearson, were caught in an explosion that killed Tom and left Tony deaf. In epilogue to the story, we see Tony talking over a grave:

> I'm moving to San Francisco...you know, the way we always talked about doing some day...sorry we didn't get around to it while you were still here. I won't be able to visit as often. But I'll still bring flowers...I'll never stop loving you... (Pasko, 1988, p. 8)

As Tony walks away from his lover's grave, we see the inscription on the gravestone: "Thomas John Pearson 1946—1987" (Figure 10.2).

Responses to the story, printed in *Action Comics* issue no. 635, were supportive of the revelation, with simple kudos such as:

> you're doing a good job in depicting gays as real people. (Greenberger, Carlin & O'Neil, 1988, n.p.)

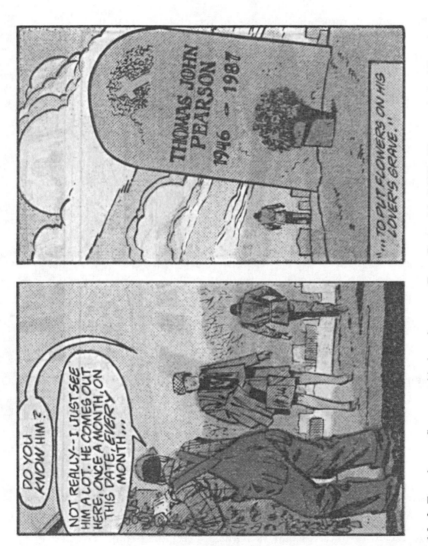

Figure 10.2. Tony leaves flowers at his lover's grave. From Pasco, M. (1988). The sound of a silent heart. *Action Comics Weekly, 1*(624), p. 8. © 1988 DC Comics.

Others liked what the "outing" did for the story:

> [I liked] this...on Tony's being gay alone. What a great twist! Great sub-
> plot. (Greenberger, Carlin & O'Neil, 1988, n.p.)

Another reader commends the value of the characterization:

> I nearly stood up and applauded...I hope you're willing to follow through
> and give this the importance it deserves...Let us see stories deal frankly
> with the gay experience. How does Tony's preference affect his work? Has
> he lost friends to AIDS? Does he face much prejudice? Are any of the [Secret]
> Six uncomfortable with him? Don't back away. (Greenberger, Carlin &
> O'Neil, 1988, n.p.)

Given the presentation of "gays as real people," there is still a desire
for a more complex presentation of the gay lifestyle, beyond normal-
ization. The editor's response to these compliments shows apprecia-
tion, but with a touch of caution:

> We try to handle subjects like Tony's homosexuality in a serious and
> sensitive manner...there's a fine line between exploration and exploitation.
> Your questions...are certainly worth examining, though. Thanks.
> (Greenberger, Carlin & O'Neil, 1988, n.p.)

From the editors' perspective, Tony's personal revelation should be a
part of the story, rather than the vehicle for discussing AIDS, peer
relationship, or civil rights. The nature of the character also implies an
early circumspection with portrayals of gay individuals. The writers
could afford to explore Tony's background as a gay man because he
was a new character with a much smaller following than Superman or
other flagship characters. Creating a new character who was gay is
much safer than revealing an established character's sexual identity.

The freedom of second-string books to address the issues
surrounding homosexuality is also apparent in the 1988 issues of
another DC book, *Green Arrow*. Unlike the previous examples, *Green
Arrow* appears without the Comics Code Authority Seal and carries a
"Suggested for Mature Readers" warning on the front cover. While
the character does not hold the status level of a Superman or Batman,
Green Arrow has been part of the DC stable of characters for decades.
Green Arrow follows the adventures of Oliver Queen, an archer known

as the Green Arrow, and his longtime love, Dinah Lance.

While working in her Seattle flower shop one evening, Dinah comments on Oliver's vast wealth, saying "We don't all have a closet full of money." At that point two men enter the store, and Oliver mutters, "Speaking of closets..." The men are Richard and his lover, two of Dinah's best customers. Richard buys a single white rose, celebrating a seven-year anniversary. "Congratulations!" says Diana. "That's longer than most marriages last" (Grell, 1988, p. 3–4). At once the statement is both supportive and essentializing, as though only heterosexual relationships can last a number of years, that long-term monogamy is desirable and "right," or that marriage is an exclusively heterosexual ritual.

Later in the story, Richard and his lover become the latest victims of gay hate crimes in the city, and the police are without leads. One detective points out the only similarities between the crimes: the location and the victims. He says: "Beyond that, we've got serial-type sociopaths, AIDS-inspired homophobia, jealous lovers, or an endless variety of concerned citizens who figure everybody ought to go out and kill a queer for Christ. We'll get 'em. Maybe." (p. 12). Oliver goes undercover to ferret out the criminals and stop the attacks.

Printed reactions were, like the other 1988 samples, quite supportive and accepting of the presentation of gay characters. Self disclosure played a role in some letters; this is a quality not present in the code-approved books. One reader writes:

> I...was very impressed with the thought and sensitivity depicted...As a gay man I commend you for not portraying the victims with any derision or cliche. Hopefully this will set a new precedent. (Gold, 1988, n.p.)

Another self-disclosing letter reads:

> Thank you. I'm gay. I've been reading comics for 25 years and have watched "The Big Two" [DC and Marvel Comics]...sidestep the issue of gay people... Then came 1988 and the head of Special Weapons and Tactics in Metropolis is a lesbian [a reference to Maggie Sawyer] and Green Arrow goes after...gay bashers...I hear so much...bullcrap about gay people...that the words of acceptance have become food of the gods...I read those words in *Green Arrow #5*. I wept....Why couldn't the survivor of the attack decide to devote his life to fighting injustice!? The first openly gay super hero?!

Just a thought...Do your bosses know how many gay comics readers there are? A *lot* [emphasis his]. Trust me. (Gold, 1988, n.p.)

Self-disclosure also came from the heterosexual readers of *Green Arrow*:

I'm not a homosexual, but I am very sympathetic towards the problems facing them. Between the AIDS epidemic and equally widespread gay-bashing, they hardly have room to breathe. That's why I enjoyed your portrayal of homosexuality in *Green Arrow #5*. The two men who entered the flower shop obviously were not perverts, weirdos [sic] or anything resembling one [sic]...they seemed very much in love. (Gold, 1988, n.p.)

Another writer concurs, but takes Oliver to task:

Mike Grell created a nice gay couple—two harmless loving men, who had no right to wind up the target of some macho, misfit youths. While Oliver was rather nasty with his "closets" remark...he was gentle with the survivor. (Gold, 1988, n.p.)

Throughout these letters, elements of self-disclosure play an important role. There are expressions, once again, of normalization. Phrases such as "two harmless loving men," suggest a certain attitude. It is easy to speculate: what if the men had been presented as vocal members of Queer Nation? The acceptance here is one of normalized gay representation, usually compared against heterosexual relationships.

A Whole New Story: The Early 1990s

Coming-out stories of the early 1990s were quite different from 1988 in such respects as presentation, terminology, and topics. The next set of examples reflects a bolder, more obvious outing system for gay and lesbian characters. The responses printed in letter columns also reflect a wider range of opinion as well. Gone are the "positive-letters-only-approach" offered in 1988; a split of supportive and non-supportive (in some cases, outright hostile) responses are displayed. The first example is in Marvel Comics' *Alpha Flight*, about a Canadian superhero team. *Alpha Flight* issue no. 106 presents the

story "The Walking Wounded" in which the French Canadian super-
hero Northstar (Jean-Paul Beaubier) adopts an abandoned infant
infected with the AIDS virus. The cover of the issue proclaims:
"Northstar as you've never known him before." In the story,
Northstar comes in conflict with a retired World War II superhero,
Major Mapleleaf (a patriotic Canadian hero, similar to Captain
America). As the adopted infant becomes the subject of nightly news
stories, Major Mapleleaf confronts Jean-Paul:

> My son, Michael was a victim of AIDS...but he was gay, so people didn't af-
> ford him the luxury of being innocent...there were no press conferences. No
> fund raisers. No nightly news updates! He was just one of thousands who died
> of AIDS last year...and now you come along! You with your cute and sweet
> and lovable and photogenic little orphaned girl! My son wasn't guilty of
> anything. But because he was gay, he didn't rate. (Lobdell, 1992, pp. 16–17)

As is often the case when two superheroes meet, the discussion turns
into combat, where Jean-Paul confesses that when it comes to the diffi-
culties homosexuals face, "No one knows them better than I...I am
gay" (p. 20) (Figure 10.3).

Gone are the subtle references to and the supporting-character
status of gay men and lesbian characters, as Jean-Paul is one of the
main characters of *Alpha Flight*. Northstar, a mainstay comic char-
acter for almost 20 years, was revealing what the comic-reading
population had long suspected. Mapleleaf, however, turns Jean-Paul's
confession against him:

> you're one of Canada's most preeminent figures...before that you were an
> Olympic athlete! Don't you realize the good that you can do?!...by closeting
> yourself...you're as responsible for my son's death as the homophobic
> politicians who refuse to address the AIDS crisis. (Lobdell, 1992, p. 22)

This dialogue is an example of how much the presentation of the gay
lifestyle had changed since 1988. With *Alpha Flight*, the discussion
included homosexuality as part of the political and cultural landscape,
going so far as to address the need for prominent gay figures to reveal
themselves. A similar presentation is the popular ACT-UP slogan
"Silence=Death" that adorns items ranging from T-shirts to bumper
stickers. Readers' letters from the same issue reveal that the outing
process was publicized to some extent:

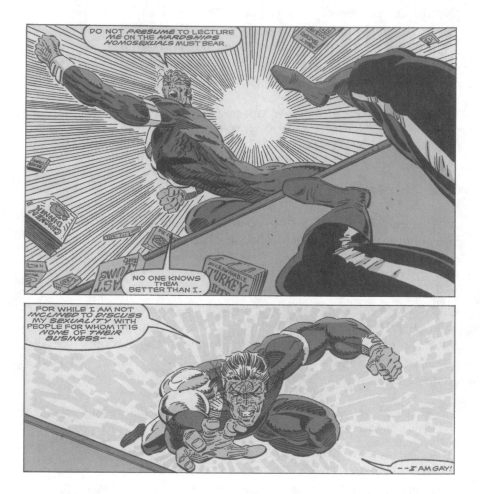

Figure 10.3. Northstar comes out. From Lobdell, S. (1992). The walking wounded. *Alpha Flight, 1*(106), p. 20. © 1992 Marvel Enterprises.

> I...hope you will be brave enough to definitely state that Jean-Paul is homosexual...I have two gay friends and a girlfriend who is bisexual, and believe me, they are all rooting for Jean-Paul to come out in the open...and perhaps even get a male lover! (Chase, 1992, n.p.)

Not all readers were supportive of the impending revelation, however:

> in your 100th issue, a reader talked [sic] about reviving Northstar as a gay character...I believe the world is in need of more open minds, but I'm bothered by this. A comic is supposed to tell the story of heroic people and their lives...I thought people looked up to heroes. I might just be closed-minded, but I don't look up to people who can't follow the natural pattern of sexual conduct. (Chase, 1992, n.p.)

The editor's response to the second letter reveals a stronger opinion on the issue than in 1988:

> You look up to lesbian and gay heroes everyday...you just don't realize that they're gay. But does it really matter? If someone risks their life to save another, is that act any less heroic because of whom that someone loves? (Chase, 1992, n.p.)

The letter column from issue no. 110 features the response letters to the actual story. The editor prefaces the letters with the warning that the letters will be run without comment, due to "the immense response" (Tokar, 1992, n.p.). Of the six letters printed, three present positive responses, and three present negative responses. In two of the "positive" letters, readers show support for gay relationships:

> I am writing to salute Northstar's "coming out"...The more gay people come out of the closet, the more straight people will have to make room for homosexuality in their "straight" morality...it's also important for kids who already know they are "queer" to see positive role models who are gay. (Tokar, 1992, n.p.)

This positive response also demonstrates the opportunity for self-disclosure:

> Having a gay super hero not only helps us who are gay—but it helps fight aggression that is used against straight kids all the time. (Tokar, 1992, n.p.)

Excerpts from negative letters indicate strong disapproval of the story:

> It is bad enough that this country is plagued with homosexuals, but it is really sad when even the comics start to portray it...I have an idea, maybe Northstar can die in a skiing accident. (Tokar, 1992, n.p.)

A letter from a self-labeled leader in the Ku Klux Klan states:

> This isn't controversial at all, it's just WRONG! I know that a huge corporation like Marvel doesn't have to care about what I think. Please read Leviticus 18:22 and Romans 1:24–32. There is not [sic] other interpretation fro [sic] this sin, "They are worthy of death—not only do the same, but also approve of those who practice them." (Tokar, 1992, n.p.)

Another negative letter was not as vituperative, but nevertheless it is difficult for gay men and lesbians to read the negative letters, particularly when they incorporate such hatred. Whether or not this was a factor in the lack of editorial responses is unknown, but the letter column indicated that the negative letters were in the minority:

> we sorted out the opinions from AF #106's over-stuffed mailbag and tallied up the responses. The approximate totals on Northstar's coming out are: Pros: 76.3 %, Cons: 21.1%, Undecided: 2.6%. (Tokar, 1992, n.p.)

Such a tally would have been useful in other coming-out stories from this period, given the polarized responses from readers. Despite the percentages, the editor selected three positive letters and three negative letters, which does not reflect the 3/4 favorable response.

DC Comics also had a more overt presentation of homosexuality at this time. The Pied Piper came out in Flash issue no. 53 late in 1991, several months before *Alpha Flight* issue no. 106. Like Northstar, Pied Piper was a firmly established character by the time of his coming-out issue. Unlike Northstar, Pied Piper first appeared in 1959 as a super-villain, a foe of the costumed super-speedster, the Flash. In the current Flash mythos, the Pied Piper has retired from his life of crime and now occupies his time as a social worker and friend to the current bearer of the Flash legacy, Wally West.

In the coming-out issue, "Fast Friends," from August, 1991, the

Piper, a.k.a. Hartley Rathaway, is having a discussion with the Flash. In a scene reminiscent of two coworkers taking a coffee break, the men discuss Hartley's former associates, such as the Joker, during his life of crime:

> Hartley: You don't really get to know guys like him [The Joker]... [he'll] kill you just to make a point. We didn't all live in a clubhouse of evil.
> Wally: Just wondering...you've heard the rumors...How, maybe, he's gay? What did he seem like to you?
> Hartley: The Joker...gay...I've never seen any reason to believe...
> Wally: (interrupting) Sure, but guys like that, you can *always* [emphasis his] tell...There are signals...
> Hartley: He's a sadist and a psychopath...I doubt he has any real human feelings of any kind...He's not gay Wally. In fact I can't think of any super-villain who is...Well, except me, of course. But you knew that, right?
> Wally: Me? Oh, sure...I mean how could I not know something as... as...
> Hartley: And it doesn't bother you?
> Wally: Gosh, no! Oops, look at the time! Got an appointment Piper. Gotta run.
> Hartley: [Grinning] Right. Glad it didn't bother you. (Messner-Loebs, 1991, p. 4)

The Flash chastises himself for not knowing his friend was gay. "Idiot," he thinks, "how could I have not noticed? I just had to get out of there and give myself time to think. Fortunately, I was slick enough so that Piper never noticed...and I really did have an appointment" (Messner-Loebs, 1991, p. 5). Wally's reaction to Hartley's disclosure showed confusion and embarrassment rather than immediate acceptance, and thus Hartley's "coming out" is presented with more complex ramifications than the DC instances from years before. The actual coming out is more direct as well, both in the use of the word "gay" and the fact that when Hartley says "except for me," the drawing is a close-up of Hartley's face, with an opposite shot of Wally's surprised reaction (Figure 10.4).

Letters selected to appear in the letter column indicated positive and negative responses to the story. The ability or choice to print negative letters had changed drastically. Whether this is a reflection of a greater, more open discussion of homosexuality in society or a more direct stance on the part of the writers and editors is unknown. In fact,

there was more national coverage of gay and lesbian issues appearing concurrently in other media. Using the Vanderbilt Media Archives electronic database to determine the number of stories about gay and lesbians in 1992, there were ten times as many stories on national news broadcasts in 1992 than there were in 1988. Regardless of the reason, the discussion had changed from an open and accepting atmosphere to one of polarized opinion, split between those who applauded the outing, and those who condemned it. Consider the editorial comments that appeared at the beginning of the "Speed Reading" letter column for *Flash* issue no. 57:

> Well, I don't believe I've ever found myself in the midst of so much... interest before. The Piper's revelation...elicited a tremendous reaction from you folks, and while we were prepared for a real controversy, the response was overwhelmingly POSITIVE [emphasis theirs]. There were a few detractors, that's expected, but so very few was wonderfully surprising. I'm proud of the story and I'm proud of all of you. (Augustyn, 1991, n.p.)

The editor expresses both an anticipation and acknowledgment of controversy and pride in the supportive readers. What follows are samples from the eight letters published in the letter column, and the editor's comments. I present this to demonstrate the flow of the column. Letter 1:

> The real highlight...was the honest and human friendship...between the Flash and the Pied Piper...I hope the Pied Piper is allowed as much spotlight as the rest of the cast...I hope his homosexuality is not ignored, yet not exploited...I am pleased to see DC and FLASH take a positive step in acknowledging the gay population and the gay comic reader. (Augustyn, 1991, n.p.)

Letter 2:

> DC does it again! Often DC... has the courage to step beyond safe and comfortable issues and storylines... Homosexuals exist in the real world and to pretend they do not is really silly. A small percentage of us are female impersonators and some of us are effeminate as the media portrays us. But many of us are not, as Wally has learned. (Augustyn, 1991, p. 22)

Once again, we see elements of self-disclosure in addition to a distinct concern for the lack of representation for homosexuals in other media. Not only are the *Flash* writers and editors more accurately

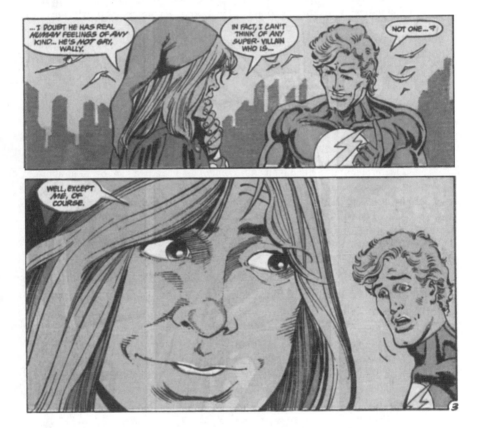

Figure 10.4. Pied Piper comes out. From Messner-Loebs, W. (1991). Fast friends. *Flash,* 2(53), p. 3. © 1991 DC Comics.

representing society, the representation of gay men has not been reduced to essentialist, stereotypical behavior. Letter 3 continues with this idea:

> Thank you for finally introducing an openly gay character to a mainstream comics title and making him a character who...does not have a problem dealing with his own sexuality...I go to my comics shop with my gay friends. The staff where I shop is mostly gay...You've taken a major step in opening up mainstream comics to diversity...I've finally found a character who reflects the reality of my life...It's a change that's been too long coming. (Augustyn, 1991, n.p.)

Letter 4 agrees and continues the idea of self-identification and the importance of representing the gay population:

> I am an openly gay man and I've been collecting comics for many years. One problem that I and many gay comic fans have is a lack of admirable gay comics characters...Maggie Sawyer was...gay but still never stated so in so many words. And now the Pied Piper, a villain and friend to our hero, has stated, out in the open, that he is gay...Not all gay men are effeminate and not all lesbians are masculine. I hope...the Piper is used to make that clear. (Augustyn, 1991, n.p.)

Letter 5 is one I would classify as a negative letter, because it accuses the editors and writers of spreading propaganda and abusing the medium:

> I love this comic! But, as of issue #53, you have turned it into an arena for homosexual propaganda...What are comics for? To entertain, right? Right. Now if there were no homosexuals in FLASH, it would still be entertaining, right? Right. Therefore, I can only perceive Piper's revelation, not as a means to entertain, but as a way to for Mr. [Messner-] Loebs to preach his view of morality. (Augustyn, 1991, n.p.)

The editors' responses take a distinctly different tone here. As opposed to responses in earlier letter columns, these are decidedly part of an agenda:

> I guess we made a mistake assuming that a comic book might be used as entertainment and as an arena for discussion. How dare we say that all people are the same, that you should treat everyone with respect and that it's good to like your friends because of who they are, not what they are. At this

rate, we'll be advocating racial harmony and an end to war next...
(Augustyn, 1991, n.p.)

Several arguments are made here, but the most prominent is the idea
that comics can be used to discuss social issues and contribute to
public dialogue, particularly regarding discriminatory practices. In-
deed, the editorial response indicates that comic books should be used
toward that end. Moreover, the editorial response serves to reaffirm an
open, tolerant discussion of homosexuality while firmly establishing
the writer of Letter 5 as intolerant. The tone of the editorial responses
toward negative letters is sarcastic and combative.

Letter 6 references the possibility of negative reaction from read-
ers, and hails an earlier instance of outing and reader reaction from an
independent book:

> When Scott McCloud wrote a very sensitive story about a gay character,
> in...*Zot!*...he received a vehemently homophobic letter from one reader,
> who mentioned that he also reads FLASH. That reader will very likely write
> an equally anti-gay letter to you...If you are straight and you support gay
> rights, don't be afraid to express yourself. (Augustyn, 1991, n.p.)

This letter calls out to other straight readers to support gay rights and
positive portrayals of gays in comics. It reaffirms the editors' and
writers' attempt to present this social issue to the readers. The letter
also beautifully sets up the next response, as the editor acknowledges:

> I could not be in more agreement. In combating any form of prejudice, fear is
> the first and greatest barrier to understanding. Thanks for your courage. Oh,
> and that fellow who wrote to *Zot!*...here he comes...(Augustyn, 1991, n.p.)

Letter 7:

> The Pied Piper's a homo!...It amazes me that despite the vast majority of
> America's population professing a belief in God and only one percent of
> America's population being exclusively homosexual, American comics are
> being created by folks such as [Messner] Loebs who are so out of touch with
> the righteous mainstream that the values of such a writer run contrary to our
> culture...How long will comics portray a milksop counterfeit friendship
> that, when there is something so critically wrong as a homo sin lifestyle,
> simply accepts the evil rather than offering to help its victim find deliver-
> ance from his destructive lifestyle... (Augustyn, 1991, n.p.)

This is one small excerpt from the longer letter that uses a religious argument to denounce the story and homosexuals in general. In many ways, this letter is simple to dismiss, given the tolerant and accepting tone previously established in the positive letters. The editor responds:

> It would be easy...and enjoyable to blow you away with some amazingly clever and dismissive rejoinder, but that would serve very little. I also think that to enter into a discussion of the pros and cons on this subject is a waste of time. Your mind is made up and thoroughly closed...It never ceases to amaze me that those people who profess so vehemently to be Christians are often not particularly good at acting like Christians...By the way, calling people derisive names like "homo" doesn't strike me as very Christian... What are you afraid of? (Augustyn, 1991, n.p.)

This is the longest editorial response in this letter column. The use of the term "dismissive rejoinder" implies that the editor is not attempting to close off discussion but rather is trying to encourage it. In the instance of the letter column, however, the editor always has the last word. The eighth and final letter excerpt serves to reinforce the editor's notion of a good "Christian attitude":

> I don't agree with homosexuality because I am a Christian...that doesn't mean I...hate...those that are. [My gay] friends know I am straight and they know I don't agree with their lifestyle, but I respect each of them as a friend. That's what counts in life...We may not all agree with homosexuality, but should always focus on the person inside. (Augustyn, 1991, p. 24)

Ending with this particular letter is a good strategy against the previous letter because doing so demonstrates that the editor was not referring to all Christians during his response to Letter 7. In short, the printing of the letters, if they are indeed "overwhelmingly positive," reinforces the idea of a community in which ideas are shared and concerns voiced. Overall, the letters, and the responses to them, create an atmosphere of tolerance and open discussion.

The next set of letters is also from *The Flash*. Issue no. 63 saw the printing of letters commenting upon the events and letters in issue no. 57. All six letters printed in this issue mentioned the previous letter column. Letter 1:

[Letter 7] in issue #57 disturbed me. What our sanctimonious friend fails to understand is the current trends in comics. The readers (as well as many artists, writers and...editors) want to see comics reflect the real world a bit more...Just about everyone in the real world has met, worked with or been friends with a homosexual...and we're still alive to talk about it...[The] use of derogatory slang was...the most offensive part of the little controversy. [The] attitude and intolerance disgust me in a way few things have...Comic books have always kept up with the times, often confronting readers with things that...get them to start thinking. (Augustyn, 1992, n.p.).

This letter has a great deal to say about the issue of intolerance, especially about other readers' reactions to the "outing." Also inherent here is the acknowledgment of comic books as a form of social commentary. Letter 2 comments on the previous letter column, albeit, in an entirely different way:

I forgot that The Pied Piper turned gay until I read over the letter column. I don't like this. I am NOT a racist or a homophobe for those wondering... There has been found to be something wrong with the brain of a homosexual...part of their brain is smaller than it is in normal people...If this deformation is found in all homosexuals...all Piper would have to do is take a pill to fix the size. (Augustyn, 1992, n.p.)

The writer of Letter 2 injects a biological argument into the discussion, even if it is not a very good one. The writer also does not want to be labeled as racist or homophobic, indicating a belief that a certain response would be generated by his or her comments; the words "for those wondering" also speaks to this concern with backlash against the opinion. In addition, the writer signs off anonymously as "Rush Limbaugh's #1 Fan" (Limbaugh being a conservative radio talk-show host) and implores the editor to "Please withhold my name and address...because I don't want any liberal fanatics sending me hate mail" (Augustyn, 1992, n.p.). The editor's response:

Well...a man with the courage of his convictions...NOT! It's a long standing tradition for a bigoted coward to hide behind anonymity while spewing out crud; apparently the younger generation of creep is carrying on...(Augustyn, 1992, n.p.)

The political spectrum has been clearly defined, with the pro-gay letters and editors and writers on one side and the anti-gay letters on

the other. Letter 5 from issue no. 63 continues this distinction:

> Why is it that those who oppose gayness have such closed minds? They,
> according to you [Augustyn, the editor] should accept all that life tolerates.
> You, on the other hand, do not have to accept any opinion that is different
> from yours...a major DC character [will not] reveal his/her "gayness"...
> sales would plummet...and the "liberal perspective" would be slapped
> down...The same can be said of any so-called social issue: Where are major
> black or Asian or Hispanic hero/heroines...underneath all the pontificating
> lies a company that will continue to give us...white values to follow.
> (Augustyn, 1992, n.p.)

The reader here makes an association between gay men and lesbians
and people of color, blanketing them under the derisive "so called
social issue" label. The editor responds:

> Disagreeing with someone's opinion or bemoaning the obvious hatred
> inherent in a diatribe, is not the same as intolerance. The letter writers I was
> responding to held that only their beliefs were correct and that no one else
> was entitled to any different position. It doesn't matter if I agree with you or
> not; I believe in your right to say it. An intolerant person would insist that
> you change. (Augustyn, 1992, n.p.)

The issue of homosexuality has been lost in the responses here. The
dialogue has instead turned to issues of power and control, and to the
ability of people to express their opinions. In the case of the writer of
Letter 5 above, it seems as though similar viewpoints, but not the right
to have those opinions, were challenged in earlier issues. It would be
easy to speculate that the writer of Letter 5 is just as bigoted and
narrow-minded as previous anti-gay letters, but that would be a moot
point.

Despite the perceived controversy, the Pied Piper remains a major
character in *The Flash*. The book has been under the charge of
several different writers since late 1991, and no one yet has attempted
to change the Piper into a heterosexual character.

Politics and History: *Quantum Leap* and Media Crossover

The final set of examples of gay and lesbian portrayals and readership
reaction to them comes from a media-crossover book, *Quantum Leap*.

The comic continues the adventures set forth in the early 1990s television program of the same name. In the program and comic, the main characters are Dr. Sam Beckett, a time-traveling scientist, and his friend Al who appears in the form of a hologram that only Beckett can see and hear. Beckett "leaps" into people's lives at critical moments to change their personal histories for the better; to "put right what once went wrong." Beckett appears as the person he has displaced in time, so he is depicted as black, aged, young or as a woman, depending on whom he has replaced.

Issue no. 9, (1993) featured "Up Against a Stone Wall," in which Beckett leaps into the life of a lesbian. The character of Stephanie, an aspiring photographer, appeared in an episode of the television program titled "Good Night Dear Heart." In the episode, Beckett determines that Stephanie was the lesbian lover of a young woman, and also her murderer. According to gay writer Andy Mangels, who penned "Stone Wall," the television episode angered many gay and lesbian fans of the show because "the first portrayal of homosexuality on the show had a lesbian kill her lover, who left her for a man" (Mangels, 1993, p.32). In his preface, Mangels explains his reasons for writing the comic book story by citing current political issues, and then calls on the reader to take action:

> In the current election, Gays and Lesbians have become the new Willie Horton, the new Red Scare, the new boogeyman for the masses. Hysterical politicians scream that we're anti-family, that we're unnatural, that we don't deserve the same rights as God-fearing Christians...In Oregon and Colorado, constitutional amendments will be voted on which would...actively take away civil rights of Gays and Lesbians...This issue has been my way of helping "put right what once went wrong." Now it's your turn. Be accepting. Nurture and honor diversity. Do unto your neighbor as you would have done unto you. Put right what once went wrong. (Mangels, 1993, p. 33)

"Up Against a Stone Wall" takes place in June of 1969, just before the Stonewall riots in Greenwich Village. Sam has temporarily taken over the life of the now paroled Stephanie, who continued her photography career in prison. While acting out this portion of Stephanie's life, Sam takes pictures of a young black cross dresser named Clarice, a recent victim of police brutality. The story culminates on the night of June 28, when Sam/Stephanie tries to steer Stephanie's

friends away from the Stonewall Inn. Given his knowledge of the future, Sam/Stephanie knows the police will soon raid the inn. One of Stephanie's friends suggests that Sam/Stephanie have her camera ready. At the end of the story, Al reports from the future, indicating to Sam that his mission as Stephanie has been successful. Al reports the altered history has Stephanie taking pictures of the Stonewall riots, which "helped to put corrupt cops behind bars" and "change New York laws." Also, because of Sam's actions, Clarice becomes a national leader in the gay rights movement. Sam leaps to his next mission, having changed peoples' lives for the better.

As in previous years' responses, reader reaction was apparently mixed, though in this letter column only one negative letter was printed. Positive letters had similar themes as those from *Flash*, *Alpha Flight*, and *Green Arrow*, such as self-disclosure:

> We don't want special [rights]...we want equal [rights]. Thank you for a warming look at my past. Things may still be wrong but the Stonewall Riots are part of the beginning to put things right. (Broderick, 1993, p. 26)

Another letter thanked the comic book for setting right the "predatory lesbian" aspects of the television episode:

> It's rare enough that television admits the existence of the gay community, it was irresponsible and inequitable of Quantum Leap [the program] to portray its first (and for a long time, only) gay character in a negative light—to say nothing of lazy thinking and sloppy writing. Your "Up Against a Stonewall" redresses the balance admirably. Thank you, Mr. Mangels. (Broderick, 1993, p. 27)

As with previous examples, the heterosexual audience showed support:

> I am writing in support of your gay rights issue. I am not gay, but this issue is very important to me. (Broderick, 1993, p. 26)

The only negative letter printed in this letter column quotes the Bible (Leviticus and Deuteronomy) and argues that homosexuality is scientifically wrong: "Man and man do not create child, they create disease" (Broderick, 1993, p. 26). The editorial response simply points out that the letter does not reflect the opinion and policies of the comic book publisher or the television production company, and

that "the editorial staff does not presume to speak on behalf of the Lord Almighty" (Broderick, 1993, p. 26). This is a rather glib, though not inappropriate, response to the combined Bible/Science argument. In general, however, the editorial tone is aligned with all of the other early 1990s editorial responses of tolerance and acceptance.

Future Directions

I have demonstrated how readers express themselves in their responses to story lines in comic books, and how these books serve as a way of learning about social issues. The combination of story, readers' responses, and editorial comments form a knowledge community that discusses certain issues in a particular way.

Further research into comic book readership could implement heuristic work. Direct interaction with readers, in group discussions, might prove useful in determining how people use the medium and to what extent. The work of Penley (1992) and Jenkins and Tulloch (1995) could provide useful models for discussing issues of representation and readership in comic books. Penley investigates how readers poach popular texts for their own uses, creating stories the established company could not. The Internet would also prove useful ground to continue the discussion I have started here. The web site "Gay League of America" (http://www.gayleague.com/) provides gay and lesbian chat rooms, volumes of fan-written fiction and discussions of gay characters, comics, and biographical stats of self-identified gay writers and artists. This web site is one new avenue for readers to express themselves in gay and lesbian fiction. The discussion is certainly not limited to gay and lesbian readership, because so little has been done with the comic book audience. Future scholarship in this area would benefit by listening to the readership, evaluating the editorial responses and reading the texts that interact to form this unique discourse community. Comics, as the industry saying implores, "aren't just for kids anymore." The medium continues to hold amazing potential for social interaction and commentary.

Notes

The author would like to thank the editors of this volume; Peter Lang Publishing; Dr. Marouf Hasian; Ms. Mindi Golden; and his parents, Morris and Linda.

1. This is not to say that gay and lesbian characters had not appeared in comics before 1988. Mangels' (1988a, 1988b) excellent articles in *Amazing Heroes* trace the appearance of gays and lesbians in comic books beginning in 1980. This early appearance, as well as others that followed in the early 1980s, were not in mainstream Comics Code Authority-approved books.

2. McAllister (1992, p. 1) addresses both the content of AIDS discourse in comic books and the medium itself. He writes: "All portrayals of AIDS in mass media and popular culture are extremely important for study...The distinction, after all, between entertainment and education is to a large degree tenuous." In this sense, the medium is epistemological in nature, allowing knowledge to be expressed about a social concern.

3. A common misperception about comic books is the audience. Some surveys indicate that the actual readers of comics are demographically different from that of the assumed child or teenager. The average age of a comic book reader is between 25 and 40, with male readers outnumbering female readers 20 to 1. About 20% of comic book readers have done postgraduate university work, and the average reader is typically a heavier reader than the general population (Benton, 1985, p. 2).

4. Two cases not mentioned here for sake of brevity, DC Comics' *Millennium* and *Suicide Squad*. Both titles featured gay men. In the case of *Millennium*, a mini-series, there were no letter columns to use. With *Suicide Squad*, the character's sexual identity was mentioned once. Readers' reaction was favorable.

5. The Maggie Sawyer story came under the writing of John Byrne, a prolific comic book author and artist. Byrne was part of the DC Comics staff charged with helping to reshape the DC Universe in the mid- to late-1980s, when he was given a wide berth for recreating the Superman mythos. Byrne also helped to revamp Wonder Woman for DC Comics and Spider-Man for Marvel Comics in the late 1990s. For Marvel, Byrne also created Northstar, a character he always claimed was gay, hinting so in his stories (Mangels, 1988a, p. 42). Thus, there might be some credence to authorial power here as well; that is, a well-known and popular writer given the license not usually afforded other writers to explore issues.

References

Abbot, L. (1986). Comic art: Characteristics and potentialities of a narrative medium. *Journal of Popular Culture, 19*(4), 155–176.

Augustyn, B. (Ed.). (1991). Speed reading. Letter column appearing in *Flash,* 2(57). New York: DC Comics.

Augustyn, B. (Ed.). (1992). Speed reading. Letter column appearing in *Flash,* 2(63). New York: DC Comics.

Bennet, A. (Ed.) (1995). *Readers and reading.* New York: Longman.

Benton, M. (1985). *Comic book collecting for fun and profit.* New York: Crown.

Broderick, G. (Ed.). (1993). Quantum leap. Letter column appearing in *Quantum Leap, 1*(11). Wheeling, WV: Innovation.

Byrne, J. (1988). Wings. *Superman, 2*(15). New York: DC Comics.

Carlin, M. (Ed.). (1988). Superman. Letter column appearing in *Superman,* 2(19). New York: DC Comics.

Chase, B. (Ed.). (1992). Alpha waves. Letter column appearing in *Alpha Flight, 1*(106). New York: Marvel Enterprises.

De Certeau, M. (1995). Reading as poaching. In A. Bennet (Ed.), *Readers and reading* (pp. 150–163). New York: Longman.

Gold, M. (Ed.). (1988) Sherwood forum. Letter column appearing in *Green Arrow, 1*(8). New York: DC Comics.

Greenberger, R., O'Neil, D., & Carlin, M. (1988). The crash of '88. Letter column appearing in *Action Comics Weekly, 1*(635). New York: DC Comics.

Grell, M. (1988). Gauntlet. *Green Arrow, 1*(5). New York: DC Comics.

Gross, L. (1995). Out of the mainstream: Sexual minorities and the mass media. In G. Dines & J. M. Humez, (Eds.), *Gender, race and class in media* (pp. 61–63). Thousand Oaks, CA: Sage.

Harvey, R. (1979). The aesthetics of the comic strip. *Journal of Popular Culture, 12*(4), 640–652.

Lobdell, S. (1992). The walking wounded. *Alpha Fight, 1*(106). New York: Marvel Enterprises.

MacDonald, A., & MacDonald, V. (1976). Sold American: The metamorphosis of Captain America. *Journal of Popular Culture, 10*(1), 249–255.

Mangels, A. (1988a). Out of the closet and into the comics. Gays in comics: The creations and the creators Part I. *Amazing Heroes, 1*(143). Westlake Villages, CA: Fantagraphics Books.

Mangels, A. (1988b). Out of the closet and into the comics. Gays in comics: The creations and the creators Part II. *Amazing Heroes, 1*(144). Westlake Villages, CA: Fantagraphics Books.

Mangels, A. (1993). Up against a stone wall. *Quantum Leap, 1*(9). Wheeling, WV: Innovation.

Matton, A. (2000). Reader responses to Doug Murray's *The 'Nam. International Journal of Comic Art, 2*(1), 33–44.

McAllister, M. P. (1992). Comic books and AIDS. *Journal of Popular Culture, 26*(2), 1–24.

Medhurst, A. (1991). Batman, deviance and camp. In R. E. Pearson & W. Uricchio (Eds.), *The many lives of the Batman: Critical approaches to a superhero and his media* (pp. 149–163). New York: Routledge.

Messner-Loebs, W. (1991). Fast friends. *Flash 2*(53). New York: DC Comics,

Mondello, S. (1976). Spider-Man: Super hero in the liberal tradition. *Journal of Popular Culture, 10*(1), 232–239..

Moritz, M. (1999). Old strategies for new texts: How American television is creating and treating lesbian characters. In L. Gross & L. Faderman (Eds.), *The Columbia reader on lesbians and gay men in media, society, and politics* (pp. 316–327). New York: Columbia University Press.

Palumbo, D. (1983). The Marvel Comics Group's Spider-Man is an existential super-hero; or "Life has no meaning without my latest Marvels!" *Journal of Popular Culture, 17*(2), 67–82.

Pasko, M. (1988). The sound of a silent heart. *Action Comics Weekly 1*(624). New York: DC Comics.

Penley, C. (1992). Feminism, psychoanalysis and the study of popular culture. In L. Grossberg, C. Nelson, & P. A. Treichler (Eds.). *Cultural studies* (pp. 479–494). New York: Routledge.

Pustz, M. J. (1999). *Comic book culture: Fanboys and true believers.* Jackson, MS: University Press of Mississippi.

Sheldon, C. (1999). Lesbians and film: Some thoughts. In L. Gross & L. Faderman (Eds.), *The Columbia reader on lesbians and gay men in media, society, and politics* (pp. 301–306). New York: Columbia University Press.

Sweeping out the closet. (1997, May 16). *Entertainment Weekly*, p. 97.

Tankel, J. D., & Murphy, B. K. (1998). Collecting comic books: A study of the fan and curatorial consumption. In C. Harris & A. Alexander (Eds.), *Theorizing fandom* (pp. 53–66). Cresskill, NJ: Hampton Press.

To Ellen and back. (1997, May 2). *Entertainment Weekly,* p. 63.

Tokar, R. (1992). Alpha waves. Letter column appearing in *Alpha Flight, 1*(110), New York: Marvel Enterprises.

Tulloch, J., & Jenkins, H. (1995). *Science fiction audiences: Watching Doctor Who and Star Trek.* London: Routledge.

Chapter 11

Queer Characters in Comic Strips

Edward H. Sewell, Jr.

"Gay and lesbian readers," Matthew Pustz says, "have felt that their experience has...been marginalized by the [comics] industry, prompting the production of titles such as *Gay Comix*, *Dykes to Watch Out For*, and *Hothead Paisan, Homicidal Lesbian Terrorist* that might better speak to this audience" (Pustz, 1999, p. 101).

This chapter explores the role of queer[1] characters in comic strips found in both dominant mainstream newspapers and in alternative queer publications or on the Internet.[2] After a discussion of opposing points of view within critical/queer theory and the foundational arguments they suggest for our critique, a few examples of comic strips with queer characters from both mainstream dominant culture newspapers and from alternative queer sources are examined in light of a queer theory perspective.

Within the critical theory community, there is a less-than-friendly debate about what ideological approach can provide the best framework for reading, understanding, and interpreting queer texts (see for example Abelove, 1995; Dilley, 1999; Fuss, 1991; Gamson, 1995, 2000; Honeychurch, 1996; Jagose, 1996; Seidman, 1993, 1996; Slagle, 1995).

Seidman provides a simple explanation of the implications of a queer theory perspective:

> Queer theory is suggesting that the study of homosexuality should not be a study of a minority—the making of the lesbian/gay/bisexual subject—but a study of those knowledges and social practices that organize "society" as a whole by sexualizing—heterosexualizing or homosexualizing—bodies, desires, acts, identities, social relationships, knowledges, culture, and social institutions.(Seidman, 1996, pp. 12–13)

Some critical scholars argue that the queer, while marginal in the dominant culture, can be tolerated in, if not openly accepted into, that

culture. Many queer theory scholars argue, however, that toleration and marginalization are not acceptable goals or even options for queers. Abelove, based on the experiences self-identified queer students have shared in class, clearly presents the queer sense of "place" when he says:

> ...they [students who call themselves queer] do not typically experience their own subjectivity as marginal, even at those moments when they feel more oppressed by homophobic and heterosexist discourses and institutions. Marginalization isn't their preferred trope. It doesn't seem to them to be cogent as a narrative device for organizing the telling of their own lives or, for that matter, of their history. What these queers prefer to say and believe or try to believe instead is that they are both present and at the center. (Abelove, 1995, p. 48)

The popular "gay" slogan of the 1970s, "We are everywhere," contrasts with the 1990s slogan of Queer Nation, "We are here. We are queer. Get used to it."

"The queer movement," Slagle points out, "is unique in that it avoids essentialism on two separate levels. First, while liberationists have argued for years that gay men, lesbians, and bisexuals are essentially no different from heterosexuals, the new activists argue that queers are different but that marginalization is not justified on the basis of these differences. Second, queer activists avoid essentializing strategies within the movement itself" (Slagle, 1995, p. 87).

One important aspect of queer theory is the performative function of being queer. Halperin argues that performative functions of sexual identity are more related to a location of identity than abstract identity:

> [T]o come out is precisely to expose oneself to a different set of dangers and constraints, to make oneself into a convenient screen onto which straight people can project all the fantasies they routinely entertain about gay people...coming out puts into play a different set of political relations and alters the dynamics of personal and political struggle. *Coming out is an act of freedom, not in the sense of liberation but in the sense of resistance* [emphasis in the original]. (Halperin, 1995, p. 30)

While coming out is an event with major personal implications, being queer is primarily a performative function defining how the queer acts once s/he has decided to live their queerness in a straight world. This performative function is the most common focus of media treatments of the queer community as demonstrated by how queer guests are portrayed on

television talk shows (Gamson, 1998) hosted by presumably straight hosts for dominant heterosexual audiences where only the extreme queer caricature is presented as normative.

The rift between assimilation into the dominant heterosexual culture and separation from it also is evident in the treatments of queer characters in mainstream newspaper comic strips and those run in alternative queer publications and on the Internet. Queer characters in mainstream comic strips are well integrated into heterosexual society in that they look and act "straight" before coming out as queer, and they look and act in a manner appropriate to the dominant heterosexual culture after coming out. They can quickly blend back into their pre-coming out comfortable context in which they may be "gay" and marginal, but still are quite acceptable to those with whom they must interact on a daily basis. There is no homophobic-induced harassment or violence, no offensive remarks about them being a "faggot," and no gay-bashing. They come out and fade back in rather quickly with no lasting consequences.

Lawrence Grossberg (1993, 1996) argues that cultural studies needs to move from essentialist models based on identity differences without separation to models based on articulation, singularity, and otherness. The logic of difference leads to negativity while the logic of otherness leads to positivity. Marginality is replaced by a sense of effectively belonging in which "agency involves relations of participation and access, the possibilities of moving into particular sites of activity and power, and of belonging to them in such a way as to be able to enact their powers" (Grossberg, 1996, p. 99). Thus, in terms of comic strips, rather than simply being different and marginal in a dominant social context, the queer character should be presented in a context that permits a sense of being unique and "other" from the dominant heterosexual culture. Queers need their own "space" in which they can acknowledge their own values, be authentic, and be powerful as individuals and not be simply seen as people with a variant "lifestyle" or "agenda."

Queer characters have not been completely absent in mainstream comic strips. Indeed, several early comic strips appearing in major newspapers made oblique references to queer characters. Milt Caniff's *Terry and the Pirates* introduced a gay male character (Papa Pyzon) in 1936 and a lesbian character (Sanjak) in 1939 (Applegate, 1994). In an interview for *The Comics Journal*, issue no. 108, Caniff said of Papa Pyzon: "People just thought he was a sissy. The idea of any kind of sexual

deviation didn't even enter into peoples' minds in those days." Likewise, he said of Sanjak that "in those days the word 'lesbian' simply wouldn't have been understood by half your audience, and the other half would have resented it" (cited in Applegate, 1994). Mark Burstein suggested in *The Fort Mudge Post,* issue no. 32 (March 1993) that Howland Owl and Churchy LeFemme, two characters in Walt Kelly's *Pogo* comic strip, may have been gay lovers. According to Applegate (1994) "[Burstein's] suggestion based on sight gags and lines taken out of context, generated outraged protests and the conclusion that Kelly may have been engaging in whimsy, but that he certainly didn't seriously intend for readers to infer that Churchy and Howland were gay."

Given these oblique or coded references to queer characters in the comic strips before the 1970s, it was not until February 11, 1976, that Garry Trudeau in the *Doonesbury* comic strip introduced the first openly gay male character (Trudeau, 1978, n.p.). Andy Lippincott was a regular character living successfully in a tolerant but heterosexual world. He was dating Joanie Caucus and there was even the assumption that they might get married. Then, one day, Andy announces that he is gay (Figure 11.1).

There is nothing to visually distinguish Andy from any other character in the strip. Indeed, when Joanie hints to a mutual friend that the relationship between she and Andy is not going to go anywhere, the friend assumes she is the queer party in the relationship.

There is no argument, no recrimination, no strong negative reaction to Andy's "coming out" of the closet. There are no homophobic remarks, no gay-bashing. What Trudeau did by introducing a gay character was admirable. It took a great deal of courage and went against all the accepted standards of the comic strips page. Andy's sexual orientation, however, basically disappears from the strip for 7 years until September 1982 when Lacey Davenport, an older female character who had been a regular in the comic strip, is running for political office in San Francisco. At a meeting of the Bay Area Gay Alliance, Andy reappears as one of the leaders in the organization. There still is nothing about his character to identify him as queer other than the context—a queer meeting—in which the reader encounters him.

While Lacey tries to understand her new gay constituency, she lacks basic knowledge about some key characteristics of what it means to be queer as illustrated in a conversation with two of the men:

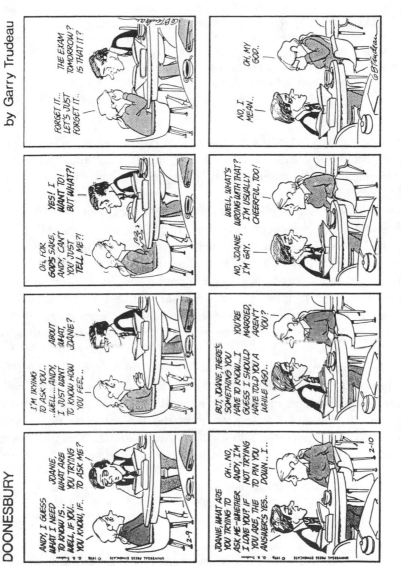

"But have you really tried, I mean, REALLY tried, dating girls your own age?" Lacey asks.

"It doesn't quite work that way, ma'am," one of the men answers.

"I must say, dears, this little chat has been most enlightening. I had no idea the gay community was facing so many problems. As you can imagine, this is all new ground for me. We never had any gays among our family and friends. Well, actually, that's not true. Dick's Uncle Orville came out of the closet last year. He's a federal judge in Chicago."

"That's great! What made him do it?" interrupts one of the men.

"High interest rates," Lacey says, "His butler tried to blackmail him, and he couldn't afford it."

Trudeau, though heterosexual, demonstrates some clear insights into the queer community as he focuses our attention on stereotypes common within the dominant culture that represent the standard cultural caricature of queers.

Lacey wins the election and some time passes until March 27, 1989, when Trudeau introduces into the strip a discussion of AIDS. Once again, Lacey Davenport is the vehicle for discussing the queer community in relationship to what was at the time being described as a national epidemic, and once again common misconceptions and humor work in tandem to make a positive point. While the queer community suffers devastating losses, the dominant culture represented by Lacey finds it difficult to even say the word AIDS when speaking to a queer gathering.

The next time Andy is mentioned in the strip is on June 2, 1990, after he has died of AIDS. The world-view of the dominant culture and the queer community in this episode are not congruent, as a conversation between Joanie and a young queer at the funeral aptly demonstrates. Joanie has just delivered a eulogy for Andy, and as she sits down, an exchange with a young man seated behind her ensues:

"Excuse me? That was a lovely eulogy!"

"Oh...thank you," Joanie responds.

"Would you mind if I asked you a personal question?" the young man asks, "Are you a transvestite?"

"No, I'm a mother of two," she answers.

"A mother of two?" he says, "Wow...Andy sure knew some interesting people!"

Between 1976 and 1990, *Doonesbury* included 27 panels related to

queer characters and issues. During this same time period, no other main-line newspaper comic strip talked about queers or AIDS.[3]

Trudeau "outed" a second queer character in September, 1993. Mark Slackmeyer, a disc jockey, has a dream in which Andy, or his ghost, appears and plants the idea in Mark's mind that he might be gay. Mark, of course, denies the possibility at first, thinks about it, and finally goes to his friend Mike Doonesbury to talk about it:

> "I'm scared, Mike," Mark confesses, "Being gay in this culture is too damn hard. I'd rather continue to be a sexual agnostic."
> "What's going on out there?" J.J. [Mike's wife], calls from another room.
> "It's Mark, J.J.—He thinks he might be gay," responds Mike.
> "Of course he's gay. I've known that for years."

J.J., who has "lots of gay friends," offers to introduce them to Mark, who says, "I don't think so, J.J., I'm not quite there yet..." J.J., though in the dominant heterosexual culture, appears to be very familiar with the queer community and actually thinks she can help Mark become a part of this marginal subculture in which she, though an outsider, feels quite comfortable.

In December 1993, Mark tells his father he is gay; in January 1994, he outs himself on National Public Radio; and in May 1994, he comes out to his mother. While there are some initial negative responses and questions, in each episode Mark is accepted and quickly assimilated back into heterosexual culture. Mark, along with his partner and co–disc jockey Chase, continues to regularly introduce gay topics into *Doonesbury* through their radio show. Commenting on congressional and presidential actions related to gay marriage, for example, Mark says:

> ...and Clinton's failure to veto the anti-gay marriage bill was a new low in election-year gutlessness! What were Clinton and Congress thinking? That their official censure would cause gays to rethink their sexual orientation? Does the family-values crowd believe in the value of commitment or don't they? Here's the irony, gang—come the election, conservatives should be prepared to accept full credit for promoting unstable, irresponsible gay relationships! (Trudeau, 1998, p. 77)

During an on-air interview with presidential candidate George W. Bush, Mark asks, "Why not unburden yourself right now so you won't be tempted to lie later?" Bush replies, "Yeah, right, why don't *you*?" Mark

accepts the challenge: "Okay, I ducked the draft, smoked pot, and I'm gay. Your turn." "Um ..." says Bush, "Gotta run" (Trudeau, 1999, p. 64).

Each time Trudeau introduced a queer theme in *Doonesbury*, some newspapers chose not to run the comic strip, some dropped it altogether, and some moved it from the comics page to the editorial page. Both characters who came out as gay had been regular characters in the strip before Trudeau "outed" them. They had established significant roles within the context of the heterosexual culture in which they lived and worked before coming out. After revealing their sexual orientation, followed by a brief time of adjustment without any strongly negative attitudes, behavior, or lasting effect from the homosexual culture, they returned to their previously established role in the dominant culture status quo.

Readers of newspaper comics learned over the years to expect socially controversial topics in *Doonesbury*, which was not the "typical" family-oriented comic strip. When Lawrence, a regular character in Lynn Johnston's *For Better or For Worse*, came out as gay in 1993, there was a quick public response, both negative and positive (Lawlor, et al., 1994). The syndicate management warned newspaper editors about the potentially controversial content that was going to be presented so they could plan their course of action.

On March 26, 1993, Lawrence, while having a typical casual teenage conversation with his best friend Michael about a new puppy that Lawrence's mother loves dearly, says:

> "I can't get over how much my mom loves that dog, man,"
> "Yeah," responds Michael, "Know what she told my mom? She said the puppy would keep her happy 'til you had children!"
> "What?" asks Lawrence with a surprised look. "Then that puppy better live a long time, Mike, because I'm probably never gonna *have* children."
> "Hey, how do you know?" asks Michael.
> "...'cause I'm probably never going to get married. Ever," replies Lawrence.
> "I don't get what you're saying, man! If you, you know—fall in love?"
> "I have fallen in love," says Lawrence, "...but it's not with a girl."

The physical expressions on each boy's face and their body reactions clearly suggest apprehension about the topic's unexpected turn and development. The conversation continues and Lawrence comes out to Michael (see the conversation in Figure 11.2).

Michael is angry with Lawrence, but with time and thought, he decides to remain friends with him. He even convinces Lawrence to tell his mom he is gay. The conversation between Lawrence and his mom goes like this:

> "This isn't going to be easy," Lawrence begins.
> "Don't worry, honey," Mom says, "Whatever it is, we'll handle it together—calmly and sensibly."
> "I'm gay," Lawrence says with an apprehensive look.
> "Don't be RIDICULOUS!" his mom exclaims, "I don't believe you!"
> "It's the truth, mom," Lawrence says.
> "It's a phase," Mom says, "You'll pass through it!"
> "It isn't a phase, mom!" Lawrence says, "I've always been gay! It's the way I AM!!"
> "It's my fault," Mom says, "I was too protective! I should have pushed you harder."

Lawrence's father throws him out of the house and his mom calls Michael's mom in panic about her missing son. A search is undertaken and Lawrence is found. In the end Lawrence is accepted and assimilated back into the dominant culture of his family and friends.

According to reports in *Editor & Publisher* (Astor, 1993a, 1993b), at least 18 newspapers cancelled *For Better or For Worse*, while about 50 ran an alternate comic strip in place of the controversial episode. Newspapers and trade magazines ran major articles on the controversy, and many newspapers received volumes of letters to the editor on both sides of the issue (Kramer, 1993; Neal, 1993).

Since his initial "coming out" experience, Lawrence continues to appear from time to time in the strip. In one sequence he took his boyfriend, Ben, to the prom. In August 1997, Johnston again angered some readers and newspaper editors when she ran an episode in which Ben, now Lawrence's partner, considers moving to Paris to study piano, and Lawrence has to decide whether to go with him. Each time Lawrence appeared in an episode, some newspapers canceled the strip or replaced it with reruns of earlier episodes (Murray, 1997; Friess, 1997).

Lynn Johnston recalls the event and her reaction:

> Lawrence has been Michael Patterson's close friend and neighbor for many years. He has always been "the kid next door." For the longest time, he appeared consistently with Michael and his friends—but a few years ago, I began to find it harder and harder to bring Lawrence into the picture.

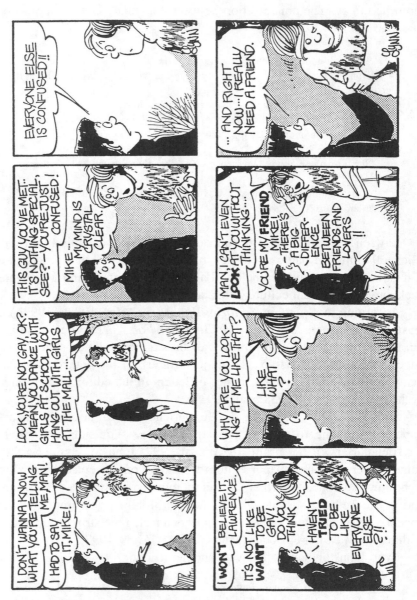

Figure 11.2. Lawrence comes out. From Johnston, L. (1993, March 26–27). *For Better or for Worse.* FOR BETTER OR FOR WORSE © UFS. Reprinted by permission. All rights reserved.

Somehow, his life had taken a different turn and I couldn't quite understand why he wasn't still part of the gang. I began to concentrate on him, see his room, his things, his life.

I know all these people so well. I know where their houses are, what their furniture's like, where they work. I know their voices and their mannerisms, their thoughts are open to me . . . and yet, I couldn't connect with Lawrence.

After "being" with him for some time, I realized that the reason he was having so much trouble communicating with Michael and his friends was because Lawrence, now in his late teens, was different. Lawrence was gay. (Johnston, 1994, p. 106)

As was the case with Trudeau, it is clear that Johnston knows something about the queer community, but she is not a part of it. She writes: "It [Lawrence's story] was written for my friend Michael Vade-Boncoeur, a comedy writer, performer, and childhood friend for whom my son [Michael] and the character in the strip were named. It was written under the guidance of my husband's brother, Ralph Johnston...who, when he came out, gave me the honor of trusting me first" (Johnston, 1999, p. 75).

Although many readers protested the inclusion of a gay character in *For Better or For Worse*, the endings are always happy. Lawrence is not beaten up. After the initial negative reaction from his dad, he is accepted back into the family. There are no offensive names directed toward Lawrence, and as Johnston says of Lawrence, "...he works at Lakeside Landscaping, where he excels in design. He is faithful to his partner, Ben, who is presently studying composition in Paris. He keeps in touch with the Patterson's, who are almost his family, and even though he says he's different...he really hasn't changed at all" (Johnston, 1999, p. 76).

Many in the queer community cannot understand or accept that the process of "coming out" in a heterosexual culture can happen with such calmness and peaceful acceptance. Only a person who is part of the dominant cultural point of view, some queer theorists would argue, could create a world where coming out as queer could have a "fairy tale" ending.

These examples clearly illustrate the acceptable narrative script for queer characters when the comic strip creator is, as far as readers know, heterosexual. Assimilation is normal and easy, being different clearly has its limits, and everyone "lives happily ever after." The world portrayed in the mainstream comic strip does not correlate well with the experiences of people who, in their real lives in the dominant culture, "come out" and identify themselves as queer.

In the 1960s, in response to an ad in the *New York Times* that read "Gay cartoonist wanted," Al Shapiro created *Harry Chess, The Man from A.U.N.T.I.E* under the pen name A. Jay. This was the first gay comic strip, and it played on the James Bond/*Man from U.N.C.L.E.* theme that was current at the time (Triptow, 1989; Streitmatter, 1995b, pp. 98, 104). Other strips from the 1960s and 1970s included Joe Johnson's *Miss Thing*, Trina Robbins' *Sandy Comes Out*, Roberta Gregory's *Dynamite Damsels*, Howard Cruse's *Barefootz*, and Alison Bechdel's *The Crush*.[5]

Robert Triptow (1989) says of the audiences for these early comic strips: "There are a lot of similarities between comics fandom and the gay subculture. The average comics reader, usually a teenage 'fanboy,' is acquainted with the oppression of conformist society—as is the average gay person. Gay life is often looked down upon as (at best) trivial and self-indulgent..." (p. 4). Gerard Donelan describes his experience as a queer cartoonist:

> Hasn't everyone at one time had the urge to cut out a cartoon because "That's me!"? That's what I wanted to do with my cartoons for the gay community. I wanted to do what Joe Johnston's *Miss Thing* in the early days of The Advocate had done for me when I was first coming out. I wanted some fairy to see one of my cartoons, say, "That's me!" and realize that there are others who do what "I" do, feel as "I" feel. I wanted to help show other gay people that "we" have a validity, a sense of humor and a sense of community. (Donelan, 1987, preface, n.p.)

Some queer newspapers in major urban centers include comic strips in their weekly editions. The *Washington (DC) Blade*, for example, runs comic strips each week including Alison Bechdel's *Dykes to Watch Out For*, Eric Orner's *The Unfabulous Social Life of Ethan Green*, John Anderson's *Honestly Ethel*, Glen Hanson and Allan Neuwirth's *Chelsea Boys*, Paige Braddock's *Jane's World*, and Noreen Stevens' *Chosen Family*. It can be argued, however, that these newspapers more and more represent a "niche" publication rather than an "alternative" one (Streitmatter 1995a, 1995b; Fejes & Lennon, 2000). Fred Fejes and Ron Lennon conclude: "The developing lesbian/gay niche media have acquired the legitimacy and the authority to define and speak for the community. Yet in doing so they run the risk again of marginalizing and making invisible groups who have already suffered and been stigmatized because of their sexual and cultural differences" (Fejes & Lennon, 2000, p. 40).

Alison Bechdel, probably the most widely known queer cartoonist,

talks about the effect of a niche market attitude in terms of editorial standards and changes: "[A] comic strip is pretty much editorial proof. Newspapers can't delete, add, or rearrange anything I do. I'm in complete control." She quickly corrects herself, however: "Actually, I lied when I said newspapers can't change anything I do. The *Washington Blade* doesn't permit swearing or reference to certain body parts in their newspaper, so I provide them with a self-bowdlerized alternative when one of my strips contains naughty words" (Bechdel, 1998, p. 185). Books based on her strip are available in mainstream bookstores and thus are readily available to a much wider non-queer audience as would be expected of a "niche" publication.

Universal Press Syndicate even approached Bechdel at a meeting of the National Lesbian and Gay Journalists Association conference about syndicating her strip, but the terms were unacceptable (Fitzgerald, 1994). One change that would have been required before syndication, according to Lee Salem of Universal Press, was that "the title would have to go [to appeal] to a mainstream audience." Other stipulations Salem said included that the strip could not be too political, and that of the four or six characters, only two could be lesbians and they would have to be nonpartisan (cited in Fitzgerald, 1994, p. 14). "I'm not interested in writing for a mainstream audience," Bechdel said: "I'm really happy. I can draw naked people. I can write about politics. I mean, papers are still suspending episodes of *Doonesbury*. I'm not interested in making those kind of compromises" (cited in Fitzgerald, 1994, p. 14). What would a queer comic strip in a mainstream newspaper look like? "I imagine it would be like a lot of the African-American strips," said Bechdel, "like *Jump Start*, which is a nice strip but all the characters are kind of assimilated. The strip would be about straight and gay people living together, maybe. Well, I don't know, but it just wouldn't have any controversy" (cited in Fitzgerald, 1994, p. 15).

Our focus is on comic strips that move beyond the niche market and are directed toward a specifically identified queer audience. Queer comic strips that do not fit into the "niche" category are printed by small alternative presses or are self-published. They are available only at queer bookstores[4] or on the Internet.

The first example is from *XY Magazine*, which is targeted at a young queer population and runs a comic strip as a regular feature. In 1997, the comic strip by Abby Denson, *Tough Love*, featured a high school

sophomore, Brian, who takes a martial arts class taught by a "cute" guy named Chris. Brian dreams of taking Chris to the prom, but he doesn't know if Chris is gay. Julie, a straight friend, has been pressuring Brian to take her to the prom until he tells her he is gay. They remain friends since she is "okay" with his sexual orientation. At school, Brian encounters Chris, half-naked, in the locker room. Brian blushes, and Chris invites him over to watch Kung Fu movies. In the course of conversation, Brian discovers that Chris did have a Chinese boyfriend, but when Li's parents discovered he was queer, they sent him back to China "to make him straight." Brian and Chris go to bed together.

Back at school, word has gotten out about Brian's sexual orientation. Some "jocks" discover that Brian is queer, find him alone in the gym and begin to bully him (Figure 11.3). As the encounter continues, the language gets more explicit when one of the jocks says, "He probably went through our lockers for underwear and shit, what a pervert!" They are interrupted when Chris arrives and uses his martial arts skills to rescue Brian. They spend the night together. Chris asks Brian if he's out to his parents, and when Brian says no, Chris asks, "Brian, are you going to tell her [Brian's mother] you're gay?" "Yes...not now... eventually," Brian replies, "I want to, but I'm afraid.... Chris, I know you're right. But I need some time. Please be patient with me on this."

It is clear that the story is written for teenagers who are dealing with their own sexuality and sexual orientation. It addresses basic experiences in the language typical of teenagers, especially those who have been labeled as gay, queer, or fag. There is little question about whether this is a "family" cartoon appropriate for a mainstream newspaper comic strips page. The only "straight" male characters are homophobic bullies who enjoy bashing queers. The experience it narrates is clearly different from that portrayed in either *Doonesbury* or *For Better or For Worse*.

Club Survival 101 by Joe Phillips, another comic strip from *X Y Magazine*, ran in 1999. The main character is a college guy, Camron (Cam to his friends), who is somewhat "out" but who has not made the transition from straight to queer culture. The strip follows him as he goes to the gay club for the first time, where his friend, Trevor, sees him:

> "My God! I can't believe you actually made it! Your first time in a gay club! I'm so proud!"
> "Whatever...I don't see what the big deal is," Cam says, "Trevor, tell me why everybody is hugging each other like they're goin' off to war."

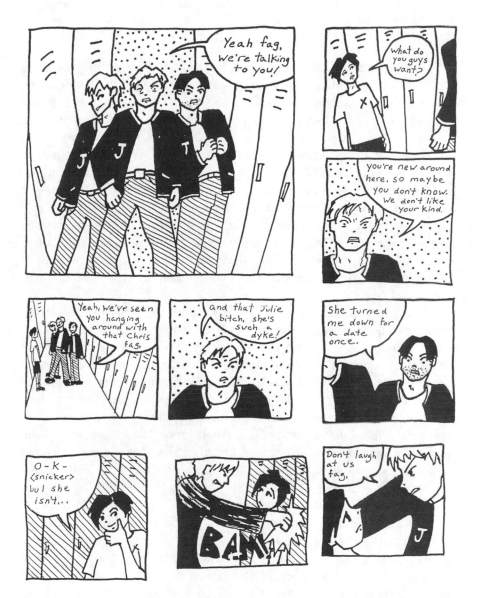

Figure 11.3. Brian is bullied by "jocks." From Denson, A. (1997, July). *Tough Love, 6*(8), p. 45. © 1997 Abby Denson, *XY Magazine*. Reprinted by permission. All rights reserved.

"Oh relax," Trevor says, "Um...Cam? Who told you to dress like a confused straight boy? I take my eyes off you for two minutes and you leave the house lookin' like beach trade."

The dialogue is filled with queer jargon that at times may be quite difficult for non-queer readers to understand completely. Trevor introduces the idea that there is something about the way a person dresses that identifies him or her as queer, at least in a queer environment. A stranger comes up behind Cam, puts his hand on Cam's shoulder, and says: "Oh no she didn't! Yer wearin' A+F after sundown! What in gay hell is wrong with you, Mary? This ain't no rave!" The stranger leads Cam into a back room where a complete transformation takes place. Including a change in the style of his clothes, Cam, now restyled and recreated into an appropriately queer image that fits into the queer club scene, returns to the dance floor. Trevor sees the transformation and says: "Oh, there you...who the hell are you now, the queer formerly known as trade?" (Figure 11.4). They watch the male dancers and mingle with the young gay crowd.

The story continues as the young college guy transitions from straight to queer culture. He meets a wide range of characters and behaves in a manner appropriate to the gay club scene. All the characters in the strip are queer. The role of clothing as a defining characteristic in the queer culture that distinguishes it from the dominant culture is emphasized when at the bottom of the last page of the strip is the notice: "Character clothing and merchandise can be found at http://www.xgear.com".

Kyle's Bed & Breakfast by Greg Fox is an on-line comic strip[5] about a queer man who owns a bed and breakfast. Its focus is the lives and experiences of several men who live there or who are friends of the owner. Each character in the strip is modeled after "typical" queer personality types. Kyle, the owner of the B&B, is a 30-something single man. Brad Steele, a 19-year-old minor league baseball player who is still "in the closet" when in the "straight" world, is just beginning to come to terms with being queer. He lives at the B&B and works as a handyman in exchange for his rent. Richard Rubin is a 24-year-old part-time club deejay, gossip, and fashion disaster. Richard means well but lacks basic social skills. Lance Powers, a 28-year-old African-American advertising executive, has just been relocated from LA to New York. Eduardo Vasquez is an 18-year-old high school senior whose parents threw him

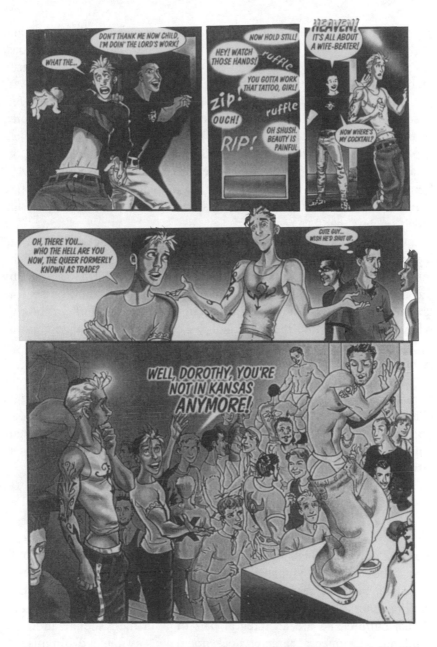

Figure 11.4. Cam is transformed. From Phillips, J. (1999, March). *Club Survival 101, 1*(17), p. 42. © 1999 Joe Phillips, *XY Magazine*. Reprinted by permission. All rights reserved.

out when he came out to them. A Hispanic, he is portrayed as young and foolish. There is one female character who makes cameo appearances, but the story centers almost entirely on male characters who clearly represent some diversity within the queer community.

One of the early episodes revolves around a new baseball player, Jeff Olsen, who has been traded to the minor league baseball team on which Brad plays. One of the men on the team says to Brad, "Well...he's supposed to be an awesome catcher, but, um...he's a little 'light in the cleats'." "Huh?" Brad interjects. The teammate continues:, "He's a *FAG*. Least that's what the rumor is. He's been bounced around between five teams this season. Good catchers don't get bounced around that much...unless there's a *reason*."

When Brad and Jeff encounter one another in the locker room, Brad makes it clear that he does not want to be associated with anyone who may even be suspected of being a queer (Figure 11.5). Jeff is harassed by the men on the team and is quickly traded to a new team, but before leaving, he and Brad have a confrontation. Kyle and Jeff are talking when Brad comes into the room and the conversation escalates into an argument centered on what it means for a man to remain in the closet rather than being honest about his sexual orientation (Figure 11.6).

The action in *Kyle's Bed & Breakfast* does not take place within the dominant heterosexual culture. It does not present a majority of straight characters. The endings are not always happy. The characters use a jargon and language that step well outside the boundaries of the dominant culture. There is little question that this comic strip is created by a queer artist/writer, about queer characters, and for a queer audience.

Conclusion

Heterosexual cartoonists may introduce queer characters into their comic strips, they may be sympathetic in their treatment, and they may even encounter negative reactions from readers and newspaper editors about their openness and empathy. They live, however, in the dominant heterosexual culture and are an integral part of it in their socialization and thinking. The queer character does not have any clear distinguishing characteristics to differentiate him (so far all the queer characters in mainstream comic strips have been men) from the dominant culture. He

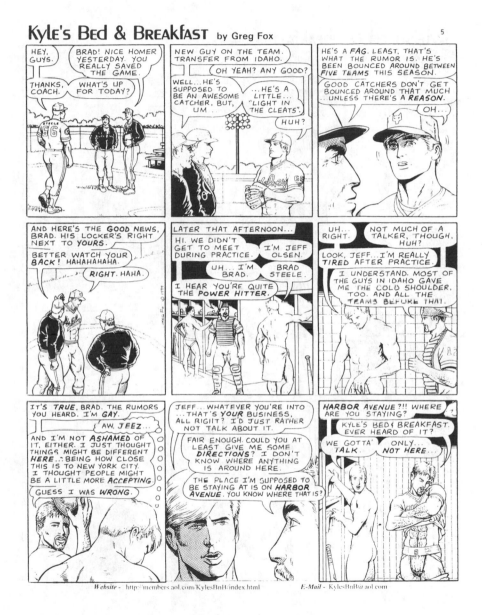

Figure 11.5. Brad learns Jeff is queer. From Fox, G. (1999). *Kyle's Bed and Breakfast, 1*(5). © 1999 Greg Fox. Reprinted by permission of the publisher. All rights reserved.

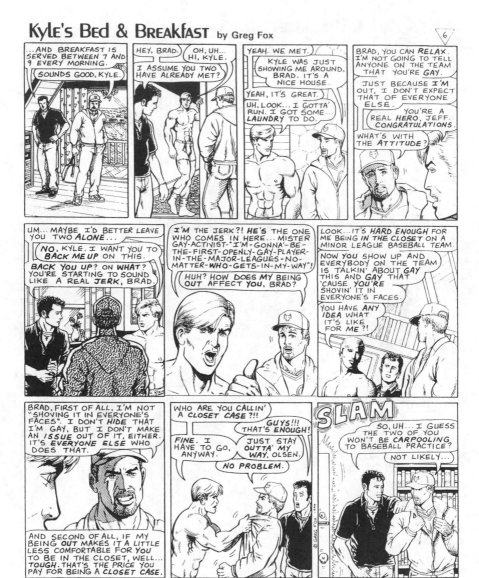

Figure 11.6. Brad and Jeff argue. From Fox, G. (1999). *Kyle's Bed and Breakfast, 1*(6). © 1999 Greg Fox. Reprinted by permission of the publisher. All rights reserved.

is different in a non-obvious, non-threatening way so he can be easily and thoroughly assimilated. He seems to look like everyone else, talk like everyone else, think like everyone else, and behave like all the other heterosexual characters.

Queer cartoonists, on the other hand, tend to include only queer characters or perhaps a small set of heterosexual characters who provide the necessary protagonist needed to create a good narrative. The focus is not on assimilation into a dominant culture, but rather on the creation of a thoroughly queer culture that often is in opposition, if not direct conflict, with the dominant heterosexual culture. Queer individuals often look different, certainly think and act different, and generally feel "out of place" or they have the need to hide their queerness when working within the "straight" world environment. Characters who cannot or will not face up to being queer, such as Brad in *Kyle's Bed & Breakfast*, have internal battles as well as external confrontations about their unwillingness to explore and possibly further own up to their sexual orientation or queerness.

The Internet provides a welcoming environment for queer comic strips. Smaller audiences can access a strip with a clearly defined focus without consideration of issues such as cost of publication, distribution, or editorial oversight—all issues that tend to thwart, if not kill, diversity on the comics pages of dominant culture newspapers.

Will an authentically queer comic strip, by an openly queer cartoonist, appear on the comics pages of your local newspaper? Perhaps the time will come. It happened with African-American and Hispanic comic strips. Queer characters must be allowed to live in a queer world doing queer things with the dominant culture playing a marginalized role. The Queer Nation slogan might be rephrased for queer comic strips as "We're here. We're queer. Give us our queer space!"

Notes

1. Terminology is always something of a problem. Throughout this chapter, the term "queer" is used rather than cumbersome combinations of gay, gay men, lesbian, bisexual, and transgender. It is used in two different ways. First, it is used to identify a sexual orientation different from heterosexual or straight. Second, it is used as a collective term for all the combinations of gay, gay men, gays, lesbians, bisexuals, homosexuals, and transgendered. In instances of direct quotations or paraphrases,

the term used by the quoted or paraphrased source is retained. For a recent discussion of this debate, see Rotello (2000).

2. The role of the Internet in the queer community cannot be overemphasized. It provides a type of "community forum" where people can meet, talk, and have no fear of being "outed" or harassed.

3. The Doonesbury website (http://www.doonesbury.com) has an excellent search engine that locates all dates when a specific topic or character appeared in the strip.

4. Robert Triptow (1989) provides an excellent collection of early queer comics art that is not readily available from any other source. A brief overview of the beginnings of queer comic books and strips is also found in Sabin (1996, p. 124), but without any visual examples.

5. *Kyle's Bed & Breakfast* can be found on-line at URL members.aol.com/KylesB&B

References

Abelove, H. (1995). The queering of lesbian/gay history. *Radical History Review, 62*, 44–57.

Applegate, D. (1994, Fall). Coming out in the comic strips. *Hogan's Alley*, 1, pp. 75–78.

Astor, D. (1993a, April 3). Comic with gay character is dropped by some newspapers. *Editor & Publisher*, p. 32.

Astor, D. (1993b, April 10). More papers cancel controversial comic. *Editor & Publisher*, pp. 34–35.

Bechdel, A. (1998). *The indelible Alison Bechdel: Confessions, comix, and miscellaneous dykes to watch out for*. Ithaca, NY: Firebrand Books.

Dilley, P. (1999). Queer theory: Under construction. *Qualitative Studies in Education, 12*, 457–472.

Donelan, G. P. (1987). *Drawing on the gay experience*. Los Angeles, CA: Liberation Publications.

Fejes, F., & Lennon, R. (2000). Defining the lesbian/gay community? Market research and the lesbian/gay press. *Journal of Homosexuality, 39*, 25–42.

Fitzgerald, M. (1994, October 15). The biggest closet in newspapering. *Editor & Publisher*, pp. 14–15.

Friess, S. (1997, Fall). Syndicate warns papers about gay-themed comic strip. *Alternatives* [newsletter of the National Lesbian & Gay Journalists Association].

Fuss, D. (1991). Inside/out. In D. Fuss (Ed.), *Inside/out: Lesbian theories, gay theories* (pp. 1–12). New York: Routledge.

Gamson, J. (1995). Must identity movements self-destruct? A queer dilemma. *Social Problems, 42*, 390–407.

Gamson, J. (1998). *Freaks talk back: Tabloid talk shows and sexual nonconformity*. Chicago, IL: University of Chicago Press.

Gamson, J. (2000). Sexualities, queer theory, and qualitative research. In N. K. Denzin & Y. S. Lincoln (Eds.), *Handbook of qualitative research*, second edition (pp. 347–365). Thousand Oaks, CA: Sage.

Grossberg, L. (1993). Cultural studies and new worlds. In C. McCarthy & W. Crichlow (Eds.), *Race, identity and representation* (pp. 89–105). New York: Routledge.

Grossberg, L. (1996). Identity and cultural studies: Is that all there is? In S. Hall & P. duGay (Eds.), *Questions of cultural identity* (pp. 87–107). Thousand Oaks, CA: Sage.

Halperin, D. (1995). *Saint Foucault: Toward a gay hagiography*. New York: Oxford University Press.

Honeychurch, K. G. (1996). Researching dissident subjectivities: Queering the grounds of theory and practice, *Harvard Educational Review, 66*, 339–355.

Jagose, A. (1996). *Queer theory: An introduction*. New York: New York University Press.

Johnston, L. (1994). *It's the thought that counts....* Kansas City, MO: Andrews & McMeel.

Johnston, L. (1999). *The lives behind the lines*. Kansas City, MO: Andrews & McMeel.

Kramer, S. D. (1993, April 13). 'Coming out.' *The Washington Post*, B5.

Lawlor, S. D., Sparkes, A., & Wood, J. (1994, July). *When Lawrence came out: Taking the funnies seriously*. Paper presented at the International Communication Association. Sydney, Australia.

Murray, J. (1997, August 25). Cartoon carries message of tolerance. *The Gazette* (Montreal), B3.

Neal, J. (1993, April 23). Family-oriented comic strip character says he's gay. *Comics Buyer's Guide*.

Pustz, M. J. (1999). *Comic book culture: Fanboys and true believers*. Jackson, MS: University Press of Mississippi.

Rotello, G. (2000, August 15). The word that failed. *The Advocate*, p. 112.

Sabin, R. (1996). *Comics, comix & graphic novels*. London: Phaidon.

Seidman, S. (1993). Identity and politics in a "postmodern" gay culture: Some historical and conceptual notes. In M. Warner (Ed.), *Fear of a queer planet: Queer politics and social theory* (pp. 105–142). Minneapolis, MN: University of Minnesota Press.

Seidman, S. (1996). Introduction. In S. Seidman (Ed.), *Queer theory/sociology* (pp. 1–29). Cambridge, MA: Blackwell.

Slagle, A. (1995). In defense of Queer Nation: From *identity politics* to a *politics of difference*. *Western Journal of Communication, 59*, 85–102.

Streitmatter, R. (1995a). Creating a venue for the "Love that dare not speak its name": Origins of the gay and lesbian press. *Journalism and Mass Communication Quarterly, 72*, 436–447.

Streitmatter, R. (1995b). *Unspeakable: The rise of the gay and lesbian press in America*. Boston: Faber and Faber.

Triptow, R. (1989). *Gay comics*. New York: New American Library.

Trudeau, G. B. (1978). *Doonesbury's greatest hits*. NY: Henry Holt.

Trudeau, G. B. (1998). *The bundled Doonesbury: A pre-millennial anthology*. Kansas City, MO: Andrews & McMeel.

Trudeau, G. B. (1999). *Buck wild Doonesbury*. Kansas City, MO: Andrews & McMeel.

Chapter 12

Power to the Cubicle-Dwellers:
An Ideological Reading of *Dilbert*

Julie Davis

Time magazine selected an eclectic group for its list of the most influential Americans of 1997. Tucked among the customary musicians, politicians, and business people was an individual who is only a fictional character—the comic strip character Dilbert. Perhaps this selection should not raise as many eyebrows as it appears to at first glance. After all, *Dilbert* is the fastest–growing syndicated comic strip of its kind in the world (Hamilton, 1999, p. 62). *The Dilbert Principle* was the top-selling management book of 1996 (Capowski, 1997, p. 16); the comic strip currently appears in 1,900 newspapers in 57 countries (Tucker, 1999, p. 64); and The Dilbert Zone world wide web site receives more than two million visitors a day (McCormally, 1997, p. 83). In addition to the print and electronic media, Dilbert and his comic strip cohorts can be found on more than 100 licensed products, including plush toys, calendars, coffee mugs, and clothing.

A phenomenon this size must raise some questions to rhetorical critics. Why do people spend countless hours examining and millions of dollars purchasing merchandise bearing the Dilbert logo? The question I find most pressing is what function does this "influential American" serve for his 150 million daily readers (*"Time's* 25 Most Influential," 1997)? I addressed this question by systematically examining artifacts from the *Dilbert* phenomenon including strips, books, calendars, and the web site. I learned that *Dilbert* functions in two ways for its audience: (1) it exposes the excesses of the American business system, and (2) it provides a type of "comic corrective" to help audience members deal with those excesses. In fulfilling these functions, *Dilbert* provides an ideological critique of American business and industry. This essay will

examine the main tenets of ideological criticism, lay out the characteristics of "supportive" comic strips, illustrate the characters and themes of *Dilbert*, examine reviewers' critiques of the phenomenon, and evaluate *Dilbert* through ideological and supportive lenses.

Ideological Criticism

The idea of ideological criticism springs from Marxist theory. Economic and social "'forces' and 'relations' of production form what Marx called the economic 'base' or 'infrastructure'" of a society (Eagleton, 1991, p. 555). From this infrastructure arises a superstructure designed to protect those who own or control the means of production. The superstructure consists of formal elements such as specific forms of law and politics. It also contains less concrete entities such as religious, ethical, aesthetic, and political ideals that Marx called ideology. Often, cultural artifacts—such as books, television shows, and comic strips—produced by a society express these taken-for-granted assumptions of ideology.

Marx believed that ideology invokes a "false consciousness" whereby people succumb to beliefs and values that sacrifice their personal interests for the benefit of the dominant class. Thus, when the revolution occurred and a proletarian society formed, Marx thought, ideology's "false" consciousness would be replaced with a "true" consciousness representative of workers' material interests (Croteau & Hoynes, 1997). However, this "true" consciousness has yet to appear on a widespread basis, leading Fiske (1992) and others to assume that culture itself is ideological.

Since ideology cannot be abolished, as Marx originally posited, its definition and role in society has evolved over time. Althusser (1971) promotes ideology as a process constantly reconstituted and reproduced as individuals interact with society. Croteau and Hoynes base their view of ideology on Althusser's work, saying,

> ...an ideology is basically a system of meaning that helps define and explain the world and that makes value judgments about that world. Ideology is related to concepts such as "worldview," "belief system," and "values," but it is broader than those terms. It refers not only to the beliefs about the world but also to the basic ways in which the world is defined. (Croteau & Hoynes, 1997, p. 163)

Other definitions of ideology stress the role of perception, social influence, and the association with "naturalness." Black (1965) remains consistent with Marx's original description of ideology as "the network of interconnected convictions that functions in a man epistemologically and that shapes his identity by how he views the world" (p. 112). Ryan (1989) sees texts as ideological if they "promulgate ideas that tend to preserve unjust social power" (p. 210), and White (1992) defines ideology as "beliefs that are taken as 'natural' when in fact they perpetuate the status quo and continue the class system of oppression" (p. 165). Despite differing vocabularies, each of these critics agrees that ideology forms the consciousness of individuals within a society.

A goal of ideologically informed rhetorical criticism is to understand cultural texts in order to change unfair economic and social relations. Wander (1995) argues that although the "ideological view" may sound imposing, "it represents little more than common sense," arguing that no statement should avoid serious questioning as to its purposes and principals (p. 107). Rhetorical criticism informed by ideological notions moves beyond the analysis of form and examines the validity of the social relationships and value systems that may underscore cultural forms. By examining ideology expressed in rhetoric, cultural critics may help give credit to and assist historically situated real people who are striving to improve the world in which we live.

As ideological analysis and criticism have expanded to include mass media, a debate has begun among critics as to whether media espouse only the "dominant ideology" or if different ideologies compete on the airwaves and pages. Many critics (Croteau & Hoynes, 1997; White, 1992; Kaplan, 1992; Fiske, 1992; Feuer, 1992) agree that the media does not produce a homogenous set of taken–for–granted assumptions about American life. Rather,

> Certain cultural practices may express issues and ideas from a prior social formation, whereas other artifacts embody progressive elements that look forward to future forms of social and material practice. In this context, cultural artifacts and texts have the potential to criticize and challenge the status quo by carrying ideological positions that are out of phase with the current, dominant mode of ideological production. (Croteau & Hoynes, 1997, p. 167)

As differing ideologies compete for space and attention in the media, they expose audiences to new or renovated ideas, laying the groundwork

for social change and political activism.

This debate extends to media portrayal of organizations and organizational life where it plays a role in reaffirming and reproducing the dominant ideology by teaching Americans what to expect from the organizations for which they work and with which they interact (Comstock, 1978; Gerbner, 1977). Yet, the media can, and does, do more than reflect current thought. It can also "serve an emancipatory role in the culture by deconstructing these dominant roles and attitudes and by liberating viewing audiences" (Vande Berg & Trujillo, 1989, p. 7). In this way, media images can lay the groundwork for social change by pointing out the flaws in the current ideology.

Once critics understand how rhetoric functions to promote dominant and oppositional ideologies, their next goal should be to show "people how rhetoric is practiced, how language is deployed as a means of coercion, and how they can resist that coercion" (Crowley, 1992, p. 464). White (1992) agrees that "ideological analysis is empowering insofar as it helps lift the blinders of false consciousness and enables people to understand the way the system...help [sic] perpetuate their oppression" (p. 165). By recognizing the ideological elements in rhetorical forms, audiences may also begin to recognize the relationship of these forms to social change.

One such rhetorical form is the comic strip. This chapter argues that one, *Dilbert,* challenges the dominant ideology of corporate upper management and stockholders, an ideology that keeps the characters in *Dilbert*, and many of its readers, working in virtually or actually intolerable conditions. In addition, the strip also serves to help people trapped in these conditions manage their frustrations with their workplaces.

Supportive Comic Strips

Although critics are only just beginning to realize the great influence of comic strips, the American people have been aware of them for decades. Ever since comic strips began in the 1890s, people have read them regularly. In fact, one survey discovered that "four out of five Americans are dedicated devotees of the funnies" (Turner, 1977, p. 25). This fascination reaches worldwide as well as American audiences:

> Two hundred million people in some sixty countries are avid followers of some American comic strips in that they read the little capsules of humor, drama, adventure, or fantasy every day for years on end... (White & Abel, 1963, p. vii)

Not only do large numbers of people—adults as well as children—read the comics, but members of all classes count themselves as avid readers (Berger, 1971).

Comics' influence goes beyond sheer numbers. A multitude of scholarly books and articles have discussed comic strips' functions as vehicles for ideology, persuasion, development communication, and even good health. As Ariel Dorfman has observed:

> Industrially produced fiction has become one of the primary shapers of our emotions and our intellect in the 20th century. Although these stories are supposed merely to entertain us, they constantly give us a secret education. We are not only taught certain styles of violence, the latest fashions, and sex roles by TV, movies, magazines, and comic strips; we are also taught how to succeed, how to love, how to buy, how to conquer, how to forget the past and suppress the future. (quoted in Solomon, 1997b)

Berger states that comics represent an important element of socialization for "the simple fact that millions of children—and adults—cannot continually be exposed to a form of communication without something happening" (Berger, 1971, p. 164). Comics deliver messages about the values, beliefs, and attitudes readers should or should not hold while they deliver humorous messages. Through humor, "they can deal with important problems we all face and yet not raise alarms that may trigger our defense mechanisms" (Berger, 1992, p. 663).

One subgenre of comics, supportive comic strips, especially aids readers in managing their problems. These comics fulfill two main functions for their readers—they help us cope with our daily problems and show that we are not alone with these problems. About this first function, Berger states that:

> Without being aware of what we are doing, we use the funnies to deal with various problems we have, to cope with pressures we face, and to fight stress and anxiety. And we often find particular episodes of strips that help us deal with specific problems. (Berger, 1992, p. 661)

Story lines allow different comics to help their readers with different sets

of problems. For instance, *Sally Forth* discusses the problems modern families face when both parents work outside the home and *Baby Blues* examines the issues encountered by families with very young children.

Along with helping readers cope with their everyday lives, comics also show us that other people face the same, or even worse, situations than we do. Sometimes, discussing a strip's plot line allows people to draw parallels to their own lives and to discuss situations and solutions with friends, family, or coworkers, and other people who share the same problems.

Dilbert relies on this tradition of comic strips as a member of function-driven genres of rhetoric to play a large role in the working life of many Americans. The strip fulfills psychological functions for its readers as they navigate the increasingly perilous waters of corporate life.

Dilbert: The Phenomenon

Dismissing *Dilbert* as a mindless entertainment phenomenon with little or no impact on its audience is tempting but not feasible. Statistics aside, *Dilbert* influences readers. *People* named Dilbert as one of their 25 most intriguing people of 1996 ("Dilbert: A Beleaguered Nerd," 1996–1997). Shortly after that honor, *Newsweek* (1997) named Adams cartoonist of the year (cover). Businesses and educational institutions use a board game based on Dilbert and his coworkers to teach ethics (Dyrud, 1998).

Of even more importance is that many Americans identify with the pot-bellied engineer and his friends. "Each day millions of workers see the banality and brutality of their own working conditions played out before their very eyes...Employees think Dilbert works right down the hall" (McCormally, 1997, p. 83). Adams writes at the beginning of *The Dilbert Principle* (1996) that regardless of how fantastic he makes the comic strip, the comment he hears most frequently is "That's just like my company" (p. 1). He also understands the influence he has on people and organizations:

> "I know, when I pen a lot of strips, that many employees will be posting it on the wall of their cubicle or office or department bulletin board," said Adams, who's quick to admit that he actually does see himself as "the voice of the employee." (quoted in Brown, 1996a, p. 49)

Readers and media writers in turn are quick to grant Adams and his creation as a source of great influence.

Scott Adams' *Dilbert* revolves around the title character, who is an engineer, and his pets and coworkers. The Dilbert Zone web site (www.dilbert.com) published Adams' syndication packet, which described Dilbert as an engineer at a large unnamed corporation in Northern California. Dilbert entelechializes the stereotype of an engineer; the "Cast of Characters" from the Dilbert Zone notes, "He's got the social skills of a mouse pad." Physically, Dilbert is overweight, wears glasses, white short-sleeved shirts, ties that flip up on the end, too—short black pants, and white socks. His hair perpetually stands on end and he lacks any type of oral cavity. Some strips focus on Dilbert's social life, including dates with women who call him Gilbert and get bored when he corrects them (Adams, 1996d). Despite his physical and social shortcomings, "he's a likable guy who keeps trying" (from The Dilbert Zone web site). However, his pet, Dogbert, constantly outmatches Dilbert.

Dogbert, Dilbert's canine companion, resembles his owner down to the glasses and absent mouth. His goal is to conquer the world, enlist some humans in Dogbert's New Ruling Class (DNRC), and convert the rest of the population to domestic servants. The other member of Dilbert's household, Ratbert, only wants to be loved. However, most humans' aversion for rodents, especially rats, makes that an unlikely scenario. So desperate for respect and affection is this character that he learned a talent, singing Barry Manilow songs while rhythmically slapping his head (Adams, 1996c, p. 122). None of the myriad positions Ratbert has taken earned him the respect and affection he craves. Yet, his resiliency allows him to continue to chase them.

Early in the strip's run, Adams realized that the strips centering on Dilbert's work life were the most popular, so he altered the focus of the strip toward workplace issues ("The Anti-management Guru," 1997, p. 64). Hence, Dilbert's coworkers play large roles in the story lines. One of the more prominent members of Dilbert's office is his supervisor. This character's distinguishing physical characteristic is his hair, which only grows in two pointy tufts above each ear. As well as giving him a vaguely satanic appearance, this hairstyle provides him with his moniker—"the Pointy-Haired Boss." This manager of an engineering department lacks technological knowledge to the point that his subordinates give him an Etch-A-Sketch instead of a laptop computer and he does not

recognize the difference (Adams, 1996b, p. 11). When The Boss reads a memo by Dilbert claiming a project was delayed "due to the ongoing bumbling of a clueless, pointy-haired individual," The Boss's only recommendation about the memo involved changing "due to" to "facilitated by," making the report grammatically incorrect (Adams, 1996d). Although he does stay current on all the latest business trends, understanding them does not rank as one of his highest priorities.

Dilbert's project team consists of fellow engineers Wally and Alice. Neither character enjoys his or her job and both expend excessive energy making others aware of his or her displeasure. These characters have switched traditional gender roles: Wally "feels put upon and wants the world to know it. Resentment gave way to bitterness years ago" (from The Dilbert Zone web site). Negative stereotypes of women include adjectives such as whiney, complaining, and nagging (Allen, 1995). These terms are also used in the characterization of Wally. Alice, on the other hand, has difficulty controlling her temper. Many strips end with her struggling to control the "fist of death." In one strip (Adams, 1996d) Alice loses control and pounds The Boss's head into his shirt collar. Society considers physical violence more acceptable among men than among women, causing this scene to be even more absurd. Along with this violation of traditional gender roles in certain instances, neither character enjoys social success, which entrenches the stereotype of engineers as enjoying technology more than humanity.

Six years into *Dilbert's* run, Adams was, ironically, asked to resign from his long-term position at Pacific Bell because of budget constraints. Although this position provided fodder for the strips, fan e-mail had mostly replaced it as a trigger for ideas. The strip's popularity in the four years since Adams left corporate America shows that readers, for the most part, agree with Gendron's (1996) assessment of the strip as "one of the country's most astute commentators on management practices in the Fortune 500" (p. 9).

Dilbert's Critics

Not all critics of *Dilbert* view the strip as a useful source for emotional support. Possibly the most scholarly, and certainly the most caustic, critique is Norman Solomon's (1997a) book *The Trouble with Dilbert:*

How Corporate Culture Gets the Last Laugh. This work claims that Adams inappropriately profits from licensing agreements with companies that use *Dilbert* imagery and that the strip prevents real reform by providing workers with a "pressure valve" to harmlessly release their frustration.

Solomon (1997a) also notes that some of the organizations that use *Dilbert* imagery practice the very techniques the strip lampoons. For instance, Xerox uses *Dilbert* images—including a strip in which Dilbert warns a new hire to run for her life—in booklets promoting its Empowerment programs. Commenting on this practice, the cartoonist Tom Tomorrow (a pseudonym for Dan Perkins) sums up Solomon's (1997a) critique by arguing, "There's something inherently dissonant in using *Dilbert* images to illustrate exactly the sort of corporate babble Scott Adams' entire career is predicated on deconstructing" (quoted in Solomon, 1997a, p. 31).

The other concern Solomon has with Adams' licensing ventures is that organizations feel that its message works to their benefit by attacking inefficiency on the part of employees and low-level managers: "In Dilbert psychodramas, the perennial villain is not inequity or vastly unequal power in the workplace. It's ineptitude, personified by sluggish workers and doltish middle managers" (Solomon, 1997b). Solomon goes on to say that not only would corporations like to use this type of cartoon against their employees, they have used it, to great effect.

> In the corporate jihad of the mid-1990s, *Dilbert* became a stealth weapon against employees. After all, bosses cracking whips commonly have about as much credibility as a slavemaster threatening galley slaves. But a clever satire of inefficiency can go where no whip-cracking is able to penetrate. (Solomon, 1997a, p. 39)

Solomon's (1997a) strongest indictment against *Dilbert* focuses on the comic strip itself. He argues that the strip, rather than fomenting rebellion, actually prevents employees from getting angry enough about their situation to change it. In fact, the book goes so far as to call the strip "a vaccine" and "a mild form of irreverence—touted as full-blown rebellion—inoculates against the authentic malady of anti-corporate fervor" (p. 32). The strip does this by constantly presenting problems without solutions. *Dilbert* shows employees something they already know, that the workplace is absurd and dehumanizing, yet the comic fails to

show causes for these problems deeper than personality conflicts with managers and coworkers. He states, "One of the best ways of teaching people how not to rebel is to offer plenty of ruts for fake rebellion" (p. 92). He says that *Dilbert* provides one of those ruts—employees expend their energy and money on "faux rebellion" by tacking up comic strips and displaying *Dilbert* coffee cups and calendars instead of lobbying for real change.

Critics of Solomon's book call it a "heavy-handed leftist attack" (Colton, 1997, p. C1) full of "scathing" assaults on Adams (Liedtke, 1997). Featherstone (1998) argues that in certain areas of analysis "Solomon overstates his case." Along with criticism of the book, Solomon himself has endured personal attacks, being called "grim" (Carroll, 1997, p. E2). Featherstone criticizes the tone of the book, saying: "You have to have a sense of humor to do battle with a popular cartoon character, and Solomon's seriousness puts him at a disadvantage." (Featherstone, 1998, n.p.)

While Solomon presents an interesting look at *Dilbert*, it is not a complete view. Other themes important to the strip and its success go unmentioned. For instance, Featherstone (1998) noted two important areas Solomon either missed or misdiagnosed. An important theme in the strip is "why work hard when you're being exploited?" This idea sets the worker's interests apart from those of the organization, and provides a message few employers would embrace. The other detail she notes is that *Dilbert*, rather than implying that organizational and employee interests merge, instead serves as "a constant reminder that workers' and companies' interests aren't the same—and mocks Corporate America's absurd rhetorical attempts to camouflage this fact of capitalist life." In this way, *Dilbert* prevents the very type of corporate appropriation Solomon (1997a) decries.

Levine (1998) also recognizes problems with Solomon's (1997a) analysis, particularly that "it's also a mistake to think Adams has some kind of obligation to use his comic strip or books as a platform from which to change the world of work." The alternatives to posting comic strips that Solomon (1997a) mentions—union organizing and public protests— would be extremely economically prohibitive, if not illegal, for most salaried office workers. Criticizing *Dilbert* for failing to provoke public outcry that did not exist before the strip's inception is blatantly unfair to the strip, and to the people who read it. Perhaps what

Dilbert inspires are more subtle forms of understanding and resistance.

Solomon's (1997a, 1997b) critique is useful in that it challenges the existing consensus about *Dilbert*. However, it assumes a very passive view of *Dilbert* readers as people who are influenced by the strip without understanding why. Vande Berg and Trujillo (1989) agree that audiences play a role in creating meaning from media images, a role Solomon (1997a; 1997b) does not grant them. People deserve more credit than he gives them. Audience members are capable of making reasoned decisions about the media they consume, and using it to their advantage. This critique ignores this ability and discounts the decisions readers make.

Dilbert as Ideological Critique of the American Workplace

Any phenomenon that gains as much attention and praise as *Dilbert* cries out for ideological criticism. Close examination of the values and power relationships espoused by the strip will illuminate the taken-for-granted assumptions it presents to its 150 million readers. This section will examine the historical context of the strip and illustrate the elements of capitalist ideology it exposes.

Dilbert differs from many representations of organizations currently available through the mass media in that it shows organizations as the evil entity behind worker discontent. For instance, Vande Berg and Trujillo (1989) state that most television images of organizations portray the companies themselves in positive ways. Any problems workers face stem from the misbehavior of idiosyncratic individuals, who are often punished by the organization for their misdeeds (p. 263). Conversely, two of the most pointed critiques of organizational life on prime-time television in the late 1990s were *Dilbert*-inspired. NBC's *Working*, a 1997–1998 sitcom that satirized corporate culture in such a way that one reviewer observed, "If you're thinking *Dilbert*, no doubt NBC did, too" (Roush, 1997, p. D3). Of course, even more directly connected was UPN's 1999–2000 animated version of *Dilbert*.

Dilbert's absurd workplace filled with ineffective managers, unproductive meetings, and senseless management fads resonates with many American workers who fear living with incomprehensible working conditions or losing their jobs. They have good reason to worry; in a five-year period ending in 1992, 3.5 million American workers lost their jobs

because of downsizing strategies (Boyett & Boyett, 1995, p. 56). Employees who survived the waves of downsizing were nevertheless affected by them. One poll showed that 63% of workers felt less loyal to their companies and 57% felt that their companies were less loyal to them. Half expected to change jobs within the next five years, one-quarter did not believe what their managers told them, and two-thirds did not trust their managers (Boyett & Boyett, 1995, p. 57). Many American workers feel betrayed by their companies. They find themselves trapped in uncertain situations where they hold little or no control.

Dilbert exposes the ideology undergirding many of the changes in organizational life delineated in the preceding paragraphs, and as such speaks to many readers' lives. The following paragraphs will examine how the strip exposes the excesses of the capitalist system that causes these changes to occur. These themes include the focus on financial gain, foregrounding of hierarchical distinctions, and the misery of employees.

Focus on Financial Gain

One of the most commonly discussed excesses of the American economic system is its focus on financial gain at the expense of the environment, humanity, and compassion. Scott Adams, in his own writings, makes no apologies for *Dilbert's* success or for his own financial gain from the empire. In fact, in a recent newsletter, a reader questioned Adams' motives for writing Dilbert:

> Dear Mr. Adams,
> I read a book written by Norman Solomon called "The Trouble With Dilbert."
> He has a theory that you're doing this whole Dilbert thing to make money, not
> to better the lives of the working class. Tell me it isn't true!—Morton. (Adams,
> 1997c, p. 3)

Adams responded to this letter in a section entitled "Dogbert Answers My Mail," where "Dogbert answers the mail that I'm too polite to answer myself" (p. 3). Dogbert's response:

> Dear Moron,
> Mr. Adams is saddened that anyone would accuse him of trying to make money
> as a famous cartoonist when he could just as easily opt to be a wretched bum. It
> seems immoral. I cannot defend Mr. Adams in this free newsletter, but he

assures me he will dedicate a whole chapter to an apology in his next hardcover book.—Dogbert. (Adams, 1997c, pp. 3–4)

Whether the excerpt represents an actual correspondence or was concocted for the amusement of Adams' readers is irrelevant. It insults the intelligence of the writer for even asking the question. Dogbert's response also implies that recourse cannot be gained through the free newsletter; the offended party must buy the next hard cover book to gain his apology. Although Adams (1998) devotes an eight-page section of *The Joy of Work* to responding to Solomon's (1997a) critique, no apology is forthcoming. Instead, he uses humor to defend his financial gain: "Apparently this money trail set me apart from all the other published cartoonists who—and this is not well known—get all of their compensation by breaking into parking meters" (p. 255). These exchanges use humor to critique society's privileging of financial rewards above humanitarian concerns. By using a seemingly innocent question and scholarly criticism as fodder for laughter, Adams expresses the taken-for-granted assumption that individuals act for their own gains, not for others' benefit.

Adams does not give Dogbert all the opportunity to crow about profit. In an *Economist* interview Adams responded to a question about overexposure by saying "you can't get to over-exposure without going through filthy rich first" ("The Anti-management Guru," p. 64). He also claims that one of his favorite ways to spend time is to examine his stock portfolios because "it's fun" (Gerson, 1998, p. 296). These statements mesh well with Adams' views of himself and his work. Despite winning numerous cartooning awards in 1998, Adams does not consider himself an artist:

> I see myself as an entrepreneur who found a way to transfer wealth from other people to himself. All the other things people say about me—"He's changing how people manage"—happen externally to me. That's not my goal. I'm not trying to encourage it. I can't stop it, and if other people are saying it's happening that's fine. Basically, I'm a small business owner. (McGarvey, 1997, p. 123)

Dilbert became the culmination of its author's lifelong dream to become a wealthy entrepreneur. "I knew I wanted to make as much money as I could, and I always figured I would make it by doing something entrepreneurial" (Gendron, 1996, p. 10). By speaking so frankly about his desire for and appreciation of financial gains and rewards, Adams

exposes the taken-for-granted assumption that material wealth is an end justifiable in itself. His use of humor softens the blow and allows readers to see how society privileges financial gain over other goals and to laugh at it and themselves for doing so.

In the *Dilbert* strip itself, the money–grubbing nature of corporate life is critiqued by exaggerating it to the point of absurdity. *The Dilbert Principle* (1996b) offers employees this advice: "Your objective as an employee is to bilk as much unearned money as possible out of the cold, oppressive entity that masquerades as an employer while it sucks the life force out of your body" (quoted in McCormally, 1997, p.84). The book goes on to list manners of achieving this goal; the first and most highly recommended involves maligning one's coworkers. Not only are employees expected to seek profit, but they are also expected to reap the rewards without providing the labor to earn them. These rewards can only be gained at the expense of one's coworkers.

All the blame for these poor attitudes cannot be given to the employees. Management expects more work for the same or lower wages. For instance, in a series of strips on "open book management," Dilbert notes: "I've learned that [the company's] repurchasing stock while I'm working unpaid overtime. Yet I remain highly motivated because I understand that income and equity are distinct concepts" (Adams, 1998, p. 156). The strip also shows that the organization rewards consultants and managers for mistreating employees. In a strip titled "Boss Types," the weasel is defined as a boss "who takes credit for your hard work" (Adams, 1997a, p. 205). A supervisor receiving a large bonus for requiring her staff to put in large amounts of unpaid overtime illustrates this definition. In this way, *Dilbert* shows that structural factors like management incentive programs play a role in economic inequity.

One strip in Adams (1996d; see Figure 12.1) involved The Boss addressing his subordinates: "I just realized I can double your workload and there's nothing you can do about it. You're lucky to have jobs in today's economy! You'll gladly sacrifice your personal life for no extra pay." Companies hold so much power over their employees that they can demand and receive that the employees subordinate private interests and activities to professional ones. Adams (1996e) echoed that same sentiment "Work is its own reward. Expect to get rewarded about twice as much next year." Both employees and management are guilty of the

unabashed search for excess production and its ensuing profit.

Foregrounding of Hierarchical Distinctions

Hierarchical distinctions are another important theme in the *Dilbert* phenomenon. Organizations and their members expend great effort to remind employees of their place in the organizational hierarchy. The individuals in these roles are expected to fulfill specific expectations and duties. For instance, employees do not expect either intelligence or helpfulness from management. *Dogbert's Top Secret Management Handbook* (1996f) helps managers meet their employees' expectations:

> Learn to hide every trace of comprehension and compassion. Your face should send this message: logic is futile. Some rookie managers make the mistake of inviting input. As far as unwarranted optimism is concerned, this is roughly equivalent to panning for gold in your own shower. (section 1.3)

This quotation is another demonstration of the expectation that managers are either unwilling or unable to accept employee suggestions for bettering the workplace and the organization. Adams (1996e) expresses a similar sentiment when he discusses "the boss zone: where time and logic do not apply." Dilbert's supervisor has perfected this technique and seems to permanently reside in this area. An Adams (1996d) strip describes him as a "thought leader." The next panel shows him in a meeting with a blank look on his face and an empty bubble above his head. These examples send a clear message to employees—do not expect support, compassion, or leadership from those on higher levels of the organizational hierarchy.

In many cases, employees lower in the organizational hierarchy are expected to display deference to those above them. For instance, when Dilbert meets his new boss, Mr. Snow, the new supervisor shakes Dilbert's hand and says, "Neal, please." Dilbert promptly genuflects, which leads Mr. Snow to remark that his name is Neal (Adams, 1999, p. 188; see Figure 12.2). Dilbert's action, while humorous, illustrates the degree of class-consciousness faced by workers within our society. Dilbert bought into his own oppression, making him a victim of hegemony. As Dogbert quipped, "Boy, it's a good think his name isn't something like 'Eatachair'" (Adams, 1999, p. 188).

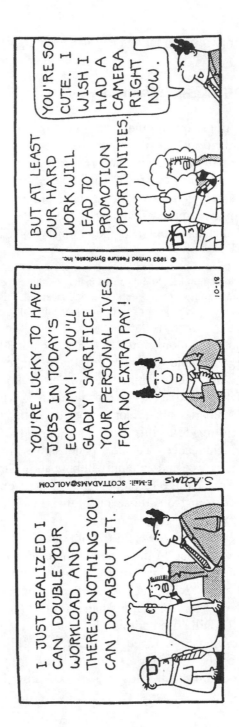

Figure 12.1. From Adams, S. (1996d). *Dilbert daily calendar*, n.p. DILBERT reprinted by permission of United Feature Syndicate, Inc.

Dilbert's low self-esteem is not the only cause of his awareness of power differentials. Management constantly reminds him and his co-workers of their low status. Adams explained that the business world routinely disempowers and humiliates workers: "They're stripped of power and that's rubbed in their faces daily" (quoted in McGarvey, 1997, p. 117). *The Dilbert Principle* (1996b) explores a scenario in which a manager tells his employees they can gauge their importance by the activities he performs while making them wait. Then he teaches himself the banjo. In another example, a new senior vice-president introduces himself by telling Wally to lick the tar off his Porsche. Wally responds, "Okay, but watch the quality of my work" (p. 70). The most brazen example is in Adams (1996d) where a senior executive invites Dilbert to lunch "to show that [senior executives] are just regular people." At lunch the executive remarks "I could squash you like a bug! HA HA HA!" After examining snippets from Dilbert's daily life, kneeling on command appears a reasonable response.

The Misery of Employees

The above-discussed characteristics of capitalism have negative effects on the emotional health of employees. For instance, Foucault (1977) argues that capitalism inherently causes misery among workers. The daily lives of Dilbert and his colleagues exemplify that misery. One strip portrays Dilbert erupting during a meeting: "My status for the week is that the ongoing dehumanization from my job has caused me to doubt my existence. There is reason to believe that I am becoming invisible" (Adams, 1996d). Ironically, no one reacts to this outburst as Dilbert disappears. In fact, his disappearance is not noticed until Ratbert starts riding around on Dilbert's back so Dilbert's colleagues will have a visual reference for his voice. Not only are workers in a capitalist system unhappy, but also this misery is so accepted that even its grossest manifestations are not recognized.

Another example of employees' misery involves the organization literally sucking the life force from its employees and turning them into limp rags. One series of strips (Adams, 1996c, p. 100) illustrates a trend Adams sees in the American workplace:

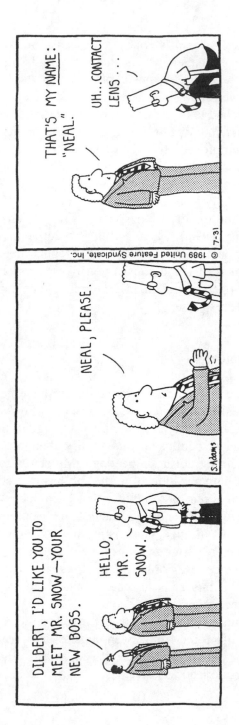

Figure 12.2 From Adams, S. (1999). *Don't step in the leadership*, p. 188. DILBERT reprinted by permission of United Feature Syndicate, Inc.

...the most pernicious thing...is to make employees work [long] hours without getting any return for that effort. Who's getting promotions these days? Raises, for the most part, are puny. So people are giving their all these days, for nothing in return, except the chance to keep their job. (Quoted in Brown, 1997b, p. 13)

A related strip charts Wally's experiences with an outplacement service after being downsized. The organization provided him with a "refurbished ego" because the company destroyed his original ego. Unfortunately, after being downsized, Wally was in such bad shape that the new ego exclaimed, "I will *not* work with that thing [emphasis in the original]" (Adams, 1997a, p. 218). Not only does corporate America destroy employees' egos, it also renders them unsuitable for new ones. While the opportunity to remain employed may satisfy the physical needs of American workers, it does nothing for their higher–order psychological and esteem requirements. Employees are forced to subordinate everything to a job that provides nothing in return except an increasingly pitiful paycheck.

Dilbert also brings to light the low expectations of many members of the American workforce. Material gain is privileged above other concerns, hierarchical distinctions oppress workers, and employees are miserable. James argues that many workers find themselves working in Dilbert's world "and what is particularly sad is that most people do not expect anything better" (quoted in Brown, 1997b, p. 12). By showing the dominant ideology of American capitalism in such an absurd manner, *Dilbert* exposes its flaws and lays the groundwork for social change.

Dilbert as a Supportive Comic Strip

Although many bosses and writers see *Dilbert* as an opportunity for American workers to vent their frustrations with the system, the strip also functions as a supportive comic strip. This function helps readers to cope with their problems.

Supportive comic strips can only be effective if readers see their own lives reflected in the daily funnies. *Dilbert* reflects life in corporate America so well that one business writer states, "It's not a comic strip, it's a documentary—it provides the best window into the reality of corporate life that I've ever seen" (Levy, 1996, p. 53). *TV Guide* explains

"this is the age of Dilbert, when a nation of desk jockeys is grateful to hear the truth about the insanity of corporate culture" (*"TV Guide* Exclusive," 1997, p. 24). One reader agrees, stating, "It's cathartic to watch the incompetent boss in the strip and know that the incompetent boss who let me go wasn't fooling everybody" (quoted in McLaughlin, 1996, p. 82). *Dilbert* recognizes that readers face this insanity on a daily basis and helps them cope with the intricacy of daily life in the American workplace, thus meeting the first of the tasks set forth in the supportive comic strip genre.

Dilbert also fulfills the second function required of supportive comic strips by showing readers that they are not alone in suffering through modern American business and industry. Adams recognized that although many workers had similar experiences, they did not know that they were common:

> There were about 35 million office workers in the United States having this shared experience but not knowing it was shared...all going home and not being able to talk about it because they assumed that it could not be *this* bad anywhere else. (Quoted in McLaughlin, 1996, p. 82)

Adams credits these similar experiences with the increasing popularity of his comic strip:

> Tens of millions of people believed they were in some private hell at work. Dilbert proved to them they were part of a larger class. It was like they suddenly belonged, or like the twins separated at birth. You're in the boat together. (Quoted in Tucker, 1999, p. 68)

Dilbert also legitimizes readers' feelings about their working life. Capowski explains, "Dilbert validates that experience. A common affirmation after reading a Dilbert strip: 'Oh my goodness, my boss/department/company isn't the only one that's crazy!' (Capowski, 1997, p. 16). Adams' comic allows readers to talk about their situations more openly because they realize that others experience similar problems. When they realize that the majority of the material comes from actual reader experiences, feelings of isolation dissipate to be replaced by the camaraderie created from shared experiences.

One way that *Dilbert* helps readers cope with their work lives is by sharing their tales of woe with each other through the Dilbert Zone web page. The Dilbert Zone offers an area, called "List of the Day," where

readers can post their own responses to topics. And many, many readers do exactly this, posting to lists like "Top 553 Clues That Your Boss Is the Worst Manager Alive," "Top 166 Projects Your Boss Canceled by Accident," "Top 256 Things You Didn't Do That Your Boss Criticized You For," "Top 556 Topics Your Ignorant Co-workers Pretend They Know About," and "Top 419 Clues That Your Boss Thinks You're an. Indentured Servant."

This site and these features provide evidence that many *Dilbert* readers actively engage the ideas of the comic strip and apply them to their own lives. Posters to the site often express their identification with the characters and situations conveyed in the strip by taking on pseudonyms similar to character names. For instance, on a list accessed in Summer 2000 titled "Top 347 Stupidest Excuses Your Boss Gave for Not Showing Up," one person—referencing Dilbert's supervisor—posted to the list as "The PHB!" Ten of the other 19 pseudonyms incorporated some incarnation of "bert," including "Embarrassed-Bert with Embarrassed-friend," "Kimber(t)," and "Total Waste of Time and Effort Bert." Other lists continue this trend, citing posts from "Professor-bert," "Dismember," and "NASA bert." These pseudonym selections indicate that readers see themselves in the strip's characters and situations, and that they use the strip as a metaphor for understanding and coping with their workplace abuse.

Visitors to the site can vote on their favorite responses. While some of these responses are obviously fictional, such as the post from "Hillary" commenting that "my manager is Bill Clinton. Need I say more" as a clue she has the worst manager alive, many of the posts appear to represent the real lived experience of the poster. For instance, the top vote–getter for the list of "Clues that your boss is the worst manager alive" stated, "You are consistently in the top 10 on the LOTD [List of the Day], even though you never vote for yourself more than once." Seeing that other readers vote for a person's postings validates that he or she does have bad, mean, or incompetent bosses or coworkers, depending on the topic of the list. This agreement by other *Dilbert* readers provides understanding and implicit emotional support to help the author cope with his or her situation, fulfilling the first function of supportive comic strips. Viewing other people's postings of bizarre workplace conditions also helps readers by seeing that they are not alone in their suffering, thus fulfilling the second function of the genre.

In addition, other lists seem to encourage an active application of Dilbertian principles by advocating resistant actions against organizations. One list in this category was "The Top 375 Assignments You Can Safely Ignore." One top vote–getter posted this contribution:

> Anything from that guy who THINKS he's your boss, but isn't. I just LOVE it when they pompously hand me something saying 'I need this right away.' I say 'OK' and toss it away. Later, Them: 'Where is it?' Me: 'Drop dead pinhead.' They always seem shocked. (Posted by Don'tblamemeIjustworkhere-bert, accessed on August 3, 2000)

Dilbert can fulfill the needs of its audience so well because of such direct reader feedback. Adams was the first comic artist to put his e-mail address in his comic strip to gain reader responses. This practice has proved successful; Adams receives hundreds of messages a day from readers, many of which contain actual incidents he uses as fodder for the strip. In fact, Adams says that, "No matter how absurd I try to make the comic strip, I can't stay ahead of what people tell me they are experiencing in their own workplaces" (1996a, p. 16).

Dilbert fulfills both of the requirements of a functional comic strip—it helps readers cope with day-to-day problems by often reflecting the lived experience of workplace realities and shows them that others share their fate. Thus, in at least one case, a comic strip became popular not just because readers enjoy it, but also because it fills certain psychological and sociological needs in a nonthreatening, humorous manner.

Conclusion

Dilbert's focus on the workplace and workplace issues makes the comic strip a good candidate for ideological critique. It shows how the excesses of the American economic system, especially the search for excess profit and the class struggle, cause employee misery. *Dilbert* does an excellent job of exposing the ideology that keeps the working class from rebelling against the often intolerable environments in which they toil. The strip uses humor to expose this ideology, implying that the modern workplace's mistreatment of its employees is so prevalent as to be laughable. Disclosing the dominant ideology as misguided and dangerous to the self-concept and sanity of workers provides an excellent example of

"criticism carry[ing] us to the point of recognizing good reasons and engaging in right action" (Wander, 1995, p. 120). Hence, this essay uses ideological critique to show that modern work methods, and the capitalism that encourages them, damage both the subordinates and the supervisors who work within it.

However, *Dilbert* provides employees in these dangerous situations with a means of surviving them and in small ways challenging them. By fulfilling certain needs for its readers, *Dilbert* functions as both an ideological critique and as a supportive comic strip. These pockets of discourse exist to fulfill needs of their audiences. "Dilbert started as the graffiti of helplessness, the laugh-to-keep-from-crying plaint of the quintessential Little Guy" (Tucker, 1999, p. 68). The strip uniquely serves the functions readers required because it actively seeks feedback from them. The current state of American business and industry infuses its workers with great anxieties, many of them well founded. *Dilbert* allows readers to view its characters in situations similar to the insanity they face every day. This close identification provides a catharsis for audience members. Also, the window into reality allows readers to see that their situation is not unique. Others face similar hardships in their workplaces. In fact, the comic strip shows that some corporate environments are actually worse than those experienced by the reader.

All comic strips must provide their readers with rewards, otherwise the readers would not support the strip. Different strips fulfill many functions for their audiences, including escapism, information about society and relationships, nostalgia, and vicarious experiences, to name a few (Berger, 1971, p. 168). *Dilbert* provides its readers with a tool for working out the psychological problems caused by coping with changing work environments and feelings of on-the-job isolation. Readers must have found these tools helpful or the strip's readership would not have skyrocketed during the last few years.

As well as fulfilling both ideological and supportive functions for its audience, *Dilbert* speaks out for positive change in the workplace. Brown (1997b) argues, "'Dilbert' is about human rights, human purpose and human potential" (p. 13). Organizations need to stop laughing and start examining the ways in which they resemble the pointy-haired boss and nameless corporation oppressing Dilbert, Wally, and Alice. Only then will they be able to change their cultures to provide better work lives for their organizational members.

References

Adams, S. (1996a, May 13). Dilbert's management handbook. *Fortune*, pp. 99–100, 102, 104, 108, 110.

Adams, S. (1996b). *The Dilbert principle*. New York: HarperBusiness.

Adams, S. (1996c). *Still pumped from using the mouse*. Kansas City, MO: Andrews & McMeel.

Adams, S. (1996d). *Dilbert daily calendar*. Canada: Andrews & McMeel.

Adams, S. (1996e). *Dilbert 1997 calendar*. Canada: Andrews & McMeel.

Adams, S. (1996f). *Dogbert's top secret management handbook*. New York: Harper-Business.

Adams, S. (1997a). *Seven years of highly ineffective people*. Kansas City, MO: Andrews & McMeel.

Adams, S. (1997b). *The Dilbert future: Thriving on stupidity in the 21st Century*. New York: HarperBusiness.

Adams, S. (1997c, December). Dogbert answers my mail. *Dilbert Newsletter 18*, 3–4.

Adams, S. (1998). *The joy of work*. New York: HarperBusiness.

Adams, S. (1999). *Don't step in the leadership*. Kansas City, MO: Andrews & McMeel.

Allen, B. P. (1995). Gender stereotypes are not accurate: A replication of Martin (1987) using diagnostic vs. self-report and behavioral criteria. *Sex Roles: A Journal of Research, 32*(9–10), 583–601.

Althusser, L. (1971). Ideology and ideological state apparatuses. In *Lenin and philosophy and other essays* (B. Brewster, Trans.), pp. 127–187. London: New Left Books.

Berger, A. A. (1971). Comics and culture. *Journal of Popular Culture, 5*(1), 164–177.

Berger, A. A. (1992, May). Funnies are good for us. *The World & I, 7*(5), 659–668.

Black, E. (1965). *Rhetorical criticism: A study in method*. Madison: University of Wisconsin Press.

Boyett, J. H., & Boyett, J. T. (1995). *Beyond workplace 2000*. New York: Penguin Books.

Brown, T. (1997a, February). The deeper side of "Dilbert." *Management Review, 85*(2), 48–53.

Brown, T. (1997b, February). What does Dilbert mean to HR? *HRFocus, 74*(2), 12–13.

Capowski, G. (1997, February). We have seen Dilbert, and he is us. *HRFocus, 74*(2), 16.

Carroll, J. (1997, November 24). "Dilbert" as stooge. *The San Francisco Chronicle*, p. E2.

Colton, M. (1997, November 17). Dilbert, corporate stooge? A leftist isn't amused at all that passive griping. It's just keeping workers in chains. *The Washington Post*, p. C1.

Comstock, G. (1978). The impact of television on American institutions. *Journal of Communication, 28*(2), 12–28.

Croteau, D., & Hoynes, W. (1997). *Media/Society: Industries, images, and audiences*. Thousand Oaks, CA: Pine Forge Press.

Crowley, S. (1992). Reflections on an argument that won't go away: Or a turn of the ideological screw. *Quarterly Journal of Speech, 78.*, 450–465.

Dilbert: A beleaguered nerd hits a workplace nerve. (1996–1997). *People*, pp. 74–75.

Dyrud, M. A. (1998). Ethics à la Dilbert. *Business Communication Quarterly, 61*(4), 113–119.

Eagleton, T. (1991). Marxism and literary criticism. In C. Kaplan & W. Anderson (Eds.), *Criticism: Major statements* (pp. 551–573). New York: St. Martins.

Featherstone, L. (1998, February 6). Dilbert: Just a cartoon. *Media Culture Review*. Retrieved 1999 from the World Wide Web: http://mediademocracy.org/MediaCulture Review/VOL98/2/interview.html.

Feuer, J. (1992). Genre study and television. In R. C. Allen (Ed.), *Channels of discourse reassembled: Television and contemporary criticism* (pp. 138–160), Chapel Hill, NC: University of North Carolina Press.

Fiske, J. (1992). British cultural studies and television In R. C. Allen (Ed.), *Channels of discourse reassembled: Television and contemporary criticism* (pp. 284–326), Chapel Hill, NC: University of North Carolina Press.

Foucault, M. (1977). *Language, counter-memory, practice: Selected essays and interviews* (D. F. Bouchard, Ed.; D. F. Bouchard & S. Simon, Trans.). Ithaca, NY: Cornell University Press.

Gendron, G. (1996, July). Dilbert fired! Starts new biz. *Inc., 18*(10), 9–11.

Gerbner, G. (1977). Television: The new state religion? *Et Cetera, 34*, 145–150.

Gerson, B. (1998, November 23). Happy Days. *Fortune*, p. 296.

Hamilton, K. (1999, January 25). Another day, another indignity, *Newsweek*, p. 62.

Kaplan, E. A. (1992). Feminist criticism and television. In R. C. Allen (Ed.), *Channels of discourse reassembled: Television and contemporary criticism* (pp. 247–283). Chapel Hill, NC: University of North Carolina Press.

Levine, D. S. (1998). The Dilbert empire strikes back [15 paragraphs]. *Disgruntled*. Retrieved 1999 from the World Wide Web: http://www.disgruntled.com/adams1098.html

Levy, S. (1996, August 12). Working in Dilbert's world. *Newsweek*, pp. 52–57.

Liedtke, M. (1997, November 18). Author debunks Dilbert's worker image. [Oakland, CA] *Contra Costa Times*.

McCormally, K. (1997, January). Dilbert gets a raise. *Kiplinger's Personal Finance Magazine, 51*(1), 83–86.

McGarvey, R. (1997, September). The Adams principle. *Entrepreneur*, pp. 117–123.

McLaughlin, L. (1996, March 18). Layoffs for laughs. *Time*, p. 82.

Newsweek. (1997, January 6). cover.

Roush, M. (1997, October 8). Just a "working" stiff. *USA Today*, p. D3.

Ryan, M. (1989). Political criticism. In G. D. Atkins & L. Morrow (Eds.), *Contemporary literary theory* (pp. 200–213). Amherst, MA: University of Massachusetts Press.

Solomon, N. (1997a). *The trouble with Dilbert*. Monroe, ME: Common Courage Press.

Solomon, N. (1997b). Embracing Dilbert in high places. *Disgruntled, 3*(1). Retrieved 1999 from the World Wide Web: http://www.disgruntled.com/solomon1297.html

Time's 25 most influential Americans. (1997, April 21). *Time,* pp. 40–61.

The anti-management guru: Scott Adams has made a business of bashing business. Why does the hand he bites love to feed him? (1997, April 5). *The Economist,* pp. 83–86.

Tucker, C. (1999, January). From cube to tube. *Southwest Airlines Spirit,* pp. 62, 64, 67–68.

Turner, K. J. (1977) Comic strips: A rhetorical perspective. *Central States Speech Journal, 28*(3), 24–35.

TV Guide exclusive: Why *Dilbert* loves TV. (1997, January 11–17). *TV Guide,* pp. 20–24.

Vande Berg, L., & Trujillo, N. (1989). *Organizational life on television.* Norwood, NJ: Ablex.

Wander, P. (1995) The ideological turn in modern criticism. In C. C. Burgchardt (Ed.), *Readings in rhetorical criticism* (pp. 106–124). State College, PA: Strata.

White D. M., & Abel, R. H. (1963). *The funnies: An American idiom.* New York: Free Press of Glencoe.

White, M. (1992). Ideological analysis and television. In R. C. Allen (Ed.), *Channels of discourse reassembled: Television and contemporary criticism* (pp. 161–202). Chapel Hill, NC: University of North Carolina Press.

Contributors

Matthew T. Althouse holds a doctorate from Louisiana State University and is an assistant professor of communication at State University of New York College at Brockport. In addition to conducting research in media studies and rhetorical criticism, he directs SUNY at Brockport's basic communication course in the general education curriculum.

Anne Cooper-Chen, professor of journalism and director of the Institute for International Journalism, Ohio University, received degrees from Vassar College, the University of Michigan, and the University of North Carolina–Chapel Hill. The author of *Mass Communication in Japan* (1997) and *Games in the Global Village* (1994), she served as a Fulbright Senior Research Scholar in Japan in 1992–1993. Her 10 years of full-time professional media experience included work on the *Asahi Evening News*, an English-language daily, and for Weatherhill Inc., a book publisher, both in Tokyo. She spent the 2000–2001 academic year in Beijing, Hong Kong, and Nagoya doing research on Asian mass media.

Lisa M. Cuklanz is associate professor of communication at Boston College. She has published articles in journals including *Critical Studies in Mass Communication, Communication Quarterly, Women's Studies in Communication, International Journal of Comic Art*, and *Communication Studies*. She is the author of *Rape on Trial: How the Mass Media Construct Legal Reform and Social Change* (University of Pennsylvania Press, 1996) and *Rape on Prime Time: Television, Masculinity, and Sexual Violence* (University of Pennsylvania Press, 2000).

Julie Davis is an assistant professor of communication at the College of Charleston in Charleston, South Carolina. She holds a doctorate from the University of Kansas. Her research interests include the study of rhetorical artifacts in organizations and organizational culture.

Morris E. Franklin III received his bachelor's degree from Trinity University in 1994 and his master's degree from the University of Utah

in 1998. He is a Ph.D. candidate at the University of Utah, where he studies mass communication, popular culture, and cultural studies. He currently teaches introduction to mass communication, introduction to cultural studies, and mass media law. His interest in comic books comes from 20 years of reading and collecting. Currently, his time is occupied by his doctoral dissertation, which is an examination of Cold War-era science fiction television.

J. Robyn Goodman received her Bachelor of Journalism from the University of Missouri-Columbia and her master's degree and doctorate from the University of Texas at Austin. She is currently an assistant professor of advertising at the University of Florida. Her research interests include gender and communication, health communication, and political communication.

Ian Gordon is an associate professor in the American Studies Centre at the National University of Singapore. He is the author of *Comic Strips and Consumer Culture, 1890–1945* (Smithsonian Institution Press, 1998) and he has published articles about comics in *American Quarterly*, the *Australasian Journal of American Studies*, and the *Journal of Australian Studies*. His other research interests focus on the use of ethnic imagery in American advertising and marketing and the cultural role of the United States in the Asia-Pacific region.

Annette Matton is a Ph.D. candidate at the University of Exeter, England, researching the representation of the Vietnam War in American comic books. Her article "Reader Responses to Doug Murray's *The 'Nam*" was published in the Spring 2000 issue of the *International Journal of Comic Art*.

Matthew P. McAllister is an associate professor in the Department of Communication Studies at Virginia Tech. His articles about comic books have been published in the *Journal of Communication* and the *Journal of Popular Culture*. He is also the author *of The Commercialization of American Culture: New Advertising, Control and Democracy* (Sage, 1996), and has published works on media criticism and political economy in *Critical Studies in Mass Communication*, the *Journal of Popular Film and Television*, and *The Communication Review*.

Edward H. Sewell, Jr. is an associate professor in the Department of Communication Studies at Virginia Tech. He has written about comics and editorial cartoons in *The 1996 Presidential Campaign: A Communication Perspective* (R. E. Denton, Ed., Praeger, 1998); *The Clinton Presidency: Images, Issues and Communication Strategies* (R. E. Denton, Ed., Praeger, 1996); *The God-Pumpers: Religion in the Electronic Age* (M. Fishwick & R. Browne. Eds., Popular Press, 1987); the *Journal of Visual Literacy*; and *Psychological Reports*.

Matthew J. Smith, when not reading comic books, is an assistant professor of speech communication at Indiana University-South Bend where he teaches courses in rhetorical theory, interpersonal communication, and computer-mediated communication. He holds a doctorate in interpersonal communication from Ohio University and is the co-author on two books, *Exploring Human Communication* (1999) and *Online Communication: Linking Technology, Identity and Culture* (2001).

Wendy Siuyi Wong is assistant professor of digital graphic communication at Hong Kong Baptist University. Her journal articles can be found in the *Journal of Design History* (2000), *Mass Communication & Society* (2000), *International Journal of Comic Art* (2000), and the *Journal of Visual Literacy* (2000). She is the author of two visual communication histories for Chinese readers: *Advertising, Culture, and Everyday Life I: Hong Kong Newspaper Advertisements, 1945–1970* (1999) and *An Illustrated History of Hong Kong Comics* (1999).

Toby Miller
General Editor

Popular Culture and Everyday Life is the new place for critical books in
cultural studies. The series stresses multiple theoretical, political, and
methodological approaches to commodity culture and lived experience by
borrowing from sociological, anthropological, and textual disciplines. Each
volume develops a critical understanding of a key topic in the area through a
combination of thorough literature review, original research, and a student-
reader orientation. The series consists of three types of books: single-authored
monographs, readers of existing classic essays, and new companion volumes
of papers on central topics. Fields to be covered include: fashion, sport,
shopping, therapy, religion, food and drink, youth, music, cultural policy,
popular literature, performance, education, queer theory, race, gender, and
class.

For additional information about this series or for the submission of
manuscripts, please contact:

Toby Miller
Department of Cinema Studies
New York University
721 Broadway, Room 600
New York, New York 10003

To order other books in this series, please contact our Customer Service
Department:

(800) 770-LANG (within the U.S.)
(212) 647-7706 (outside the U.S.)
(212) 647-7707 FAX

Or browse online by series:

www.peterlangusa.com